THE HISTORY OF THE
HONITON LACE INDUSTRY

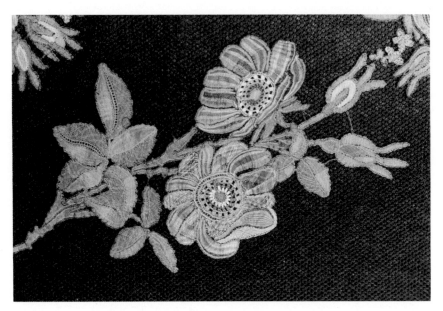

1. Colyton Chromatic (Victoria and Albert Museum, T148-1911).

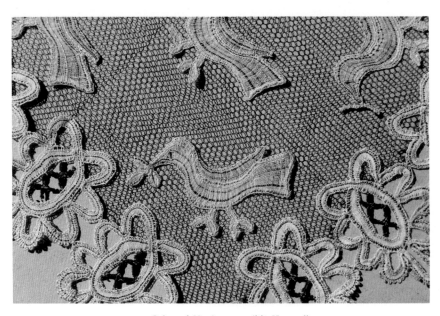

2. Coloured Honiton, possibly Kerswell.

The History of The Honiton Lace Industry

H. J. YALLOP

UNIVERSITY
of
EXETER
PRESS

First published in 1992 by
University of Exeter Press
Reed Hall, Streatham Drive
Exeter EX4 4QR
UK

Reprinted in 1999

British Library Cataloguing in Publication Data
A catalogue record for this book is available from the British Library

ISBN 0 85989 379 0

Typeset in 10½ pt Garamond
by Kestrel Data, Exeter

Printed and bound by Short Run Press Ltd, Exeter

Contents

Preface

This book is based on a thesis of the same title submitted, successfully, to the University of Exeter for the degree of Doctor of Philosophy in 1987. I have edited out various sections appropriate to a university thesis rather than a book and have increased the number of photographs to take account of notable pieces of Honiton lace which have come to light since 1987. The photographs have been placed together so that, as well as illustrating the text, they may be regarded as a self contained section. Purchasers will thus have two books for the price of one!

Acknowledgements for help in the original research are recorded in the thesis (BL Microfilm DX83911). In the preparation of the book I am greatly indebted to Santina Levey who kindly read through a copy of the thesis and whose perceptive comments have been the basis for several revisions from which the text has benefitted: I alone, however, bear the responsibility for the final result. I am also indebted to Elizabeth Saxby, Secretary to the University Press, who has patiently listened to and given me much guidance in the task of turning a thesis into a book. My thanks also go to my daughter, Rachel Yallop, who placed at my disposal her professional skills as a graphic designer and letterer. In particular she designed and executed the lettering on the front cover.

I have endeavoured to make the references to sources as unobtrusive as possible for the benefit of the general reader, whilst making sure that each can be found in full by those who so wish. The basic system is that they are indicated by superscribed numerals in the text and these lead to a reference section at the end of each chapter. There abbreviated references are given which are generally of the form:- Author's surname or other designation/year of publication if there is more than one work under a given name/volume (if more than one) and page number—eg. Roberts, 1856, p.381. To obtain the full reference from this turn to the bibliography, which is in alphabetical order of authors, and find the work by Roberts published in 1856. The result is:

> Roberts, G *A social history of the people of the southern counties of England in past centuries* (London) 1856. p.381

which is all the information required to locate the original source.

In a few instances, such as record office manuscripts, the collection reference number is quoted and miscellaneous sources, such as private communications, are indicated as such. References to items in newspapers are by date of the issue concerned followed by the page and column in brackets—eg. 19 October 1851 (3b). Acts of Parliament are identified by the conventional method of Year of reign/Monarch/Act number—eg. 13/14 Charles 2 c13. References to photographs are given in the form [Plate x].

Abbreviations of some sources have been used, as follows:

BL	British Library
CSPD	Calendars of the State Papers, Domestic Series
CJ	Journals of the House of Commons
CLRO	City of London Record Office
CSPV	Calendars of the State Papers, Venetian Series
CTB	Calendars of the Treasury Books
DCC	Devon County Council
DCNQ	Devon and Cornwall Notes and Queries
DEI	Devon and Exeter Institute
DRO	Devon Record Office
HLRO	House of Lords Record Office
HMC	Historic Manuscripts Commission
LJ	Journals of the House of Lords
PRO	Public Record Office

Lest any reader should be puzzled about the pun alluded to in the caption to photograph [Plate 55], it should be made clear that the first syllable of the name Honiton is, by long tradition, pronounced in the same way as the first syllable of honey. The derivation of the name of the town is from a Saxon settler named Huna, so please describe the product of this industry as 'Huniton Lace'.

Foreword

The middle decades of the nineteenth century saw a spectacular revival of lace as a fashionable fabric after fifty or more years of relative neglect. Elaborately-patterned lace was again made by hand, and copied by the machines. The revived techniques and many of the designs were based on those of earlier periods and antique lace also began to be worn by those who could afford its high cost. Out of this enthusiasm came the first attempts to identify and classify surviving lace and to put together a history of the craft. In 1865 Mrs Bury Palliser published her *History of Lace* which, in the 1902 edition revised and enlarged by M. Jourdain and A. Dryden, was to become the classic English textbook on the subject. But Mrs Bury Palliser was not alone and an extensive literature was built up in Europe and North America during the later nineteenth and early twentieth centuries. With a few important exceptions however, the texts concentrated on technique and indentification, coupled with largely anecdotal historical backgrounds. They also relied lavishly and uncritically on one another.

The collapse of the lace industry after World War I was reflected in the dwindling number of books devoted to its history, a situation that was not to change until lacemaking was revived as a hobby during the 1960s. Since then, lacemaking has become steadily more popular and one outcome has been the growing interest in its history and a resulting demand for information. A few of the old texts were reprinted but new standards and expectations had been established by economic and social historians working in other areas and by the pioneering work of such lace historians as Madame Paulis and Madame Risselin-Steenebrugen in Belgium and Miss Anne Buck in England. By the mid 1980s, the general outline of the history of the European lace industry was agreed and useful work had been done on technical and stylistic aspects of the subject, but it had also become clear that what was now needed was a series of detailed studies of individual centres of production in order to fill-out and amend this general picture.

It is in this context that Dr Yallop's book is to be warmly welcomed. As he observes, passing references to the Honiton industry appear in many books and its importance is taken for granted, but very little firm information has been published about its early history or later development. Until Dr Yallop

made his researches, there had been no attempt to assess the Honiton industry within a wider social or economic context, nor to account for its initial establishment and subsequent rise and fall. I am sure that I shall not be alone in my enjoyment of the resulting account of the industry as it is authoritatively unfolded within the covers of this book.

Santina M. Levey

Introduction

. . . a little thread descanted on by art and industry
Thomas Fuller, 1662

The history of the Honiton lace industry

Honiton lace is one of the classic laces, is known world wide and references
to it, including pictures of examples, mainly of the 19th century product, are
to be found in many books on lace. The history of the industry which
produced it has, however, received only fragmentary mention.

It became apparent, therefore, that there was need for a new and thorough
investigation into this industry which, though localised and definable in both
space and time, had much wider implications since for some three centuries
it served the top fashion market both at home and abroad. Such an
investigation would also make an important and original contribution to the
history of lace in general.

Lace

There is no generally agreed definition of lace, but an acceptable one is that
it is a textile which is based on a pattern of holes produced by the manipulation
of threads, thereby establishing that it is a textile rather than a continuous
substance such as paper, that it has a predetermined design of holes rather
than random or incidental ones, and that the holes are produced by working
the threads rather than by processes such as punching or cutting. It is
confusing that the word lace has also been used for two other commodities,
a braid sewn on to garments for decorative purposes and a narrow strip of
material constructed from threads by weaving, plaiting or other techniques,
used in costume for tying, for example corset and shoe laces. This can lead
to difficulty in interpreting older documents, such as Acts of Parliament and
inventories, to the extent that in some instances the original meaning cannot
now be recovered with certainty. To avoid confusion modern writers tend

to refer to the textile as 'lace' and to the others as 'laces', though consistent usage is not always possible nor observed. Honiton lace is an example of the textile.

Types of lace

For convenience lace is commonly classified into four types according to the construction methods used.

1. Needlepoint lace
This is made with a sewing needle and thread and is essentially based on the buttonhole stitch worked on an outline structure of thick threads secured along the lines of a design drawn on parchment.

2. Bobbin lace
This is made on a pillow, to which a parchment is pinned having the outline of the pattern pricked upon it. The threads, carried on bobbins, are manipulated with each other and held in place by pins placed successively in the holes to form the lace into the predetermined pattern. In documents prior to the mid eighteenth century bobbin lace is frequently referred to as bone lace but it has never been established what the precise function of bone was, though it is probable that the bobbins were made of it. The term thread lace is also found, an expression used to distinguish the textile from the metallic braids made from gold or silver wire. The term pillow lace may also be found.

Bobbin lace can be of two forms

a. Straight lace
In this form the work is taken back and forth across the whole pattern. Since the wider the lace the greater the number of threads there is a practical limit to the width and, although pieces have been made with 800 and more bobbins, most workers find it more convenient to use less. Wide pieces of straight lace are, therefore, made by joining strips in parallel until a sufficient width is attained for a given purpose.

b. Free lace
In this form the work is broken down into small components of the pattern, each of which can be made independently with a small number of bobbins, and these motifs or sprigs are then joined to make a complete piece of lace which can be of any size or shape, hence the term 'free lace'. Some writers prefer the term 'part lace' since the completed work is made in parts, and

others prefer 'non-continuous' to distinguish it from the continuous straight lace. Honiton lace is of this type.

3. Machine lace

Much lace has been made by various types of machinery, both to designs in imitation of popular bobbin laces and to original ones which exploit the technological possibilities of the medium.

4. Miscellaneous laces

Many techniques, such as crochet, knitting and drawn-thread work have been exploited to produce lace-like materials but opinions differ on which of these should be classified as lace.

Honiton lace

The earlier references to bobbin lace making in England show that the technique was widely scattered but a number of the places are only known by isolated references. Among these are London, Manchester, Marlborough, Norwich, Ripon, Rothwell, Warminster and Wells where, save for gold and silver lace in London, no sustained industry appears to have developed. The English bobbin lace industry settled itself in two main areas, Buckinghamshire and adjacent parts of surrounding counties, and in East Devon.

The system used for naming types of lace has been, from earliest times, based on distinctions in methods of construction, and, to a lesser extent, of design. Each lace is almost always named after a geographical locality, usually a town, in which it was originally made, but this must not be taken to imply that it was made solely in the name town. The lace made in the East Devon area was associated from the earliest period with the town of Honiton and, though later records show that it was made over much of East Devon and some of West Dorset as well, the product has rightly long been known as Honiton lace.

The Honiton lace industry

The chief accounts of the Honiton lace industry, as opposed to descriptions of the lace, are a chapter in Mrs Bury Palliser's *History of Lace* and Pam Inder's *Honiton Lace*. Mrs Palliser's book was a pioneering work published in 1865 before ready access was available to much important source material, besides which it is apparent in her text that she frequently relied on unchecked secondary sources and hearsay evidence for facts. Though to be acknowledged

as an early effort this chapter is quite inadequate for a modern exposition on the subject. Inder's is a scholarly production but is a short booklet with only twenty-one pages of text written for sale by the Royal Albert Museum, Exeter and is, therefore, a very limited statement.

The first and basic objective of my research programme was, therefore, the establishment of the facts concerning the history of the industry. Preliminary investigation soon showed that much previous writing relied on secondary sources, themselves based on secondary sources to a number of removes, and that quotations from primary sources were not always accurate or complete. In consequence my research was rigorously taken back to primary sources throughout so that purported facts could be shown really to be facts. The study of the facts of the history of the industry has been taken from its inception, with consideration of when, why and how this occurred, through the years of its prosperity in the seventeenth and eighteenth centuries and the years of decline in the nineteenth to its demise in the twentieth.

The history of the industry is inseparable from the lives of the people who worked in it and this aspect had hitherto received only minimal notice. Attention was, therefore, given to establishing the facts of their lives and work. The key people, who were known as manufacturers, organised the industry and their methods of doing so were studied from the raw material to the distribution of the finished product. The most numerous class of persons was the lacemakers and the details of their lives have been established including their sex and marital status, their training, earnings, methods of payment (in particular the long survival of the truck system), working conditions and health. The aesthetics of design is inseparable from the success of an industry supplying high fashion markets and this aspect of the history was studied.

With a firm basis of fact established it was then possible to attempt interpretations and various aspects of the industry which have hitherto received virtually no attention were considered. Topics which were investigated are the contribution of the industry to the economy of East Devon and the inter-relationships, if any, between various economic historical hypotheses, in particular Thirsk's studies of the rise of industries in the countryside and their relationship to the ambient agriculture, and Mendel's concept of proto-industrialisation. Another important aspect examined is the relationship between the hand made lace techniques and the development of machine methods, and the comparison between this process in the Honiton lace industry with corresponding ones in the general textile scene.

The results of the research have established that the making of Honiton lace constituted an industry which although confined to a limited area, mainly

in East Devon, a relatively remote part of England, nevertheless for some 250 years supplied a luxury product to the major fashion markets of England and Europe. In so doing it provided a living for a significant part of the population of the area. The invention of successful lace making machinery in 1809 provided competition to the hand industry, which resulted in a struggle for survival which lasted, with decreasing success, until the demise of the industry in the second quarter of the twentieth century.

The detailed investigation of the various features of the industry has established many hitherto unknown or barely recognised aspects of economic, social, local and aesthetic history, and has provided a new body of data of potential value for the testing of hypotheses in these branches of knowledge.

Part One

The Rise and Decline of an Industry

Chapter One

The Origin of The Industry

As to the Honiton Lace manufactory there is no record or tradition when it was first established . . .

Courtney Gidley 1820

The date of origin

The earliest primary evidence for the existence of the Honiton lace industry is the inscription on the tomb of James Rodge [Plate 96] in Honiton church yard,

HERE LYETH Ye BODY OF IAMES RODGE OF HONINTON IN Ye COUNTY OF DEVONSHIRE (BONELACE SILLER HATH GIVEN VNTO THE POORE OF HONINTON PISHE THE BENYFIT OF 100L FOR EVER) WHO DECEASED Ye 27 OF IVLY AD 1617 ATATAE SVAE 50: Remember the poore.

The Rodge bequest was incorporated with other bequests into the Hayes Trust[1] and the monies from this still form part of the Honiton United Charities. It is apparent from the size of the bequest that Rodge must have been a successful business man for he may be contrasted with Thomas Marwood, physician to Elizabeth I, who also died in 1617 and is buried nearby. The inscription on his tombstone records a bequest of £10 to the poor of Honiton. This, together with the fact that Rodge was described as a lace seller, suggests that the Honiton lace industry must have been in being for some time before his death.

Estimates for the earliest possible date for the origin can be made from several types of data.

9

a. Early pattern books

Honiton lace is a bobbin lace and development of this form represents the earliest possible date at which the Honiton lace industry could have had its origin. Only a very small minority of the pieces of lace in the world's collections can be dated by documentary or other primary evidence and the period of the introduction of bobbin lace cannot be determined by a study of lace itself. There are, however, a considerable number of surviving early dated pattern books,[2] of which two were devoted to bobbin lace. The earlier was *Le Pompe,* first printed in Venice in 1557, and the later *Nüw Modelbuch, allerley Gattungen Däntelschnür,* printed in Zurich, in the preface of which the anonymous author (RM) states that bobbin lace was introduced by merchants from Venice in 1536, some 25 years earlier, thereby giving a date of publication of 1561. It is clear from this that bobbin lace making was an established craft by 1560; how much earlier it was developed has not so far been determined though the available evidence suggests that it was not more than a few decades.[3]

b. English portraits

A study of the portraits in the Tudor Room at the National Portrait Gallery shows that there is no real depiction of lace until the 1560's, when a number of the portraits indicate its use in costume. Thereafter more portraits depict lace than not and it is apparent therefore that a date around 1560 marks the beginning of the popularity of this form of adornment in England.

c. Books of Rates

Another source of information on the existence of bobbin lace in England is the various Books of Rates produced for use by the customs officers. The items included in these lists represent those which the officers could be expected to encounter, any unusual item being dealt with by agreement with the importer as to its value, so the listed commodities are, therefore, a guide to those which formed significant articles of commerce at the time of compilation of the book.

A study of the Books of Rates, which extend from c1490 to 1825,[4] shows that items which incorporate the word 'lace' in their description fall into three types, as shown in Table 1.1. The first, described as bone lace or thread lace, is clearly bobbin lace and further evidence that this interpretation is correct is that the quantities are specified in lengths, ie. by the yard. The second type is quoted by weight or value and includes gold and silver lace and silk bone lace. It is clear that these entries also refer to bobbin lace. The remaining items where the word 'lace' is used are all quoted by quantity,

Table 1.1 Books of Rates - inclusion of items incorporating the word 'lace' in imports

Commodity	c1490	1507	1545	1558	1562	1582	1590	1653	1656/7	1660	1787	1803	1825
A. Bobbin lace (quoted by length)													
Bone lace of thread or thread lace					x	x	x	x	x	x	x	x	x
B. Metal and other lace (quoted by weight or value)													
Gold and silver lace, silk lace					x			x	x	x			
Silk bone lace								x	x	x		x	x
C. Other items (quoted by quantity)													
Brittain lace(s)			x	x									
Cruel lace					x	x	x	x	x	x		x	
Pomet lace				x	x	x		x	x	x			
Purle lace					x	x	x	x	x	x			
Antlet lace					x	x	x			x			
Flaunders lace		x											
Cantlet lace						x	x						
Passermin lace					x	x	x						
Lether laces			x										
Laces					x	x	x						
Passermine lace of silk (and thread)				x									

usually the gross, and all these, therefore, would appear to refer to laces for tying.

No entries for bobbin lace appear up to 1558 but from 1562 there is regular reference to bone lace of thread and less regular reference to metal and silk lace. It may be concluded, therefore, that bobbin lace was not regarded as of sufficient importance to include it before 1562, but from then on it had become a sufficiently important article of commerce as to warrant a regular entry.

This evidence suggests the establishment of a significant interest in bobbin lace in England by 1560, concurrently with the first pattern books, and this may be taken as the earliest credible date for the beginning of the Honiton lace industry. It is apparent, therefore, that the industry developed during the reign of Elizabeth I and consideration of the reasons for its foundation leads to an argument for a more precise date.

The foundation of the industry

More than thirty authors[5] of books and articles have claimed, either tentatively or unconditionally, that the Honiton lace industry originated with an influx of refugees in the reign of Elizabeth I. These are usually described as Flemings who had fled from the Alva persecutions around 1570 and who landed on the East Devon coast. The story has been repeated in a large number of newspaper and magazine articles. At first sight this is an impressive body of testimony which has, almost without exception, been accepted as true, but investigation shows that none of the authors offers any primary evidence to support the contention and I have been unable to find any. In 1953 Pearse[6] made a public appeal for evidence and received no reply, nor has any been forthcoming in the subsequent years.

In the absence of primary evidence several attempts have been made to support the story by deductions. The best known, and the most often repeated,[7] is that put forward by Palliser.[8] 'Towards the latter end of the sixteenth century various, and, indeed, numerous patronymics of Flemish origin appear among the entries in the church registers still preserved in Honiton' and she specified the names shown in column 1 of Table 1.2. However she gave no authority for her assertion that the names are Flemish. Most of them are to be found in Reaney's *Dictionary of Surnames*[9] and in no instance does he suggest a Flemish origin. In each case he quotes the earliest known date of the use of the name in England and these are shown in column 2. It is apparent that even if Reaney's derivations are questioned and that these names could be regarded as of Flemish origin, their use in England

long before the invention of lacemaking vitiates any argument based on them for an influx of Flemings in the later 16th century.

Table 1.2 Alleged Flemish names quoted by Mrs Palliser

Names given by Mrs Palliser	Earliest known use in England (Reaney)	Earliest pre-nineteenth century date in Honiton registers
Brock	1119	1727*
Burd	1275	1615
Couch	1279	1607
Genest	no entry	1753
Gerard	1086	no entry
Groot	no entry	no entry
Maynard	1086	1753
Murch	1327	1773
Raymunds	1086	no entry
Stocker	1275	no entry
Trump	1235	1717

*There is an isolated entry in 1565, 'Brocke Androowe a very olde man.'

Quite apart from these considerations Palliser's statement is, in any case, not true, for none of these names appears in the Honiton church registers in the latter part of the 16th century. The earliest entries for the names up to the end of the 18th century are given in column 3. Since the industry is known to have been well established by 1617 it is evident that virtually none of the people with these names could have been involved in its origin and most probably none at all if this was appreciably earlier than 1600.

In view of these facts it is ironic that Mrs Palliser wrote in the preface to her book that 'Little, indeed scarce any knowledge on this subject can be gained from books; one author copies his statistics from another, seldom troubling himself to verify the accuracy of his predecessor. Wardrobe accounts, household bills, and public Acts are the most truthful guides; and from these documents alone we write,'

Another argument sometimes put forward in support of the Flemish refugee hypothesis is that there is a resemblance in design between Honiton

and Brussels lace. This argument cannot be applied to the earlier period since no piece of lace is at present known which can be shown unequivocally to have been made in Devon in the 16th, 17th and much of the 18th centuries. There are pieces which are believed to have been so made but opinion, however authoritative, is not primary evidence. Furthermore there is doubt whether a bobbin lace industry existed in Flanders at the time of the Alva persecutions.[10] There is a resemblance in the 18th and 19th centuries, but the latter was a period when much copying went on and imitations of foreign laces, including Brussels, were made in Devon (Chapter 8). In any case design comparison of a material which followed the everchanging dictates of fashion is of slight value as evidence for an event said to have occurred many decades earlier.

There are a number of arguments against the hypothesis, the simplest of which is the commonsense one of geographical improbability. Flanders lies to the east of Southern England and the direct route for refugees would be into the mouth of the Thames, and to Essex and East Kent. Surviving records[11] show that all the refugees mentioned arrived and settled in these areas (Figure 1.1). In contrast a voyage to East Devon would have involved sailing through the Straits of Dover and down the English Channel for some 250 miles, passing many ports on the way, in order to land on an open beach. No propounder of the hypothesis has offered any explanation for such an undertaking, or has even mentioned the point. It might be argued that the refugees were following the trade route of the Devon cloth industry, but then they would have put into Exeter, the maritime centre of the trade. An article in the *Devon and Exeter Daily Gazette* for 1 January 1886 gives a graphic account of a band of footsore refugees, under the leadership of James Rodge, pausing to rest at Honiton and deciding to remain there to ply the trade of lacemaking. This, which appears to be the only suggestion of an overland route, is unsupported by any evidence or explanation of why they were there or to where they were going, and may be dismissed as a piece of journalistic imagination.

Although there are records of landings on the east coast of England there are none of refugees arriving in East Devon. Supporters of the hypothesis are, therefore, faced with the dilemma that there is no lace industry in the area where they are known to have arrived, but there is a lace industry in an area where there is no record of the arrival of refugees (Figure 1.1). The obvious inference is that there is no connection between Flemish refugees and the origin of the Honiton lace industry. How then did the idea arise?

Apart from the numerous authors already mentioned who in referring to the Honiton lace industry ascribe its origin to refugees from the Low

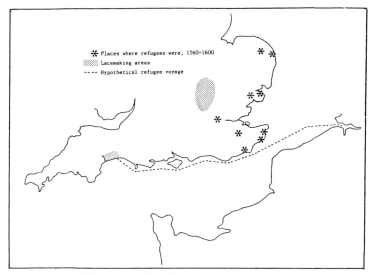

Figure 1.1 Flemish refugees—fact and fiction

Figure 1.2 Straight and free laces—the maritime trade route

Countries, an even larger number can be identified who consider the industry but make no mention of its origin.[12] These two categories are summarized in Table 1.3 which shows the incidence of each form of the statement in the reference given, in periods of twenty five years.

Table 1.3 Incidence of statements of origin of the Honiton lace industry

Period	Reference to refugees	No references to refugees
1625–49	—	1
1650–74	—	2
1675–99	—	1
1700–24	—	2
1725–49	—	1
1750–74	—	6
1775–99	—	3
1800–24	1	7
1825–49	3	7
1850–74	4	5
1875–99	10	7
1900–24	11	7
1925–49	3	5
1950–74	1	—
1975–99	1	—

It will be seen that there are no references to the refugee hypothesis until the first quarter of the nineteenth century, some two and a half centuries after the supposed event. This reference appears in 1822 in the classic work of Devon history, Lysons' *Magna Britannia* Volume XI, completed by Daniel Lysons after the death of his brother Samuel.

The actual wording used by Lysons and by his nineteenth century successors[13] leaves little room for doubt that the subsequent ones are derivative from Lysons. In many cases the words have a close similarity and it is to be noted that none of the authors offers any authority for what they state, save Cunningham who gives Palliser as a reference. The value of this as an authority has already been discussed. It appears, therefore, that Lysons'

text is fundamental to the whole hypothesis and the question arises as to where he obtained this information.

Daniel Lysons collected information by correspondence and the letters he received have survived. One of these contains information about the Honiton lace industry[14] and was written by Mr Courtenay Gidley from Honiton on 24 April 1820. Mr Gidley was a solicitor in practice in the town, was Steward of the Honiton Charities, was clearly conversant with the town's history and was, therefore, a suitable person to provide information on its lace industry. The part of his letter relating to the origin of the industry is as follows:-

> As to the Honiton lace manufactory there is no record or tradition when it was first established . . . But the opinion of the manufacturers here is that it was brought into England by the Lollards who took refuge here in the 14th Century from the religious persecutions in Germany and that many of them settled on the East Coast of Devon and in confirmation of their opinion as to their settlement it is a well known fact that the lacemakers of Devonsh. are only to be found between the Rivers Ax and Exe and in all the villages & hamlets throughout that line of coast hence to the first market towns inland. Those emigrants are said to have come from Michlin Brussels Ghent Antwerp and Bruges and to have also brought into Devonshire the manufacture of woollens.

There does not appear to be any good reason why the lace manufacturers of Honiton in 1820 should be a reliable source for an opinion on an historical topic and such doubt appears fully justified, for it would be difficult to include more historical misinformation into such a small compass. The 14th Century is much too late for the introduction of the woollen industry and it is known that there was a fulling mill in Honiton in 1244.[15] It is far too early for the lace industry since, as has been shown above, this was essentially a development of the 16th Century. The Lollards were English followers of John Wycliffe[16] and although they were persecuted for their religious beliefs, this took place in England. The towns listed are all in Flanders and Brabant.

In Lysons' hands this information was transformed into:-

> The manufacture of bone or thread lace at Honiton . . . was introduced probably in the reign of Queen Elizabeth (p.cccv)
>
> This is said to have been the first town in the county in which serges were made; both this manufacture and that of lace, for which Honiton has long been celebrated, are supposed to have been introduced by the Lollards, who came to England during the religious persecutions in Flanders (p.280).

It will be seen that he totally ignored Gidley's clear factual statement that there is no record or tradition, preferring to use the conjecture of the lace manufacturers. However he transferred the whole process forward by two centuries but retained the Lollards, who by that time had died out, and transferred them from Germany to Flanders.

It is apparent, therefore, that the whole structure of the hypothesis that lace making was brought into East Devon by Flemish refugees is founded on a passage in Gidley's letter, as altered by Lysons. In view of the totally erroneous nature of the views of the lace manufacturers, as quoted by Gidley, it is apparent that the story is a great structure built upon a non-existant foundation, a basis, unfortunately, more likely to result in persistence than otherwise. The failure to find any primary evidence is, therefore, entirely explicable and this fact confirms the view expressed by Joseph Seguin in 1875[17] in what appears to be the only published denial of the Flemish refugee hypothesis. He wrote (trans) 'There is a tradition that the art of making bobbin lace was brought to England by the Flemish emigrants who, fleeing from the tyranny of the Duke of Alva, went to settle in England. This tradition is entirely false for the lace industry did not exist in Flanders when the Duke of Alva went there [1567] . . .' Seguin's book, despite its authoritative character, has never been translated into English and seems to have been but little studied by English writers on lace, a notable exception being Mrs Jackson. It contains a number of perceptive observations. Maybe the lack of translation is due to his (justifiable) criticisms of Mrs Palliser's standards of scholarship at a time when she was regarded as THE authority. Seguin's view is supported by the compilation of the Huguenot Society of London[18] which shows that of the thousands of refugees who came to England at this period only one can be identified as a lacemaker, as opposed to a few makers of laces, and even she was 'the wife of Jerom Savage, an Englishman'.

Turning from speculation to history, the latter part of the sixteenth century saw the beginnings of a great expansion of the production of consumer goods in England.[19] New industries sprang up in many places, and these range from well documented projects under government inspiration to small local enterprises which could turn a humble hamlet into a prosperous village community without leaving any trace of formal documentation. Such projects did not appear just anywhere but settled themselves in places where facilities existed which were likely to give the enterprise a promising start. This would be an important consideration for an entrepreneur seeking a place to plant his scheme, but would be equally important for the success of some small development arising from the enterprise of a much more humble local originator.

For the potential success of a project four criteria can be distinguished. These are the presence of relevant skills, the availability of the necessary raw materials, an appropriate framework of working organisation and good connections with the market for the finished product. Consideration of Honiton at the period of the early lace industry shows that it met these criteria very well and would, therefore, have been one of the places in England favourable for a lace making industry to flourish.

Bobbin lace making is, in essence, a form of weaving and the existence of the Devon cloth industry is well known,[20] Honiton being one of the centres of production.[21] The cloths for which the area was famous were kersies and serges, both made from wool, but the parish registers of Honiton and other places in the vicinity show that the industry had a broader base and range of techniques. Occasional references to occupations are to be found in the registers and in the sixteenth and early seventeenth centuries these include weavers, fullers, tuckers and dyers, as would be expected. However, in addition, pointmakers are found in Honiton in 1573 and Colyton in 1609 and 1612. Points were narrow braids or laces used for tying garments and their manufacture involved special forms of weaving, one of which is akin to bobbin lace making. Other significant entries are to fustian weavers in Colyton in 1609 and 1610 and in Honiton in 1613. Fustian was a mixed cloth involving the use of linen and weavers of it would be conversant with the handling both of woollen and linen threads. It is apparent therefore that the weaving skills of Honiton and adjacent parts of East Devon were more diverse than their fame as a kersey and serge region would lead one to suppose.

The only raw material needed in bobbin lace making is the thread and this, until the nineteenth century, was made of linen. Suitable thread was available in the area for Westcote[22] wrote that '. . . at Axminster you may be furnished with fine flax thread, there spun'. The significance that Westcote attached to the term 'fine' in respect of spinning is shown in his discussion on Kirton spinning.[23]

> . . . which spinning is very fine indeed: which to express the better to gain your belief it is very true that 140 threads of woollen yarn spun in that town were drawn together hrough the eye of a tailor's needle; which needle and threads were, for many years together, to be seen in Watling street in London, in the shop of one Mr Duncombe, at the sign of the golden bottle.

Experiments with modern needles and a sample of fleece of a type likely to have been used, have shown that this statement is entirely credible. It is clear,

therefore, that spinning skills of a high order were to be found in Devon at that period and that, if these were applied to flax, then linen thread comparable to the finest ever produced for lace making could have been spun.

The cloth industry of the Tudor, pre-factory, age was organised on variants of the putting out system[24] whereby successive stages of the work were carried out by individual craftsmen in their own homes. The working of such a system in early seventeenth century Devon is described by Westcote.[25]

> First the gentleman farmer, or husbandman, sends his wool to the market, which is bought either by the comber or spinster, and they, the next week, bring it thither again in yarn, which the weaver buys; and the market following brings that thither again in cloth; where it is sold either to the clothier or to the merchant who transports it.

It is evident that the successive stages of the making of bobbin lace of the free type would fit well into such a tradition, and these could have been that the farmer sent his flax to the market, the spinner would have bought it and returned it as thread, the sprig maker would have bought this and returned it as sprigs, the assembler would have bought these and returned them as lace, which the dealer would have bought and transported to the customers. A chain of events of this sort could well have been the forerunner of the later, known, organisation in which the dealer/manufacturer provided thread to the sprig makers, bought the sprigs from them and put them out to the assemblers and then transported the finished lace to the centres of consumption. Such a scheme would also be consistent with the successful development of the industry in Honiton, a market town, and with the fact that in the late seventeenth century when the first numerical data becomes available, the next most important centres were Ottery St Mary, Lyme Regis and Colyton, all market towns.

The geography of East Devon was a vital factor in determining the location of Honiton and its character as a town through which transport and trade flowed. Westcote described[26] it as '. . . a great thoroughfare from Cornwall, Plymouth, and Exeter, to London; and for the better receipt of travellers, very well furnished with Inns', so it is evident that Tudor and Stuart Honiton was well placed for getting the products of its lace industry to the chief market for luxury goods in the capital.

It may be seen, therefore, that at the time of the early Honiton lace industry there were in the town and surrounding area diverse skills in weaving, local supplies of the raw material required, industry organised in a way into which lace making would readily fit and a good communication with the chief

market. These factors added up to a most favourable set of conditions which then only needed initial impetus for the emergence, and success of a bobbin lace industry.

The actual foundation could have been due to an enterprising London merchant, either native or foreign, seeking a favourable place to start a new venture, designed to cash in on the market for fashion accessories. Alternatively an equally enterprising Honitonian may have been inspired by seeing a sample of lace and have realised the potential of his town for making it. Westcote[27] was impressed by the Devon merchants of his age.

> Next stands forth the merchant, for the good of his country. These inhabit the towns: they abound more than in the inland countries; and their trade much greater than in former ages, as in more diversity of regions, as generally in every place where gain is to be gotton; transporting cloth, tin, lead; returning for it what is most needful for the common weal; and are generally careful, frugal, and industrious; attaining thereby great wealth, worthy of their endeavours.

Numerous references to projects are to be found in contemporary documents and a list of such projects was compiled by Howes[28] in 1614. More recently Hulme[29] compiled and published a more systematic list. Many of the contemporary references are to be found in the BL Lansdowne and Cotton manuscripts and other sources include the BL Additional Manuscripts, the Historic Manuscripts Commission volumes and the Calendars of the State Papers, Domestic series. However in none of these does there appear to be any proposal to make bobbin lace, either at Honiton or anywhere else in Britain.

A possible explanation for this lack of a reference is that such a project was proposed, and came into being, but that the documentation relating to it has not survived, or has done so in some obscure and unsuspected place. Such a possibility could never be proved to be wrong. However, in view of the wealth of surviving evidence on projects an alternative explanation is possible, even probable, namely that no project for bobbin lace making was ever mooted. Some negative evidence consistent with such a view emerges from the Honiton church registers. In many cases projectors were themselves immigrants possessing a skill new to England or were natives who brought in foreign craftsmen to aid in establishing the manufacture. The Honiton records up to 1620 contain 593 surnames (plus a number of variant spellings) and among these there is no evidence for any influx of foreigners.

The interest in bobbin lace developed around 1560, and if this were to

correspond with the start of the industry for making it, then it could have been established in a range of centres before the policy of granting patents of monopoly for projects really developed later in the decade. The lack of evidence for a project is, therefore, consistent with a start to the Honiton lace industry at a period near the beginning of the reign of Elizabeth I. It may be significant that the first bobbin lace pattern books, the rise in interest of lace in England and a potential date for the start of the Honiton lace industry deduced from other considerations, all point to much the same date. Taking all the evidence, both positive and negative, into account there is a case for postulating a start for the Honiton lace industry around 1560.

Further evidence for an early start to the bobbin lace industry in England emerges from a petition of the lacemakers of Buckinghamshire[30] in 1698 in which it is stated that the manufacture had been exercised several hundred years in England. This cannot be taken literally, but implies that the industry started well before living memory, including the extra period represented by the remembrance of what old people had said, and this takes the date substantially back into the sixteenth century.

Why is Honiton lace a free lace?

A further question of interest in connection with the start of the Honiton lace industry is the identification of the possible route whereby the knowledge of bobbin lace, and of the technique of making it, spread to England. The evidence of the early pattern books strongly points to Venice as the original home of the material though, until recently, Seguin[31] appears to have been the only lace historian to have upheld this view. Recent authoritative writers,[32] however, now subscribe to this hypothesis. The author of the *Nüw Modelbuch* states that the technique was taken to Zurich by Venetian merchants, from whence it could have reached England via Alsace and Flanders, the last step by merchants, not refugees. Seguin[33] considered that the knowledge spread to France and hence to Flanders owing to the activities of the pedlars of Savoy, Auvergne and Lorraine, and although he offered no evidence in support of his statement, as an Auvergnat he was, presumably, conversant with the general history of his region. He suggested that these pedlars were responsible for the spread from Northern Italy to Auvergne, where the Le Puy lace industry developed, and thence to Velay, Lorraine and Burgoyne, from whence it penetrated to Flanders. Whilst these two hypotheses provide plausible overland routes for the spread of the lace and manufacturing knowledge there is another which should be considered.

In the sixteenth century Italian culture was much in favour in England and

Giovanni Michiel[34] in a report to the Venetian senate in 1557 stated that the young Duke of Savoy '. . . was educated in conformity with Italian manners and customs, which the English value and imitate more than those of other nations'. There was an Italian colony in London[35] which included both merchants and courtiers and frequent references to Italians are to be found in the state papers of the period. The trade engendered by these contacts resulted in the establishment of a maritime connection carried on both by Venetian[36] and English[37] ships, the ports of call being London and, up to the third quarter of the sixteenth century, Southampton.[38] There is also a possibility that there was a direct link with Devon, since in 1585[39] the fishermen and owners of ships on the south Devon coast petitioned the justices of the county, asking them to procure permission from the Council to transport their fish to France and Italy despite the current prohibition. There is no record of the outcome, but the existence of the petition suggests that such trade may have occurred in the past. Venetian maritime trade extended also to the Low Countries, in particular Antwerp.[40]

This trade route, which was actively in use in the middle of the sixteenth century, formed a direct link between Venice and the two northern lace areas of England and Flanders. It is possible, therefore, that this link may have been the channel whereby the knowledge of bobbin lace reached England, and perhaps Flanders as well. Such a possibility provides an explanation for the hitherto unexplained distribution of the lace making centres which specialised in free lace, namely Venice, Milan, Honiton and Brussels. The geographical distribution of these, together with the known early straight lace making areas is illustrated in Figure 1.2.

The date at which free lace making was started in each area is not known and both the dating and provenancing of the earliest pieces believed to be associated with them is uncertain. It seems likely that the technique evolved in Venice and this supposition receives support from two of the designs in *Le Pompe* which involve representations of human figures reminiscent of free lace motifs. It is of interest to note that when Payne[41] set about the working of these designs she specifically used a Honiton lace technique at one point and a contemporary Honiton lace teacher[42] has described the working of these figures as akin to that for Honiton, as distinct from that for straight lace. It could well be that the genesis of free lace is enshrined in *Le Pompe*

An early notable surviving example of Venetian free lace is a large cover in the Victoria and Albert Museum[43] traditionally associated with Phillip IV of Spain. Levey[44] describes this as technically a direct descendant of the laces in *Le Pompe* and is of the opinion that it is probably of Venetian origin,

dating from the second quarter of the seventeenth century. An early example of free lace designated as probably Milanese is in the Metropolitan Museum, New York,[45] has design affinities with the last piece and is assigned to the 1620's. The earliest apparent example of surviving Flemish free lace is the so-called Archduke's bedspread in the Musees Royaux d'Art et d'Histoire in Brussels, usually dated as 1599[46] though this is opinion only and there is reason to assign a date in the 1620's.[47] Although the design is closely modelled on Flemish subjects Paulis[48] has observed that documentation on this piece is lacking and it is of interest to note that Ricci[49] described the decorative motifs rightly as 'pure Venetian' and ascribed this to the influence of Venice, though, whilst a Flemish origin for the design may be correct, a Venetian origin for the work is a possibility which cannot be discounted. An early surviving piece of what may be Honiton lace (c1635) is in the collection of Allhallows Museum, Honiton [Plate 4]. This also shows an affinity to some of the designs in Le Pompe. It will be seen, therefore, that early surviving examples from the four free lace areas all date from the first decades of the seventeenth century and all show an affinity to Venetian design.

The spread of Venetian ideas and techniques to Milan is easily explained, for in the late sixteenth century the Venetian mainland territory (Terra Firma) stretched nearly to that city. The other two free lace areas, beyond and among various straight lace ones, appear inexplicably dissociated if the spread is thought of in terms of overland routes. The Venetian maritime Atlantic trade route, however, provides a direct connection between there and these areas, and furnishes a credible explanation for the spread of bobbin lace and its technique to England and Flanders. It also provides an explanation for the existence of two apparently isolated free lace areas in the north and does away with the long standing and sterile arguments on whether Honiton copied Brussels or vice versa by providing the answer that they each derived it from a common source, namely Venice. Thereafter each developed its own similar but distinctive style.

What the earliest Honiton lace was like is not known since no provenanced pieces or references have yet been identified. There are references to bone lace in various sixteenth century documents, in particular Elizabeth I's wardrobe accounts, and it is possible that some of these relate to products of the Honiton lace industry. The descriptions are, however, insufficient for identification of the source to be possible in the present state of knowledge.

References

1. Gidley, 1814
2. Levey and Payne cite 111 books running to 291 editions printed between 1523 and 1600.
3. Levey, 1983, p.5,6.
4. A list of those of which copies are known is given in the bibliography under Books of Rates.
5. Billins, Honiton. Black, p.164. Coxhead, 1952, p.23. Cunningham, 1897, p.177. Dryden, 1904, p.239. Farquharson, 1891, p.232. Glenavon, p.227. Inder, p.2. Jourdain, 1908, p.89. Knight and Dutton, p.112. Lowes, p.162. Lysons, 1822, p.cccv, 280. Mate (Honiton), 1903, pages unnumbered. Mincoff and Marriage, p.48. Moody, 1907, p.8. Moore, 1829, p.384. Moore, 1904, p.189. Moule, I p.273. Murray, p.38. Palliser, 1865, p.373. Rogers, 1942. Rogers, 1888, p.273. Smiles, p.110. Treadwin, 1883, p.231. Ward Lock, 1910/11, p.11; 1925/26, p.47; 1933/34, p.47; 1936/37, p.47. White, all editions, Honiton. Worth, p.80.
6. Pearse, p.106.
7. eg. Coxhead, 1952, p.23. Lowes, p.162. Smiles, p.110.
8. Palliser, 1865, p.373.
9. Reaney
10. Seguin, p.140. Levey, p.9.
11. CSPD, 1561, 1562, 1563, 1566, 1567, 1570, 1571, 1572, 1575, 1583, 1586, 1587.
12. Anderson, p.69. Anon, 1793, p.113. Bowen, Honiton. Britton and Bayley, p.300. Camden, I p.37. Campbell, 1774, p.347. Cosmo 3, p.107. Crosby, p.244. Defoe, 1918, p.145. Dodsley, p.7. Evans, p.76. Fiennes, p.136. Fuller, I p.396. Gay, p.203. Kelly, Devonshire—all editions. Lefebure, p.307. Lewis, Honiton. McCulloch, p.1015. Milles, Honiton. Morris, Honiton. Page, 1893, p.48. Penny Cyclopaedia, Honiton. Pigot, 1830 and 1844, Honiton. Postlethwayt, lace. Powys, 1899, p.77. Robins, Honiton. Southey, p.309. Stirling, p.179. Thompson and Clark, p.95. Universal British Dictionary, Honiton. Unknown author, Honiton. Vancouver, p.394. Ward and Baddeley, Honiton. Westcote, p.61, 227. Wyatt, lace.
13. Lysons, 1822, p.cccv, 280. Moore, 1829, p.384. Moule, I p.273. White, 1850, p.364. Billins, Honiton. Palliser, 1865, p.373. Black, p.164. Cunningham, 1897, p.177.
14. BL Add MS 9427 Item 255.
15. Hoskins, 1972, p.125.
16. eg. McFarlane.
17. Seguin, p.140.
18. Huguenot Society, 1900.
19. Thirsk, 1978, chapters 2,3.
20. eg. Hoskins, 1972, p.124-130.
21. eg. Coxhead, 1952, chapter 1.

22. Westcote, p.61, 246.
23. Westcote, p.121.
24. Coleman, 1975, p.23.
25. Westcote, p.61.
26. Westcote, p.226.
27. Westcote, p.51.
28. Stow, p.1038.
29. Hulme.
30. CJ, XIII, p.85.
31. Seguin, p.21.
32. Levey, p.9. Casonova, p.15.
33. Seguin, p.22.
34. CSPV, VI p.1086.
35. Einstein, p.189, 190, 192, 213.
36. Lane, p.23.
37. Tenenti, p.59.
38. Ruddock, p.232.
39. CSPD, 1585, p.276.
40. CSPD, 1561, p.188.
41. Levey and Payne, p.104, 105, 112, 113.
42. Mrs Perryman of Honiton.
43. V and A, 870-1880.
44. Levey, p.22.
45. 20.186.354.
46. Overloop, p.35.
47. Croix, p.89.
48. Paulis, 1942, p.114.
49. Ricci, p.44.

Chapter Two

1617–1707
An Age of Legislation

The making Bonelace has been an ancient Manufacture of England; and the Wisdom of our Parliaments all along thought it the Interest of this Kingdom to prohibit its Importation from Foreign Parts.

Lacemakers memorandum to Parliament 1698

During the ninety years from the first specific mention of the Honiton lace industry, the epitaph of James Rodge in 1617, to the Act of Parliament of 1707, which finally abolished restrictions on the importation of foreign lace, the bobbin lace industry in England was much affected by national concerns. Protection, of variable effectiveness, from foreign competition occurred through the ban on imports from Flanders during the war with Spain from 1625 to 1630, by a royal proclamation which banned all importation of foreign lace from 1635 to 1639, and by Act of Parliament which imposed a similar ban in 1662 and which remained in force until repealed in 1707. Thus there were protective measures in force for a total of fifty four years out of ninety. The prohibitions encouraged smuggling—a lacemakers memorandum of 1698 observed that '. . . the Art of Smuggling being grown to greater Perfection than formerly . . .'—with the consequent activities of informers and preventive officers. Hindrances to the industry included a number of periods of trade depression, the Civil War when the royal and parliamentary armies passed through Honiton itself on a number of occasions and when extra taxes included one on lace, the Commonwealth period when the puritan outlook did not favour luxury adornment, and the Monmouth rebellion when the Honiton lacemaking district was closely involved both with the

rebellion and with the subsequent Bloody Assizes. Moreover James II later stated that the crucial event which led to his downfall in 1688 occurred at Honiton. During this period the Honiton lace industry must be observed in the context of these events and it will be seen that the surviving records provide a picture of an enterprise which successfully continued despite all of them.

The early seventeenth century

The inscription on James Rodge's tombstone suggests that in 1617 the Honiton lace industry was prospering in Honiton itself. How far it had spread through the hinterland is not known but evidently it had not reached Beer, a place later well-known for lace making, since the parish registers record many occupations between 1584 and 1612, but neither lace making nor dealing is mentioned. No actual figure for the numbers of lacemakers is available but it is possible to make an estimate from the fact that in 1626 Edward Sackville, Earl of Dorset, stated in the House of Lords[1] that the total number of lacemakers in England was in excess of 20,000. This figure is similar to the total given in the lacemakers' memorandum of 1698, which showed that at that time approximately 25% were in East Devon and West Dorset. If a similar proportion obtained earlier in the century it appears that the Honiton lace industry could have made a significant contribution to the economy of the area.

The slump of 1620–24 had its effects on the lace trade in the East Midlands for on 8 April 1623 a communication to the High Sheriff of Buckinghamshire stated that the decay of the clothing and of the bone-lace trade was causing great poverty,[2] but if the Honiton lace industry was likewise affected it certainly recovered rapidly for Westcote[3] writing in 1630, but reflecting conditions of the previous year or two, observed of Honiton that '. . . here is made abundance of bone lace, a pretty toy now greatly in request . . .' and added a free rendering from Martialis,

> In praise of toys such as this
> Honiton to none second is.

This indicates the importance of Honiton itself in the local lace industry and perhaps in the country, though some allowance should be made for a Devonian's natural pride in the achievements of his native county.

Protectionism 1626–1639

The first warning of the two edged nature of protectionist measures for the lace industry was sounded by the Earl of Dorset in his address to the House of Lords in 1626. In the debate, which was on an apparel bill, he stated that he was against the bill '. . . more especially for that the making of laces meintenyes at leaste 20,000 folkes, and yf we ennacte anythinge here whereby the ymportacion of forreyn commodities may be stayed, yt is to be doubted that other countreyes wyll doe the lyke with us.' In spite of this plea the bill was agreed but did not reach the statute book, a victim of Charles I's differences with his parliaments.

This was followed in 1635 by the first positive restriction on the importation of foreign bone lace, ostensibly to protect the livelihood of the English lacemakers, though it appears to have been in reality a minor money raising scheme by Charles I, who was at that time attempting to rule without a parliament, and also a method of rewarding a subject. A royal proclamation[4] issued at Hampton Court on 30 September stated that a petition had been received from a great many lacemakers which maintained that they were hindered from making a living owing to the frequent importation of foreign lace, were now in great distress and asked that there should be restriction on such importations together with the sealing of English lace '. . . whereby the foreign might be better discovered.' Charles decreed that there should be a complete ban on the importation of foreign lace, that English lace should be sealed and ordered all makers, sellers and retailers of lace not to put any on sale until '. . . the same shall be duly sealed or marked by our welbeloved Subject Thomas Smith Gentleman or his Deputies whom Wee have thereunto appointed . . .' For '. . . ease of our Subjects' Thomas Smith was empowered to appoint deputies in all the market towns as he saw fit; the dealers were required to return the seals after sale so that they could not be reused and were given the relief that all existing stocks were to be sealed without payment of a fee. On the other hand Thomas Smith, with a constable, was permitted to enter any premises to search out foreign lace and all justices and other officers were instructed to assist.

Thomas Smith's licence[5] states that the average duty collected by the farmers of customs over the previous seven years was £20 13s 4d and that he was to pay £40 per year for his privilege. It is apparent that the importation of foreign lace was quite small, that the king was not going to raise any significant revenue from this measure and that the scheme seems to have been one for rewarding Thomas Smith for some unknown service to the king with

an open ended leave to raise money from what amounted to a tax on the English bobbin lace industry.

The scheme did not meet with universal approval, nor did it appear to fulfill its ostensible purpose. On 24 June 1636 the House of Lords is on record with the opinion that these letters patent had resulted in a heavy burden on '. . . divers of his Majesty's poor subjects . . .' and furthermore were not effective in preventing the importation of foreign lace as was intended.[6] They ordered, therefore, that any further application of the scheme be stopped until further notice. This was followed on 11 November 1638 by a resolution of the Committee of Council of War[7] to the effect that all projects should be taken off which gave no considerable profit and which were grievous to the king's subjects. Among many such projects listed, the sealing of bone lace is included.

The king appears to have succumbed to the pressures in respect of this and various other like patents and issued a further proclamation from his manor at York on 9 April 1639[8] explaining that he had been misinformed in these matters. 'Forasmuch as his most excellent Majesty (whose Royal care and providence is ever intentive on the publick good of his people) doth now discern than the particular Grants, Licences and Commissions hereafter expressed, have been found in consequence, far from those grounds and reasons whereupon they were founded, and in their execution have been notoriously abused;' This piece of cynicism is followed by the revocation of an extensive list of grants, a number of which were 'upon feigned Suggestions obtained from him to publick damage,' and the latter includes the office for the sealing of bone lace. Thus ended the first venture in protecting the English bobbin lace industry by attempting to shield it from foreign competition.

Honiton, a centre for training lacemakers

Whatever effect the attempt at protection had on the bobbin lace industry generally it is apparent that at this time that of Honiton was flourishing. An order of the Devon Assize Court on 12 March 1638 stated[9]

> Whereas this court is enformed by the humble peticion of the church-
> wardens and overseers of the poore of Honyton that there be a greate
> many strangers come into the towne of Honyton that have been placed
> on other parishes as poore and are from them placed into the towne
> aforesaid, besides other poore out of divers places that are brought into
> the trade of bone lace makinge, whereby the towne is like to come into
> great poverty.

It is evident from this that the lace trade in the town was capable of providing work for more people than its own citizens and that therefore an influx was taking place. Since these people were poor it is easy to see why the overseers had become anxious, for a slump in the industry could have resulted in the town having to support an excessive number of paupers. The court therefore ordered that if any master in another parish placed his apprentice into Honiton without the consent of the justices, he was to be ordered to take the apprentice back again, thus ensuring that the town should have control over the number of poor apprentices for whom it had a liability. Even with the situation under control it appears that some influx into the town to learn lacemaking was expected to occur. Having completed their training a proportion of these newcomers would probably have returned to their native parishes, so that the document also gives an insight into one mechanism whereby the technique of Honiton lacemaking spread into the town's hinterland.

The Civil War and the Commonwealth

During the course of the Civil War both royalist and parliamentary armies passed through Honiton on at least seven occasions,[10] but the only records of events in the town are that the king stayed the night on 25 July and 23 September 1644 and Sir Thomas Fairfax on 14 October 1645. Perhaps the townsmen, long accustomed to the entertainment of travellers, were content to emulate the vicar of Bray, professing sympathy with whichever side came along and providing for their needs—at a price. It is even possible that they gained from the war through a decrease in foreign competition for, on 22 July 1643, the Lords and Commons, faced with the need to raise money to support the parliamentary forces, placed a new excise duty on a wide range of goods.[11] The tax placed on imported bone lace was three shillings on a dozen yards, which was amended in 1653 to three shillings on every twenty shillings in value. The latter rate did not go unchallenged[12] for the merchants and retailers of London addressed the Council, pointing out that taxes can hamper trade and stating that by the last Excise Act bone lace was taxed at three shillings in twenty shillings, but that they believed that the receipts from the tax would prove less than when the rate was only one shilling.

An unexpected bonus for the lace historian arose from the Civil War in consequence of the appointment of Thomas Fuller to be chaplain to Sir Ralph Hopton in 1643. Thereafter Fuller followed the army, but having time available as he travelled he gathered the materials on which he based his well-known work *Worthies of England*. This was first published posthumously in 1662 and contains an important statement on the Honiton lace industry.

Apart from the people implied by the title Fuller gave some general account of each county and in connection with Buckinghamshire observed[13] that there were no handicrafts of note save that of 'bone-lace, much there of being made about Owldney in this county; though more, I believe, in Devonshire, where we shall meet more properly therewith,' a statement which could be taken to imply that at that time the Honiton lace area constituted the major seat of the English bobbin lace industry.

Fuller's observations for Devon includes the following[14]

BONE LACE

Much of this is made in and about Honiton, and weekly returned to London. Some will have it called lace, a lancinia, used as a fringe on the borders of cloths. Bone-lace it is named, because first made with bone (since wooden) bobbins. This it is usual for such utensils, both in the Latin and English names gratefully to retain the memory of the first matter they were made of; as cochleare, a spoon (whether made of wood or metal) because cockle-shells were first used for that purpose. Modern the use thereof in England, not exceeding the middle of the reign of Queen Elizabeth: let it not be condemned for a superfluous wearing, because it doth neither hide nor heat, seeing it doth adorn. Besides, though private persons pay for it, it stands the State in nothing: not expensive in bullion, like other lace, costing nothing save a little thread descanted on by art and industry. Hereby many children, who otherwise would be burthensome to the parish, prove beneficial to their parents. Yea, many lame in their limbs, and impotent in their arms, if able in their fingers, gain a livelihood thereby; not to say that it saveth some thousands of pounds yearly, formerly sent overseas to fetch lace from Flanders.

Fuller is the only writer before the nineteenth century to provide an explanation for the term 'bone lace', an explanation which is the more credible for being an early one, and for the fact that from 1634 to 1641 he was vicar of Broadwindsor in West Dorset, close to, if not in the lace making area, so that his experience of the industry was not confined to a mere visit with the royalist army. Courtenay Gidley in his letter to Daniel Lysons[15] in 1820 stated that '. . . it was originally called Bonne lace signifying the good lace . . .', a derivation which cannot seriously be entertained. Mrs Palliser[16] in 1865 referred to Fuller and added that the Devonshire lace makers 'deriving their knowledge from tradition' claimed that the name was derived from fish bones used as a substitute for pins. There appears to be no evidence to support this idea and, though the possibility cannot be discounted, the reliability of the

source must be considered doubtful. Fuller's final observation shows that the chief source of foreign lace at that time was evidently Flanders and the comment on the saving of foreign exchange may have been prompted by a fall in imports as forseen by the London merchants in 1653. It could be that the high rate of tax benefitted the English lace industry more than the Exchequer.

More than half the passage is devoted to a defence of lace in which he points out that it should not be condemned as a superfluous luxury because it helps both the state and people, some of whom would otherwise not be able to earn a living. Fuller was a royalist and this argument appears to be a counterblast against the puritan distrust of luxury.

The introduction of protectionist legislation 1660–1675

After the restoration of the monarchy in 1660 a number of rather curious and apparently contradictory legislative proceedings affecting bobbin lace were carried out. One of the first actions of Parliament after the restoration was to pass a Tonnage and Poundage Act[17] in order to provide an adequate income whereby the crown could fulfill its obligations, and this was accompanied by a new book of rates, operative for the duration of the king's life, and coming into effect on 24 June. The list of import duties included an item for bone lace of thread, which was charged at a rate of £4 for a dozen yards. This represents a punitive tax, for information surviving from the period[18] gives values ranging from 1s to 11s 6d per yard for Flanders lace, so it seems possible that it might have been intended to protect the home industry by discouraging foreign competition.

On 20 November 1661 the king issued a proclamation[19] in which he declared that various past Acts of Parliament[20] had stated that sundry goods should not be imported and he specifically mentioned 'Laces, Ribbands, Fringes, Imbroidery, Laces of Silver or of Gold, Hats, Knives, Scissars, Painted Ware, Caskets, Poynts, Gloves, Locks or Brushes.' He continued by stating that the artificers of the realm had complained that notwithstanding these laws many of these goods were being brought into the country to the detriment of their livelihood, and so he was issuing this proclamation to remind merchants that the former acts were still operative, and he added a specific embargo on 'Foreign Bone-Lace, Cut-Work, Imbroidery, Fringe of Gold, Silver, Silk, or Thread, Lace of Gold or Silver, Ribbonds, or Bever-Hats (or any other the Wares or Merchandises above mentioned, or by the said Acts of Parliament, or any other Prohibited to be Imported).' The king does not appear to have been very well advised as to the provisions

of the earlier acts, for none of them mentions cut work, embroidery, gold or silver fringe, laces or bone lace. Even more strange is the fact that bone lace had been listed in successive books of rates since 1562, including that approved only the previous year, and had, presumably, long been regarded as a lawful material for importation. The recent book of rates also listed nine other items included in this proclamation, a situation which must surely have given rise to some disagreements between importers and customs officers.

The anomalous position with regard to some of the items was evidently recognised for on 19 February 1662[21] it was ordered that a bill be prepared against the wearing of foreign bone lace and Sir Courtnay Poole and Mr Peter Prideaux, the members for Honiton, together with Mr Sandys, the member for Evesham, were ordered to take the necessary action. On 5 March[22] the object of the bill was changed to banning the importation of foreign bone lace and this bill went through the usual stages[23] and became law[24] as an act prohibiting the importation of bone lace, cut work, embroidery, fringe, band strings, buttons and needlework. The preamble of the act states that the makers of these commodities produce articles as good as any made abroad and have imported great quantities of thread to the benefit of the king's customs, but of late their trade has decayed because large quantities of these commodities have been smuggled in; furthermore this has resulted in much money being sent abroad 'to the great Impoverishment of the Nation' and contrary to the several statutes already noted in the royal proclamation of 1661.

Almost immediately the king was faced with an embarrassing situation, for a royal order for lace from abroad was ready for delivery, though it could well be that the order had been placed before the proclamation of the previous year. The king extricated himself from this situation[25] by giving a warrant for a special import licence so that the lace could come in for the use of the royal family and as patterns for the manufacture of similar goods in England. This is not the last that was heard of the latter excuse.

These various steps do not appear to have been particularly effective. On 26 October 1665[26] the king observed that vast sums were yearly exported for foreign manufactures and contrasted this with the situation both in France and Holland where vigorous methods were used to discourage English goods. He and the queen were resolved, therefore, not to wear anything, inside or out, that was not of English manufacture, save linen and calico, and enjoined the whole court to follow their example. At the same time he reminded the London shopkeepers that they were not to send abroad for laces, silks, stuffs etc. On 28 October 1669[27] it was observed in the Lords that 'the pocket commodities and laces that came from France and Flanders do unto us. There

is no discouraging them but by great persons not wearing or using them.' On 14 July 1675[28] the king took up the same point when he declared in Council that he would not wear any foreign points or laces and ordered that after Michaelmas none of his subjects were to wear any such points or laces, and that the Lord Chamberlain was not to permit any of his subjects wearing them to appear in his presence. In spite of these endeavours much smuggling continued and the state papers of the period contain numerous references to seizures of foreign lace by the customs officers.

The state of the industry 1669–1685

At this period two visitors recorded observations about the Honiton lace industry which indicate a thriving state in spite of the apparent lack of success of the protectionist measures. In 1669 Cosmo III, Grand Duke of Tuscany, visited England[29] and observed of Devon that 'there is not a cottage in all the county nor that of Somerset, where white lace is not made in great quantities so that not only the whole kingdom is supplied with it but it is exported in great abundance.' This cannot be accepted fully as an eyewitness statement since the Grand Duke's route from Plymouth, where he landed, took him via Okehampton to Exeter, and thence through Honiton and Axminster eastwards, thus leaving large areas of the county unexplored, though he did pass through the East Devon lace area and doubtless his curiosity was aroused by seeing many lacemakers at work. Ten years later Dr Yonge[30] wrote that Honiton 'hath a great trade in making lace.' In addition Chamberlain[31] writing in 1683 observed that bone lace was the 'chief of the Ornamentals worn in this Nation', and that 'so general is this Manufacture in many Parts of England that the Poor of whole Towns are almost totally employed, and in a great measure maintained thereby; Particularly Honiton in Devonshire is a noted Town for this sort of Workmanship . . .' He also names Blandford, Salisbury, Marlborough, Olney, Amersham and Chesham.

Not all observations were, however, as favourable as these. John Pinney[32] of Bettiscombe in West Dorset was ordained in 1648, admitted to the nearby living of Broadwindsor in 1649, was ejected from it in 1662, received a licence as a nonconformist preacher in 1672, became a minister in Dublin in 1682, returned to Bettiscombe in 1689 where he remained until his death in 1705. Apart from his activities as a minister John Pinney was a lace manufacturer and dealer, and some of his letters during his period in Dublin suggest a far from flourishing business. Writing to his daughter Hester in August 1683 he observed that 'here is a dead trade and they break dayly' and to his daughter

Sarah on 11 June 1685 '. . . if the trade be as bad there as heare, I should ad vise you to be red of sum of the workers . . .', and again on 14 June '. . . here is no trade for anything . . . Let yor sistr Hoar be carefull in tyme to limit her trade & trust.' In August he wrote to his daughter Rachel that '. . . here is no trade but breaking still . . . But litle of the broad lace is sold. More narrowlace could have bin sold . . .', and on 30 November again to Sarah '. . . ye lace be not above halfe of it sold off . . .'.

Some of these problems may not, however, have arisen from general trading conditions but rather from the limitations of the Pinney family as businessmen. Writing to Rachel on 31 July 1682 John Pinney observed 'The broken Jade that came to Dublin in May spoyled all trade there so that we could sell little (I thinke) but 2 pec. of lace after she came: for she sold at halfe price.' The broken Jade was his daughter-in-law who appears to have been somewhat of a trial to the family and was referred to on one occasion as a thorn in their flesh. In 1686 Sarah was apparently left in charge of the business with disastrous results, for writing to Hester on 28 May John Pinney observes '. . . yor mother so grieves at her Carriage (yt lost 600L & upwards in money & goods when she came hither in her trust & now not get not know what is become of a penny of it . . .)'. Perhaps John Pinney's son Nathaniel was wise when writing from London on 10 September 1689 to his father, who had now returned from Dublin, for he recommend him ' . . . Not to trouble yor Selves at this age to receive in Lace againe and when I have soe often advised against the medleing with it . . .'.

The Monmouth rebellion

John Pinney's troubles were not confined to his lace business, for when James Duke of Monmouth landed at Lyme Regis in 1685 at the start of his ill-fated attempt to oust his uncle, James II, Azariah Pinney, the 'Jade's' husband, joined the rebels. He was subsequently captured and condemned to death, but owing to some action of an undetermined financial nature by his sisters this was commuted to exile in the Caribbean for ten years.[33] He went to Nevis where he was able to set up as a factor, being supplied with goods, which included lace, by his brother Nathaniel. Azariah prospered, as did several succeeding generations of the Pinney family thereby generating a 'West-India fortune' which was founded, in some part, on the Honiton lace industry.

The general impact of the Monmouth rebellion on the Honiton lace industry is difficult to assess owing to the paucity of information arising from a marked lack of surviving documents. Monmouth landed at Lyme Regis

and then marched through Axminster, Chardstock and Chard, gathering recruits as he went. The so- called Monmouth Roll (BL Add. Ms. 30,077) is a list of numbers of reputed rebels compiled by the parish constable with an accuracy which is quite uncertain, but the information recorded indicates a total of 828 men from the lace area. (Table 2.1). Their distribution is shown in Figure 2.1 and it will be seen that of the five places which produced the largest numbers of recruits three were on the line of march, the other two being Honiton and Colyton. Some of the entries in the Roll record occupations and from these it has been shown that the majority of Monmouth's rebels were urban tradesmen, rather than the rustics of popular legend. Unfortunately only one place in the lace area, Lyme Regis, has a record of occupations and none of these has any connection with the lace industry. However, information which became available in 1698 (Chapter 3) shows that several of the places which produced many rebels were also notable lace towns and it seems possible, therefore, that some men associated with the industry joined Monmouth, but the main impact will have fallen on the women of the area. Many rebels were killed in battle, executed, or transported never to return, so there must have been many widows and orphans in the lacemaking area who would have found in the Honiton lace industry a much needed lifeline.

Table 2.1 Places in the lacemaking area and numbers of reputed rebels listed in the Monmouth Roll

Axminster	79	Combe Raleigh	6	Ottery St Mary	9
Axmouth	32	East Budleigh	1	Pilsdon	5
Beaminster	24	Gittisham	8	Sidbury	9
Bridport	20	Honiton	53	Sidmouth	14
Broadwindsor	7	Luppitt	32	Stockland	19
Burstock	2	Lyme	114	Symondsbury	3
Chard	99	Marshwood	10	Thorncombe	38
Chardstock	21	Membury	18	Unidentified place	13
Charmouth	15	Monkton Wylde	6	Upottery	32
Colyton	87	Musbury	23	Wootton Fitzpayne	15
Combpyne	5	Offwell	2	Yarcombe	7

Smuggling

Although smuggling was a national problem most of the seizures of lace recorded in the state papers at this time are at ports in Kent and Essex, and

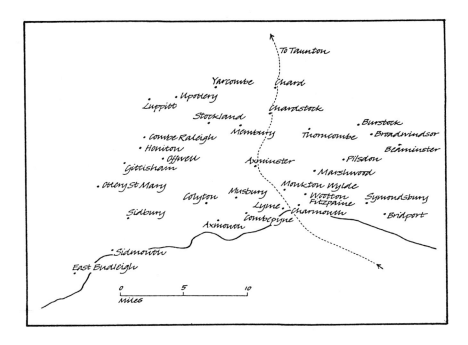

Figure 2.1. The Monmouth rebellion, 1685. Monmouth's line of invasion and places in the lacemaking area from which he gained recruits.

in London itself. Nevertheless there is evidence that the problem also arose in the Honiton lace area for on 24 July 1683[34] eight tidesmen were appointed as additional strength for the Exeter port area, which included the East Devon coast. This appears not to have been effective for on 31 March 1685[35] Mr Treasurer Rochester sent a memorandum to the justices of Devon informing them that he had received the petition forwarded by them from William Bird and others, on behalf of themselves and the rest of the bone lace makers in Honiton, Ottery St Mary and other places in Devon. The justices had certified that there had been a great decay in trading and manufacture of lace in Devon owing to the importation of foreign lace, and had desired the Treasurer to request the Customs Commissioners to prevent such illegal importations. The Commissioners replied that they already were making every endeavour to prevent such importation and that their officers were making daily seizures. They stated that they were always ready on reasonable notice from the petitions to assist in searching and seizing such foreign lace, and had now decreed that a proportion of the value of any such seizure would be paid to

the informers, considering this to be the most effective method then available to prevent the smuggling.

On 15 October[36] the Treasurer again addressed the Customs Commissioners proposing that it was necessary to appoint special persons to see that the ban on importation was carried into effect, and announced that he proposed to put an extra import duty on the fine thread used for lacemaking in order to meet the expenses involved. This suggests the formation of a corps of lace specialists and if so these are the earliest lace identification experts on record.

On 3 December[37] the Earl of Sunderland, the king's secretary, addressed a memorandum to the justices for Devon, or any of them near Honiton, as follows

> His Majesty being informed that a party of Lord Cornbury's troop and a party of Cap. Churchill's came lately from Honiton and Autrey [Ottery St. Mary], where they are quartered, to Culliton [Colyton] and there broke open the house of William Bird and carried away a parcel of bone-lace which cost him 325L. 17s. 9d. the making, as has been proved on oath, besides the damage done by breaking open the house and frightening his wife and children[38] to the danger of their lives; and intending that the offenders should be punished according to the utmost severity of the law and that full reparation should be made to Bird, he would have you or some of you repair to Culliton and strictly examine this fact and the persons accused and commit such of them to the county gaol as shall appear to be guilty, taking care that they may be proceeded against according to law. He would have you send up an account of the whole matter of what damages Bird has sustained. The king has commanded Lord Cornbury to go down to Culliton to be present at the examination.

There is no record of the eventual outcome. It is clear from the memorandum that the troops, who were presumably in Honiton and Ottery in the aftermath of the Monmouth rebellion, did not go to Bird's house by chance, but were acting 'on information received', and it is of interest to consider who may have put them up to this foolish venture which excited the displeasure of the king himself thereby showing that Bird was a loyalist. It may be noted that Bird was the prime mover in the anti-smuggling petition earlier in the year which apparently stirred the Commissioners of Customs into renewed endeavours. Perhaps this episode should be seen as an act of the local smuggling fraternity, smarting under the interference with their livelihood

and, seeing Bird as the cause of this, coming to an arrangement with some of the soldiers as a means of revenge.

Another Bird, this time Edward from Blandford, whose relationship, if any, to William is unknown, also had problems over illegal importations of lace[39] for on 16 September 1688 the Commissioners ordered that part only of a consignment of foreign lace, valued at 56L, 12s. 10½d., which had been seized should be released to Bird. Bird had claimed that he employed many hundreds of people in Blandford and other parts of the west of England making bone lace, an art which he had brought to such a perfection that in a short time it would be as good as any brought from France and Italy, and stating that the lace which had been seized was for use as patterns. He claimed to deal in several thousand pounds worth of lace per annum and 'it cannot be presumed that the points and laces now seized were brought over for advantage, that being to destroy his own manufacture, which with encouragement herein will daily increase to the relief at some thousands of his Majesty's poor subjects and augment his Majesty's customs upon thread.' The plausibility of this plea is somewhat marred by the fact that the packet of lace had been found concealed under the ship's ballast, a circumstance which speaks better for the thoroughness of the customs officers than for Bird's veracity, though it is difficult to see what else he could have done to keep abreast of continental fashion.

However Edward Bird came to the attention of the Commissioners again in 1691[40] in an essentially similar way, the value of the seized lace being 30L. This time he claimed to be employing many hundreds of people in several towns in Devon, Dorset and Wiltshire and that they were producing lace which was as good as any from any part of the world. He made no attempt at an excuse but asked for the lace to be released on his giving security for its re-export.

The protectionist legislation strengthened 1685–1697

It is clear that Parliament was not unaware of the failure of the legislation to prevent the inflow of foreign lace into the country, for in 1685, when a bill for preventing the importation of foreign buttons had reached the committee stage,[41] a petition was received from the traders and makers 'of Bone-lace in the several Counties of this Kingdom' and this was referred to the committee with instructions to add a clause to the bill to prohibit bone lace as well. After consideration it was resolved to bring in a separate bill in respect of bone lace, but when this was presented to the house it was decided not to

proceed. Even had the bill been proceeded with it is not clear how it would have affected the situation.

The question was taken up again in 1690[42] when Sir Walter Yonge, member for Honiton, was instructed to prepare a bill for 'the more effectual prohibiting the Importation of Bone Lace and Point Lace.' He did so, the bill was presented to the house and read a first time, but no further action was taken.

A third attempt met with better success.[43] On 23 December 1697 Sir William Drake and Sir Walter Yonge, the members for Honiton, together with Sir Henry Hobart, the member for Norfolk, were ordered to prepare a bill 'for rendering the laws more effectual for preventing the Importation of foreign Bonelace, Needlework, Point and Cutwork.' At the committee stage a petition was received from some of the retailers of bone lace in London claiming that the bill would ruin their trade in English lace, together with another one from other London retailers praying that the bill may pass since it would be beneficial to the English lace trade. The committee appears to have regarded the second petition as being the more persuasive, for when Sir William Drake reported back to the House he stated that the committee had made some amendments to strengthen the bill and commended it for adoption; it duly passed into law.[44] The essential purpose of the act was to increase the penalties for infringements of the existing legislation.

Shortly before this the Customs Commissioners took action to check smuggling in the Honiton lace area. On 26 February 1697[45] they appointed a new tide surveyor at Exeter to fill the post of one who had died, but at a reduced salary. The amount saved was used to pay for a new man who was appointed as waiter and searcher at the mouth of the river Otter, 'there being a need for a preventive officer for the guard of the said river which is a place very convenient for running of goods inwards and outwards.'

Lace and cloth, a conflict of interests

These actions by Parliament and by the Customs Commissioners resulted in a reasonably effective measure of protection for the English lace industry, but it soon became apparent that the Earl of Dorset's warning over 70 years previously of the possible consequences of such a situation was by no means an idle speculation. On 14 February 1699[46] the House of Commons received a petition from the cloth workers and traders of Rochdale, Lancashire, stating that the prohibitions and heavy duties placed on Flemish goods had resulted in a renewal of the Flemish cloth manufactory and, moreover, there was reason to fear that this would be followed by a prohibition of English woollen

41

manufactures, to the detriment of their livelihood. They therefore asked that consideration should be given to repealing the recent act which prohibited the importation of foreign lace. The petition was referred to a committee, the members of which included Sir William Drake and Sir Walter Yonge.

This petition was followed by others from Leeds, Riverton, Shrewsbury, Halifax, Newbury and Salisbury, all expressing essentially the same points and these too were referred to the committee. The lacemakers retaliated and petitions, which were also referred to the committee, were received from Ottery St. Mary and from Honiton, setting out that the late act has proved very beneficial to their industry and praying that it be not repealed. No action had been taken by the time the session ended in May, but it was ordered that a bill to repeal the lace act should be brought in six months after the end of the session.

A digest of each of these petitions is included in the *Commons Journals* but the petitions themselves were all destroyed in the great fire at the Palace of Westminster in 1834,[47] and no copies are known to exist. There are however two surviving copies of a printed memorandum[48] addressed to the House of Commons which appears to emanate from the lacemakers as a whole. This states that laws prohibiting the importation of bone lace are of very long standing but, owing to a great deal of evasion, the recent act strengthening the provisions had been introduced, and makes the point that should this act now be repealed, leaving the former ones in operation, then everyone will conclude '. . . the meaning of the Parliament to be, that the former Acts should be winked at, and the officers will Act accordingly . . . and [this] will be the first Instance in England, that several laws remained in Force, and another to render them Effectual was Repealed.' The memorandum then goes on to argue that what had happened in Flanders was not a consequence of the lace act by quoting the preamble of the Flemish law which had prohibited the importation of foreign woollen manufactures, and showing that it contained no reference to the trade barrier against their lace, but to the barriers against their woollens and linens. It is also stated that information from Flanders shows that the projected development of a woollen cloth industry had not in fact taken place and that there was a prospect of the prohibition on woollen goods would be lifted. The memorandum also states that English lace is as good as any made in Flanders, especially since the late act, that above 100,000 people get their living in the industry, which is greatest next to the woollen and asked Parliament to deliberate very carefully before repealing he act lest they '. . . take away Work from Multitudes who are already Employed.' Whether this memorandum ever reached Parliament is not known and whether its arguments were ever heard by the com-

mittee is equally unknown, but if they were they evidently carried little or no weight.

Another aspect of the mixed blessing of the protective legislation was the harassment caused to the lace manufacturers and dealers by informers. On 9 March 1698[49] George Furnase a merchant of London stated that formerly he had traded in bone lace, but that he proposed '. . . to trade no more, being desirous to live quietly and free from the persecutions of informers.'

Concern about the possible adverse effects of the new lace act was not confined to the petitioners from the cloth-making area and George Furnase, but also arose in government circles, for James Vernon, Secretary of State Northern Department, addressed a number of letters to Mr Hill, English Envoy Extraordinary to the Elector of Bavaria[50] who evidently had the ear of the Flemish authorities. On 27 May 1698 Vernon expressed sorrow at what he had learned of the effect of the lace act but thought that the situation was not without remedy, and pointed out that what the Flemings complained about was nothing new, adding that the next parliament could well alter things. However 'since it may not be proper to be repealing a law as soon as ever it is made and if in the meantime they will suspend their prohibition till this Act pinches them, I hope the matter will be accommodated.' He followed **this** on 10 June with an appeal to Hill to try to persuade the Flemings not to take hasty action, expressing the view that the law might be altered adding that 'our managers in the House of Commons have reprimanded the patrons of our bone lace for going so far in that particular, and declare themselves very willing to redress it in the next session.' On 5 July he again urged Hill to stave off retaliation on our woollen manufactures.

At the beginning of the new session, before the proposed bill was introduced, a new petition was received from the cloth workers of Salisbury, stating that the woollen manufacture was much decayed owing to the Flemish import ban and requesting that the lace act be repealed. This was referred to a committee which included, as usual, Sir William Drake and Sir Walter Yonge. As before, further petitions followed, those from the cloth trade requesting the repeal of the act being received from Rochdale, Reading, Kinsare, Halifax and Newbury, and those from the lace industry requesting the retention of the act being received from Buckinghamshire, Lyme Regis and Shaftsbury.

Before the committee reported Vernon again wrote to Hill (24 February 1700[51]) that 'we are all very heartily concerned at the lace bill we were surprised into, and therefore they ought to have a little patience till we have an opportunity to redress the mischief', which appears to be a very strange

statement since consideration of the bill had been going on for over a decade before it was eventually passed, having gone through the usual stages both in he Commons and Lords.

On 6 March 1700 the committee which had been considering the bill reported to the House and gave an account of the witnesses they had examined. They had heard evidence on behalf of the cloth industry from witnesses from Salisbury, Leeds (3), Halifax, Rochdale and Shropshire (2), all of whom reported a decay in their trade owing to the Flemish prohibition which they regarded as retaliation for our lace act. Witnesses from the lace industry were from Buckinghamshire (3), Hertfordshire (2) and Salisbury, all of whom testified to the flourishing state of their trade which they ascribed to the lace act. Evidence was also taken from various merchants, those in the cloth trade supporting that industry's view and those in the lace trade supporting the lace industry. A striking omission is the failure, apparently, to examine any witnesses from the Honiton branch of the lace industry, despite the fact that three of the five petitions received from the lacemakers came from that area (Honiton, Ottery St, Mary and Lyme Regis). Having considered the report, the House expressed agreement with the view that the decay in the woollen industry was a result of the lace act and resolved to bring in legislation to repeal it. This was accordingly done, though the lacemakers made one last plea to the House of Lords on 26 March[52] during the hearing of which the Flemish prohibition decree was read, but this failed to move the House and the act received the Royal Assent on 11 April 1700.[53] On 7 April[54] Vernon wrote to Hill thanking him for a copy of the Flemish edict and informing him that a repeal was going forward. He added 'They had a notion then that, upon our revoking the Lace Bill, those in Flanders would put a stop to this edict; but, upon looking it over, I can't be of that opinion. I see their intention is to set up their own manufactures; and the method they take toward it is as much levelled against the Dutch as us; and I suppose the annulling of our late Lace Act will not produce the effect we propose, though we likewise made void all former Acts prohibiting the importing of lace . . .' It is obvious that having been furnished with the Flemish decree he had come to the same conclusion about it as had the lacemakers as expressed in their memorandum, though why he had not seen a copy of the Flemish document two years earlier when the lacemakers did is not clear.

In the event the Flemish embargo was taken off but there is no evidence to show whether this was because of the repeal of our lace act or whether, as forecast by the lacemakers, it was an action independent of this. In any event this left the anomaly argued by the lacemakers that the former acts

were still in force and that Parliament had, in effect, produced an instruction to ignore them. This situation was resolved in 1707 when a resolution was passed to repeal all acts which prohibited the importation of foreign bone lace,[55] and this was accordingly done[56] though the ban remained for any lace from the 'Dominions of the French King'. This latter provision fell into disuse, though it remained law until the Statute Law Revision Act of 1867, but in reality the protectionist measures for the English lace industry ceased in 1707, foreign lace thereafter being freely imported on payment of normal customs duties.

Protection and the Honiton lace industry

Did these protectionist measures aid the Honiton lace industry in the 17th century? It is not possible to say since there was no control experiment or adequate quantitative data on which to judge the issue, but it may be noted that the various comments made by travellers and topographers give no suggestion of an industry in difficulties either before or after the introduction of protection. The overall impression is of an industry which had established itself and which was affording employment to many people through war and peace, times of good trade and bad, despite the periodic jeremiads directed to government and parliament.

References

1. Gardiner, p.141.
2. CSPD, 1623, p.555.
3. Westcote, p.61, 227.
4. Sanderson, XIX p.690.
5. CSPD, 1635, p.378.
6. CSPD, 1636, p.16.
7. CSPD, 1638, p.98.
8. Sanderson, XX p.340.
9. Cockburn, p.635.
10. Andriette, p.90, 112, 153. Coxhead, 1984, p.25.
11. Firth and Rait, p.202.
12. CSPD, 1654, p.118.
13. Fuller, I p.194.
14. Fuller, I p.396.
15. BL Add MS 9427, Item 255.

16. Palliser, 1865, p.269.
17. 12 Charles 2 c4.
18. see Chapter 13.
19. PRO, SP45/11.
20. 3 Edward 6 c5. 1 Richard 3 c12. 19 Henry 7 c 21. 5 Elizabeth 1 c7.
21. CJ, VIII p.368.
22. CJ, VIII p.378.
23. CJ, VIII p.383, 392, 393.
24. 13/14 Charles 2 c13.
25. CSPD, 1662, p.386.
26. CSPD, 1665, p.31.
27. HLRO.
28. CSPD, 1675, p.211.
29. Cosmo III, p.107.
30. Poynter.
31. Chamberlain, p.75.
32. For details of John Pinney and his family see Pares and also Nuttall. The Pinney family papers are in Bristol University Library.
33. Wigfield, 1984, p.17.
34. CTB, 1683, p.874.
35. CTB, 1685, p.98.
36. CTB, 1685, p.511.
37. CSPD, 1685, p.400.
38. Colyton parish registers show that at this date there were five children under five years of age.
39. CTB, 1688, p.2068.
40. CTB, 1691, p.1041.
41. CJ, IX p.735, 736, 746, 754, 760.
42. CJ, X p.464, 471, 474.
43. CJ, XII p.16, 41, 45, 47, 89, 90, 98, 121, 144, 147.
44. 9 William 3 c9.
45. CTB, 1697, p.411.
46. For this and other matters relating to the repeal of the Lace Act see: LJ, XVI p.560, 562, 563, 564, 578. CJ, XII p.510, 514, 522, 523, 584, 602, 607, 635. CJ, XIII p.61, 85, 91, 96, 99, 114, 120, 129, 269, 270, 271, 285, 288, 295, 306.
47. Private communication, Deputy Clerk of the Records, House of Lords.
48. Some considerations . . .
49. CSPD, 1698, p.235.
50. CSPD, 1698, p.273, 296, 338.
51. CSPD, 1700, p.73.
52. HMC, (17) VII (new series), p.132.
53. 11/12 William 3 c11.
54. CSPD, 1700, p.128.

55. For this and other matters relating to the repeal of all acts prohibiting the importation of foreign lace see: LJ, XVIII p.276, 281, 282, 283, 287. CJ, XV p.270, 281, 295, 302, 315, 326, 346, 351, 357.

56. 5 Anne c17.

Chapter Three

The English Lace Industry
in 1698

Here follows an Account of the Numbers of the people in a few places, which get their Living by Making of Lace, certified by Persons of Reputation.

Lacemakers' memorandum to Parliament 1698

Geographical distribution

Appended to the lacemakers' memorandum of 1698 there is a list of places where lace was made at that time, together with the numbers of people working in each. The list is stated to be incomplete and that '. . . if there were time to procure the rest, it would appear that there are much above One hundred thousand', a statement which does not carry conviction since the total number of persons listed is 23,358, less than a quarter of the suggested total. Moreover the list appears to cover a very large proportion of the places in which any kind of reference to lace making at any time is on record. Perhaps James Vernon's reference to a reprimand to the 'patrons of our bone lace' shows a knowledge of an exaggeration of the size, and hence the importance, of the industry. Unless, therefore, one is to postulate the virtual total disappearance without trace of all record of some three quarters or more of the lace industry, and there appears to be no plausible reason for doing so, this list can be taken as giving a picture of its general state in the closing years of the seventeenth century.

In assessing the reliability of the individual figures it is evident that, as with the total, there would have been an incentive to overstate them. However, lace making at this period was an occupation for men, women and

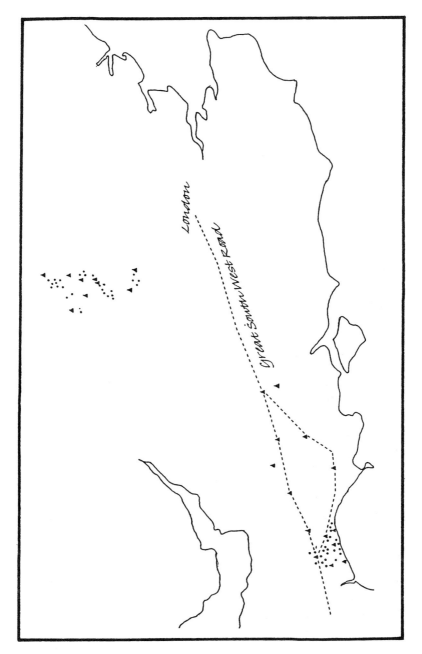

Figure 3.1 1698. The lacemaking places of England (▲ = market towns).

49

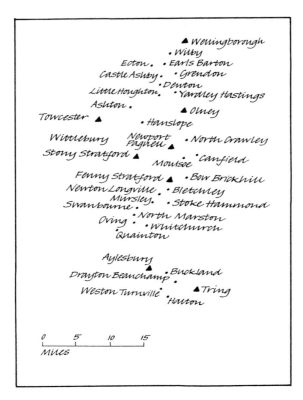

Figure 3.2 1698. The lacemaking places in the East Midlands (▲ = market towns).

children (Chapter 10) and this fact, combined with the 'putting-out' nature of the industry, would mean that both whole time and part time work was involved. Thus numbers which might appear rather high in the case of a full time male occupation, for example mining, could correctly represent the total of those involved in the hand lace industry.

Analysis of the final digits of a set of numerical data is a diagnostic technique for evidence of rounding off and other adjustments, for in the absence of such activities these digits approximate to a set of random numbers where each is more or less equally represented and the mean tends towards a value of 4.50. In the case of the 1698 data there is no indication of distortions due to rounding off or other adjustments and the mean is 4.46. Further evidence for the essential reliability of the figures in the case of the Honiton area emerges from a comparison (Table 3.3) with the populations of the places

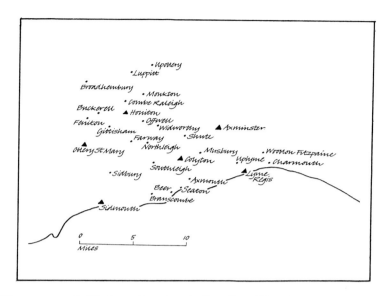

*Figure 3.3 1698. The lacemaking places in East Devon/West Dorset (▲ = market
towns).*

*Figure 3.4 1698. The lacemaking places in Dorset/Somerset/Wiltshire (▲ = market
towns).*

concerned, estimated from the Compton Census, where the proportions of lacemakers is shown to be plausible for such an occupation. It may be concluded that the data for the Honiton lace industry, at least, was arrived at by some form of counting and that conclusions drawn from them can be taken as having a reasonable foundation in fact.

The geographical location of the places listed is shown in Figure 3.1 and it will be seen that there are two major groups. One of these is of forty one in the East Midlands, (Figure 3.2) primarily in Buckinghamshire with a lesser number just to the north in Northamptonshire, two just in Bedfordshire and one just in Hertfordshire. The other is of twenty seven (Figure 3.3) nearly all in East Devon with three just in West Dorset. The remaining places (Figure 3.4) are Chard, Yeovil and Wincanton in Somerset, Dorchester, Blandford and Shaftsbury in Dorset, and Salisbury and Downton in Wiltshire. In connection with these it is significant to note that the great south west road from London followed the route now designated A30 to Salisbury, but from here there were two alternatives. A northern route took the line now designated A30 to Honiton, whereas a southern one took the line now designated A354/A35 to Honiton, from where a common route continued on the line A30 to Exeter and eventually Lands End.[1] It is a striking fact that nearly all the lace places mentioned to the east of the Honiton group lie on one or other of these roads, and the obvious explanation for this is that the lace industry developed there through the manufacturers who followed the trade routes from the Honiton area to the chief market in London. Such a process would be analogous to that of the spread from Venice to Zurich.[2]

The places involved in the Honiton lace industry, and the numbers of lacemakers quoted, are shown in Table 3.1 classified by area, and this shows that the numbers are almost equally divided between the concentrated area round Honiton and the extensions to Salisbury with totals of 5339 and 5741 respectively.

Table 3.1 Places and numbers in the 1698 memorandum arranged in areas

East Devon and West Dorset

Gittesham	139	Colyton*	353	Combe Raleigh	65
Northleigh	32	Sidmouth*	302	Axmouth	73
Sidbury	321	Buckerell	90	Farway	70

Monkton	64	Upottery	118	Shute & Musbury	25
Southleigh	45	Feniton	60	Branscombe, Beer	
Widworthy		Broadhembury	118	& Seaton	326
of Offwell	128	Luppit	215	Axminster*	60
Honiton*	1341	Lyme Regis*	404	Wotton Fitzpaine	48
Ottery St Mary	814	Uplyme	41		
Charmouth	87			Total	5339

Remainder of South West

Downton*	336	Salisbury*	1081	Chard*	156
Blandford*	500	Wincanton* and		Shaftsbury*	947
Yeovil*	711	adjacent parishes	1456	Dorchester*	554
				Total	5741

Spellings modernised. Places marked * are old market towns.

A further analysis which can be made is a division of the numbers working in market towns and of those working in the villages and rural areas. The results are shown in Table 3.2. It will be seen from this that in the South West some three quarters of the workforce was to be found in towns, a pattern which is consistent with Westcote's description of the working of the Devon cloth industry[3] and which, it has been suggested, could have been found a convenient pattern of working for the Honiton lace industry. It is also consistent with the observation in 1638 that many people were going into the town of Honiton to learn the lace trade,[4] with Fuller's observation[5] that the lace was made in and about Honiton, with Yonge's statement[6] that Honiton 'hath a great trade in making lace', with Chamberlain's observation[7] that the lace trade provided employment for almost all the poor of whole towns and with Edward Bird's claim[8] to employ many hundreds of people in several towns in Devon, Dorset and Wiltshire. It is also consistent with the pattern to be observed when the first reliable data became available with the 1841 census, in which the lacemakers are found to be located primarily in the streets of towns, and even in the villages are in the village centres rather than in the surrounding countryside.

Table 3.2 Analysis of numbers of lacemakers in 1698

Area	Number of Lacemakers	Lacemakers in Towns	
		Number	%
E. Devon and W. Dorset	5339	3274	61.3
South West	5741	5153[1]	89.7
All South West	11080	8427	76.1

[1] This figure includes 62% of Wincanton figure on the assumption that the split between town and surrounding area is similar to the quoted figures for Honiton and its contiguous parishes.

The tendency in the East Midlands is less pronounced, though even here more than half the lacemakers are in the towns. This may reflect the difference between the techniques of making straight and free laces, the latter being dependent on the highly skilled occupation of assembly, practitioners of which are known to have been located in the towns, in particular Honiton, at a later date. The overall figures show some 63% of the lacemakers listed to have been working in towns and it appears, therefore, that the English bobbin lace industry should be regarded to a considerable extent as an urban occupation.

In her analysis of rural industries[9] Thirsk suggested that it would be of value to consider the agricultural and social situation in which they began. She pointed out that the reasons for any particular development would be complex, though it is often possible to point to significant factors without claiming these to be all the ones involved, and suggested that an analysis of the farming economy could throw light on some of the circumstances which favoured the growth of rural industries on one region rather than another. In her subsequent study of developments of industry[10] in the sixteenth century she suggested that the favourable situation was one where farmers persued a pastoral rather than an arable system, since the former gave rise to more spare labour available for bye-occupations. In doing so she disclaimed any intention to propound a theory which could be applied mechanically to all situations, suggested that the possible application of the hypothesis to further industries would repay study and suggested the lace industry as one which could merit attention.

Spenceley[11] followed this with a study of the development of the bobbin

lace industry in England and concluded that it did not appear to conform to such a pattern. The Honiton lace area, including some of the eastward extension, is certainly one where the agricultural activities are predominantly pastoral, but other parts and the East Midlands lace area, which lies on the edge of the Midlands plain, are based on farming with a substantial arable content. Spenceley sought to explain the apparent inapplicability of the hypothesis to the lace industry in terms of spare labour generated by the general rise in population in the sixteenth century, which would apply equally to pastoral and arable areas. However, if this were the correct explanation it would have applied equally to the cases studied by Thirsk and the hypothesis would never have been formulated. An alternative explanation which applies specifically to the bobbin lace industry emerges from the analysis of the 1698 figures for lacemakers, which shows that the industry was, to a substantial extent, an urban one. A model based on rural industries would not, therefore, be applicable since an urban based industry, in this case little dependent on local raw materials or local markets, could likewise be little dependent on the nature of the agricultural activities of the surrounding countryside.

The Honiton lace area of East Devon and West Dorset is, geographically, a dissected plateau consisting of a series of valleys separated by flat topped ridges of approximately 800 feet elevation. The towns and villages lie in the valleys and this dictates the community pattern, so that even with to-day's ease of transport there remains a pronounced feeling of community within a valley as compared with those who live 'up over'. It is convenient and meaningful, therefore to divide the lacemaking places of the 1698 list into groups according to the valleys of the rivers Otter, Coly, Axe, Sid, Lim, Char and the isolated Branscombe brook, and this is done in Table 3.3. The figures are also shown graphically in Figure 7.1 in which each place is surrounded by a circle proportionate in area to the number of lacemakers who worked there. It will be seen that the Otter valley had the predominant position with 57 per cent of all the lacemakers in the area, which is over twice the amount for the whole of both the Coly or Sid valleys, the next in numbers. Honiton itself had more lacemakers than these two valleys combined. This pre-eminence is in conformity with the pronounced tendency of seventeenth and eighteenth century writers to associate the industry either wholly or principally with the town of Honiton.

Table 3.3　Analysis of numbers of lacemakers and places in the Honiton group in 1698

Valley	Place	Lacemakers		Population	
		Number	%	Number	% Lacemakers
Otter	Honiton	1341	25	2383	56
	Ottery St Mary	814		3343	24
	Luppitt	215		702	31
	Gittesham	139		315	44
	Upottery	118		891	13
	Broadhembury	118		878	13
	Buckerell	90		542	17
	Combe Raleigh	65		256	25
	Monkton	64		87	73
	Feniton	60		501	12
	Total	3024	57	9898	31
Coly	Colyton	353		1699	21
	Farway	70		359	19
	Widworthy	64		310	21
	Offwell	64		282	23
	Southleigh	45		212	21
	Northleigh	32		123	26
	Total	629	12	2095	21
Axe	Seaton/Beer	218		437	50
	Axmouth	73		403	18
	Axminster	60		1768	3
	Musbury	13		422	3
	Shute	12		622	2
	Total	376	7	3652	10
Sid	Sidbury	321		1335	24
	Sidmouth	302		1710	18
	Total	623	12	3045	20

Lim	Lyme Regis	404		NA	
	Uplyme	41		402	10
	Total	445	8		
Char	Charmouth	87		NA	
	Wootton Fitzpaine	8		NA	
	Total	95	2		
Branscombe	Branscombe	108	2	603	18
	Grand Total	5299	100	20585	23*

Population figures derived from the Compton Census, 1676.
*Figure for Devon places only

An analysis of the numbers of lacemakers as a proportion of the population and hence their relative importance in the economy of the district is difficult owing to the lack of reliable data on populations in the late seventeenth century. The 1674 hearth tax returns are available but are incomplete, with important omissions such as Ottery St. Mary, Sidmouth and Sidbury, and there are uncertainties in a number of the figures that have survived. A more satisfactory basis is the Compton Census of 1676 since figures are available for all the Devon places, though no breakdown of the individual places in Dorset exists. Stanes[12] has provided a transcript of the Devon values, has discussed their limitations and calculated estimated populations and these are shown in Table 3.3. It will be seen that the overall figure indicates that about a quarter of the inhabitants of the lace making places were engaged in lace making but that there are local variations. The Otter valley has the highest proportion at 31 per cent. The figure for Monkton is suspect and it is possible that the number given for lacemakers may have included those in the adjacent parish of Cotleigh which is a notable omission from the list. If this were to be the case the percentage for Monkton would drop to 14 and the overall figure for the Otter valley to 29 per cent. The values for the Coly and Sid valleys are noticably constant with individual percentages ranging from 18 to 26. In contrast there are marked differences within the Axe valley with a high value for Seaton/Beer, an average one for Axmouth but very low ones

for Axminster, Shute and Musbury which lie further inland. A possible explanation for these low values is that the available manpower was employed in some other way and an obvious possibility is that they were engaged in spinning for the local flax industry.

Although the hearth tax returns are markedly incomplete those which do exist[13] can be used to make an estimate of the numbers of paupers in the populations concerned and the values available are shown in Table 3.4 together with the corresponding percentages of lacemakers. There is no correlation between the two sets of figures (correlation coefficient 0.07) and it is apparent that the percentage of lacemakers was independent of that of paupers. It may be concluded, therefore that lace making was not an occupation either confined to or even tending towards the poor.

Table 3.4 Analysis of proportion of lacemakers and paupers

Place	% Paupers	% Lacemakers
Axmouth	23	18
Northleigh	25	26
Offwell	31	23
Broadhembury	34	13
Monkton	35	73
Combe Raleigh	36	25
Honiton	37	56
Feniton	39	12
Upottery	41	13
Widworthy	47	21
Seaton/Beer	47	50
Colyton	52	21
Branscombe	53	18

The output of the industry

Virtually no manufacturer's day books, accounts or other sets of business records appear to have survived even from recent times, let alone from the heyday of the industry, but it is possible to make an estimate of the output at the end of the seventeenth century by using the figures of the 1698

memorandum and reasonable assumptions on the speed of working and hours worked.

Mrs Perryman, of Honiton, an experienced lacemaker, has supplied a number of estimates for the area of lace which can be produced in a given time, and these vary according to the complexity of the design and the fineness of the thread between 0.13 and 0.3 square inches per hour per person. A mean value of 0.2 square inches appears to be a realistic figure to use. If it is assumed that there was a maximum of a ten hour working day (see Chapter 10), a six day working week and a fifty week working year there would be a 3000 hour working year. Thus each worker would produce 3000 x 0.2 = 600 square inches of lace per year. The number of workers in the East Devon/West Dorset area was 5339 and so their total output could have been rather more than 3.2 million square inches per year.

By making further assumptions as to the average size of various articles this output can be translated into 400 broad flounces, 1000 pairs of lappets, 1000 cap backs, 2000 collars, 2000 cravats and 20,000 yards of trimming lace. If the eastern extension of the industry is added these figures can be doubled with enough left over for a further 2000 small items such as cuffs.

Estimates of the financial value of the output at the end of the 17th century may be made in two ways from independent data, namely prices and wages. Figures for prices at the end of the seventeenth century (Chapter 13) indicate Honiton lace as between £3 and £6 per yard. However these figures come from persons interested in attempting to boost the importance of the lace industry and probably represent only the best work. The figures for Buckinghamshire lace at this time show that as a result of the 1697 Lace Act the price had increased over a few years by a factor of 3.75 and if such a multiplier is applied to the most expensive Honiton lace of the 1691 figures the value is found to be £1 2s 6d per yard. It seems realistic therefore to assume an average value of £1 per yard. The number of yards represented by 3.2 million square inches depends on the width of the lace and thus may be taken as varying from two inch wide edgings to twelve inch wide flounces. Taking a width of six inches to represent a fair average the monetary value of the output can be assessed at a maximum of around £500,000, with an average probably somewhat less.

The alternative is to base an estimate on the wages paid (Chapter 10). The rates quoted for Buckinghamshire in 1700 are three shillings per week taken all round and seven shillings was stated to be earned by the best workers. Since the Honiton lace was more expensive a figure of five shillings, between these two, may be taken as a basis for calculation. Assuming a fifty week year the workers in the East Devon/West Dorset area would have been paid

around £67,000. To this must be added the costs of material, in this case very little, and the manufacturer's and retailers mark up, which together would be unlikely to be less than a threefold increase, giving an output value of around £200,000.

The two methods thus give figures of comparable order of magnitude and, in the absence of more direct knowledge, may be taken to represent a plausible estimate. The significance of these sums may be assessed by comparing them with figures for the local serge industry compiled by Hoskins,[14] who shows that the exports from Exeter of this material in 1700 were valued at £392,000, whilst those from London were £418,000. Thus the East Devon/West Dorset area of the Honiton lace industry produced goods comparable in value to the serge exports of Exeter or London, and the whole area goods comparable to the two combined.

Such estimates are no more accurate than the assumptions on which they rest, but it seems likely that they are sufficiently realistic as to indicate correctly the order of magnitude of the output and its money value. The figures establish that the Honiton lace industry at the end of the seventeenth century was one of no inconsiderable extent, which must have made an important contribution to the economy of the region, and suggest that the claim in the 1698 memorandum that 'The Lace Manufacture in England is the greatest next to the Woollen' was not entirely without substance.

References

1. Sheldon, p67, and numerous travel diaries and route books of the period.
2. RM, preface.
3. Westcote, p61.
4. Cockburn, p635.
5. Fuller, I p396.
6. Poynter.
7. Chamberlain, p75.
8. CTB, 1691, p1041.
9. Thirsk, 1961, p70-77.
10. Thirsk, 1978.
11. Spenceley, 1973, p81-93.
12. Stanes.
13. Stoate.
14. Hoskins, 1968, Industry, p154.

Chapter Four

1617–1707—The Products
of the Industry

'. . . shewing that he has encouraged the English manufacture with points
and bone lace and improved the same to so great a perfection that there
is as good point and bone lace now [made] in the West of England as
in any part of the world:'

<div align="right">Petition of Edward Bird 1691</div>

A high quality lace

What the lace produced by the Honiton lace industry in the 17th century
looked like is uncertain since no provenanced pieces are known. There are,
however, examples which have been ascribed to the industry [Plates 3-9],
others which are ascribable are illustrated by Levey (163-168) and others still
are in the Victoria and Albert Museum (334.1979, T21.1922, T374.1912).

It is apparent, however, from several references, that it was a lace of high
quality. In 1691[1] Edward Bird claimed that he had 'encouraged the English
manufacture with points and bone lace and improved the same to so great a
perfection that there is as good point and bone lace now [made] in the West
of England as in any part of the world'. Celia Fiennes[2] visited Honiton in
1695 and wrote that '. . . here it is they make the fine bone lace in imitation
of the Antwerp and Flanders lace, and indeed I think its as fine . . .' a passage
that leaves no doubt that she considered the Honiton lace to be on a par with
the world's best.

Evidence available on prices shows that the products of the Honiton lace
industry were much more costly than those produced in the East Midlands
area. The lacemakers' memorandum of 1698 quoted prices before and after

the last lace act, as also did witnesses who appeared before the House of Commons committee which was appointed to consider the repeal of this act.[3] The various figures quoted, reduced to a common basis of shillings, are shown in Table 4.1. It will be seen that before the lace act there was a considerable differential in price between the products of the two regions, though this may be exaggerated by the limited data. However after 1698 the products of the Honiton area are valued at some three times those from the East Midlands, themselves by no means inferior laces. The inescapable conclusion is that the Honiton lace industry produced a high quality product.

Table 4.1 Lace Prices Honiton/E. Midlands

| | Price in shillings per yard | | | |
| | E. Midland | | Honiton | |
	Pre 1698	Post 1698	Pre 1698	Post 1698
1698 Memorandum	8	30		80
1700 Witness 1	5	36		
" " 2	6	10		
" " 3	5	25		
" " 4			80	100-120
" Exhibits		26		60
Average	6.0	25.4	80.0	80-86.6
Ratio H/EM			13.3	3.1-3.4

Sir Copleston Bampfield's sash?

There is a strong probability that a piece of lace in the collection of the Art Institute of Chicago[4] is an example of Honiton lace made in 1661 [Plate 5]. It is catalogued as 'Probably West England, Devonshire, Dorset' but an analysis of the design features provides a number of clues for a more definite attribution.

The overall design consists of a pattern repeated three times, with part of a fourth, and each repeat contains two crowns, two Tudor roses and the three feather emblem used by the Prince of Wales. There is, therefore, a clear connection with British royalty and the royal personage concerned is equally clearly indicated by the words CAROLUS REX (King Charles) which occur twice in the whole piece, and the date 1661, the year following the restoration

of the monarchy in the person of Charles II. This identification is further strengthened by the fact that the whole design is united with sprays of oak involving both leaves and acorns, a device which has traditionally been associated with Charles II in memory of his escape by hiding in an oak tree after the battle of Worcester. The piece also contains the words VIVE LE ROY (Long live the king!) repeated twice. This is a sentiment used by loyal subjects which is most unlikely to have been used by the king himself, and it may be concluded, therefore, that the piece of lace was commissioned by a royalist.

Further examination shows that the letters C and B are placed on each side of the date and it has been suggested that these letters stand for Catherine of Braganza, whose marriage to the king was arranged in 1661. However this suggestion leaves unsolved the problem of the significance of the final incorporated wording, namely CB BARONET, which cannot refer either to the king or to Catherine. An obvious explanation is that the lace was commissioned by a baronet whose initials were CB, who was an ardent royalist and who had special reason for marking the year 1661.

There were two baronets with these initials in 1661,[5] one being Sir Cecil Bishopp of Parham in Sussex. Whilst there is no evidence to show that Sir Cecil did not commission this piece of lace, there is nothing known about his life to suggest that he was at all likely to have done so. The other baronet was Sir Copleston Bampfield (or Bampfylde) of Poltimore, Devon. John Prince (1643–1723), who was a near contemporary of Sir Copleston, included an account of his life in the book *The Worthies of Devon*[6] from which it appears that he was very active in public affairs during the period between the death of Cromwell in 1658 and the restoration of the monarchy in 1660. After the Restoration he raised a troop of gentlemen who rode about the county where they '. . . brought all the disaffected in those parts into due subjection to the government in a little time.' After that:-

> When these dangers now happily over, and the nation once more settled on its antient bottom, this honourable person had the whole posse comitatus of Devon put into his hands by King Charles the Second; he being the first high-sheriff of this county, which he made after his return to the throne, and this was in the year of our Lord 1661. Which office, Sir Copleston executed with splendour in an extraordinary number of liveries, and attendants, as gave occasion to the stinting sheriffs for the future, not to exceed forty upon their own account.

Furthermore Sir Copleston was among the Devonshire gentlemen who were

chosen by the king for a proposed new order of chivalry, the Knights of the Royal Oak,[7] though he was never invested since the project was abandoned.

It may be concluded, therefore, that Sir Copleston Bampfield fulfills with great accuracy the specification suggested for the person who commissioned this piece of lace, for he was a baronet with the initials CB, a royalist who had a special reason for marking a royal favour in 1661 and an enthusiast for dress.

Close examination of this piece of lace shows that its present form is not original, for whereas the ground of the main portion is six point star a piece in the corner, which clearly represents a join, is droschel. Both these net forms are found in 18th century Honiton laces and this suggests that this specimen was originally a straight strip which was later cut up and joined into its present L shape. Reconstruction experiments have shown[8] that this strip was most probably originally a sash, mounted on coloured silk or other rich cloth, and that it would have been of a dimension suitable for wear by a man of Sir Copleston Bampfield's stature.

The next point which must be considered is whether Sir Copleston would have been likely to have commissioned this piece from the Honiton lace industry, and a number of observations suggest that he would have done so. Poltimore is situated about 4 miles to the north east of Exeter and so is close to the lace making district. Honiton is about 11 miles distant so Sir Copleston could have visited a lace manufacturer and have returned home in the course of a few hours. A lace manufacturer could equally easily have visited Poltimore. With a lace industry so conveniently at hand it seems most unlikely that Sir Copleston would have considered going further afield, and there is certainly evidence from later times which shows the local gentry patronising the Honiton lace industry.[9]

The year 1661 was one in which the ban on the importation of foreign lace was publically known through the royal proclamation[10] and so, in theory, this piece of lace should not have been commissioned abroad, though as has been shown, the laws were not always obeyed. However the penalties for being caught were not only a fine but also the confiscation of the lace. A lace dealer, motivated by hope of commercial gain, might consider this to be an acceptable risk, but surely such considerations would not apply to a piece specially commissioned, especially when the commissioner was a man of established position and proven loyalty to the crown. Moreover Sir Copleston had not shared the king's exile and would not, therefore, have had personal contact with the continental lace industry. It seems unlikely that he would have gone to the trouble of trying to place such a special order in a foreign

country with manufacturers he did not know rather than with his own countrymen who operated a notable industry close at hand.

The fact that Sir Copleston Bampfield so closely fulfills the characteristics of the person who commissioned this piece of lace as indicated by its design features and dimensions, and that it is most unlikely that he would have commissioned it from anywhere other than his local source, show beyond reasonable doubt that this is an example of 17th century Honiton lace.

The observations by Celia Fiennes

Celia Fiennes' observation that at Honiton '. . . they make the fine bone lace in imitation of the Antwerp and Flanders lace . . .' has often been interpreted as showing that the Honiton lace was a copy of the Flemish product. It is unlikely, however, that she would have been in possession of the detailed historical, commercial and technical information required for such as assertion and it is likely that her observation should only be taken to imply that the lace produced at the three centres named was similar in appearance. This interpretation is supported by her reference to Antwerp, for though the Antwerp lace of the period bore a resemblance in design to Sir Copleston Bampfield's sash, including the six point star ground, the former was a straight lace whereas the latter is a free lace.

Point d'Angleterre and Dentelle d'Angleterre

In searching for the possible products of the 17th century Honiton lace industry the lace usually designated Point d'Angleterre, which came into prominence in the second half of the 17th century, must be considered, for it is a free lace showing an obvious affinity to the 18th century Honiton type and some writers have claimed that it did so originate,[11] though most have regarded it as a name for a lace made solely in Brussels. The problem for those holding the majority view is the question of why a Brussels lace should have been called English. Mrs Palliser's attempted explanation,[12] which clearly stems from Aubry,[13] has been repeated in esence by many subsequent writers, and is:-

> In usage, it is termed Point d'Angleterre, an error explained to us by history. In 1662, the English Parliament, alarmed at the sums of money expended on foreign point, and desirous to protect the English bone lace manufacture, passed an Act prohibiting the importation of all foreign lace. The English lace merchants, at a loss how to supply the Brussels

point required at the court of Charles II, invited Flemish lacemakers to settle in England, and there establish the manufacture. The scheme, however, was unsuccessful. England did not produce the necessary flax, and the lace made was of an inferior quality. The merchants therefore adopted a more simple expedient. Possessed of large capital, they bought up the choicest laces on the Brussels market, and then smuggling them over to England, sold them under the name of Point d'Angleterre or 'English Point'.

No references to sources, primary or otherwise, are given to support any of the statements in this 'explanation', and apart from the 1662 Act, I have been unable to find any. Nor, apparently, has anyone else been successful in doing so and it appears to be based on imagination rather than evidence. The statement about the thread is obviously incorrect, since the preamble to the prohibition act makes clear that the thread used was imported and was not banned by that act; it is also difficult to understand how the excise officers would have been deceived into accepting that a foreign lace was home produced when it was given a French name. This 'explanation' cannot be seriously entertained.

Another suggestion,[14] put forward by A.S. Cole, was that the lace took its name from its market, but there are a number of objections to this proposal. In the late seventeenth century it was, and has remained so ever since, the normal practice to designate types of bobbin lace by their place of origin, as described by Savary[15] in his dictionary (trans):-

> Thread lace. One uses this term sometimes to distinguish the true thread laces from those of gold, silver or silk. Ordinarily however the thread laces are described only by the name of the places or towns where they are made, or at least where they were first made, without necessarily adding that they are made of thread. Thus when one says English, Mechlin, Dieppe etc. laces one understands at once all these sorts of laces are only made of thread.

Jacques Savary des Bruslons (1657–1716), who has frequently been confused with his father Jacques Savary (1622–1690) author of *Le Parfait Negociant* (1676), was appointed Inspector- General of Manufactures in the Department of Customs in 1686 and retained this post for the rest of his life. He used the unrivalled opportunities of such a position to compile his dictionary of commerce which is, in consequence, a highly authoritative source of information of commerce in general and that of France in particular in the later seventeenth and early eighteenth centuries. A further difficulty in Cole's

suggestion is to understand how a lace could derive its name from a market which was only open by the process of smuggling, and it is to be noted that in the Treasury Books from 1661 to 1703 there is record of one hundred and forty one seizures of lace, under a total of thirty four names, but that there is no mention of Point d'Angleterre. It is to be concluded that this suggested explanation is likewise unsatisfactory.

In seeking the true origin of this material and its possible connection with Honiton lace certain facts must be borne in mind, the first being that the term point in lace terminology is normally reserved for the needle made laces. However all evidence concerning Point d'Angleterre indicates it to be a bobbin lace and it is apparent that some high quality bobbin laces have also been designated point,[16] probably because they were regarded as of comparable fineness to the needlepoints. In consequence references to Point d'Angleterre (English point) and to Dentelle d'Angleterre (English lace) in French sources must be treated with care and may or may not be interchangeable terms according to context.

The second is that the name Point d'Angleterre first appears about three quarters of the way through the seventeenth century and that nearly all known early references are in French sources. This suggests a possible connection with Jean Baptiste Colbert who became Minister of Commerce to Louis XIV in 1668 and who pursued a vigorous policy of building up French industry with a view to self sufficiency. Among the manufactures he sought to establish was that of making Venetian point lace and his success in this matter is well-known,[17] the French version becoming known as French Point. Another example is serge, a fine woollen cloth made, among other places, in Honiton and exported to France through London. Savary[18] records the manufacture in Normandy of cloth in English style (facon d'Angleterre) at Rouen, Dieppe and other places, and of London serge (serges de Londres) at Gournay.

These facts suggest the possibility that English lace was at this time likewise esteemed in France, that Colbert set about imitating that also, and that the resultant product received the designation of English Point. Such a possibility would be in conformity with Savary's observations on the normal system of lace nomenclature and could have led to the usage of the term English Point in France to designate a style of lace irrespective of its actual place of manufacture, to the subsequent confusion of lace historians.

In considering this hypothesis it is first necessary to establish whether English lace was known and esteemed in France at this period, as it certainly was in 1636 when the Earl of Leicester, English ambassador in Paris, elected to make a present of English lace to the Queen of France.[19] An important contemporary source is *La Revolte des Passaments*[20] a satirical prose and verse

extravaganza published in Paris in 1661 as a humourous counterblast to an edict of 1660 forbidding the wearing of lace. The work depicts the laces meeting together for discussion and deciding to mount a rebellion, which did not succeed. In all, nineteen laces are named and, as might be expected, the largest national group is eight from France. This is followed by four from England, three from Italy, two from Flanders, and two from Spain (assuming that Moorish style lace was Spanish), thus showing that English laces were undoubtedly familiar to Parisians at that time.

One of the English laces is named simply an English lace and in her speech takes the view that a halberd could pass through and through her without harm. It is possible that this is an allusion to a guipure lace with gaps in it through which a blade could indeed pass without damaging the fabric. The second type is named black English lace, who is described as hiring herself out cheaply as a net to catch woodcocks in the forest and this is stated to be a role which suited her well in the dress which fashion had recently given her. This passage suggests a lace involving a net ground and that this form had only been adopted lately. The third type, described as a large or important (grande) English lace is depicted as making a lengthy speech, in which she expresses cynicism at the glamour of the smart set (trans) '. . . reposing now on the arms, now around the charming throat of Philis, or even of Amaranthe. What joy to touch, uncovered, a beautiful youthful breast, to kiss the bloom of a cheek not yet dulled by age . . .', sentiments indicating a lace esteemed in Society for outward show. The fourth English lace is referred to in the description of the line of battle, where it is stated that the right wing consisted of six squadrons each of one hundred and fifty units of English laces, English style lace and Moorish style lace, and it is evident that a distinction is drawn between English and English style lace. Such a distinction only appears to make sense if the latter is lace made in the English manner somewhere other than England, and could well mean that at this time English lace was being copied in France.

Evidence for an inflow of English lace into France at this period is found in Savary's *Dictionary*. He states that (IV 8) the customs mark on thread laces coming from Flanders, the Low Countries and England, as also on the points of Genoa and Venice and other foreign countries was established in France in 1660, by royal order in the month of July of that year. A further order (II 1150) laid down specific points of entry for laces from foreign countries and these included no less than three for those from England, namely Calais, Dieppe and Le Havre, as opposed to one each for other countries. It is furthermore stated (I 937) that the English are great exporters and among the list of exports quoted are thread and silk laces, made both by bobbin and

needle. The evidence from these contemporary sources establishes that English lace was imported into and known in France at the time when the first references to English point occur.

Evidence for the manufacture of English style lace in France at this time may be found in several sources, apart from that already quoted from *La Revolte des Passaments*. In June 1686[21], following the disturbances created by the revocation of the Edict of Nantes the previous year, Jean Bourget and an associate, under the patronage of Père de la Chaise, installed in a house at Villiers-le-Bel which had been left vacant by protestant refugees, a manufactory of English style and Mechlin style bobbin laces. On 12 March 1691 an edict was issued by the king in council[22] in which it was stated that the king had been informed that some years previously the lacemakers had invented a type of lace which was made in pieces which were subsequently joined together by bobbins, a clear description of a free lace. It was stated that this lace was known in commerce as English lace or as Brussels lace, and that it was made not only in French Flanders but also in other provinces of the kingdom. In June 1699, Clément de Gouffreville,[23] who was a native of Brussels, made an application to start up a lace manufactory at St Denis, was given leave and royal patronage to do so, and was permitted to use the designation (trans) 'Royal manufactory of English laces.'

The manufacture of English point lace is also referred to in two contemporary documents. One is a memorandum written from London in 1695 by an unknown person to the ambassadors designate of Venice to England, giving much advice for their journey and details of what to expect in London.[24] English point lace is referred to in one passage (trans)

> The points from there [ie Venice] are not brought here at present while there is mourning [ie for Queen Mary, d1694] and even before that they were hardly more fashionable, and as for that called English point I would tell you that it is not made here but in Flanders and is called English only to distinguish it from the others.

This has invariably been taken to be evidence that English point lace was made in what is now Belgium, but such an interpretation fails to take account of the boundary changes between northern France and the Spanish Low Countries consequent upon the treaty of Aix-la-Chapelle in 1668, whereby the department of French Flanders came into being. It has been shown by the decree of 1691 that a free lace of the type of English point was made in this province and so the Italian passage could equally well refer to the French department, and 'the others' signify other French laces. Since such an

interpretation is consistent with the other evidence the balance of probability is in its favour; the passage certainly cannot be used as definite evidence of manufacture in Spanish Flanders.

The other passage appears in Savary's Dictionary (I 939) in the section on the commerce of England and is as follows (trans)

> As regards the thread laces that are named English points, they are very fine and very beautiful: but since they have been imitated and surpassed in Flanders, Picardy and Champagne they are no longer brought from London for France.

This makes clear, with the considerable authority of Savary, that the origin of the lace named English point lay in England, as commonsense suggests from the designation, and that, as the other evidence shows, it was imitated and improved on in three provinces of northern France, in the same way that Venice point gave rise to French point.

The making of lace based on English was not confined to France and Savary observed in his dictionary (I 900) in the entry relating to Flemish Flanders (ie the Spanish Low Countries) (trans)

> The manufacture of English style laces, and those which are called Brussels and Mechlin, flourish there in many places; and it is from this Province there comes to Paris most of those which pass there for real English and Mechlin laces.

The subsequent confusion caused in France by Belgian production of a lace similar to English and called English by the French is illustrated by two quotations from 1713. Laprade[25] quotes from a letter from the Intendant of Amiens to the Contrôleur Général dated 3 and 7 May 1713 (trans)

> The laces called English thus called to distinguish them from those of Mechlin and others of Flanders, are made neither in Artois as the king seems to have believed, nor in Lille, nor in Tournay, but only in Brussels.

which suggests that the production of English point in French Flanders had declined, since Artois, Lille and Tourney were all in that province.

On 22 July[26] the Contrôleur Général made it known that Clément de Gouffreville, who had stated that his business had been ruined by the war, had received royal approval to re-establish himself and he is described as former proprietor of the manufactory of Brussels style laces, having been

described in 1699 as manufacturer of English laces. Thereafter the name English Point was used somewhat indeterminantly degenerating in the nineteenth century into a meaningless term, as for example in this extract from a newspaper[27] of 21 January 1862:

> English laces are quite the rage in France. Brussels, Alencon, and Valenciennes have been obliged to make way for them, so much so that fashionable modistes scorn to trim ladies' dresses with anything but point d'Angleterre—the general term for Honiton, Limerick, Carrickmacross and a kind of lace made in the South of Ireland.

It may be concluded from contemporary evidence, mainly French, that English lace was known and appreciated in France at the period when the name English point came into use in that country, that laces known as English, English style and English point were made there and that these were derivatives of English lace. Since the available evidence indicates that the laces concerned were free laces their origin must have been in the products of the Honiton lace industry, the only free lace making area of England. It is evident that similar lace was made in Brussels and that in France this too was designated English. It would appear that lace in the world's collections now classified as Point d'Angleterre and that classified as later seventeenth and eighteenth century Brussels bobbin lace most probably consists of material produced in England, in France and in Belgium. Considerable further research is likely to be needed before diagnostic features are identified which could distinguish between the places of origin, if such a thing be possible at all.

Rag or abstraction?

In the 19th century low quality Honiton lace, designated 'rag lace', was produced alongside the high quality pieces. There is some evidence to indicate a similar thing in the 17th century as may be seen by comparing plates 6 and 8 with 7 and 9. The two flounces are clearly based on the same design but the depiction is much rougher and more sketchy in 7 and 9. An obvious interpretation is that the latter represents a degenerate form of the former in the way that the horses on British Celtic coinage changed into nearly unrecognisable forms. It may be noted, however, that a recent authority[28] claims that the coinage change was due to deliberate abstraction rather than degeneracy. The possibility that such an explanation in the case of the lace cannot therefore be discounted.

References

1. CTB, 1691, p1041.
2. Fiennes, p136.
3. CJ, XIII p269-271.
4. Art Institute of Chicago, 1937.452.
5. GEC, I p156, II p101.
6. Prince, p121.
7. Chalke, p324.
8. Yallop, 1984, Example.
9. eg. Woolmer's Exeter and Plymouth Gazette, 20.5.1848(6).
10. PRO, SP45/11.
11. Seguin, p70. Jackson, 1900, p154. Powys, 1981, p4,25.
12. Palliser, 1865, p102.
13. Aubry, p62.
14. Cole, 1884.
15. Savary, 1726, II c50.
16. Savary, 1726, II c1150.
17. Cole, 1939, II p238-286.
18. Savary, 1726, I c866. Kerridge, 1985, p28,29 gives other examples of continental copies of English cloth bearing the designation English.
19. HMC 77VI p82, 105.
20. Whiting, p5-39.
21. de Laprade, p192.
22. Bibliothèque Nationale de Paris, Manuscrits Français, 21788.319.
23. de Laprade, p192.
24. Unknown author, Carte
25. de Laprade, p107.
26. de Laprade, p193.
27. DRO, 1037M/F2/1.
28. Van Arsdell, p33-36.

Chapter Five

1707–1816—Continuation and Contraction

The neighbourhood of Honiton is celebrated for its laces, which are made there of great beauty and are in high estimation . . . it furnishes employment to a considerable number of the women of the place, and its vicinity.

'J.T.' Remarks on the present state of the county of Devon 1810

The period covered by this chapter is from 1707, when all laws prohibiting the importation of foreign lace made of thread were repealed (5 Anne c17) to 1816, the year in whch John Heathcoat set up the alternative method of lace making by machinery in East Devon at Tiverton. Throughout much of this period the observations of travellers and other commentators indicate a generally thriving industry centred on Honiton. Although Defoe, early in the period, describes an extension westwards of the lace making area, many omissions of any reference to lacemaking in the towns to the east of the Honiton group suggests that in that area the industry contracted and had virtually disappeared by the end of the period. Parliament continued to interest itself from time to time in the lace industry and various legislative measures were enacted with the object of assisting the industry and the workers engaged in it. Towards the end of the period changes in fashion reduced the demand for lace and this is reflected in various difficulties recorded. The overall picture is of an industry continuing to thrive in East Devon though contracting elsewhere, but retaining throughout a high reputation for its products.

Legislation

A number of legislative measures during the period were concerned solely with gold and silver lace,[1] but since there is no evidence or tradition that these types were ever produced by the Honiton lace industry they are not relevant to the present discussion. The first act which was concerned with bone lace was one of 1717 (4 Geo I c6) which provided a measure of relief to lace wholesalers who had found themselves in difficulties in consequence of the act of 1696 (8/9 William 3 c25) which provided for the licensing of hawkers and pedlars '. . . for a Provision of Payment of the Interest of the Transport-debt for the reducing of Ireland,' and which was continued by 9/10 William 3 c27 in 1697. The licence entailed the payment of £4 per annum for each horse or other beast of burden employed, and a penalty of £12 per offence of trading without a licence, the penalty money to be divided equally betwen the informer and the poor of the parish wherein the offence was discovered. The preamble of the act states that '. . . several of the Makers and Traders in English Bone-lace, who trade by wholesale, and employ many thousands of poor People in the said Manufacture of Bone-lace, have been lately informed against, prosecuted and molested in the carrying on of their trades, under Pretence that they ought to take and have Licences according to the Directions and Provisions of the Act before-mentioned, or of some other Acts touching Hawkers and Pedlars.' It was enacted that makers and traders in English bone lace who sold by wholesale should not be deemed to be hawkers, pedlars or chapmen, nor should their children, apprentices, servants or agents, and that such persons could go freely from house to house and from shop to shop to their customers, whether the latter sold by wholesale or retail. Parliament had resolved[2] to bring in such legislation in 1699 but the fact that this matter was now considered to be important enough to warrant legislation suggests that the burden on the lace trade was a serious one, and that the relief afforded would have had a significant effect on the profit margins of the industry. This episode also throws light on the mechanism used for the distribution of the products of the industry and this is considered further in Chapter 13.

From time to time foreign lace was seized by customs officers but dealers were able to obtain this material and put it on the home market, to the disadvantage of the home industry and also the public revenue. In 1767 Parliament redressed this situation (7 Geo 3 c47) by decreeing that no foreign lace which had been seized was to be released from any customs warehouse save on the condition that it was for export only.

The truck system, whereby workers were paid in goods rather than money,

led to many abuses and consequent dissatisfaction and legislation over a very long period.[3] In 1779 Parliament considered the state of the lace industry in this connection[4] and as a result passed an act (19 Geo 3 c49) specifically to safeguard lacemakers, which stated that '. . . all Lace Merchants and Dealers in Lace, and all other Persons who shall employ any Person or Persons in the making of Bone or Thread Lace, or who shall buy any Bone or Thread Lace of the Maker or Makers thereof, shall and are hereby required to pay such Person or Persons for their Labour, and for all the Lace so bought of them, in Money only, and not with Goods . . .'. The reason for the introduction of this legislation at this time is not apparent, though it seems likely that it is to be associated with the East Midlands branch of the industry, since the three members who were instructed to prepare the bill represented Buckinghamshire, Northamptonshire and Aylesbury Borough respectively. The instruction was given on the same day as the reference to a committee of a petition, referred to below, from the lace industry but this was entirely concerned with the damage done to trade as the result of smuggling, a problem which could not be alleviated by a truck act. The provisions of the act appear to have been virtually entirely ignored and the payment of lacemakers in goods continued until well into the 19th Century. The possible reasons for this are discussed in Chapter 10 but one is apparent in the wording of the act, for this provided that any breach of the provisions should be dealt with by a complaint of an aggrieved party to a local Justice of the Peace. Apart from the reluctance that a poor, probably illiterate, lacemaker would have in invoking the law there would clearly be the intimidatory thought that anyone taking such action could well receive no further work. Indeed this Act, however well intentioned as righting an injustice, appears to be somewhat naive in the provisions made for its implementation. There is no record of any proceedings under the act in either the Buckinghamshire or Devon Sessions records in the years immediately succeeding, so it does not seem to have been the result of any urgent problems.

Another matter in connection with the English lace industry which engaged the attention of Parliament was a petition from the lace manufacturers of the counties of Buckingham, Bedford, Northampton and other parts of the kingdom,[5] the latter presumably including the Honiton lacemaking area. Their complaint was that the industry was being damaged owing to a decline in demand for their product and that this state of affairs was occasioned by the smuggling of large quantities of foreign lace into the country, which was being sold as having paid duty '. . . a fallacious Pretence that succeeds with uncommon Impunity', and that in consequence the honest traders, not being able to compete on fair terms, were being overwhelmed. The petitioners

suggested that there should be a complete prohibition on the lowest priced laces, with a graduated scale of duty for the higher priced ones, and claimed that duty lost would be made up by the duty on increased importations of thread for use by the home industry. They also drew attention to a fraudulent practice by the French importers who passed their lace into the country as being German (presumably from Hanover) and succeeded in this deception owing to the inability of the customs officers to distinguish the one from the other. The House of Commons ordered that the petition should lie upon the table, but later referred it to a committee.

Action to deal with the lacemakers' complaint was taken in an act (19 Geo 3 c66) for preventing 'the pernicious Practices of Smuggling' by 'Gangs of daring and dissolute Persons, armed with offensive Weapons, and associated and assembled to carry with Execution their evil and pernicious Purposes . . .'. Clauses 24 to 28 dealt specifically with the smuggling of foreign lace into Great Britain, and provided that all foreign lace imported should be sealed at both ends by the customs officers at the port of importation. Provision was also made for sealing lace already in the country, for unsealing foreign lace on re-export and for penalties for forging seals. This was clearly an attempt to meet the complaint but by a method different from that suggested by the petitioners.

Parliament did not, however, thereby get away from the question of the customs duties on foreign lace.[6] A petition was received from the merchants and inhabitants of Cullompton, together with others from Tiverton and Wellington to much the same effect, namely that they had learned from foreign correspondents that unless the duty on linen and lace from Flanders was reduced, a duty would be imposed on all British woollen manufactures imported into that country, to the detriment of the English woollen trade, of which these towns were important centres. The arguments are reminiscent of those put forward in connection with the repeal of the lace act of 1697 and, as then, the petitions were referred to a committee. Further petitions of a similar nature were received from the merchants and traders of London and the merchants and manufacturers of Manchester, but these were left on the table.

On 2 May 1780 the committee reported to the House at length, quoting witnesses and producing letters, including one in French from a merchant in Ghent. The essence of the Flemish complaint was the inequitable method of assessing lace for import duty, which was sixteen pence per yard irrespective of value, and this amounted to an absolute prohibition on the lower priced laces which, valued at six pence per yard, could not support such a surcharge. It was pointed out that hitherto such laces had come into the country by

smuggling but that the recent anti-smuggling act had effectively closed that channel. Various of the witnesses suggested that a fairer system would be a charge of 10% on the value of the lace and one of them added that '. . . if the English Manufacturer cannot bring his Commodity to Market on equal Terms with the Foreign Lace charged with 10 per Cent. Duty, exclusive of Freight and other Charges attending the Importation, it appears to me that the English Manufacturer merits little Preference from Government;'. The House resolved to adopt the 10% proposal and a panel of six members was instructed to prepare a bill to that effect. One of the six was Sir George Younge, member for Honiton and grandson of a former member, Sir Walter Yonge, who had been much involved with the lace legislation in the last decade of the previous century.

On 24 May the lace manufacturers sent in a petition protesting that the new proposals would be ruinous to them and praying that the current situation should remain. The petitioners' counsel was heard by the House but failed to carry conviction and the bill went forward, one of its supporters being Sir George Yonge who evidently thought this course best for his constituents. Whether his constituents agreed is not known, for though Sir George served for the town in subsequent parliaments it was at a time when Honiton was notoriously corrupt and election depended on the candidate's purse rather than his politics. In the event the bill did not become law, not having passed all stages before the prorogation and not being proceeded with in the next session.

It was a long time before a change to an ad valorem system took place. In 1787 an act regulating customs duties (27 Geo 3 c13) contained a book of rates in which lace was still charged on the simple length basis. In 1803 an act which allowed foreign silk lace to be imported (43 Geo 3 c68) contained a book of rates in which thread lace was charged at two rates, one an ad valorem rate for lace of value less than twenty shillings per yard and the other a yardage rate for lace of higher value. This was superceded in 1806 by an act (46 Geo 3 c81) '. . . for better encouraging the manufacture of thread lace in Great Britain' which laid down duties on a six tier system charging on a yardage basis for the lower value laces and an ad valorem basis for laces exceeding twenty five shillings per yard in value. Finally in 1825 (6 Geo 4 c104) the customs duties on lace were set on a simple ad valorem basis of £30 for every £100 in value—forty five years after the House of Commons had agreed to a bill to bring in such a system!

The product

During the period under review the products of the Honiton lace industry continued to enjoy a high reputation and the quality was remarked upon by a number of observers. Defoe[7] writing in 1724 observed of Blandford that it was 'chiefly famous for making the finest bone lace in England, and where they shew'd me some so exquisitely fine, as I think I never saw better in Flanders, France or Italy, and which they said, they rated at about 30L. sterling a yard; but I suppose there was not much of this to be had, but 'tis most certaing, that they make exceeding rich lace in that county, such as no part of England can equal.'

The high quality of the product was shown in 1753 when the Anti-Gallican Society offered prizes for the best English lace lappets and the first prize of 15 guineas was won by Mrs Lydia Maynard of Honiton.[8]

In 1760 Mrs Powys recorded in her diary[9] that she and her party '. . . reached Exeter early on Friday, stayed there the whole day, and got the next morn by twelve to Honiton. When we were before at this town, knowing we were to return thro' it, we defer'd till then seeing the making of bone lace; so now, as soon as we had breakfasted, went to view their chief manufacture, which really gave us great pleasure, and much more to see 'twas our own country-women that could arrive at such perfection in this work, as I hope will prevent our ladies from forming the least wish to have the right Flanders; for really, on comparing two pieces, ours had the first preference; and if so, how very cruel not to encourage the industrious poor of our native land.'

In 1764 Anderson[10] observed that Devonshire had manufactures of the finest bone lace, whilst in 1793[11] an unknown writer in the Gentleman's Magazine observed that rich lace and edgings were made at Honiton. In 1810 another unknown writer, identified only as JT, contributed 'remarks on the present state of the county of Devon' as an introduction to a new edition of Risdon's *Survey*. He observed[12] that 'The neighbourhood of Honiton is celebrated for its laces, which are made there of great beauty and are in high estimation. Dresses of them are sometimes made which cost very large sums of money.'

The lace was made in the form of edgings of various types and widths [Plate 12], lappets (Plate 10) and other articles [Plates 11, 13, 16]. One aspect which appears to have attracted attention was expressed in 1747 by Bowen[13] when writing of Honiton 'the people are chiefly employed in the manufacture of lace; the broadest sort that is made in England;'. Various topographers and travel book writers repeat this remark but the wording is so similar that

it is doubtful if they are independent observations. The expression 'the broadest lace' clearly implies a free lace, such as has apparently always been made by the Honiton lace workers, and this reference may well relate to the broad flounces of mid 18th Century style which can be associated with the industry [Plates 14, 15]. These bear a resemblance to the broad flounces of unknown origin which are usually designated Brabant and it is probable that pieces of this type were made both by the Honiton and Brussels lace industries. Sharing the common free lace technique and following current fashions it is only to be expected that the products of the two regions should have a similarity of appearance.

The fashion changes towards the end of the 18th Century produced a demand for very light lace consisting mainly or even wholly of net and such net was produced on the pillow in narrow strips, about ¾ inch wide, which were then joined with such skill that the joins were near to invisible [Plate 17]. Edgings could then be sewn on and, if desired, some motifs could be applied to the body of the net (appliqué technique) to produce scarves and shawls in keeping with the delicacy of the fashionable requirements [Plate 18].

Bath lace

In 1749 John Wood[14] wrote

> To Bath Rings, Bath Metal, and Bath Stone, we may now add Bath Lace as a commodity the sale of which has proved a very considerable Branch of the Trade of the City; for the Manufacture is not made here; and it was partly from the great Consumption of it in the Town, and party from the Manufacturers receiving their Patterns from hence, that it first took the Name of Bath Lace.
>
> This Commodity has, within the Compass of an Age been advanced from small Edgings of eighteen Pence, to fine broad Laces of three Guineas a Yard; and the Manufactories are so considerable that they principally consist of four large Towns in the Neighbouring County of Devon; in one of which I have heard of a single Trader whose Expenses in Letters, to procure new Patterns for his Laces, amounts to Seventy Pounds a Year! and I am well satisfied that the Art of Designing might, by our Bath Lace, receive an encouragement worthy of the Attention of Men of the finest Genius for Ornament. By this Lace the Milliners Business is not a little enhanced; Suits of Wedding Cloathes for the ladies, from far and near, being constantly making in the Shops of the City; and Matrons themselves preferring those shops to the Shops of almost any other place for their Head Attire.

It is apparent from this that the lace designated Bath lace was a product of the Honiton lace industry and it is possible that the 'fine broad laces' referred to are the same as the 'broadest lace in England' mentioned by Bowen and other writers. The probable identity of the four towns referred to emerges from the Milles Parochial Returns of 1756, in which the incumbents of eight places in East Devon reported that lacemaking was carried on in their parish. In four instances, namely Honiton, Ottery St Mary, Sidbury and Sidmouth, there is a statement about the marketing of the product and in each both London and Bath are referred to specifically, with an indication that there were other, unnamed, markets as well.

A variant on the name Bath lace is Bath Brussels lace which Levey[15] has identified in late 18th Century accounts. An explanation of this term was given by Gidley[16] in 1820 when he wrote of the Honiton lace industry '. . . afterwards when large quantities were taken off by Bath & London it acquired the name of Bath Brussells Lace, given it by the retailers. It however now seems to have resumed its original name of Honiton Bonne Lace.' Certainly the name Honiton lace appears in *La Belle Assemblé* for 1810 (p.296) where the Duchess of Rutland is described as wearing a 'petticoat of Honiton lace over pink sarsnet'.

The explanations given by Wood and by Gidley show that Bath and Bath Brussels laces were not a distinctive type but were examples of the products of the 18th Century Honiton lace industry. The fact that they found a substantial market in Bath, a noted resort of the fashionable ladies of the time, is a further indication of their high quality.

Devon trolly lace

In his letter already quoted Gidley also wrote 'The lace makers along the coast continue to make an inferior lace of British thread called Trolly Lace of which they sell great quantities.' Trolly lace is a straight lace [Plate 67] and is, therefore, different in the technique of making from the free lace of the Honiton industry. Gidley's letter is the earliest known reference to the making of this form of lace in Devon and, although his wording suggests an established technique, it seems possible that it was not of long standing, especially since its location was in a restricted part only of the Honiton lace making area. The question arises, threfore, of how this manufacture, which had been carried on elsewhere, in Flanders, Normandy and the East Midlands at least, for some two centuries, came to the East Devon coastal villages.

One possible origin of the Devon trolly lace industry is a spread from the East Midlands, and whilst this is a possibility which cannot be discounted

there appears to be no evidence that this was so. The fact that in the early 19th Century, and later, the technique was confined to the coastal area suggests the possibility that it was brought directly from abroad, an obvious hypothesis being that it came with refugees from Normandy around the time of the French revolution. Certainly French refugee lacemakers were reported as going to the East Midlands lace area in 1794.[17] Connections between France, the Channel Islands and East Devon are clearly shown in various parish registers. A son of Joseph 'a french man borne in Axminster' was baptised at Farway in 1622, a daughter of John Banden 'a ffrench man' was baptised at Seaton in 1631, a daughter of James 'a Frenchman' was baptised at Axminster in 1706 and Oliver Nicholas of Alderney married Mary Ford of Branscombe in 1794. The Seaton and Beer registers for burials contain records from 1804 to 1824 of men of the parish who had not been buried but had died at sea. Twenty six names are given, two of whom are specified as French, all are described as having been engaged in smuggling and four are stated to have been drowned off the French coast. Other evidence of connections between Northern France, the Channel Islands and East Devon have been recorded.[18] It is possible, therefore, that some refugees could have reached the coastal villages of East Devon via this established connection.

The East Devon parish registers at the end of the 18th century give no support for a hypothesis of any general influx of French refugees, but there are some suggestive entries in those for Seaton and Beer. A family named Rosier appears in 1784 and, although this name was known in North Devon in the 17th and early 18th centuries, this particular family appears to have come from elsewhere. A family named Laroum appears in 1780 and 1782 and John-Morice son of Morice and Anne Jarvice in 1784 must surely be of French origin. The fact that these people all appear at a time when events in France were foreshadowing the revolution and that no other names possibly of French origin appear in any other registers of the East Devon parishes at this time is consistent with some French people reaching Beer via the smuggling route. Though this is not conclusive evidence for a French origin for Devon trolly lace it is consistent with it and with the known geographical distribution of this technique in the area.

The extent of the industry

The areas in which the English lace industry in general and the Honiton lace industry in particular were to be found at the close of the 17th Century are discussed in Chapter 3. As regards the Honiton group in the period 1707–1816 it is clear that Honiton itself retained its pre-eminence, for writers of

topographical and travel books as well as compilers of gazetteers single out Honiton for mention in connection with lace. In 1720 John Gay described a journey from London to Exeter in verse[19] and although he visited Salisbury, Blandford, Dorchester and Axminster it was only when he referred to Honiton that he mentioned lace

> Now from the steep, midst scatter'd Farms and groves,
> Our Eye through Honiton's fair Valley roves.
> Behind us soon the busy Town we leave,
> Where finest Lace industrious Lasses weave.

In 1747 Bowen[20] wrote of Honiton 'The people are chiefly employed in the manufacture of lace; the broadest sort that is made in England; of which great quantities are sent to London.' Essentially the same words were written in 1756 by the Dodsley's,[21] in 1759 by Brice,[22] in 1774 by Postlethwayt,[23] in 1792 by an unidentified writer,[24] in 1803 by Britton and Bayley[25] and in 1810 by Evans.[26] The observations of Mrs Powys in 1760, Anderson in 1764, an unknown contributor to the Gentleman's Magazine in 1793 and 'JT' in 1810 have already been referred to and in 1775 Milles[27] wrote of Honiton 'The town is chiefly supported by its thoroughfare being in the great western road from London, and by its manufacture of lace, in which they excell, and make it from y lowest price to 4 or £5 a yard.' In 1803 Gough[28] wrote of Honiton 'It is a great thoroughfare to the west and is famous for a lace and serge manufactory'.

References to lacemaking at other places within the group are scarce. Defoe[29] writing in 1728 refers to lace making generally in Wiltshire and Dorset and his comment on Blandford has already been referred to. Brice,[30] however, writing in 1759, says of Blandford that 'formerly its chief Manufacture was Bandstrings, and afterwards Straw-hats and Bone lace: but Maltsters and Clothiers are now the princ: Traders here.' References to a very much decayed lace industry in Salisbury at the end of the 18th Century are to be found.[31] The second and third prizes awarded by the Anti-Gallican Society in 1753 were taken by Mrs Mary Channon and Mrs Heber both of Lyme Regis,[32] and Roberts,[33] writing of the lacemakers of Lyme Regis in the 18th Century states that they took in work from Honiton and Colyton. The Milles Parochial Returns refer to lacemaking at Aylesbeare, East Budleigh, Otterton, Ottery St Mary, Sidbury, Sidmouth and Withycombe Raleigh, and in parish registers illegitimate children are recorded as born to Jane Brake of Ottery St Mary in 1813, Mary Churchill of Ottery St Mary in 1814 and Anne Trott of Seaton in 1815, all the ladies being designated as lacemakers. The paucity

of these references, a number of which are in obscure sources, compared with the references to Honiton show that the public image of the Honiton lace industry in the 18th and early 19th Centuries centred on Honiton itself.

Defoe[34] observed in 1724 that '. . . the valuable manufactures of lace for which the inhabitants of Devon have long been conspicuous are extending now from Exmouth to Torre Bay,' indicating that the lacemaking area had extended beyond that indicated by the 1698 memorandum. This is, however, the sole evidence for such an extension and since Defoe's knowledge of the topography of Devon may be questioned—he gave an entirely wrong location for the South Hams—this may not be a reliable statement. In contrast a number of the writers who refer to places to the east of the Honiton group which are listed in the 1698 memorandum make no mention of lace in connection with them. Thus the Dodsleys[35] mention Salisbury, Yeovil, Blandford and Dorchester, Brice[36] and Britton[37] both refer to Salisbury and Crosby[38] refers to Salisbury, Blandford, Dorchester and Shaftesbury, all without any mention of lacemaking.

In 1820 Gidley[16] write of the Honiton lace industry that 'About 40 or 50 years since when this manufacture flourished the number of females employed by Honiton in Honiton and the neighbouring villages was abt. 2400 but it has gradually gone to decay since that time and the no. at present imployed by Honiton does not exceed 300.' This contraction can be attributed in part to late eighteenth century changes in fashion but chiefly to other factors which are discussed in Chapter 6.

The number of lacemakers given in the Memorandum of 1698 for Honiton and the surrounding villages, that is those with boundaries contiguous with Honiton parish, is 2048 or 2149 if an average value is assigned to the unquoted Awliscombe. Comparison of this figure with Gidley's pre-decline estimate indicates that in the first eight decades of the century the industry in the Honiton area had continued at a steady, or perhaps slightly improved, level. However it is evident that lacemaking in the Dorset/Somerset/Wiltshire area to the east had largely died out, and, since in 1698 this area represented about half the workforce, there had been a substantial failure of the industry to retain its market. This failure is all the more marked in view of the fact that the eighteenth century was one of expanding population in England and Wales owing to a reduced death rate, so that, until the changes towards the end of the century, there was potentially an expanding market.

The contraction of the English lace industry as whole is also reflected in the import figures for sister's thread[39] which was used in the lace industry. Figure 5.1 shows the quantity imported year by year from 1700 to 1773 and it will be seen that there is some decline in the first quarter of the century,

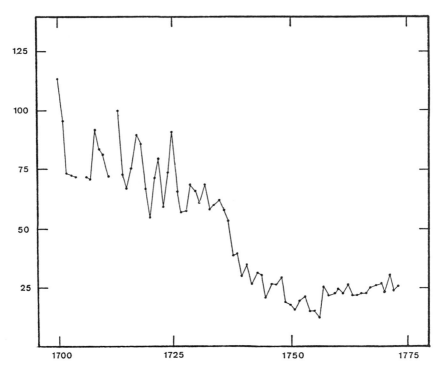

Figure 5.1 1700–1773. Annual importation of sisters thread (thousands of pounds weight)
into England and Wales. Source: Schumpeter E. English overseas trade statistics.

followed by a steeper one in the second and a moderately steady demand in
the third. Some decrease could be expected since measurements have shown
that the lighter laces in vogue in mid-century would have required only some
80 per cent of the quantity of thread required for the more solid ones at the
beginning. Since, however, the decrease is to some 25 per cent it is evident
that these figures indicate either a real decline in the industry or a change
towards English spun thread. There is no known evidence for the latter.

 It seems probable that the industry's failure to take advantage of the
opportunity offered arose from the realisation of the fears of those who had
argued at the end of the previous century that the removal of protective
legislation would lead to a decline. The removal of import restrictions opened
the home market to many more suppliers and hence to greater competition,
the adverse potential of which would have been intensified by the common
tendency to favour foreign productions, as being considered more exotic and
attractive than the domestic ones, even when the latter were equally good.

As Chamberlain observed[41] in 1683 '. . . all foreign Artifices usually (especially the French) have ever the chiefest vogue among our Galants', a sentiment echoed over two centuries later by W.S. Gilbert in The Mikado when he referred to '. . . the idiot who praises, with enthusiastic tone, all centuries but this and every country but his own.' In the event the end of the period saw a reduced industry consolidated into its original home in East Devon, the area with which it has remained associated.

References

1. 12 Anne c26. 15 George 2 c20. 22 George 2 c36. 28 George 3 c7. 17/18 George 3 c1, Parliament of Ireland.
2. CJ, XII p633.
3. The principal Acts from 4 Edward 4 c1 onwards are set out in 1/2 William 4 c36, which preceded the general Truck Act 1/2 William 4 c37.
4. CJ, XXXVII p303, 336, 362, 401, 406, 421.
5. CJ, XXXVII p185, 303.
6. CJ, XXXVII p595, 597, 621, 705, 709, 791, 813, 846, 854, 868, 874, 897, 903, 909, 918, 920, 923.
7. Defoe, 1927, p217.
8. Gentleman's Magazine, 1753, p389.
9. Powys, 1899, p77.
10. Anderson, p69.
11. Gentleman's Magazine, 1793, p113.
12. Risdon, pXXVII.
13. Bowen.
14. Wood, II p436.
15. Levey, p84.
16. BL, Add MS 9427 Item 255.
17. Annual Register, 1794, Chronicle, p21.
18. Rattenbury. Coxhead, 1956.
19. Gay, I p203.
20. Bowen.
31. Dodsley, p7.
22. Brice, p709.
23. Postlethwayte Devonshire.
24. The Universal British Dictionary, Honiton.
25. Britton and Bayley, IV p300.
26. Evans, p76.
27. Milles.
28. Camden, Honiton.
29. Defoe, 1927, p216, 217.

30. Brice, p189.
31. Victoria County History, Wiltshire, VI p180.
32. Gentleman's Magazine, 1753, p389.
33. Roberts, 1834, p156, 157.
34. Defoe, 1918, p145.
35. Dodsley, p5, 7, 22.
36. Brice, p1136.
37. Britton and Bayley, XV p61.
38. Crosby, p57, 150, 426, 431.
39. Schumpter, Table XV.
40. Chamberlain, p75.

Chapter Six

1768–1820—The Machine Revolution

There are in HONITON a great number of Lace-makers out of employ and in great distress.

Exeter Flying Post 27 Feb. 1817

Courtenay Gidley's letter of 1820 shows that, although the Honiton lace industry in East Devon had been in a thriving condition some forty or fifty years previously, that is in the 1770's, it had since then declined. Some of this decline can be attributed to the fashion changes which occurred from the 1780's, but much of it must be assigned to the effects of a development which was to have a lasting and eventually fatal effect on the bobbin lace industry—the production of net and subsequently lace by machinery.

Lace making machinery traces its origin to the stocking frame, a hand operated mechanical device for producing knitted fabric more rapidly than by the use of knitting needles. The first such machine is normally attributed to Rev. William Lee[1] and the date most commonly quoted for his invention is 1589. The first steps in the evolution of the mechanical production of lace are usually held to have occurred in 1769, for in that year a man named Hammond modified the mechanism of his stocking frame so that it produced a net fabric. In the same year Crane of Edmonton produced a machine which combined the stocking frame with a warp frame, whilst Else and Harvey constructed the pin machine, both devices which, like Hammond's, produced a form of knitted net. Soon afterwards some unknown person devised a technique whereby some of the stitches were removed so as to leave large interstices like the open works in hand made lace and, around 1777, Robert Frost improved on this by the production of flowered net in which these

holes were formed into the shape of leaves and flowers. The appearance of these nets on the market must have provided some competition for the hand lace makers and have started a decline in the latter industry, but such competition was limited owing to an important defect in the earlier machine made product. This was that, being based on a knitting technique, the nets were made by looping one continuous thread to form the meshes and, in consequence, any breakage of a thread could lead to extensive unroving, often termed laddering.

Many machine designers attempted to solve the problem of producing an economically viable net which did not have this weakness and this was eventually successfully accomplished by John Heathcoat of Loughborough with his machine constructed in 1808 which was described in Patent No. 3151. He owed his success to a careful study of a pillow lace maker when she was at work making net, and also to an analysis of the product, which revealed to him that three sets of threads were involved, two of which traversed diagonally to left and right whilst the third remained straight. The existence of the traversing observed by Heathcoat can be seen in [Plate 17], which shows part of a hand made net in which the traverse is revealed owing to the irregularities in diameter of the hand spun linen yarn used. Heathcoat succeeded in constructing a machine which imitated this action, though at first he could only produce narrow strips. However he followed his success with improved models which could produce net in widths of 18, 30 and 36 inches, increasing to 54 inches in 1810. In honour of his inspiration Heathcoat called the product 'bobbinet'. From this invention there followed further machines, in particular the Levers, to which the Jacquard control mechanism were applied and these gave rise to the whole machine lace industry.

It will be seen that the development of machinery for making lace took a somewhat different course from that in the major fields of textile production. The impetus for the development of spinning and weaving machinery, such as Arkwright's spinning jenny and Kay's flying shuttle, came from within the industry through pressures to improve the speed of output, but this was not the case with lacemaking. The initial modification of a stocking frame by Hammond is traditionally ascribed to technical curiosity, an interest to see whether he could cause his machine to produce something akin to a piece of lace which his wife had acquired. Heathcoat's successful venture is likewise ascribed to the challenge presented by the technical problem of producing a device to do something where others had failed. The developments from Hammond onwards were all the work of people unconnected either technically or geographically with the hand lace industry, and there is no evidence that there was ever any pressure for mechanisation from within.

It is apparent, therefore, that the conditions of working within the hand lace industry in the eighteenth century were not a precursor of the factory based machine lace industry of the nineteenth. Although the conditions closely resembled those postulated by Mendels[2] as a state of proto-industrialisation, which would lead to full industrialisation, the Honiton lace industry must be included in the long list of examples where that theory does not obtain.[3] The actual course of development, moreover, would appear to lie more in the field of the history of scientific and technological discovery than of economics and it is pertinent to note Earnshaw's observation[4] that '. . . the main source of Heathcoat's inspiration must have lain in the energy and enthusiasm of his own temprament. His eager mind explored areas even quite unconnected with lace . . .'

Heathcoat had the misfortune to have his factory at Loughborough completely wrecked in a Luddite attack on 28 June 1816, during the course of which one of the attackers, James Towle, fired a pistol at one of Heathcoat's staff. This constituted the capital offence of attempted murder and Towle was duly executed '. . . in presence of an immense multitude, shewing undaunted self-possession . . .' The proprietors of the wrecked machinery sued the county for damages and a payment of £10,000 was agreed. However the magistrates stipulated that the money should be expended locally, but Heathcoat refused saying that '. . . his life had been threatened; and he would go as far off as possible from such desperate men as these frame breakers were' and so he never received the money. Mr James Dean,[5] a land surveyor of Heavitre, near Exeter, succeeded in purchasing for Heathcoat a large mill at Tiverton which had formerly been used in the wool trade, and here Heathcoat set up a fresh enterprise which continues in his family to the present day. By this move an important centre of the machine lace industry came to be established in East Devon, close to the Honiton lace area. Other lace factories in the area appear to have met with less success. One at Exeter[6] was sold in 1824 and one at Colyton[7] in 1848 with no evidence of the continued existence of either. That at Barnstaple[8] appears to have survived the longest but this closed in the 1890's.

The effect on the Honiton lace industry of the development of a successful machine made net is revealed in a statement by Mrs Treadwin, the Exeter lacemaker and dealer.[9] Referring to pillow made net she wrote

> This kind of nett was very expensive, and one of the old people formerly in the trade showed me a piece about eighteen inches square, which she had made just previous to the machine netts coming into use, and which cost her in making fifteen pounds, although it was plain nett only. From

the great difference of price, as the same size piece of lace at the very commencement of its manufacture by machinery was sold for about as many shillings, and now for fewer pence, the trade of hand made nett was completely destroyed, and I know of but two now alive in Devonshire who can make it. The sprigs and edges still continued to be used, being sewn on the machine nett; but little, however, was done in this way, and the great change was the occasion of much suffering throughout the country as in the endeavour to compete with machinery the prices were brought so low that a pittance sufficient to sustain life could not be obtained by it.

It will be seen, therefore, that the price of net, an important fashion product of the time, the making of which must have given employment to a substantial proportion of the workforce of the Honiton lace industry, fell permanently in price by 95 per cent within a very short time and later by more than 99½ per cent. In these circumstances Gidley's observation of a fall in employment from 2400 to 300 is not to be wondered at, save perhaps that the fall was not even greater.

Some temporary assistance for the unemployed lacemakers was organised as a result of the initiative of the Lord Mayor of London in trying to alleviate conditions in another branch of the textile industry. On 27 November 1816 the Lord Mayor called a meeting at the Mansion House[10] with a view to launching a scheme to assist the Spitalfields silk weavers. At this time they were in great distress too and it was stated at the meeting that of the 15,000 looms in the district 10,000 were lying idle and 45,000 people had no work. The cause of this was stated to be a trade depression brought on by the peace following the final defeat of Napoleon[11] and also by the fact that ladies, now free to travel in Europe, were bringing back quantities of silk instead of patronising the home industry. The Lord Mayor proposed 'a subscription of one pound from every individual able to contribute, for the purchase of goods manufactured in Spitalfields would be the most beneficial charity. This collection would form a fund for the purchase of the articles that now found no market; and every subscriber would receive the value of his subscription at the place of his residence, with no other condition than that he took Spitalfields goods . . .'

This scheme suggested[12]

a plan for the RELIEF of the HONITON LACE-MAKERS, of whom there are about one hundred out of employ. Mr Aberdein and Mesdms. Tuckett and Martin the principal Manufacturers readily consented to the plan, and have agreed to deliver Honiton lace at the wholesale prices, to

subscribers to the amount of their subscriptions, and to lay out the whole of such subscriptions in labour, under the inspection and direction of the undermentioned persons. If the sum of £300 is thus raised, it will furnish employment for the above number of Females at 3s. per week, for about five months. The plan is therefore earnestly recommended to the attention of the benevolent.

This announcement dated 24 December 1816 from Honiton was signed by John Newberry, Isaac Cox, Richard Brown and W C Trenow, each of whom made a contribution to the fund. A further announcement on 27 February 1817[13] stated that the plan

> ... was originally submitted to the public with a view to the employment of the lace-makers in the Town of Honiton only, but the great liberality with which it has been met, has stimulated us to endeavour to extend the benefit to the neighbourhood, in which there are many hundreds unemployed, and consequently distressed. We have pleasure in stating that a great number of the Lace-makers in the town are already employed, who, but for this subscription, would have experienced the hard pinchings of cold and hunger.

Presumably in the hope of attracting subscriptions the organisers added a note that 'the Honiton lace is precisely the same fabric and equally elegant with the Brussels'. The appended list of subscribers shows that more than ninety five people had subscribed £304-5-0, a little in excess of the sum mentioned as required for the town's lacemakers to receive 3s per week, so it seems unlikely that the unemployed outside the town received much help. The subscription list was headed by £30 from Princess Charlotte and £25 from Lady Arden of St James Palace, the latter perhaps a gift from a royal source. The Lady Mayoress of London contributed £10 and other people lesser sums which included £5-5-0 from Rev H A Hughes, the Rector of Honiton, and an unexpected gift totalling £29-19-0 from twenty three people which was transmitted through Miss Dilworth of Lancaster. Such schemes could be no more than temporary palliatives since the underlying reason for the depressed state of the industry lay in the changes of technology which were occurring in industry, rather than in some temporary set-back in trading conditions, though there is no evidence that this was appreciated at the time.

The effect of distress in Honiton is reflected in the report of the Charity Commissioners who spent 16 to 25 May 1820 in Honiton[14] enquiring into the state of the town's charities. They made reference to the increased numbers

of the poor of Honiton and in connection with Richard Minifie's gift stated that an audit in 1819 showed that this fund had £30-12-10 in hand, and

> It was intended that this sum should have been distributed in the course of last winter, but in consequence of large voluntary subscriptions being raised amongst the inhabitants of Honiton for the relief of the poor, it was not thought necessary to have recourse to the fund

This large voluntary subscription, which was used to relieve three hundred and eighty families by selling subsidised food to them,[15] followed only three years after that inspired by the Lord Mayor of London's scheme. The method of disbursement of the charity funds consisted of regular giving of small sums in money or kind on St Luke's day, Christmas and Good Friday, supplemented by special sums to alleviate distress at other times. It is notable that over the period 1816–1819 for which data are available the regular distributions decreased and the special relief payments increased markedly —£45-17-6 in 1816–17, £69 in 1817-18 and £111-15-6 in 1818/19.

The magnitude of the disaster which overtook the Honiton lace industry in the early nineteenth century can hardly be exaggerated. The figures quoted by Gidley show that there had been a decline over forty years which amounted to an 88 per cent drop in the employment available in the lace industry, and it is probable that the greater part of this occurred in the decade 1810-1820, following the introduction of Heathcoat's net making machines. The total number of lacemakers left in Honiton in 1816/17 is not known but was presumably only a few hundreds, so that to have a hundred of them unemployed must have represented a serious problem. The extent of their distress is shown by the fact that earnings of three shillings a week were regarded as giving appreciable help at a time when this represented no more than a third to a quarter of the average agricultural wage. It must be remembered, too, that all this took place long before the twentieth century system of social security came into being and when the only help available was from the charities, poor relief and the ultimate sanctuary of the dreaded workhouse. There would have been but little comfort to those involved in Felkin's philosophy[16] that 'the principle, that to shorten human labour by mechanical skill and power, is to increase riches and capital, and furnish more and better paid employment and consequently comforts to the artizan, has not even yet become sufficiently understood in England'. The Honiton lace makers of the early nineteenth century were victims of the problem of reconciling technological advance with human values, a problem which is still with us. With such a disaster and the fact that the technology of making

lace cheaply by machinery was steadily advancing, a date around 1820 could well have seen the demise of the Honiton lace industry. In fact it survived, on a fluctuating basis, for rather more than another century.

References

1. This, and other facts concerning the development of lace manufacturing machinery is taken from the classic work: Felkin.
2. Mendels.
3. See, for example: Berg, p109, 220. Coleman, 1983. Houston and Snell.
4. Earnshaw, 1986, p72.
5. House of Lords, 1818, p127.
6. Exeter Flying Post, 15.7.1824 (1a)
7. Exeter Flying Post, 30.3.1848 (3a)
8. See the various editions of Kelly's Directory of Devon.
9. Wyatt.
10. The Times, 27.11.1816 (3a).
11. See also: Checkland, p6. Gayer, Rostow and Schwartz, I p110.
12. Exeter Flying Post, 26.12.1816 (4d).
13. Exeter Flying Post, 27.2.1817 (1 c/d).
14. Charity Commissioners, I p125-141. Gidley, 1814.
15. Woolmer's Exeter and Plymouth Gazette, 20.1.1820 (4d).
16. Felkin, p23.

Chapter Seven

1820–1940—The Years of Decline

The history of the industry is a repetition of failures, alternating with short periods bright with promises of success, always unfulfilled.

Hon. Albinia Broderick, 1888

By 1820 the Honiton lace industry had reached a very low ebb, but, nevertheless, a few workers still produced some lace and this state of affairs continued until around 1840, when an increased interest in Honiton lace developed owing to a variety of factors which included fashion changes and royal patronage. As a result the decade 1841–1851 saw a quadrupling of the number of workers in the East Devon lace making area, and the 1850s can be regarded as the peak period for the industry in the machine age. Thereafter there was a slow, but steady, decline and, although there was talk of a revival in the early years of the twentieth century, no significant revival in fact occurred. The dating of the end of the industry is as indefinite as that of its beginning, but by 1940 the possibility of earning a living by bobbin lace making had passed and even the earning of appreciable pin money was scarcely possible. During the years of decline many factors which were causing it were proposed but, it is suggested that the real reason was the labour intensive nature of bobbin lace making, but this appears to have been appreciated by few contemporaries.

During the years of decline many different attempts were made to halt and to reverse it and these are the subject of the next chapter.

1820–1840 The depths of depression

The fact that some manufacture of Honiton lace continued in the 1820s and 1830s is attested by facts from several sources. Thus a notice by the firm of H & F Davis of Cathedral Yard, Exeter, appeared in the *Exeter Flying Post* for 18 March 1830 (2c) stating that '. . . a MALICIOUS REPORT has been circulated that they had left Exeter . . .' but that this was quite untrue and that they continued in business selling Honiton sprigs and borders for veils, caps etc. [Plate 87] The state of the trade at the time may, perhaps, be inferred by the statements that 'orders will be thankfully received' and that the new assortment of borders, sprigs etc. for the current season were available at 'very reduced prices'. In the same paper Amy Lathy of Honiton, who held a royal warrant [Plate 94], advertised on 19 August 1830 (2c) stating that she had 'an elegant assortment of veils, pelerines, caps, cuffs, a great variety of sprigs, borders etc. and that she would speedily carry out orders and forward the goods to any part of the kingdom'.

The Seaton and Beer parish registers record the names of three lacemakers in Seaton and eight in Beer between 1821 and 1837, and between 1820 and 1826 six lacemakers are referred to in the Honiton parish registers. It is apparent that these entries represent only a few of the lacemakers in these places, since occupations of females are only given in the case of the mothers of illegitimate children, as all these seventeen ladies were. It is equally apparent that these data should not be taken as evidence that lacemaking was particularly to be associated with immorality, since between 1817 and 1837 the Honiton registers record fifty six illegitimate births, but only seven of the mothers are designated as lacemakers.

The state of the industry was, however, less than satisfactory and Moore[1] writing in 1829 stated that Honiton '. . . lace long maintained its superiority, yet latterly, on account of its high price, and the introduction of bobbin-net, the trade has been greatly reduced.' He added that the demand '. . . has been superseded in general use by an article made by machinery, called bobbin-net, or Nottingham lace, which resembles that made at Honiton, and is ornamented in a similar manner with sprigs.' In 1843 McCullock[2] stated that 'At Honiton, in Devon, the manufacture had arrived at that perfection, was so tasteful in the design, and so delicate and beautiful in the workmanship, as not to be excelled even by the best specimens of Brussels lace. During the late war, veils of this lace were sold in London at from 20 to 100 guineas; they are now sold from 8 to 15 guineas. The effects of the competition of machinery, however, were about this time felt; and in 1815, the broad laces began to be superceded by the new product.' The nature of the increasing

competition from machinery is revealed in the further statement that '. . . a square yard of middle quality bobbin net, which in 1812 sold for about 40s per yard, could be purchased in 1835 at 10d.' He added that 'a pillow lace maker even of the present day can only fabricate from 4 to 5 meshes per minute: the earliest machines accomplished 1,000 meshes per minute; but at present not less than 30,000 meshes per minute are made by the machines.' When one machine could do the work of some 6000 pillow lace makers there is little wonder that the latter were suffering a depression, or that Moule[3] should write in 1837 that 'Honiton was formerly celebrated for lace . . .'.

The reality of the situation is revealed in the returns for the census of 1841, the first in which occupations were recorded, and, consequently, the first reliable figures for numbers of people engaged in the Honiton lace industry. The numbers for each parish in the East Devon lace area have been abstracted[4] together with the corresponding figures for the next four decennial census returns and those given in the 1698 memorandum. The numbers quoted are totals for lace makers, manufacturers and dealers as recorded in the enumerators' returns since in most cases the manufacturers and dealers themselves made lace and the inclusion of any small number who did not would not distort the significance of the numerical data.

The change from the situation in 1698 is very marked. The total for East Devon parishes in 1698 was 4695, whereas that for the corresponding places in 1841 was only 531, a decrease of nearly 89 per cent, and even when all other parishes are included the total is only 927, a decrease of 80 per cent. These facts are presented diagrammatically in Figures 7.1 and 7.2 in which the numbers are shown by poportionate area circles centred on each place. No comment can be made on the south western part of the area since no data for this were given in the 1698 memorandum, and there is no evidence to show whether this omission was due to a lack of lace making or to a failure to collect figures in time for inclusion in the list. The five places with the largest numbers in 1841, namely Sidbury, Branscombe, Honiton, Beer and Sidmouth, had succeeded in retaining something of their importance since they were all in the upper half in 1698, though the numbers were much reduced. The remaining places in the upper half in 1698 had fared much worse, for Ottery St Mary had declined from 814 to 17, Colyton from 353 to 2, Gittisham from 139 to 1 and in Luppitt, Broadhembury, Upottery and Seaton lacemaking had died out completely.

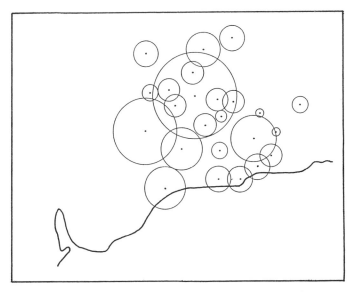

Figure 7.1 1698. Location of lacemakers in East Devon. Areas of circles in proportion to numbers in each place.

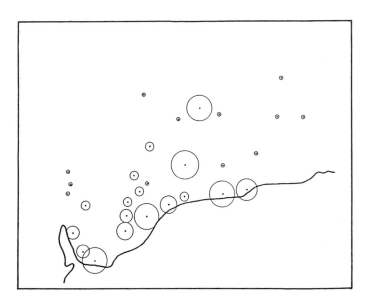

Figure 7.2 1841. Location of lacemakers in East Devon. Areas of circles in proportion to numbers in each place.

1840–1860 Mid-century revival

The continuation of the industry into the 1840s is shown by Lewis[5] in 1842 when he wrote of Honiton that 'The serge trade has long since declined; but lace is still made, particularly sprigs for the decoration of patent net' and by Pigot[6] in 1844 who stated that 'At Honiton the most beautiful and the broadest cushion laces in the kingdom are made; but this branch of female industry is not so prosperous as formerly' and that 'this trade is, however, on the decline.' These not very encouraging observations are, however, but the preface to a considerable revival to be seen in the census returns for 1851, which show that the numbers of lacemakers had risen from 941 in 1841 to 4101, a greater than four-fold increase. The distribution of the increase is illustrated in Figure 7.3 which makes a striking contrast with Figure 7.2. It will be seen that the numbers of workers in the main places of 1841 had all increased and that in many of the minor ones they had developed significantly, though none so strikingly as Colyton where the numbers increased from 2 to 216, thus restoring it to something of its former status. Another feature of the expansion was the establishment, or re-establishment, of lacemaking in twenty five places where it had not been in 1841, the numbers ranging from less than ten in most of the places to over fifty in Axmouth and Topsham, and no less than 98 in Seaton, a figure which would have ranked it fourth in 1841.

This revival has long been recognised, though not hitherto quantified, and it has often been suggested that it resulted from the fact that Queen Victoria patronised the Honiton lace industry for her wedding, when she wore a Honiton lace trimming, flouce and veil [Plate 24] and also had a Honiton lace morning dress among her trousseau (see Chapter 8). The suggestion is that the Queen's example was followed by ladies of the court and other notables, and though there is obviously truth in this suggestion the reasons for the revival were probably more complex, since other potentially con- tributary factors can be recognised. This period saw the full development of lace making machinery so that large quantities of excellent lace were available cheaply and were much worn. Such a situation would have been an inducement for the well-to-do to patronise the hand lace industry, since the wearing of its products would have constituted a status symbol. Another, indirect, contribution to this revival was the development of the railway, for the first train from London steamed into Exeter on 1 May 1844, thus inaugurating the era of fast and cheap travel. This led to an increase in the tourist trade in the area, which in turn would have widened the knowledge of Honiton lace and increased the selling of it to people on holiday. This

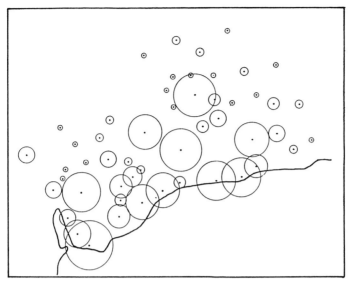

Figure 7.3 1851. Location of lacemakers in East Devon. Areas of circles in proportion to numbers in each place.

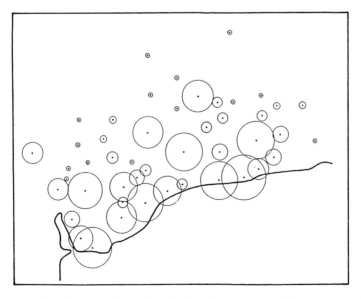

Figure 7.4 1861. Location of lacemakers in East Devon. Areas of circles in proportion to numbers in each place.

view is supported by the numbers of lace manufacturers and dealers listed in the Devon directories of the time, as shown in Table 7.1 It will be seen that the numbers in the seaside resorts of Exmouth and Sidmouth considerable increased and remained for some years at the increased level, whereas in Honiton no such increase took place.

Table 7.1 Lace manufacturers and dealers in Devon Directories

Place	1830 Pigot	1844 Pigot	1850 White	1852 Slater	1856 Kelly	1857 Billins	1866 Kelly
Exmouth	1	5	8	9	11	10	10
Sidmouth	3	5	9	7	10	8	9
Honiton	4	5	4	4	7	3	4

The greater prosperity is reflected in Roberts' observations[7] in 1856 that 'The trade . . . affords a good livelihood to many thousand hands, the majority of the female labouring population.' 'Some years ago poverty and lace-making were associated. Such is not now the case.' The depression years had, however, taken their toll on the morale and skills of the workpeople and Mrs Treadwin, referring to this period, wrote

> The demand for the lace had now so much increased that in 1850 the quality of the work was much deteriorated, for the workpeople, finding that whatever was made met with a ready sale, were not desirous of improving their patterns. They preferred common work that could easily be executed to better but more difficult designs, requiring more taste and care, and not even when tempted by a higher rate of pay would they undertake the higher class of work. From thus cause I found it impossible to get more than one large piece (a flounce) executed for the Exhibition of 1851, and so careless of the beauty of their work were they becoming, that any piece which required a new drawing I was invariably obliged to have made under my own personal superintendence.

She also stated[9] that '. . . during the time I was employed about the flounce . . . I did not leave my work-room at all during working hours.' However the judges[10] at the exhibition were clearly impressed when they wrote of

Honiton lace that '. . . during the past twenty years considerable progress has been made . . .' and they looked forward to a bright future. 'It is a gratifying reflection that the growing appreciation of the wealthy and refined class, of the increasing merit of these really useful and ornamental articles of British manufacture gives suitable employment to a large number of females in their own homes, thereby increasing their comforts, encouraging habits of industry, and adding to the general prosperity of the nation'.

1860–1900 Steady decline

By the time of the 1861 census it could be seen that the revival was not being sustained, for the total numbers in the industry had fallen to 3694, a drop of some 10 per cent, and although Black[11] in 1866 stated of Honiton that 'Every lady in England is familiar with its rich and delicate hand-made lace, of which the Queen's bridal robe was fashioned', the census of 1871 showed a further fall to 3531, a total decrease of 14 per cent (Figures 7.4 and 7.5). By this time the state of the industry was causing concern and the *Exeter Flying Post* on 5 August 1874 (7e) stated that

> The depressed condition of the point lace trade in Honiton has been for some time past a subject of great concern and regret to all who are interested in this most beautiful branch of our manufactures, and who, having seen the great efforts which have been made in the county during the last few years to make the designs really artistic and worthy of the consummate skill and care of the workers, are anxious to see the trade again flourishing in its original home and centre.

On 6 February 1875 a writer in *The Graphic* repeated this passage and added the opinion that it would be '. . . impossible to find among the lacemakers of any country experience, skill, and care surpassing those shown by the women of Honiton and the neighbourhood.' By way of explanation for the decline the writer added that the workers have had '. . . to contend with three great drawbacks, the truck-system, which led them to consider inferior work a sufficient equivalent for adulterated stores: the unreasoning preference shown by the public for foreign over native productions: and, chiefest, the want of good patterns.'

In spite of this concern and attempts to encourage the industry the 1881 census returns make sorry reading, for they show that the number of workers had fallen to 1908, some 53 per cent below he 1851 peak (Figure 7.6). In fifteen places lacemaking had died out completely and in another fourteen

Figure 7.5 1871. Location of lacemakers in East Devon. Areas of circles in proportion to numbers in each place.

Figure 7.6 1881. Location of lacemakers in East Devon. Areas of circles in proportion to numbers in each place.

the number of workers had fallen to five or less—the mid century revival was over. Although the totals for the whole lace making area show a peak in 1851, followed by decline which became most pronounced between 1871 and 1881, there were considerable divergences from this pattern within the area, some places reaching their maximum numbers in 1851, others in 1861 and others again in 1871. Thus, for example the numbers in Ottery St Mary reached their peak in 1871 when those in Honiton had dropped by 56 per cent from their maximum twenty years earlier, whilst the two parishes of Littleham and Withycombe Raleigh which together contain the town of Exmouth reached their maxima in 1851 and 1871 respectively. These local variations were evidently the result of local circumstances such as the presence of more or less enterprising manufacturers, the rise or fall of a local lace school and the availability and attractiveness of alternative employment, all factors which could change considerably over a twenty-year period.

In spite of this evidence of decline some writers in the 1880s remained optimistic. An article in the *Devon and Exeter Daily Gazette* for 1 January 1886 (6d) observed that

> There must be some who wonder why ladies should prefer discoloured and fragile pieces of lace handed down through two or three generations to the pillow-lace made during the last few years. But the days will come when the delicate Devonshire point will also be old lace, when the fingers that turned the bobbins work no longer, and those who bought will have left their chattels to their grand-daughter. Then it will come out victorious, as fine as the finest Flemish with the soft yellow tint we value so much, and the faint smell of otto-of-roses that always lingers in the lace-box.

Another writer[12] in 1887 observed that

> It is to be hoped that, when the technical schools are further developed, the art of lace-making will be an important feature of the curriculum, so that the wives and daughters of our artizans may, in their own homes, without hindrance to their domestic duties, pursue an occupation which not only brings remuneration, but gives them interesting employment.

The writer added that 'It may now be said that a large proportion of the female population of that part of Devon, from Seaton, Exmouth, and thence round to Honiton, gain a comfortable livelihood from this interesting and beautiful work.'

Most contemporary commentators, perhaps better informed, were drawing

attention to the decline of the industry. A letter to the *Times* of 17 September 1888 (13b) over the pseudonym 'Honiton Lace' asked 'will you allow me to draw attention to the fact that the beautiful Honiton lace industry is fast dying out? Twenty years ago there were three or four shops in Honiton for its sale alone; now the only shop cannot make a living, and half of it is devoted to under-clothing'. The Hon. Albinia Broderick writing in the *Queen* the same year (p.523) stated that

> In many of the little villages a large portion of the elder female population earn a few shillings a week by the industry: in a certain number it is, or has been in the past, the sole industry. Its decay is, therefore, a most serious evil. But, in addition to the economic side of the question, this decay in the lace making industry is greatly to be deplored. For it is unfortunately certain that unless steps are promptly taken to assist in redevelopment of the trade Honiton will shortly be a thing of the past, and England will have lost the only lace which has competed successfully with the manufactures of France and Belgium.

She attributed the decline to debased designs and preference for foreign laces. Another writer of the period[13] observed that 'some of the more enterprising spirits in the west country are much exercised just now by the ways and means of reviving the Honiton lace industry, which sadly languishes in these latter days' and quoted Mrs Treadwin's opinion that '. . . decline in the industry was largely due to the injury suffered through the inferiority of the article produced by persons who had not learned the art with the thoroughness and proficiency of their ancestors.'

In this situation Sir John Kennaway, the member of Parliament for Honiton, took up the cause and Mr Alan S. Cole of the South Kensington Museum was appointed Commissioner to enquire into the condition and prospects of the Honiton lace industry. He spent from 31 May to 7 June 1887 in the lace making area, where he visited various lace makers and dealers successively in Exeter, Beer, Colyton, Branscombe, Sidmouth, Sidbury, Honiton, Ottery St Mary, Exmouth, Otterton and Woodbury, discussed the state of the industry with them and others and purchased examples of lace, most of which have been preserved in the House of Lords Record Office. The report provides an extensive and valuable insight into the details of the industry and its working practices at that time. The report[14] was presented to the House of Commons on 20 March 1888 and in it Mr Cole made some recommendations. In these he pointed out that the Education Act of 1870 had had the effect of closing the old lace schools through which children had

come into the industry, and observed that 'The literary tendency of the elementary school courses has apparently cultivated a distaste in children for the industry, and may not have given them any substitute for the training to a domestic industry such as the lace schools provided.' He went on to propose that some instruction in lace making should be included in elementary schools in the lace district, and suggested that specialisation in the various parts of the craft of lacemaking, that is the cloth work, the fillings and the grounding, should be taught, pointing out that this system was in use in Bohemia and elsewhere. He also recommended that attention should be paid to the provision of new patterns, with various suggestions how this should be done, drawing for this purpose on his experience with similar endeavours in Ireland.

Although references to the Cole report are not infrequent by subsequent writers, evidence of actual implementation of the proposals is not found until some years later. In 1897 Alice Dryden[15] asked 'why, then, will the Education Department persist in ignoring the uses and advantages of lace making? If the children are not taught soon the trade must die out; and school is the proper place to teach them in . . .' However she did observe that some courses had been started under the County Council Technical Committee. Nevertheless Murray[16] observed in 1895 that '. . . it is worth considering whether a little more patronage by those who lead the fashions now might not save this native industry from total decay' and refers the reader to the Cole report.

1900–1910 Hopes of revival

The new century saw the bleak statement[17] that

> It is estimated by Messrs Treadwin of Exeter, and Mrs Fowler of Honiton, two of the principal dealers in Honiton lace, that about 1870 over 2000 women and children were employed in this industry, whereas now there are not 500 lacemakers in all the above districts and they are all women over 25 years, no children having been taught the art for the last 12 years; of these 500, only about 250 are actually employed—i.e. 70 in Honiton, 60 in Beer, 40 in Branscombe, 40 in Sidbury and Sidmouth and some 20 each in Exmouth, Woodbury and Colyton.

The figure for 1870 is an underestimate, the actual number being 3531, and the other figures cannot be taken too literally since the same statement was made in the 1889, 1893, 1897 and 1906 editions of the *Directory,* though since the compilers had seen no reason to change it the general air of depression

in the industry which is suggested can be accepted. Alice Dryden[18] writing in 1904 observed that '. . . the majority of the people have sought for a livelihood by meeting the demand for cheap and shoddy articles' and that 'a greater part of the lace made at the present time is wasted labour . . .', whilst a writer in *Hearth and Home* of 9 June the same year, though observing that lace was very fashionable at the time, warned against the purchase of inferior Honiton lace which was '. . . sold to the unwary at seaside resorts . . .', adding that 'The connoisseur leaves such rubbish severely alone, since to buy it is no help to the Honiton industry; rather, indeed, the reverse, as it assists only the unskilled and lazy workers.'

However in 1902 the Devon County Council took action to follow Cole's recommendation on the introduction of teaching of lacemaking. A sub-committee had been appointed to consider '. . . the condition of the Lace Industry and the best means of developing and organising it in East Devon.' and the report stated that there had been some increased demand for Honiton lace recently and that there appeared to be at least 700 persons engaged in lacemaking (even so less than in 1841). It was recommended that a teacher be appointed with the task of organising instruction in lacemaking, that the classes be organised as evening schools under the Board of Education regulations '. . . so as to earn grants from the Board.', that exhibitions with prizes should be organised and that a sufficient sum should be made available to implement these proposals. The council resolved that the report be received and adopted.

The scheme was welcomed and it was stated[19] in 1905 that a school had also been established by Mrs Fowler in Honiton [Plate 81], and that in 1907 Mrs Fowler had over 200 lacemakers working for her.[20] Penderel Moody[21] writing in 1907 stated that 'The low water mark of Devon lace had been reached in 1901 . . .' but that 'The past few years have been eventful ones, and the trade has been steadily reviving. The future seems to be brightening . . .' and in 1909 she added[22] that '. . . the lace revival, although it has come with great force, is still young. As yet it is difficult to prophesy how far it may extend.'

Another aspect which appeared to give hope was the spread to other places of the Honiton lace making technique. This had already happened in the 19th century when the Japanese government opened a lace school in Tokyo on 5 July 1880 and engaged a Mrs Dallas and a Mrs Smith to teach the making of Honiton lace.[23] A collar and cuffs of Japanese design which was made in this school were shown in an exhibition in London in 1885 and are now in the collection of the Victoria and Albert museum. In 1901, R.H. Matthews, mayor of Honiton, in a speech at the annual mayor's dinner is reported[24] as

having said '. . . it was satisfactory to know that sometime ago they received a request from India to send ladies to teach the art of lacemaking which had saved many in connection with the recent famine.' In 1898 Mrs Jackson, a native of Devon, who was headmistress of the Girl's School on St Helena, introduced lacemaking to the island[25] in the hope of giving employment. She taught Honiton, Torchon and Bucks. techniques[26]. Nearer home, in Norfolk, the Diss Lace Association was founded in 1901 with the objective of teaching Honiton lace making to married women and girls unable to go into service,[27] and by 1908 there were fifty workers.

This more cheerful view of the industry is belied by statistical evidence contained in the long series of Kelly's *Directories of Devonshire* from 1856 to 1939. The directories list lace manufacturers and dealers and, although the absolute numbers given may be in some error, it is reasonable to assume that this organisation used a consistent technique in compiling the data and that, therefore, valid comparisons may be made between the numbers given in succesive volumes. The collected figures are shown in Appendix 2 with numbers for each place and sub-totals for some sub-divisions of the county, of which East Devon is the most important, as is to be expected. The data are expressed in graphical form in Figure 7.9. and it will be seen that county totals show a steady and almost linear decrease from the time of the mid 19th century boom, to the end of the series in 1939, with no indication of any significant check in the process in the early 20th century. The totals for East Devon do show evidence of a reduction in the rate of decline starting around 1885 and extending to around 1920. The remaining two lines show the East Devon figures separated into those for seaside places and those for inland ones, and it will be seen that the decrease for the seaside is virtually linear over the whole period. The relationship for the inland places if markedly different with a decrease to around 1885, followed by an appreciably steady period or even slight increase until the final decline after 1925. A possible reason for this was the development of the seaside resorts with alternative and better paid employment opportunities, and this explanation is consistent with Penderel Moody's observation that there was plenty of work available in the towns and that this was why lacemakers were only to be found in villages or small country towns.[28] It is evident that the revival which some people thought they could detect in the early years of the 20th century was insufficient to make any significant check to the decline of the industry.

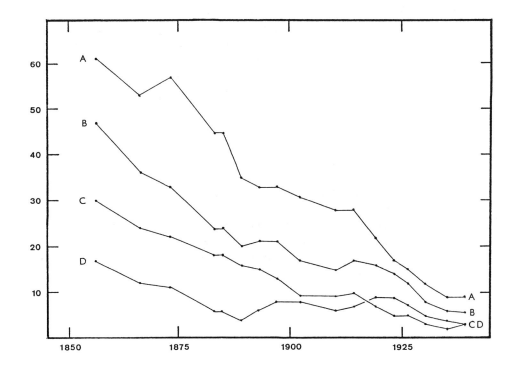

Figure 7.9 1856–1939. Devon lace manufacturers/dealers:
A = Number in all Devon.
B = Number in East Devon
C = Number in East Devon, seaside places.
D = Number in East Devon, inland places.
Source: Kelly's Directories of Devonshire.

1910–1940 The final years

In 1910 the Honiton lace industry was stated[29] to have 'greatly declined' and the sight of a lacemaker at a cottage door was described[30] as growing rarer every year. Nevertheless talk of revival still continued and in 1913 it was claimed[31] that 'Another thing which has helped forward the present revival is the motor-car. Wealthy tourists, who visit Honiton, can often be seen making purchases of lace. By this means the fame of Honiton lace is disseminated throughout the country, and among a class who spare no money

to get what they require.' In 1922 it was stated[32] that '. . . some nice lace has been produced of late years, and it is to be hoped that the efforts made to revive the industry may meet with increasing success.'

Such hopes, however, were unfulfilled and even though a second lace shop opened in Honiton in the 1920s, time was running out, for the 1921 census showed that there were only 76 hand lace makers left in Devon. On 3 November 1938 the *Western Morning News* carried a feature on Miss Ward and her shop in Honiton. This business had received royal warrants from four successive queens, Adelaide, Victoria, Alexandra and Mary, as manufacturers of Honiton lace, and the writer recorded that the warrants hung on the shop walls. Nevertheless 'it is years now since the workshop here closed' and the article ends with these words

> A customer arrived. The narrow filling for which she asked is almost unobtainable now. 'I have a little, but I need a great deal more to complete a set of luncheon mats' bewailed Miss Ward. 'When this stock goes it can never be replenished.' She turned away to straighten the pottery displayed nearby. As her stock of lace dwindles this newer art encroaches more and more upon her shelves.

The cause of the decline

During the long period of decline various reasons, as has been shown, were put forward for this state of affairs. These were the lack of young recruits consequent upon the Education Acts, the persistence of the truck system, the preference of purchasers for foreign over home produced lace, careless workmanship and, the most often mentioned, the use of poor designs. No doubt all these factors made some contribution to the decline, but it is probable that the basic reason, which went largely unrecognised, lay in a fundamental technological weakness of the process of making lace by hand when in competition with machinery, namely its labour intensive nature. The existence of labour intensiveness was recognised in the jury report for the Great Exhibition in 1851,

> It is deserving of consideration that the worth of the actual material bears such a small proportion to the value of the article itself, as to make the amount paid for the labour expended in its production to be almost the sole cost.

though the obvious consequence was not forseen, for the passage continues

This industrial product, therefore, cannot fail to enlist sympathy on its behalf, as it furnishes, in comparison with its price, a surprising extent of employment and maintenance, and these benefits, moreover, are afforded to a class of persons who otherwise would have difficulty in earning a livelihood.

Other writers came near to appreciating the weakness, as for example McCulloch's observation already referred to, which showed that at the time of writing one machine could do the work of several times the total workforce then available in the Honiton lace industry, though he too failed to draw the obvious conclusion. Such conditions meant that if the hand made lace was to retain any market at all it would have to be kept competitive in price by the only way possible, the reduction of labour costs by the payment of very low wages and these would be liable to reach such a low level as to fail to retain workers in competition with alternative employment. Such a state of affairs was revealed in the *Bridport Gazette* of 20 October 1905,

> But the remuneration which the lacemakers receive for their labour appears to be at the bottom of the difficulty of getting girls to the trade. An expert laceworker at Axmouth declares it pays her better to go out charing at eighteenpence a day than to sit at her pillow making lace, for at the latter she has to labour long to earn sixpence.

Perhaps the various commentators, who were for the most part connected in some way with the world of lace, were too near the trees to see the wood, for an outsider expressed the fundamental weakness clearly. This was Peter Orlando Hutchinson, the Sidmouth antiquary, who on 12 December 1890 wrote in his diary

> Yesterday was buried Mrs Treadwin of Exeter, and I think once of Honiton. She has for some years been the chief dealer of Honiton lace. Though decidedly out of my line I admire Honiton lace, as I would admire anything that is pretty and ingenious. It is certain however that Honiton lace is doomed. *It does not pay.* That fact is enough to annihilate any trade or occupation. Times are changed, wages have advanced, and machinery has been so much improved that it can now do almost anything hands can do. Formerly when I was driving through Branscombe, in passing the open doors of the cottages, I could see regular schools of girls being taught to make lace. Now they are taught other trades that pay better.

References

1. Moore, 1829, p.384.
2. McCullock, p.790.
3. Moule, I p.289.
4. Appendix 1.
5. Lewis, Honiton.
6. Pigot, 1844, Honiton.
7. Roberts, 1856, p.381.
8. Treadwin, 1873, p.40.
9. Wyatt.
10. Great Exhibition, p.1013.
11. Black, p.164.
12. A newspaper cutting dated 5.11.1887 in Stone's Newspaper Scrapbooks in the Devon and Exeter Institute. The newspaper is not identified.
13. A newspaper cutting from an unidentified source in a scrapbook 'Sidmouth and District newspaper cuttings' in the West Country Studies Library, Exeter. The date is probably c.1889.
14. Cole, 1888.
15. Dryden, 1897.
16. Murray, p.38.
17. Kelly, 1902, Honiton.
18. Dryden, 1904.
19. Mate, Sidmouth, 1905.
20. Mate, Honiton, 1907.
21. Moody, 1907, p.29.
22. Moody, 1909, p.13.
23. Private communication from Yusai Fukuyama.
24. Western Times 11.1.1901 (6f)
25. Annual report of the Governor of St Helena, 1898.
26. Gosse, p.429.
27. Daily Mail Exhibition Catalogue, 1908.
28. Moody, 1909, p.7.
29. Knight and Dutton, p.112.
30. Ward Lock, SE Devon, 1910/11 p.11.
31. Devon Arts and Crafts, II p.167.
32. Head p.91.

Chapter Eight

1820–1940—Attempts to Halt the Decline

We trust that the patronage of Her Majesty, whose correct judgement
in all matters of taste is so well known, will draw the attention and favour
of the public towards this valuable production of British industry.

Woolmer's Exeter and Plymouth Gazette, 10 June 1843

During the long period of the decline of the Honiton lace industry various
changes of technique were adopted by the lacemakers in their endeavours to
come to terms with the new economic conditions which were the result of
the introduction of machine lace making. In addition the manufacturers
attempted to halt the decline and to improve the prospects in the industry
by seeking what the taste and fashion of the times regarded as improved
designs, by introducing other types of lace to the area, by seeking royal
and other patronage, and by the publicity engendered through exhibiting
specially wrought pieces of Honiton lace at national and international exhibi-
tions. These various activities constitute an important element in the history
of the industry, and provide the background for the interpretation of the
appearance and form of the surviving pieces of lace from the 19th and early
20th centuries.

Changes of technique

The Honiton lace which was being made in 1820 was the type usually
designated Honiton appliqué, consisting of motifs sewn onto pieces of pillow
made net [*plate 18*], but with the coming of the bobbinet machinery the
production of the pillow made type ceased and the skills were lost. The last

person who could make it is reported to have died in Exeter in 1872[1], or in Honiton in 1874.[2] There was, however, still work for the motif makers who continued to supply the lace sewers so that they could likewise continue to produce Honiton appliqué lace, but using a basis of machine made net [Plate 19]. Such lace could also be made by amateurs, and advertisements of the time include both net[3] and sprigs, borders etc.[4] in addition to actual lace articles such as veils.

Another change was the introduction of Honiton guipure lace in which the motifs were joined by a series of bars instead of being sewn onto net, or being joined by a net ground. The principle of this technique was not new and can be seen in eighteenth century Honiton lace in conjunction with net ground. What was new was the use of bars as the sole connecting medium in the lace. The date of the introduction of this technique is uncertain owing to the paucity of adequately provenanced specimens. Roberts[5] writing in 1856 described it as '. . . invented within the last twenty years', whilst Jourdain[6] assigns the introduction to about 1845, which is not inconsistent with Roberts' comment. Some forms of bars can be seen in the flounces shown both by Mrs Treadwin [Plate 25] and by Mrs Clarke [Plate 26] at the Great Exhibition of 1851, so a date in the 1840s appears to be a reasonable estimate. Whilst the introduction of the guipure technique did nothing to speed production it did contribute to the versatility of the industry, by enabling it to produce articles with handling characteristics more suited to such things as handkerchiefs than was the appliqué lace.

Perhaps the most noticeable changes were a series of simplifications which were made in the construction of both motifs and ground and which produced marked differences in appearance of the product. There are no records of when the various changes were introduced and it is unlikely that they formed any orderly progression, for different workers adopted their own favoured methods to the extent that different techniques of working can be observed in the motifs used for the creation of a single piece. These changes can conveniently be classified into four groups, namely the introduction of emphasis, the form of the motifs, the construction of net ground and the construction of guipure bars.

1. Techniques for emphasis

There are a number of methods whereby emphasis can be given to a lace motif so as to enhance the quality of the representation or the interest of the pattern. These are —

a. Raised work by use of the rib technique, whereby an upper layer is constructed along a line to be accentuated by manipulation of bobbins to form a woven strip [Plate 57A]. This is a classic technique found in eighteenth century Honiton lace and in the high quality pieces in the nineteenth.

b. Raised work by the roll and tie technique, whereby a bundle of parallel threads is laid along the line to be accentuated and the bundle secured by a limited number of the threads taken over the bundle, either at right angles or at about 45° to the axis [Plate 57B]. This may be regarded as a simplified version of rib work and may be found in conjunction with or as a substitute for it.

c. Close and open cloth work whereby part of a whole stitch area is worked with the 'warp' threads closer together, usually about twice the number of threads per unit width, so as to produce a surface with two levels of brilliance [Plate 57D].

d. The introduction of a gimp or shiny thread, referred to in continental laces as cordonnet, consisting of a thicker and often shinier thread as an outline to individual parts of a motif [Plate 57C].

e. In contrast pieces may be found in which none of these methods of emphasis has been employed and an entirely flat effect results [Plate 57E].

2. Forms of motif

1. In the finest work of the nineteenth century the most common form of motif was the depiction of a flower or a leaf, usually of a type found in the East Devon hedgerows. In the best work these were such realistic representations that the species can be recognised almost as readily as in a botanical illustration and similar realism was used in the depiction of birds and insects [Plates 60, 61].

b. A quicker method of depicting natural objects consisted in making an outline with whole stitch worked tape and then filling the spaces with filling stitches, one of the marked characteristics of Honiton lace in the nineteenth century [Plate 58A].

c. An even simpler method of producing a motif was to make a piece of tape, which was either straight or curved, and use this to fill in a gap in the assembly [Plate 58B]. Such pieces were known as slugs, presumably from their slug like appearance, and this term was sufficiently recognised that in the 1851 census returns Ann Ebdon of Aylesbeare is recorded as being a lace and slug maker. Other shaped scraps were also used.

d. The quickest method of all for producing a motif was to use machine made segmented tape [Plate 63] to form parts of the lace [Plate 58C], but this

technique was regarded with disfavour by lacemakers of even moderate ability, as is shown by the candid annotation [Plate 88] 'vile work, half of it machine made' written in a London retailer's catalogue by Mrs Pearson, who kept a lace shop in Sidbury between 1893 and 1926.

3. Net ground
a. The classic form of net ground in 19th Century Honiton lace is a bobbin made net [Plate 56A] similar to that used by John Heathcoat as the basis for his machine made bobbinet.

b. An alternative form of net ground which was quicker to make was a needle made type similar to that of Alencon [Plate 56B] though often quite coarse.

4. Guipure bars
The guipure bars used to join motifs in nineteenth century Honiton lace took a number of forms.

a. In the best work they were bobbin made and decorated with short loops [Plate 56C] variously referred to as picots or pearls, hence the term 'pearl bars'. Such bars were often used in eighteenth century Honiton lace.

b. Another form of bobbin made guipure consisted of the use of filling stitches, usually that designated diamond [Plate 56D].

c. Guipure bars made by needle were also used and in better quality work these could be oversewn as in needlepoint laces [Plate 56F].

d. The simplest form of guipure bar was a plain needle made one consisting simply of several parallel threads [Plate 56E].

These variations in constructional techniques are summarised in Table 8.1, in which in each group they are placed, approximately, in descending order as to the quality of the lace in which they are found. Thus in a high quality piece made to order or for exhibition by one of the top manufacturers one finds a combination of 1a, 2a and either 3a or 4a, whereas in an example of the very low quality work designated 'rag lace' [Plate 59] one finds the combination 1e, 2c and d, and 4d. Between these extremes many different combinations were used and can be observed.

Table 8.1 Constructional techniques in nineteenth century Honiton lace

1. Emphasis	a. rib raised work
	b. roll and tie raised work
	c. close and open whole stitch work
	d. outlining thread
	e. no emphasis
2. Form of motif	a. realistic depiction of natural object
	b. tape outline with fillings
	c. slug
	d. machine tape
3. Net ground	a. bobbin made
	b. needle made
4. Guipure bars	a. pearl bars
	b. filling stitches
	c. oversewn needle bars
	d. plain needle bars

Improved designs

In the jury report of the Great Exhibition of 1851 it was stated (p.1013) in connection with Honiton lace that the

> eminent houses in the trade . . . are fully alive to the convictions that the more the British manufacture becomes assimilated to the charactersitics of the foreign (which are chiefly suitable, beautiful, and clearly defined patterns, with refinement of execution), the more the demand for this lace will extend; and proportionally with such increased demand, they will be induced to expend still larger sums, in order to produce a higher class of design. They are further encouraged in their exertions by the fact, that although the British lace cannot boast of design so exquisite and execution so delicate as Brussels lace, it yet possesses remarkable and valuable qualities . . .

This is but one of many adverse comments made about the design of Honiton lace during the nineteenth century, though it is arguable that they were often judgements deriving from current fashion preferences rather than

from more fundamental aspects of taste and aesthetics (see Chapter 12). Various manufacturers tried to obtain or produce what they regarded as improved designs in the hope that this would halt, or even reverse, the decline in the industry. Two approaches may be recognised, the obtaining of designs from various sources and the production of copies of old laces held in esteem.

Designs were obtained from various Government sponsored schools of design. Mrs Treadwin obtained the outline of the design for the flounce which she exhibited at the Great Exhibition from the school of design at Somerset House,[7] though '. . . the filling up, which is exceedingly ingenious, artistic, and beautiful, is the work of Mrs Treadwin.' [Plate 25] Mrs Treadwin also obtained designs from a design school in Nottingham and from an unidentified source in Paris,[8] a city which she visited in the course of business on several occasions.[9] In 1904 Devon County Council invited art schools and students in the county to submit designs suitable for Honiton lace sprigs and for a collar into which the sprigs could be introduced.[10] Among individual designers who attempted to produce better designs perhaps the best known was Lady Paulina Trevelyan, of Seaton, whose prize winning handkerchief [Plate 29] at the Bath and West show of 1864 is now in the Victoria and Albert Museum's collection.

Mrs Treadwin devoted some effort to the study of old laces and is reputed to have made reproductions of them. However, apart from a needlepoint reproduction of lace depicted on the tomb of Lady Dodderidge in Exeter cathedral which has survived in the Royal Albert Museum, Exeter, no pieces of this type which are definitely provenanced as by her are at present known. In contrast Miss Audrey Trevelyan, a great niece of Lady Paulina, introduced the making of reproductions in Beer and illustrations of 'Beer Italian' laces in the Milanese style may be found in contemporary sources,[11] though here again no surviving examples are at present known.

Other types of lace

During the nineteenth century there were various attempts to introduce the making of different types of lace to the area with the object of extending the scope of the industry. These endeavours may be conveniently classified as coloured variants of Honiton lace, needle laces, copies of old laces and miscellaneous.

1. Coloured variants of Honiton
a. Colyton chromatic.

In the Great Exhibition of 1851 W.L. Gill of Colyton exhibited Honiton lace (Class 19, Exhibitor 386) which included a 'chromatic silk berthé' which gained for itself the designation Colyton chromatic. An item in the Victoria and Albert Museum collection (T148-1911) which may be Gill's piece is made of black silk machine net onto which has been applied a series of motifs depicting lifelike roses [Plate 1]. These are worked in coloured silk threads in such a way that in an area of whole stitch work depicting a leaf or petal there is a range of related colours which give life to the depiction in a way reminiscent of the painter's broken colour technique. Maybe Gill or his designer was an admirer of Turner. The museum records show that this piece was purchased in 1911 from Mrs. A.W. Brown who stated that it had been shown in the 1851 exhibition. The only doubt about the attibution arises from the fact that it is a triangular shawl which would not normally be described as a berthé, but the weight of the evidence is in favour of this piece being Gill's essay in Colyton chromatic. The 1851 catalogue entry is equivocal but suggests that there were some more pieces made by the same technique which may, one day, come to light.

b. Kerswell lace

At the Arts and Crafts Exhibition Society's second exhibition in London in 1889 Item 350 was described as a Kerswell pillow lace border designed by Maud Searley and executed by Harriet Rowe. Further light is thrown on this by an article in the *Torquay Directory* for 1889 in which it is stated that 'A special feature of the forthcoming exhibition will be some specimens of the new 'Kerswell lace', that the promoters of the village art schools hope will revive the pillow lace industry of Devon.' An explanation of the project is given as follows,

> On all hands colour is being called in for decorative purposes, and with more or less of discretion and of taste, is being applied by all sorts and conditions of men and women in their homes, and in all their appoint-ments, and few things can be named that will lend themselves more to decorative feminine costume than coloured laces, which, with trained judgement in the ordering of the colour on the lace makers pillow and its application on the dress, will produce very soft and beautiful effects. Special yarns have been procured for this work and they are dyed in the required soft shades by Mr A.W. Searley of Kinkerswell.

This attempt to introduce colour seems to have been even less successful than Gill's, for nothing further appears to have been heard of the project.

Two pieces of coloured Honiton lace in the Allhallows Museum collection [Plate 2] may be survivors of this venture, but they are unprovenanced.

c. Black lace

Black clothing was greatly in demand in the nineteenth century since it was de rigeur in periods of mourning and this led to some demand for black Honiton lace [Plate 35]. The industry was able to produce such an article but surviving specimens are not common and this may be due to a small output arising from technical problems. The handling of black thread is very trying on the eyes of the lacemaker, but the obvious expedient of making the lace in white thread and then dying it black was not a satisfactory solution, since the dye processes in use at that time for the cellulosic fibres cotton and linen, apart from chemical problems, involved boiling, an undesirable thing to do to a piece of lace. It was necessary, therefore, to use black thread, but this could not be cotton or linen since the black dyes available resulted in a thread with a built in propensity for chemical deterioration owing to the use of iron mordant.[12] Satisfactory black dyes were available for the protein fibres wool and silk, so the makers of black lace had no choice but to use black silk thread. This not only presented problems of eye strain but also in working because of the low coefficient of friction between fibres and Mrs Treadwin observed[13] that 'It also requires greater care in working, to see that every bobbin is very firmly tied off, otherwise the silk is very apt to untie, thus rendering the sprig almost useless.' A contemporary expert Honiton lace maker who made a black motif has stated that she found the work exceedingly trying and had no difficulty in believing that only limited quantities were made.

d. Ecru lace

In the third quarter of the nineteenth century there was a vogue for lace to be of a colour suggesting age. In fact old lace which has become discoloured with age assumes a beige colour as a result of a mixture of cellulose decomposition products and common dirt, and a carefully executed washing operation by a conservator will restore it to its original colour, namely white. However, people wanted lace to have a yellow shade, so Mrs Treadwin gave this instruction on how to achieve it[14]

> . . . take a quarter of a pound of the very best coffee—inferior coffee will not produce the same shade—infuse it by throwing six pints of quite boiling water on it; let it remain for about half an hour; strain it through a piece of thick muslin; then throw the coffee over the lace until it is

thoroughly saturated . . . The depth of colour is to be regulated by the strength of the coffee;

Pieces of lace discoloured in this way are still occasionally found and it may be presumed that this treatment did something to aid the sales at this time.

2. Needle laces
a. Honiton point
In the second half of the 19th century the making of tape laces became a popular hobby for ladies of leisure and the patterns concerned were given names, among which Honiton was used [Plate 64]. This form spread to the United States and became mistaken for the real Honiton lace,[15] an error which still continues since a piece of lace of this sort was presented by an American lady to Allhallows Museum in 1982 as Honiton lace. The term Honiton point may be found in documents of the period and it is this tape lace that is generally being referred to.

b. Branscombe point
The making of a tape lace was established around 1850[16] in Sidmouth and in Branscombe among the lace workers and the latter, which was more delicate and in general better executed than the normal run of tape laces became known as Branscombe Point lace [Plate 65]. It seems likely that the quality was due to interest shown by the Branscombe dealer John Tucker and his daughter Mary, who was an excellent designer, for in the Ford correspondence[17] there are many letters written to Mary Tucker from their London agent in which references are made to suppliers of black and white tapes from both English and French sources. The making of this lace clearly had some economic advantage to the workers for 'Primrose' of Branscombe describing her work in the *Girls Own Paper* in 1897 wrote

> Ladies often send their Honiton Lace to be cleaned and put on new net; which is called transferring and then it will look like new lace; and that is real pillow lace which I have learnt; but it went down in price years agone and now if wanted they don't pay the full price for so the Point lace is done quicker and then we get really more for it.

c. Embroidered nets
The machine made net was not only used as a substitute for hand made net

but also for producing a different product. Mrs Treadwin is 1883 stated[18]

> The introduction of the machine net led to a new industry in Devonshire and especially at Exeter. It was a successful attempt at the imitation of the famous Chantilly lace, by means of sprigs and flowers worked with the needle in floss silk on the machine net, thus producing a good imitation of the real Chantilly in veils, flounces, neckerchief &c. While a veil of this kind could be sold for £5, a real Chantilly would cost £30; and as the real Chantilly lace has always been made of silk, and black, the floss silk flowers and patterns would bear a close resemblance to its more costly original. A house in High Street, Exeter, some years ago dealt largely in this imitation article.

It seems probably that the firm referred to was G. Seward of 239 High Street whose advertisement in the *Exeter Flying Post* for 29 September 1825 referred to '. . . his winter STOCK of BLACK LACE VEILS which consists of nearly two hundred different patterns, many of them quite equal to real Chantilly veils both in appearance and durability.' Nevertheless it is noticable that the designers of this Exeter lace were sometimes influenced by Honiton designs. [Plate 66]

Whilst workers in the Honiton lace area were using a needle technique to imitate Chantilly lace, others elsewhere were using similar ideas to imitate Honiton. The catalogue to the Great Exhibition of 1851, Class 19 includes item 19 'Tamboured lace scarf, imitation of Honiton, manufactured in London' and item 140 'A veil worked by the needle, in imitation of Honiton lace, and in the hope that it may be the means of giving employment to many poor needle-women.' The latter was designed and made at Soham, Cambridgeshire.

3. Copies of old laces
These have already been referred to as being made under the direction of Mrs Treadwin and Miss Trevelyan.

4. Miscellaneous other laces
a. Devonia.
At an unknown date, later than 1874, Miss .E.W. Jones[19] published a book entitled *The Honiton lace book* under the pseudonym 'Devonia'. In it she described a variant of Honiton lace in which '. . . the inner petals of

the flowers, the butterflies' wings, &c, are made to stand out in bold relief, so as to imitate the natural forms' and she proposed the name Devonia for this lace [Plate 69]. The lace was worked in layers on the pillow and the layers raised by needle and thread. The following instruction is then given (p.78).

> Having done all this, the finishing touch must be put as follows: Boil a quarter of an ounce of rice in about a pint of water, so as to get the thinnest possible starch, to give a soupcon merely of stiffness; when cold strain it off, and with a camel's hair pencil brush over the inside of the parts standing out in relief.

Such lace would clearly have been somewhat impracticable for wearing as the author evidently recognised for she wrote 'The Devonia kind of lace does not fold over well, as may readily be apprehended;' It is doubtful if much was made and surviving specimens are rare.

b. Woodbury Greek

At Woodbury a form of torchon lace was made which is usually referred to as Woodbury Greek [Plate 68] from its resemblance to Greek laces though it also resembles some of the 19th century Maltese revival laces. A few specimens survive in the Treadwin collection in Exeter but no contemporary information on its origin has been found, though Mrs Palliser[20] stated that it was introduced by the dowager Queen Adelaide from Malta in 1839, but no evidence is given in support of this statement.

Royal patronage

It has long been the custom for British monarchs to attempt to encourage trade, in earlier times by the controversial system of monopolies and more recently by patronage, and the latter type forms an important element in the endeavours to assist the Honiton lace industry during its long period of decline. Queen Adelaide lent her support and in the *Exeter Flying Post* for 14 October 1830 it was stated that

> A most superb dress for her Majesty the Queen has been made at Miss Lathy's lace manufactory, Honiton. It is sprigged all over, and has at the bottom an elegant border, over which are placed a variety of handsome sprigs, the whole being surmounted with an exquisitely wrought wreath of flowers, forming the name Adelaide.

The flowers concerned are usually stated to have been Aramanth, Daphne, Eglantine, Lilac, Auricula, Ivy, Dahlia and, again, Eglantine, but who was responsible for compiling this ingenious list is not known. This dress was not, as has sometimes been stated, made for the coronation, having been completed nearly a year before that event. Another example of this queen's patronage is shown by a pricking for a handkerchief [Plate 84] in the collections of Allhallows Museum, Honiton, which is annotated with the information that it was made for Queen Adelaide and with the names of the lacemakers who worked on it.

Queen Victoria was a major patron of the industry and many examples of her interest are on record. The best known, but by no means the best understood, was her action in ordering Honiton lace for her wedding. Thanks to the researches of Staniland and Levey[21] much light has been thrown on the history of this lace, but much still remains obscure in connection with the order and its execution. The order was given to Miss Bidney, a native of Beer, resident in London and holding the appointment of 'Honiton Brussels point lace manufacturer in ordinary.' It has not been established why Miss Bidney was chosen in preference to either Mrs Esther Clarke of Honiton, who likewise held a royal appointment as Honiton lace manufacturer, or Miss A Lathy, also of Honiton, who held the royal appointment to the Queen Dowager, though they may have been engaged on other commissions since Mrs Clarke produced a Honiton lace morning dress for the Queen's trousseau.[22] Equal obscurity surrounds the question of the number of lace makers involved. A newspaper report[22] states that the lace was made at Beer and that more than 200 persons were employed on it, and another report[23] states that about 150 of these partook of a celebration tea at the New Inn. However, the census of 1841 shows that the total number of lace makers in Beer at the time was only 79 so it is evident that only part of the work could have been done there and that workers were drawn in from further afield. There were none in Seaton but there were 123 in Branscombe, so Beer and Branscombe together could have provided the necessary workforce. Another possibility which cannot be discounted is that some workers in Honiton were involved and that the actual assembly was carried out there, for on 13 March 1841 Ann Channon, a lace sewer of Honiton, was interviewed by a Parliamentary Commissioner[24] who reported

> The 'sewers on', she says, are considered 'the best off in the lace-making trade', and this work of finishing is the most desirable department of it; the number of 'sewers on' is very limited, and they are nearly all at

Honiton. She sews and finishes for 'Miss Bidney' of London; and the sprigs she sews on for her come principally from Beer.

This statement is supported, in part, by the fact that in the 1841 census the only people described as lace sewers were in Honiton. The force of the Queen's example is shown in a comment concerning Beer in *Woolmer's Exeter and Plymouth Gazette* for 27 August 1842 (3b) that 'here the betrothed maid of fashion may visit the lace-making children of industry and toil, and bespeak the beauteous veil or role, after the model of that which the Queen did not disdain to wear on her bridal day.'

Queen Victoria continued to patronise the Honiton lace industry. On 10 June 1843 (3c) *Woolmers Exeter and Plymouth Gazette* reported that

> We are given to understand that the Queen, from an anxious desire to encourage the British manufacturer, ordered some collars of lace to be made at Beer, a retired village in Devonshire, the shape being furnished by her Majesty. They have just been completed, and forwarded to Buckingham Palace;

On 14 October (93d) of the same year this paper reported the making of a pair of Honiton lace shoes for the Prince of Wales by Mrs Albion Davey of Honiton, and on 20 July 1850 (Supplement) that the Honiton lace industry was '. . . extensively patronised by Her Majesty . . .' The Queen extended her patronage around the lace making area for the *Western Morning News* of 7 September 1964 stated in its Hundred Years Ago item that she had ordered lace from Mrs Hayman of Sidmouth, the *Exeter Flying Post* of 5 August 1874 (7e) stated that she had ordered fourteen yards of lace from A. and W. Ward of Honiton, an unidentified newspaper cutting of 5 November 1887 in the Devon and Exeter Institute's collection reported that Mrs Treadwin of Exeter had recently been honoured with an order from Her Majesty, and *The Queen* for 13 June 1891 reported that Miss Herbert, Mrs Treadwin's successor, had received an order after her attendance on the Queen at Windsor.

There is some evidence to suggest that the Prince Consort also patronised the industry, for J. Ll. W. Page, writing in 1895,[25] reported a conversation with the husband of an old lacemaker in which the man asserted that his wife had made '. . . a pair of Honiton lace breeches for Prince Albert, an' he wored 'em over blue satin.' This could refer to lace trimmed blue satin breeches, but there is no known record of the Prince ever wearing such a garment. However on 13 June 1851 the Queen held a costume ball with the theme of the Restoration at which many of the men wore Honiton lace[26] and the

pictures in the *Illustrated London News* show numerous lace trimmed breeches. However the descriptions of the Prince's costume show that his breeches were of crimson velvet ornamented with gold lace,[27] but it could be that the old man's tale is an imperfectly remembered recollection of an order for this occasion transposed by the passage of time from gentry to royalty.

Queen Victoria's children also made use of the products of the industry and the christening robe made for them has been used in the royal family ever since. Descriptions of the weddings of the Queen's children show that the Honiton lace industry was much patronised by the brides, as they also did on other occasions such as a state ball in 1868 when the Princess of Wales wore a white tulle, silk and satin dress trimmed with Honiton lace.[28]

When the Princess of Wales became Queen she continued her patronage of the industry, as did her successor Queen Mary. The latter's bridal gown was festooned with Honiton lace at the top together with three flounces on the skirt, whilst in addition she wore her mother's Honiton lace wedding veil.[29] She became patroness of Mrs Fowler's Honiton lace school, ordered from here a dozen frocks for her eldest son,[30] later King Edward VIII, and continued to show an interest in the industry for the rest of her life, by which time it had ceased to be.

Other patronage

It was always the hope that royal patronage would not only help the Honiton lace industry by reason of the work engendered by the order itself, but that the Queen's example would be followed by others, especially the nobility and gentry. Ladies close to the Queen in court circles, especially those from Devon, certainly patronised the industry and there are many references to the wearing of Honiton lace in the descriptions of dresses worn at formal occasions. Honiton lace veils were popular with Victorian brides.

Notable and sustained patronage of the industry was given by Sir John and Lady Yarde-Buller, of Clifton Ferrers, Devon. They were married on 24 January 1823[31] and the bride wore a Honiton applique veil which has been preserved in the family [Plate 20]. There is no record of either the designer or manufacturer of this piece but there is some possibility that it may have been the work of Amy Lathy of Honiton. The only known specimen of her work is a pricking for a handkerchief [Plate 84] which is annotated as having been made by four named workers under Amy's direction. Examination of the ages of the persons concerned shows that they were implausibly young for such an undertaking at the time of the wedding in 1818. However, the word 'wedding' in the annotatuon may be an error for 'coronation' and 1830

produces plausible ages. Either way it represents a design used by Amy around the period of the veil and comparison reveals a distinct affinity between the two. Lady Yarde-Buller did not confine her interest in Honiton lace to her wedding and *Woolmer's Exeter and Plymouth Gazette* for 8 July 1843 (3c) reported that she had worn a train of Honiton lace at the Queen's Drawing Room, and that for 20 May 1848 (3d) reported that the dowager Lady Clinton, Lady Yarde-Buller and Miss Yarde-Buller had all worn Honiton lace at the baptism of Princess Louisa.

In 1850 Sir John, together with Lady Rolle, was responsible for one of the highlights of patronage of the Honiton lace industry. In connection with the Great Exhibition of 1851 *Woolmer's Exeter and Plymouth Gazette* for 18 October 1851 (3b) reported that

> At the time when subscriptions were being raised for the purpose of guaranteeing the cost of erecting a building in which to hold the mighty collection of specimens of industry and art which have been subsequently gathered at Hyde Park, Lady Rolle and Sir John Buller Bar[t], were requested to subscribe to the local fund. In place of doing so they more wisely resolved that the funds which they intended respectively to appropriate for the furtherence of the Exhibition, should be devoted to the encouragement of the manufacturing industry of their own locality. In consequence of their resolve, Mrs Esther Clarke, of 18 Margaret Street, Cavendish-square, was sent for, as being a lady much experienced in this manufacture. Mrs Clarke was accordingly instructed to at once proceed with arrangements for the purpose of furnishing an example of Honiton lace such as never yet had been exhibited. No expense was to be spared, it being at the same time intimated to Mrs Clarke that the funds requisited for the defrayal of the necessary expenses would be provided, as required by her noble patroness and patron. The designing was immediately placed in the hands of Miss Eliza Clarke, Mrs Clarke's sister-in-law, and as finished, Mrs Clarke proceeded in setting out the work, and placing it in the hands of the operators. The article chosen was a flounce, now exhibited in a separate case on a bridge connecting the two south-western galleries. The wages paid to the workpeople amounted to £400. This will be the more easily believed when we state that it constantly occupied forty women eight months, in addition to which, during the last month, ten women were also employed at night.

Mrs Clarke was awarded a prize medal and the flounce [Plate 26] received much praise, including that of the French representative on the jury who wrote[32] that (trans) '. . . no finer piece has been made in modern guipure;

the quality of a perfection without equal, the design clear and pure, of a great richness of detail without being heavy make this work a piece beyond comparison.'

There is no known record of where this fine piece was made, but it seems probable that it was in Honiton itself. Mrs Clarke was the sister of Amy Lathy (holder of royal appointments from Queens Adelaide and Victoria) and widow of Theophilus Clarke who had been a lace dealer in Honiton and whose sister Eliza also from Honiton was the designer. The fact that there was no direct entry for the Great Exhibition from the lacemakers of Honiton could be explained if the most skilled workers were engaged on Mrs Clarke's flounce. £500 was offered for the flounce at the end of the exhibition[33] but this was refused and it remains in the family.

Some patronage also came from corporate bodies, as when the Fanmakers Company commissioned a Honiton lace fan for presentation to Queen Mary on the occasion of her coronation. The fan [Plate 51] was designed by Mr G. Wolliscroft Rhead and made in Honiton under the direction of Mrs Fowler,[34] though not apparently without some mishap since one of the pairs of shields worked back to front [Plate 52] is among the material from Mrs Fowler's shop now in the Allhallows Museum collection.

Exhibitions

Examples of Honiton lace were shown in many exhibitions and there would be little point in attempting to make a complete catalogue of such occasions. Some however were clearly important in bringing Honiton lace to public notice and to encourage designers and manufacturers during the years of decline, the most prestigious being the great international exhibitions. The progenitor of these was the Great Exhibition of 1851 and the flounces exhibited there by Mrs Esther Clarke and by Mrs Treadwin have been described. In addition prize medals were awarded for Honiton lace exhibited by two London dealers as well as honourable mention for another and for W.L. Gill of Colyton.

At the Paris Universal Exhibition of 1855 Class 23 Section 7 was lace and most of the British entries in this section were machine laces from Nottingham. There were, however, ten exhibitors of hand made lade, of whom two showed Honiton. These were Mrs Esther Clarke, who was awarded a bronze medal, and Mrs Treadwin who received a silver one, which she subsequently portrayed on her trade card together with that for the Great Exhibition [Plate 91].

At the International Exhibition of 1862 in London Mrs Esther Clarke again exhibited a flounce and other specimens of Honiton lace, though Mrs Treadwin was not an exhibitor on this occasion. The notable item of Honiton lace in this exhibition was a flounce exhibited by Howell James & Co of London (Exhibitor 4422) and which had been produced by John Tucker of Branscombe to the design of his daughter Mary [Plate 27]. This fine piece, which is in the Victoria and Albert Museum's collection, was shown in a later international exhibition, Cinque secoli di merletti europei: i capolavori, at Burano in 1984 where it was exhibited next to a Brussels flounce catalogued as 18th Century. The direct comparison thus made possible showed that the Tucker flounce could hold its own in the highest international class.

The catalogue of the British section of the Paris Universal Exhibition of 1867 shows that Mrs Treadwin exhibited a Honiton lace shawl [Plate 28] and was joined by two newcomers to the international scene, Mrs Caroline Hayman and Miss Harriet Radford, both of Sidmouth. Thereafter international exhibitions became popular and Honiton lace was shown at many with success,[35] for Mrs Fowler of Honiton alone gained a bronze medal at Edinburgh 1886, a silver medal at Paris 1900, a gold medal at Chicago 1893, another gold medal at St Louis 1904 [Plates 50, 95] and a grand prize at the Franco-British exhibition of 1908. The last important international exhibition at which items of current or recently manufactured Honiton lace of note were shown was the British exhibition in Paris 1914. Queen Mary lent three pieces which had been specially made for her in recent years, two fan leaves made by the lacemakers of Honiton under the direction of Mrs Fowler and a handkerchief [Plate 53] made by Mrs Fowler to a design [Plate 85] by her niece Miss D.B. Ward.

A somewhat different form of exhibition, specifically confined to Honiton lace, was instituted by the Bath and West of England Agricultural Society when at their annual show in 1864 prizes were offered for a range of articles in Honiton lace, with the express intention of encouraging good design as well as workmanship. The articles concerned, which included sprigs, nosegays and borders, were deliberately confined to small items so as to encourage entries from a wide range of people and, as a further inducement to enter, all items were offered for sale at the show. Similar exhibitions were held in a number of succeeding years, but it seems unlikely that the original objective was attained since the event from the second year onwards became largely one for the winning of prizes by the lace manufacturers of Sidmouth,[36] who took 46 per cent of the awards in 1864 and thereafter never fell below 56, reaching 82 in 1877. There is no indication that Mrs Treadwin entered, she certainly was not among the prizewinner, though she staged a special

exhibition in 1869 together with demonstrations of lacemaking by two of her workers. The report in *Woolmer's Exeter and Plymouth Gazette* for 2 June 1871 (6d) observed that no second prize was given for banner screens though two others had been exhibited '. . . and of these No 769 appeared to have much merit', whilst the report in *The Western Times* (6c) of the same date drew attention to '. . . a very handsome banner screen' exhibited by Miss A Ward but not included in the prize list and added that '. . . the judging of lace was performed by gentlemen from South Kensington.' Miss Ward later became Mrs Fowler and revealed[37] that the judges did not believe that the piece was made in England owing to its high quality, that she had offered to make another like it in front of them, that they had later sent her a prize which she had refused to accept. This episode reveals only too clearly the lack of repute in which the generality of Honiton lace was held at the time, and also why Mrs Fowler went on to her subsequent distinguished career.

In the early twentieth century two exhibitions were organised in London specifically for the cnouragement of the English hand made lace industry. The Daily Mail exhibition in 1908 attracted entries from Audrey Trevelyan's East Devon Cottage Lace Industry covering Beer and Branscombe, independently from Beer by Mrs Collier, Miss Copp of Exmouth and Mrs Fowler of Honiton. Although the organisers were able to attract a catalogue preface by Alan S. Cole, one known surviving piece from the exhibition is not of a high standard, nor is much confidence engendered by Specimen 164 in the loan section which is described as 'Devon about 1825' to which is added 'This flounce of Limerick lace, embroidered on Mecklin net . . . made at Wincanton, Somerset.' The other exhibition was mounted by the National Association for the Organisation of Hand-made lace in England in 1913. Queen Mary lent a number of specimens which had been made for her, the Association showed a series of designs and some pieces made from them under the direction of Audrey Trevelyan, Mrs Pearson of Sidbury and Miss Savory of Diss, Norfolk. Mrs Fowler exhibited two pieces designed respectively by Mrs Bernard of Combe Raleigh and by Miss D.B. Ward, and there were also items from the Devon County Council classes. Whether this organisation would have achieved any useful progress towards its objective is debatable, but the long term perspective of the declining industry now available suggests that it was too late for such a venture to succeed.

Conclusions

These various measures failed to halt the decline which, as Figure 7.9 shows,

continued its inexorable progress with only minor fluctuations throughout the period. It seems doubtful whether royal orders, noble patronage and prestigious exhibitions could have achieved much, since the market for this class of goods was inevitably limited. This may be illustrated by a wedding veil [Plate 30] in Allhallows Museum, Honiton which was made by Mrs Treadwin for Adeline Frances Dart in 1869 at a cost of £82, which represented about 2.5 years earnings for a Devon agricultural labourer at the time[38]—thus showing that this level of spending was for the very rich, who, moreover, unlike their predecessors in previous centuries, had available to them the increasingly sophisticated products of the machine lace industry at much lower prices.

It is apparent, however, on the evidence of 'Primrose', that the introduction of Branscombe Point lace did provide some work in that village to lacemakers who might otherwise have been without any. It is probable that the simplifications of technique, though deplored by many writers, could have provided some earnings for workers, who would otherwise have been destitute, in supplying goods for the expanding tourist trade. Observation of the current scene in some other countries shows that tourists will buy low quality lace if it bears the cachet 'hand made' and there is no reason to doubt that visitors to East Devon during the period of decline of the Honiton lace industry would have been equally undiscriminating.

References

1. Treadwin, 1873, p.40.
2. Farquharson, 1891.
3. eg. G Seward of Exeter in Exeter Flying Post, 29.9.1825 (4e), 13.11.1828 (2d), 13.10.1831 (2e).
4. eg. H and F Davis of Exeter in Exeter Flying Post, 18.3.1830 (2c), and A Lathy of Honiton in the same newspaper, 19.8.1830 (2c).
5. Roberts, 1856, p.382.
6. Jourdain, 1908, p.94.
7. Woolmer's Exeter and Plymouth Gazette, 1.3.1851 (5c).
8. Wyatt.
9. Exeter Flying Post, 11.3.1859 (4e), 10.4.1861 (4b), 3.5.1865 (5a), 24.4.1867 (4e).
10. Cole, 1904.
11. Dryden, 1897. Glenavon.
12. Ponting, p.128.
13. Treadwin, 1873, p.62.
14. Treadwin, 1873, p.69.
15. Moody, 1907, p.35.

16. House of Commons, 1863, evidence of Mary Ann Power.
17. DRO, M/F2/1.
18. Treadwin, 1883.
19. DCNQ, IX p.249.
20. Palliser, 1865, p.389.
21. Staniland and Levey.
22. Besley's Devonshire Chronicle and Exeter News, 18.2.1840 (2c).
23. Woolmer's Exeter and Plymouth Gazette, 15.2.1840 (3c).
24. House of Commons, 1843.
25. Page 1895, p.418.
26. The Morning Chronicle, 16.6.1851.
27. See also Jarvis and Raine.
28. Illustrated London News, 4.7.1868 (7a)
29. Gentlewoman.
30. Dryden, 1897, p.503.
31. Not June as quoted by some authorities. Notices of the wedding are given in Trewman's Exeter Flying Post, 30.1.1823 and Woolmer's Exeter and Plymouth Gazette, 1.2.1823.
32. Aubry, p.65.
33. Letter written by Mrs Clarke, annotated by Lady Yarde-Buller and kept with the flounce.
34. Illustrated London News, 1.7.1911.
35. Bright.
36. Full reports of the exhibitions and prizewinners are given in the show reports in Woolmer's Exeter and Plymouth Gazette for the appropriate years.
37. Cole, 1888, p.5.
38. Bowley.

Part Two

The People of The Industry

The Manufacturers

... I am trobelled gretly, what you^u can doe with the workkers thes times, for heare is no trade, ... if the trade be as bad thare as heare, I should ad vise yo^u to be red of sum of the workkers, not to trune thim of, but to bat thim away ...

Jane Pinney (in Dublin) to her daughter Sarah (in Dorset),
11 June 1685

The inter-relationships between the various persons involved in the Honiton lace industry are shown in Figure 9.1 and it will be seen that the manufacturers held the key position. They obtained designs and thread, and supplied these to the lacemakers who worked on an essentially self employed basis, though often exclusively for one particular manufacturer. When the motifs were received fom the lacemakers they were assembled into pieces of lace by the sewers and the pieces were finished by the finishers, both of whom were usually directly employed by the manufacturers, who also employed repairers for dealing with the trade in reconditioning old lace. Finally the manufacturers sold the lace wholesale to the dealers, who were normally called lacemen in the Honiton lace area, and who retailed it to customers. There were variations in this general scheme, for some manufacturers also kept shops and acted in whole or in part as their own lacemen, whilst occasionally lacemakers made direct sales to customers.

The activities controlled by the manufacturers are reflected in the census enumerators' books for 1841 to 1881 where the expressions shown in Table 9.1 are used for occupations in the lace industry, other than lacemaker, manufacturer or dealer. It seems unlikely that the differences in numbers indicate any real changes but rather the idiosyncracies of individual enumerators trying to interpret what they had been told. It may be noted however

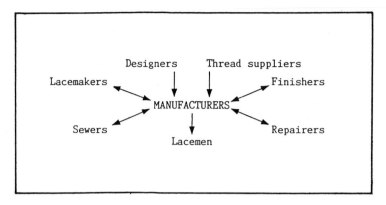

Figure 9.1 Interrelationships within the Honiton lace industry, illustrating the central role of the manufacturers.

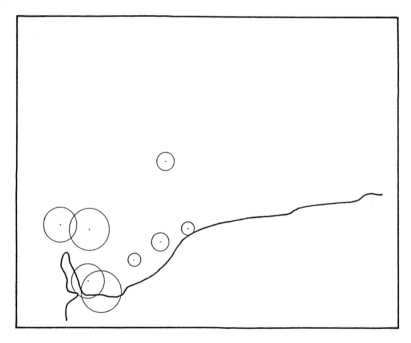

Figure 9.2 Location of the use of the term 'sprig' in East Devon. Areas of circles in proportion to the number of references in each place. 1841-1881 census returns.

that the term 'sprig maker' to denote a person who made motifs, which are sometimes referred to as sprigs, appears to have had a restircted geographical usage, being largely confined to the south western corner of the lace making area (Figure 9.2). Another feature of nomenclature which may have significance is that in 1861 and 1871 all the lacemakers in Beer were specifically recorded as Honiton lace makers, an expression not universally applied throughout the area. Since the Childrens Employment Commissioner in 1841[1] had recorded the making of both Honiton and trolly lace in the village it is probable that the making of trolly lace had died out there by 1861.

Table 9.1 Expressions used to denote lace workers in census returns

Occupation		1841	1851	1861	1871	1881
Making	Sprig maker	2	2	—	29	4
	Slug maker	—	1	—	—	—
	Filler	—	—	—	2	—
Assembly	Sewer	2	21	1	2	2
	Joiner	—	—	—	1	1
	Fastener	—	—	—	1	—
Finishing	Dresser	1	—	—	—	—
	Finisher	—	—	—	1	9
Repair	Cleaner	—	—	—	—	2
	Mender	2	6	1	6	11
	Transferer	—	1	1	2	1
Unidentified	Traveller	—	2	—	—	—
	Pointer	—	—	—	—	1

Apparently the earliest use of the expression 'manufacturer' to denote the entrepreneur who organised the production of Honiton lace was in relation to Edward Bird in 1688.[2] In documents of the late seventeenth and early eighteenth century the term 'maker of lace' was also used but from mid-century onwards all such persons were designated 'manufacturer.'

The organisation of manufacture

1. Making the motifs

The lacemakers' personal equipment consisted of pillow, bobbins and pins but in addition they required patterns and thread. These two latter items were provided by the manufacturer, though the circumstances of providing them differed. There are no records of the provision of patterns in the Honiton area before the nineteenth century but Edward Hooten of Newport Pagnell in Buckinghamshire informed a parliamentary committee in 1699[3] that he employed many lacemakers and provided them with patterns. It seems probable that this was the general method at the time. The Childrens Employment Commissioner in 1863[4] was told by Mrs Godolphin of Honiton that she gave out the patterns to the lacemakers, and Mrs Hayman of Sidmouth said the same, making it clear that there was no charge for them. Alan Cole in 1887[5] was informed by a manufacturer in Branscombe that she pricked the patterns for the lacemakers and by another at Exmouth that she made up the patterns and pricked them for the workers. The available evidence indicates, therefore, that it was the normal practice for the manufacturers to provide the patterns free to the lacemakers.

Information on the system used for the provision of thread is very scanty. Edward Hooten stated that he provided the thread and a similar arrangement obtained in Honiton in the early twentieth century, for Mrs Millie Perryman (b. 1904) has stated that 'I remember Gran used to make a bit of extra money selling collars to summer visitors if she could get a bit of extra thread but it wasn't really allowed as the Miss Wards gave them the thread knowing how much it would make . . .' On the other hand the Childrens Employment Commissioner of 1863 recorded that both Mrs Godolphin of Honiton and Mrs Hayman of Sidmouth sold the thread to the lacemakers. It appears, therefore, that two systems were in operation, though which, if either, predominated at any given period can not be determined from the surviving information.

The numbers of workers producing motifs for a manufacturer varied considerably, as also did the area over which they were spread. In 1688 Edward Bird claimed[6] to '. . . employ many hundreds of his Majesty's subjects in Blandford and in other parts of the West of England in making points and bone lace . . .' and in 1691[7] that '. . . daily is at great charge in employing many hundred hands for carrying on the said manufacture, which is a great subsistance to several towns in the counties of Devon, Dorset and Wilts;'. In 1755 it was stated by the incumbant of Sidbury that the lacemakers of that place were employed by persons of Honiton,[8] and another claim to be an

employer over a wide area was made by Mrs Davey of Honiton in 1863 for it was recorded[4] that she '. . . employs lacemakers here and in most villages for 10 or 12 miles distant.' If this statement is even approximately true it means that Mrs Davey drew on the work of lacemakers over almost the whole lacemaking area. It is possible that this may have been so since she was a long established and well-known manufacturer, who had received a royal appointment from Queen Adelaide in 1830 and another from Queen Victoria in 1850, and could have been in a position to employ only the best workers. In the 1861 census return John Tucker of Branscombe is recorded as the employer of 2000 lacemakers, but it seems likely that this is an exaggeration since it would represent 54 percent of the total lacemakers of East Devon. Possibly the figure is an error and 200 was intended.

There were, however, manufacturers who worked on a much smaller scale, as is to be expected with the truck system being in operation in villages. An estimate of the average number of workers kept in employment in East Devon by each manufacturer during the period 1841–1881 may be obtained by dividing the number of lacemakers recorded in each census by the number of manufacturers shown in the county directory nearest in date. The results are shown in Table 9.2.

Table 9.2 Lacemakers per manufacturer 1841–1881

Census		Directory		Lacemakers per manufacturer
Year	Lacemakers	Year	Manufacturers	
1841	927	1844	15	62
1851	4101	1856	47	87
1861	3694	1866	36	103
1871	3531	1873	33	107
1881	1908	1883	24	80

In 1887 Alan Cole recorded numbers of lacemakers kept in employment at that time and, in some cases, at a generally indeterminate 'formerly', as shown in Table 9.3.

Table 9.3 Lacemakers per manufacturer recorded by A.S. Cole in 1887

Manufacturer	Place	Lacemakers employed Formerly	1887
B	Beer	—	30
F	Colyton	100	—
G	Branscombe	—	30-40
H	Branscombe	40-50	6
I	Sidmouth	—	10-12
Fowler	Honiton	200	70
L	Ottery St Mary	300	6
P	Woodbury	—	30

These figures indicate that during the mid century boom manufacturers employed an average of some 100 lacemakers but that before and after this the numbers were substantially less. Cole's information, however, indicates that there were considerable divergences from the average and it may be noted that Mrs Fowler, who was well-known for high standards, retained a considerable workforce at a time that was well into the final decline of the industry.

When the motifs were completed it was the normal practice for the lacemakers to take them to the manufacturer and to receive payment for them in money or in kind. On at least one occasion this proved to be unexpectedly hazardous for *Woolmer's Exeter and Plymouth Gazette* for 16 March 1816 [4b] reported that

> On Monday last, towards the evening, a young woman was overtaken, near Ottery St. Mary by a man, who demanded her money; on her informing him that she did not possess any, he stripped her of almost the whole of her apparel, with which, together with a few yards of lace she was about to dispose of at Ottery, he decamped. Search has been made after the offender, but without success.

The expression 'yards' for the lace may be journalistic licence, though it is possible that what she had was trolly lace.

Although the procedure described represented the normal method of business between manufacturer and lacemaker there is evidence of two other systems. Mrs Treadwin[9] found that for the highest class work it was necessary

to have the workers in her own house '. . . where I can hourly superintend the manner in which it is worked'. She added that during the work on the flounce which she exhibited at the Great Exhibition she did not leave her work room at all during working hours. No other manufacturer has recorded a similar observation, but it is possible that such personal close supervision was given for other important pieces, and this could only be done effectively on the manufacturer's premises.

Woolmer's Exeter and Plymouth Gazette for 23 February 1850(8b) reported, under the heading 'FEMALE STUPIDITY', the following occurrence

> A party of lacemakers have sent a quantity of lace, value £5, to a gent in London, as per agreement, for which the gent sent them half a £5 note, stating, on receipt of that, the other should follow—but the poor girls, eager to have their money, ran to the bank to have it cashed,—the clerk telling them that it was of no use without the other half, they at once confirmed it a loss, and sent it back to the party from whence it came, sadly lamenting on their toiling so many days as they thought for nothing, until they were better informed by some other party.

This report suggests that a number of young women had formed a cooperative enterprise in which they combined the roles of lacemaker, manufacturer and dealer. This is the only known reference to such a venture and if it succeeded could have given the girls a higher than normal reward for their work, thus demonstrating that the male chauvinism of the heading was misplaced.

2. Assembly

The assembly of the motifs into pieces of lace was regarded as an activity separate from making them and was carried out by workers known as 'sewers' in the case of appliqué lace and as 'guipurers' in the case of bar or net ground. The work was more skilled than the more or less mechanical making of motifs since artistic judgement was involved, as described by Ann Channon of Honiton in 1841, 'The great requisite in a sewer on is taste in the arrangement of the sprigs, as the "mere sewing is easy." Sometimes she "uses her own taste" in getting up a veil or dress, and sometimes she "works by a pattern" '. Since this work involved greater skill those engaged in it were better paid. In the case of Ann Channon 'The "sewers-on", she says, are considered "the best off in the lace-making trade," and this work of finishing is the most desirable department of it, the number of "sewers on" is very limited . . .' In the same report Elizabeth Fildew, also of Honiton, gave

evidence that 'she thinks that there are "only between 20 and 30 who do this kind of work at Honiton," and "scarcely any out of the town." Only a small number are required, "and so there are few that give their time to it." It is generally considered the best paid of all the lace-work, and she can earn "five or six shillings a week and more." "The principal difficulty is the disposing of the sprigs with taste" '.

The significance of the figure of five or six shillings a week is not easy to assess though, depending on interpretation of the available data, it could represent earnings in the upper quartile or top 25 per cent. A far bigger differential was quoted to the Truck Commissioners[10] in 1871 who were informed that the lacemakers could earn from 2s 6d to 6s per week but that the sewers could earn about £2. Cole recorded in connection with Exmouth that 'it has recently become a branch of the industry to fill in a needlepoint net between the sprigs. The needlepoint workers get a higher rate of pay than that of the pillow lace workers.' He did not record what the actual pay was but observed of these people that 'they belong to a better class and are more thrifty.'

The assembly work was usually carried out at the manufacturer's premises. Mrs Godolphin[4] stated that unless she was very busy this was done at her own house, the truck commissioners were informed that the sewers mostly lived in the manufacturer's house and Cole[5] was informed by B, of Beer, that the making up was done by his daughters and by G, of Branscombe, that she did the making up herself. The practice was not, however, universal for Mrs Hayman of Sidmouth[4] stated that although she used to have a young woman in her house for making up work she had changed to giving it out, and her namesake at Otterton gave this type of work out to young women 'girls not being skillfull enough . . .'

3. Finishing

Although there are references in the census returns to a dresser and a number of finishers the only known description of their activities is that given by Mrs Treadwin.[11] She divided the processes into three as follows:-

a. Stiffening. This was a normal starching using an ounce of starch to a pint of water for 'Old Devonshire' and to a pint and a half for Honiton. The former was evidently the pre 19th century lace made from linen thread.

b. Finishing. For this the lace, partly dry, was laid face downward on a cloth and pinned out to its correct size and shape. When dry the pins were to be removed and the edges ironed with an ordinary flat iron to prevent the pinholes showing.

c. Raising. This was carried out by passing a small bone pointed instrument under any raised work to raise it to its three dimensional effect.

These processes make a contrast with modern conservation practice in which neither starch or any other additives are used and wet lace dried face upwards, thereby eliminating any need for raising. Pins, if used, are put through existing pinholes in the lace, which are always present owing to the technique of the making process.

4. Transferring, altering, mending and cleaning

In the later nineteenth and early twentieth centuries, at least, the manufacturers undertook various operations in connection with used lace. An advertisement by Mrs Pollard, Honiton lace manufacturer, of Exeter in *Exeter Flying Post* for 24 May 1871(4f) states 'every kind of real or imitation lace altered, transferred, mended or cleaned', and her successor, C. B. Cossins, advertising in the same paper for 28 April 1875(4f) offers the same services. Similar services were offered by Mrs Fowler [Plate 93] and Mrs Allen [Plate 92] and the childrens Employment Commissioner in 1863 was informed that at Mrs Treadwin's establishment 'The only young people employed on the premises are three or four girls of from 12 to 15 or 16 years old, who "rip off sprigs" i.e., remove patterns from one piece of lace to be transferred to others. These girls grow up to be transferrers, &c., in which more skill is required.'

Mrs Treadwin described[11] these processes and gave advice for, she wrote '. . . I have seen some of the most beautiful laces entirely spoiled by their being transferred, while others, on the other hand, may be very properly reappliqued and look equal to new.' Her advice covered many different laces but with regard to Honiton she wrote that the old material with net ground should be mended [Plate 38] but the appliqué on machine net could be reapplied so '. . . as to render it quite equal to the original piece of work.' Some manufacturers clearly took the process further and remade the lace with additional motifs to conform with 'the latest fashion'. Mrs Treadwin rightly warned against attempting to alter white lace to black by dyeing, giving as her reason that black lace was always made from silk, but she may not have appreciated that the reason for this lay in the limitations of dye technology at that time. Her description of the cleaning process, presumably reflecting the practice of the period, includes a twelve hour soak in soapy water followed by rinsing, transferring to a 'copper (not iron)' boiler to which was added a gallon of water with four ounces of soap dissolved in it. The boiler was then set on the fire and left '. . . to boil for at least two hours.' Further washing followed and then the lace was dried, finished and raised. In the case of black lace less vigorous treatment was described involving a soak in cold water

and Eau de Cologne, followed by a short treatment in a mixture of water, Eau de Cologne and beer.

A hazard of these activities not mentioned by Mrs Treadwin was encountered by Penderel Moody[12] following an attempt by a collector to clean a piece of appliqué lace by washing. The motifs had been gummed on to the net, instead of sewn, and Miss Moody was requested to reassemble the lace from a collection of component pieces salvaged from the washing water. On another occasion Miss Moody herself dismembered a similar piece of lace by ironing it. Allhallows Museum possesses a fragment of appliqué lace assembled in this manner but to what extent the technique was used is not known, though Moody states that such lace was still coming on to the market in 1909.

Sex and marital status

Prior to 1856 some lace manufacturers/dealers can be identified in isolated entries in parish registers, broadsheets, title deeds and other documents, and towards the end of the period in newspapers. The information does not, however, form a sufficiently consistent set as to be analysable and, though it can be noted that most of the names recoverable are of men in Honiton, it is doubtful whether any significance can be attached to this as an indication of the ratio of male to female manufacturers, or of their distribution.

From 1856 to 1939 the entries in the series of Kelly's *Directories of Devonshire* are available. It is not possible to distinguish between manufactures who did not keep shops, manufacturers who did, dealers who acted as manufacturers and dealers who did not, and so Table 9.3 shows the total numbers of people listed as manufacturers or dealers excluding a few obvious cases of haberdashers who merely stocked some lace and people engaged in the machine lace industry. The numbers are expressed graphically in Figure 9.2 and it will be seen that the totals of males engaging in this occupation declined fairly regularly over the period, with the numbers approximately halving every twenty years, leaving only one in business in 1939.

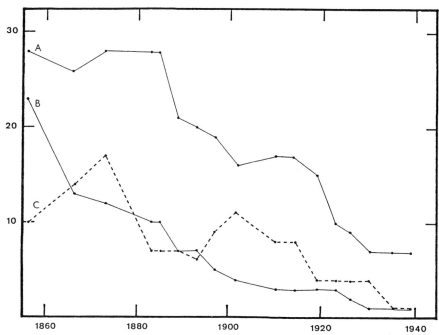

Figure 9.2 1856–1939. Lace manufacturers/dealers in Devon:
A = Number of married women.
B = Number of men.
C = Number of unmarried women.
Source: Kelly's Directories of Devonshire.

Table 9.3 Manufacturers and dealers in *Kelly's Directories of*
Devonshire **by sex and marital status.**

	Male		Female, married		Female, unmarried		Total
Year	No	%	No	%	No	%	
1856	23	38	28	46	10	16	61
1866	13	25	26	49	14	26	53
1873	12	21	28	49	17	30	57
1883	10	22	28	62	7	16	45
1885	10	22	28	62	7	16	45
1889	7	20	21	60	7	20	35
1893	7	21	20	61	6	18	33
1897	5	15	19	58	9	27	33

1902	4	13	16	52	11	35	31
1910	3	11	17	60	8	29	28
1914	3	11	17	61	8	29	28
1919	3	14	15	68	4	18	22
1923	3	18	10	59	4	24	17
1926	2	13	9	60	4	27	15
1930/1	1	8	7	58	4	33	12
1935	1	11	7	78	1	11	9
1939	1	11	7	78	1	11	9

The numbers of married women remained more or less constant until 1885, after which there was fairly steady decline until 1900, when there was another period of stability until the final decline after 1920. The initial period of stability coincided with the years following the mid-century boom, and its existence could be explained by the ability of married women to continue in a business which supplemented their husband's income or, if widows, to continue with decreasing fortunes through force of circumstances until reality had to be accepted. The second period of stability coincided with the so-called revival and may likewise represent a period of hope in which businesses which supplemented a husband's income could be continued until the hope was shown to be illusionary.

The case of the unmarried women is much more complicated. There was a pronounced rise between 1856 and 1873 which was due mainly to increases in numbers in Sidmouth (+4), Exmouth (+3), Torquay (+2) and Honiton (+2). This suggests an association with the developing tourist trade, which in East Devon had received a boost when the South Western railway was extended through Honiton to Exeter in 1860, with a branch to Exmouth the next year. It is evident, however, that the trade could not sustain the extra businesses for there was a sharp decline between 1873 and 1883 due to decreases in the same four towns:- Sidmouth (-5), Honiton (-3), Torquay (-2) and Exmouth (-1). In Sidmouth only one of the new businesses which had made their appearance between 1857 and 1873 survived to 1883. It would seem that these ladies opened more businesses than the market could support. A further rise occurred between 1893 and 1902 but this resulted from single new businesses being started in the scattered locations of Beer, East Budleigh, Newton Poppleford, Otterton, Morchard Bishop and Ilfracombe. It seems probable that this rise is to be associated with the hoped-for revival of the late nineteenth/early twentieth century. Thereafter the numbers decreased until, as with the men, there was only one business left in 1939.

The contrast beween the more or less steady diminution of male and

Table 9.4 Occupations combined with lace manufacturer/dealer given in Devon directories

Occupation	S 1852	K 1856	B 1857	K 1866	M 1870	K 1873	H 1878	K 1883	K 1885	K 1889	K 1893	K 1897	K 1902	K 1906	K 1926
1 Baby linen warehouse	1														
2 Baby linen & underclothing warehouse							1								
3 Boot and shoe maker		1													
4 China and glass dealer					1										
5 Cider retailer					1										
6 Draper					1									1	
7 Draper and grocer		2	2												
8 Draper, grocer & insurance agent		1													
9 Draper & insurance agent			2												
10 Draper & tea dealer		1													
11 Dressmaker														1	
12 Farmer		1													
13 Furrier						1		1	1	1					
14 Greengrocer							1								
15 Grocer		3	1		2			2	2		1			1	
16 Grocer & provision dealer						1									
17 Newsagent															1
18 Postmaster					1										
19 Shopkeeper		5	3	1	1	1		1	1	1	1	3	3	1	
20 Shopkeeper & insurance agent		1													
21 Stationer, fancy repository & post office											1	1	1	1	
22 Toy dealer		1													

Note: B = Billins. H = Harrods. K = Kelly. S = Slater.
Directories not listed have no appropriate entries.

married women lace manufacturers, and the more variable trend of the unmarried women is striking, and illustrates that in the second half of the nineteenth century lace manufacture and dealing offered business opportunities for spinsters.

Occupations combined with lace manufacture

The Devon directories record sixty seven instances in which lace manufacture is combined with some other occupation and these are summarized in Table 9.4. In view of the widespread use of the truck system it is not surprising to find that many of the occupations were the retailing of comestibles, namely cider retailer, grocer, tea dealer and greengrocer. Nearly all the shopkeepers listed are in villages and probably represented village stores which dealt in groceries, whilst the stationer, fancy repository and post office is known to have dealt in groceries.[13] Other occupations which could be involved in truck payments were shopkeeping in connection with clothing and the table includes retailers of baby linen, underclothing, boots and shoes, drapery and furs as well as a dressmaker. The number of entries covered by these occupations is 62, over 92 per cent of the total, and although not all the people concerned necessarily operated a truck system, the very high proportion who were purveyors of the type of goods frequently referred to in reports on truck payments is consistent with many doing so. Also consistent with these reports is the fact that the two most frequently quoted occupations are grocer and shopkeeper.

Royal appointments

Various people received royal appointments as lace manufacturers and a list of these compiled from the royal wardrobe letter books[14] and from surviving warrant certificates[15] is given in Table 9.5. Some other references to royal appointments for lace manufacture have been found and, though there is no reference to these in the letter books nor are surviving certificates known, they are shown, together with their sources, in Table 9.6. False claims to having royal appointments were made from time to time by tradesmen who had supplied some article to the monarch, but they were only entitled to claim royal patronage. The letter books make it clear that the term 'by royal appointment' could only be used by those who held a warrant, that the monarch would only grant one to a regular supplier and would not consider an application based on a single sale.

Table 9.5 Royal Appointments as lace manufacturers compiled from royal wardrobe letter books and surviving certificates

Date	Name	Place	Description
24.8.1830	Amy Lathy	Honiton	Maufacturer of thread lace
17.3.1834	Messrs. James Hoby, Edward	—	Silk lace maufacturer in ordinary
14.8.1837	Mr George Frederick Urling	—	Manufacturer of British lace in ordinary
14.8.1837	Miss Jane Bidney	—	Honiton Brussels point lace manufacturer in ordinary
18.12.1837	Mrs Esther Clarke	Honiton	Honiton lace manufacturer in ordinary
31.3.1838	Mrs Frances Potts and Mr George Potts	—	Manufacturers of lace and embroidery in ordinary
30.3.1839	Madme. Ferrières Perroud	Paris	Lace worker and embroidress in ordinary
16.6.1840	Mr Robert Hopkins	Newport I.O.W.	Manufacturer of Isle of Wight lace in ordinary
4.11.1840	Madame J.B. Vanderhagen van overloop	Brussels	Lace manufacturer in ordinary
28.6.1842	Mrs Eliza Darwall	Dalston	Manufacturer of Honiton lace
18.4.1845	Mr William Lloyd	Limerick	Lace manufacturer
28.6.1848	Miss Charlotte Elizabeth Dobbs[1]	Exeter	Manufacturers of Honiton Brussels point lace
26.8.1848	Mrs Martha Gaudee	Richmond	Manufacturer of Honoiton point lace
28.3.1850	Mrs Amy Davey[2]	Honiton	Manufacturer of thread lace
13.11.1851	Mons. Albert Delehaye	Brussels	Lace manufacturer
26.1.1860	Mrs H.C. Browne	London	Pillow lace manufacturer
18.3.1911	Mrs Anne Fowler	Honiton	Lacemaker in ordinary

1. Afterwards Mrs Treadwin
2. Formerly Miss Amy Lathy and sister to Mrs Esther Clarke

Table 9.6 Alleged royal appointments not confirmed by public records

Date	Name	Place	Source
5.12.1842	Mr Richard Simons	Honiton	*Exeter Flying Post* 8.12.1842 (2d) 'lace maker to her Majesty'
1857	Mrs Hughes	Torquay	Advertisement in *Billins Directory of Devon*, 'by appointment' and 'to Her Majesty the Queen and HRH the Duchess of Kent' with the arms of the Prince Consort
1882	Mrs Anne Fowler	Honiton	P.M. Inder *Honiton Lace*, 1971, p.7, also stated on Mrs Fowler's notepaper in 1910
1891	Miss E Herbert	Exeter	P.M. Inder *Honiton Lace*, 1971, p.7.

It will be seen that seven ladies were granted royal appointments as manufacturers of Honiton lace—Miss Amy Lathy (later Mrs Davey), Miss Jane Bidney, Mrs Esther Clarke, Mrs Eliza Darwall, Miss Charlotte Dobbs (later Mrs Treadwin), Mrs Martha Gaudee and Mrs Anne Fowler. Various sums of money which were paid to them are recorded in the quarterly accounts in the letter books and these are shown in Table 9.7. It will be seen that between their appointments in 1837 and 1842 both Miss Bidney and Mrs Clarke were regular suppliers, the total paid to the latter being slightly the greater. An apparent inconsistency in the payments to Miss Bidney is the absence of the £1000 alleged[16] to have been the cost of the lace for Queen Victoria's wedding dress. However the sum of £250 appears in the account for the quarter ended 31 March 1840 and this would seem to represent the payment to her for this work. An estimate of the cost of producing this lace using reasonable assumptions as to working rate and average wages together

with the known size of the lace shows that £250 would have been a plausible payment, so the £1000 may probably be dismissed as journalistic licence, which has, unfortunately, frequently been repeated in print ever since.

Table 9.7 Payments (£.s.d.) to holders of royal appointments as Honiton lacemakers recorded in royal wardrobe accounts

Year	Name	Amount
1837	Miss Bidney	12.12.0
1837	Mrs Clarke	66.16.0
1838	Miss Bidney	168.16.0
1838	Mrs Clarke	140.17.0
1839	Miss Bidney	34. 0.0
1839	Mrs Clarke	210. 0.0
1840	Miss Bidney	250. 0.0
1840	Mrs Clarke	86. 1.0
1841	Mrs Clarke	25.10.0
1842	Miss Bidney	62. 0.0
1842	Mrs Clarke	68. 1.0
1842	Mrs Darwall	16. 5.0
1848	Miss Dobbs	7. 7.0
1850	Miss Darwall	—.15.0
1850	Mrs Davey	5. 0.0
1852	Mrs Davey	21. 5.0
1854	Mrs Darwall	16. 4.0
1855	Mrs Darwall	21. 0.0
1856	Mrs Darwall	28.19.4
1856	Mrs Davey	7. 3.0
1857	Mrs Davey	13. 0.0
1875	Mrs Treadwin (nee Dobbs)	59.11.0
1881	Mrs Treadwin	50.16.0
1885	Mrs Treadwin	50.15.6
1887	Mrs Treadwin	38.16.0

Totals

Name	Amount
Miss Bidney	527.8.0
Mrs Clarke	597.5.0
Mrs Darwal	83.3.4
Mrs Treadwin	207.5.6
Mrs Gaudee	nil
Mrs Davey	46.8.0

Notes 1. In March 1840 it was proposed that some accounts should be paid in part only and the balance held over. It was proposed to pay Miss Bidney £120, but there is no record of the payment of the rest.

2. Payments of £14.0.0 were made in March 1844 to Chick and Tucker, and of £9.4.0 in June 1846 to Tucker. These presumably were for Honiton lace.

3. The payment to Mrs Davey in 1850 was for a 'Honiton pin cushion'.

Another problem of these royal appointments is that, though Miss Lathy, Miss Bidney, Mrs Clarke, Mrs Treadwin and Mrs Fowler achieved various degrees of fame in the Honiton lace industry, the only known references to Mrs Darwall and Mrs Gaudee are on the pages of the letter books. The latter is not recorded as having supplied any lace at all, so it is difficult to see how she came to receive the appointment, and the location of these two ladies is the only known reference to outposts of the Honiton lace industry in the suburbs of London.

There are seventeen appointments in the list, of which nearly half are in connection with Honiton lace, compared with less than a third for other English laces, showing that the former was held in highest esteem in royal circles. It may be noted that one appointment was made in Paris in 1839 and two in Brussels in 1840 and in 1851: it seems unlikely that the first two were known to a contributor to *Woolmer's Exeter and Plymouth Gazette* for 10 June 1843 (3c) who wrote 'We are given to understand that the Queen, from an anxious desire to encourage the British manufacturer, ordered some collars of lace to be made in Beer . . .' These appointments may, however, have been in the nature of an honour for no payments to any of these people are recorded in the accounts. The payment for the collars is probably represented

by the £14 to Chick and Tucker in the accounts for the quarter ended 31 March 1844.

The term 'Honiton Brussels' lace belongs to the same tradition as the eighteenth century use of 'Bath Brussels' (see Chapter 5) and the even older one of regarding Brussels lace as inevitably superior to the products of the Honiton lace industry, in spite of its reputation by such observers as Celia Fiennes and Mrs Powys.

The thread

Westcote's statement[17] that '. . . at Axminster you may be furnished with fine flax thread, there spun' shows that in the early days of the industry the manufacturers were able to obtain suitable thread for lace making locally and, no doubt, it was used. It is evident, however, that at least from the mid seventeenth century the English lace industry made use of imported thread, for the rate book of 1660, annexed to 12 Charles 2 c4, lists 'sisters thread' which was used for lacemaking and which, since the duty was fifteen shillings per pound weight, cost £15 per pound. The preamble to the Act of 1662 (12/13 Charles 2 c13), which prohibited the importation of foreign lace, refers to the lace and other workers in thread as having '. . . procured great Quantities of Thread and Silk to be brought into the Kingdom from foreign Parts, whereby his Majesty's Customs and Revenues have been much advanced,' and a 1697 broadsheet[18] setting out reasons for strengthening this by a further act (i.e. 9 William 3 c9) claimed that importation of foreign lace hindered '. . . the bringing into England great quantities of fine thread which otherwise would be imported and used in the said Manufacture here, and pay the King a great duty.'

The use of this imported thread by the Honiton lace industry is suggested by a letter[19] written by John Pinney to his daughter Rachel on 28 March 1679 in which he stated 'We have sent a pcell of 4 peices of lace to Mr Hill to Exchange for thred, wch if he refuse to doe, Its ordered him to delivr it to you what of it he liketh not.' Where Rachel was located is not entirely clear but evidence from the correspondence indicates that she was in London and if the thread to be received was likewise there it was most probably imported; certainly it would not have originated in East Devon.

The subject of the importation of thread was taken up again in a petition to the House of Commons[20] by the lace manufacturers of the East Midlands '. . . and other Parts of the Kingdom . . .' in 1779, where it was stated that a change of duties on foreign lace to protect the home industry would cause an increase in the importation of thread.

It has often been stated, following Mrs Palliser,[21] that English flax was unsuitable for making fine linen thread. This is not so for the suitability of flax for fine spinning is largely dependent on the processing, one important feature being the retting which releases the fibres [Plates 75, 76]. Vancouver,[22] writing in 1808, observed that at that time flax grown in the Otter valley was always dew retted which would, therefore, have resulted in thread not of the finest. However he also observed that flax grown at Harberton was water retted, so it is possible that Devon produced material capable of being spun into thread comparable with that which was imported, but there is no known evidence that this was done in the eighteenth century.

The source of the thread is obscure. Mrs Palliser[23] stated in connection with Honiton pillow made net that '. . . it was made of the finest thread procured from Antwerp, the market price of which, in 1790, was 70L. per lb; and an old lacemaker told the author her father had, during the war, paid a hundred guineas a pound to the smugglers for this highly prized and then almost unattainable commodity.', and in a footnote that 'Mrs Aberdein of Honiton, informs us her father often paid 95 guineas per lb for the thread at Antwerp'. Many writers have concluded from this, and similar statements, that the origin of the fine thread used in eighteenth century Honiton lace was the Austrian Netherlands, later Belgium. However, just as in the case of Point d'Angleterre (see Chapter 4), this interpretation is not conclusive. Savary[24] writing at the beginning of the century stated that thread on a scale of fineness from 14 to 300 was produced in French Flanders and was known as Espinay thread, whilst the finest thread, was produced in Flemish Flanders at Mechlin. He added that the latter was also measured on the Espinay number scale, but since it was much used in lace making at Mechlin it was frequently known by that name, and it might be supposed that this was what was imported from Antwerp by the Honiton lace manufacturers. However Mr Edward Bridgen, of Paternoster Row, London, an importer of lace and thread, giving evidence before a committee[25] of the House of Commons in 1780 stated that the thread '. . . is smuggled out of French Flanders into the Austrian Dominions, bleached in Flanders, and imported into Great Britain— that he mentioned this circumstance of the Thread, because it is in the Power of the Imperial Court to prohibit it, to the Ruin of the Manufactory here.' It is apparent, therefore, that thread from more than one source was to be found in 18th century Flemish Flanders leaving uncertainty as to what was actually exported from Antwerp. Since microscopic examination of the threads of Honiton and Flemish laces of the period has so far failed to reveal any detectable difference between them, it is unlikely that the place or places of origin of those used in the Honiton lace industry will be determinable.

Superficial differences in overall appearance of specimens of lace are dependant in the washing, storage and usage history of each piece and are not reliable guides to the possible origin of the threads used.

In the early nineteenth century Messrs. Houldsworth of Manchester became spinners of fine high quality cotton yarns,[26] and offered various thicknesses in the range from No.200 to No.300 in 1805 adding Nos. 320, 340 and 352 in 1812. The prices of the former range went from £3 3s 6d to £12 8s 6d per pound and of the latter from £15 2s 0d to £27 8s 0d. In view of the large scale availability and relatively low price of these threads (which in due course became considerably lower) they virtually entirely superceded the hand spun linen thread in the Honiton lace industry.

The thicknesses of threads used can only be determined approximately by optical measurement of thread diameters in pieces of lace. The linen threads of the seventeenth century have a diameter of about 0.2 mm which is comparable with that of machine spun cotton of No. 20 count. The threads of the eighteenth century are finer and tend to show greater variations in thickness along the length, with diameter variations from about 0.05 to 0.1 mm. These are comparable with cottons of No.400 and No.100 count respectively, and an average can be equated to No.300.

The machine spun cotton threads were made to specific sizes, but the identification of the count number by optical measurement can only be very approximate since, for example, the theoretical diameter of No.100 thread is 0.097 mm and of No.200 is 0.069 mm, a difference which cannot be distinguished optically owing to the imprecision of the outline of a soft textile yarn. The measurement of many 19th century pieces suggests that threads in the 100-250 range were commonly used. The Honiton lacemakers' yarns were, however, generally measured by a skip number, which was defined as the number of skeins in a ¼ oz. hank and this can be converted into the standard count system by multiplying by a factor of 17.75. Cole recorded a number of facts about the use of particular thicknesses of yarn in 1887 and these, together with a figure quoted later by Miss Ward,[27] are summarised in Table 9.8.

Table 9.8 Thread thickness and their uses

Skip No.	Count No.	Use	Authority
6	105	Coarser type of lace	Cole
8	140	"	"
10	175		

12	215	Samples bought by Cole	Cole
14	250	"	"
16	285	'Finest used in Branscombe'	"
18	320	"	"
20	355		
22	390	Used for a fine flounce made at Sidmouth	Cole
24	425		
26	460		
28	500	'Finest ever used'	Ward

References

1. House of Commons, 1843.
2. CTB, 1688, p.2068.
3. CJ, XII, p.633.
4. House of Commons, 1863.
5. Cole, 1888.
6. CTB, 1688, p.2068.
7. CTB, 1691, p.1041.
8. Milles, Sidbury.
9. Wyatt.
10. House of Commons, 1871.
11. Treadwin, 1873, p.66.
12. Moody, 1909, p.30.
13. Private communication from Miss Doris Pigeon, 6.9.1983, whose mother worked in this shop as a child.
14. PRO, LC13/1-4.
15. In Allhallows Museum.
16. Besley's Devonshire Chronicle and Exeter News, 18.2.1840(2c).
17. Westcote, p.61.
18. BL 816 m13 Item 17.
19. Nuttall.
20. CJ, XXXVII p.185.
21. Palliser, 1865, p.102.
22. Vancouver, p.206.
23. Palliser, 1865, p.381.
24. Savary, 1726, II c47.
25. CJ, XXXVII p.813.
26. Felkin, p.169.
27. Bright.

Chapter Ten

The Lacemakers—At Work

. . . promise to teach and Instruct or Cause to be taught and Instructed
their said Apprentice the Art or Mistery of Lacemaking after the best
manner they Can or are Able to doe under due and Moderate Correction;
Apprentice indenture for Martha Forde of Honiton
28 December 1691

By far the most numerous class of persons engaged in the Honiton lace
industry was that of the lacemakers, those, that is, who worked with pillow
and bobbins to produce the actual fabric. Very little information about these
people has survived from before the nineteenth century, but thereafter, in
spite of the almost complete absence of the business records of the dealers
and manufacturers, it is possible to obtain some idea of them and their lives
during the period of the long decline of the industry. It is possible to identify
the social and economic position of the lacemakers in the society of their
time, to formulate details of their training by means of home instruction, by
apprenticeship, in the special lace schools and Devon County Council classes,
to study their working conditions and the effects of these on health and to
obtain estimates of their earnings. The payment of earnings is a matter of
particular interest for, although an act specifically forbidding payment in kind
instead of money in the lace industry was passed in 1779, such payments
continued in the Honiton lace industry until well into the twentieth century.

Distribution of sexes

The detailed information which is available in the nineteenth century census
returns shows that the lacemakers at that period were virtually exclusively
female, and this has, no doubt, created the popular image of lacemaking as

women's work. Information from earlier periods shows, however, that this state of affairs did not always obtain and the earliest known person in the area to be described as a lacemaker was John Nott of Combe Raleigh, who was bound over at the Devon Quarter Sessions on 17 April 1638 in the sum of £20 to keep the peace towards Baptist Basely.[1]

The Honiton church registers record a number of people as lacemakers in the second half of the seventeenth century; between 1650 and 1656 Phillip More, William Cross and Thomas Clark, and between 1680 and 1692 Sarah Pulman, John Bishop, Thomas Pearce, Emblin Stockman, James Dark, Stephen Chard, William Crosse, Isaac Baston, Elizabeth Horman, Elizabeth Skarr, Mary Dark, Daniel Humphrey, John Bishop (not the one above) and John Baker. The Ottery St Mary church registers between 1680 and 1688 similarly record Anne Yalden, Margaret Veriard, Joane Eveleigh, Mary Reeves, Mary Lake, Richard Oake, Thomasin Churchill and Margaret Hill, whilst a Honiton apprentice indenture[2] of 1697 gives the occupation of Mary and Elizabeth Abbott as 'lacemakers'. This information gives a total of fourteen men and fourteen women and, though the representative nature of the sample cannot be assessed, it shows that both male and female lacemakers were to be found in the seventeenth century.

Towards the end of the century there are several references which deal with the lace industry generally. The lacemakers memorandum of 1698[3] stated that '. . . the Persons employed in it, are for the most part Women and Children, who have no other means of Subsistence', and Thomas Robinson of Buckinghamshire informed the House of Commons[4] in 1700 that the lace was made by men, women and children. In 1760, however, Mrs Powys[5] referred to the lacemakers in Honiton as 'our own country-women' and, since this was an observation made when visiting the town, there may have been, by then, a movement towards the nineteenth century situation. However some male lacemakers were still to be found in 1825, for Elizabeth Chalice of Lympstone informed the Children's Employment Commissioner in 1841 that seventeen years previously, and somewhat later, there were frequently three or four boys learning to make lace in each lace school, though Maria Lewis of Lympstone, aged sixteen, stated that she had never seen boys making lace. The reason for the decline in male lacemakers was evidently fore-shadowing that of the general decline in the twentieth century, for Susan Crutchell of Exmouth told the commissioner that she did not know of any boys then employed in lace making 'as they get more money at cockling and other trades.'

These changes are probably to be accounted for in terms of changes in possible earnings. Thomas Robinson's reference to men, women and children

includes the statement that a good worker could earn seven shillings a week and this is the same as the figure quoted by Cole and Postgate[6] for labourer's earnings at that date. Evidently, therefore, a man could potentially earn as much at lacemaking as labouring and many may have chosen the lighter work. In the nineteenth century, however, the earnings of labourers were, in general, in advance of those of lacemakers and so men would turn to the physically more demanding work for its higher pay, leaving lacemaking to become a source of income supplement in the hands of the women of the family.

Social and economic position in society

Before the detailed information provided by the 1841 census there is very little on which to assess the position of the lacemakers in the society of their times. The information in the 1698 memorandum shows that lacemaking was, to a considerable extent, a town occupation and that there is no correlation between the numbers of lacemakers and the numbers of paupers in the various places. It may be concluded that at that time, and possibly throughout the heyday of the industry, lacemaking was a skilled occupation followed by many of the manual workers in the places where the craft was established. It is probable that some degree of hierarchical order existed depending on the degree of skill of individuals but no definite evidence for this is known.

The 1841 census, the first in which occupations were recorded in the enumerators' books for the places in East Devon, gives a number of insights into the status of the lacemakers at that time.

1. Connection with other occupations.

Table 10.1 shows, for those places with more than 30 lacemakers, the numbers of those who were wives, daughters or grand-daughters of male heads of household analysed by the nature of his occupation. It is immediately apparent that some 50 per cent of these lacemakers were in the households of agricultural labourers; if the households of labourers are added the proportion rises to 54 per cent. The next most common occupation was shoemaker at 9 per cent, then mason and carpenter at 5 per cent each, followed by lesser numbers spread over thirty six other occupations. The association with labourers' households suggests that the lacemakers were drawn especially from the economically lowest stratum of society, apart from paupers, and that they worked to provide a family income supplement. A high incidence of labouring households is not surprising in the largely rural parishes of Bicton, Branscombe and Sidbury, but the reality of the correlation can be

Table 10.1 1841 census–Lacemakers; wives, daughters and grandaughters of male heads of household classified by his occupation –places with more than thirty lacemakers

Occupation	Beer	Bicton	Branscombe	East Budleigh	Honiton	Littleham	Otterton	Sidbury	Sidmouth	Total
Agricultural Labourer	1	28	54	16	10	2	23	50	6	190
Baker				3						3
Blacksmith							1	1	3	5
Bricklayer						1				1
Brickmaker		1								1
Carpenter			6		6		2	5	1	20
Chimney sweep					1				3	4
Clothes cleaner					2					2
Cooper					2					2
Cordwainer					1					1
Customs officer						1	1			2
Dairyman			2							2
Farmer							2			2
Farrier				1						1
Fish dealer	6									6
Fisherman					1				2	3
Gamekeeper							3			3
Gardener					1		1		2	4
Horsekeeper					2		1			3
Huckster					1					1
Independent					1					1
Joiner					1					1
Labourer			1	1	10	2				14
Lath maker					1					1
Maltster					1					1
Mariner		1								1
Mason			3	1	3	4	1	4	3	19
Painter						1				1
Pauper						2				2
Pilot	2					6				8
Plumber									1	1
Postboy					1	1				2
Potter					3					3
Sawyer					4					4
Schoolmaster						1				1
Servant					1			2		3
Shoemaker			2	2	7	5	6	10	2	34
Tailor			1	1	3		4	1		10
Thatcher			8				1			9
Tinman					1					1
Unknown			1							1
Wheelwright			2					1		3
Total	9	30	80	25	64	26	46	74	23	377

demonstrated by an analysis of figures from Honiton where, as will be seen in the table, a wide range of occupations obtained. Data for households with male heads can be classified by the two parameters of whether the head was a labourer or followed some other specified occupation, and of whether there was a relative in the household engaged in lacemaking. This information can be formed into a conventional statistical 2 x 2 table as follows:

| | Occupation of head of household | | |
	Labourer or Ag. labourer	Other specified occupation	Totals
Lacemaker in family	17	33	50
No lacemaker in family	80	446	526
Totals	97	479	576

These figures show that lacemakers were to be found in 17.5 percent of labourers' households, but in only 7 percent of households where the head followed some other specified occupation. The probability that such a difference would occur by chance is less than 1 in 200 so this fact supports the view that lacemaking was used to a marked extent at that time to supplement the incomes of the poorest families.

Further connections, and lack of them, emerge from a comparison between the most common occupations for males over 20 years old in 1841 in Devon as a whole, and the information in Table 10.1. Table 10.2 lists the nineteen occupations for which more than a thousand men are recorded with the numbers, and also with these expressed as a percentage of the whole. Also recorded is the incidence of each of these occupations in Table 10.1, likewise expressed as a percentage of the total in that table. It will be seen that there are a number of occupations which, although followed by a considerable number of men, are virtually or entirely absent from list of occupations of men in whose households lace was made. It is understandable that the mobility of men in the army and navy would preclude the learning of lacemaking in their families and the absence of significant ship yards in East Devon could explain the absence of men engaged in ship construction. There is no apparent reason for the total lack of butchers in Table 10.1.

Table 10.2 The commonest occupations for males over 20 in Devon compared with occupations of males with lacemakers in their households, 1841 census

Occupation	Number	Percentage	Percentage in Table 10.1
Agricultural labourer	31,584	23.9	50.4
Farmer	11,187	8.5	0.5
Servant	6,155	4.7	0.3
Cordwainer and shoemaker	5,458	4.1	9.3
Labourer	5,314	4.0	3.7
Carpenter and joiner	5,110	3.9	5.6
Indepedent	5,062	3.8	0.3
Mason	4,050	3.1	4.5
Tailor	2,843	2.2	2.7
Blacksmith	2,759	2.1	1.3
Army	2,356	1.8	—
Paupers etc.	2,276	1.7	0.3
Mariner/seaman	2,151	1.6	1.1
Gardener	1,306	1.0	1.1
Ship carpenter and joiner	1,298	1.0	—
Navy	1,231	0.9	—
Butcher	1,219	0.9	—
Painter, plumber, joiner	1,018	0.8	4.8
Baker	1,004	0.8	0.8
Total	131,975		

The second commonest occupation was farmer and the fact that virtually no lacemaking is recorded in farmers' households reflects the same observation as that made for 1698, namely that lacemaking was associated with centres of population and was only to a minor extent an industry of the countryside. The almost complete absence of lacemakers from the households of those of independent means is understandable and the only example is Susannah Churchill of Honiton whose daughters Aphrah, Amelia, Thirza and Harriet were all lacemakers. On the other hand there is no obvious explanation of the lack of lacemakers in the households of the commonly followed occupation of servant, the only example, again from Honiton being Henry Aning whose wife was a lacemaker. The lack of correlation between lacemaking and paupers observed for 1698 is likewise seen in Table 10.2.

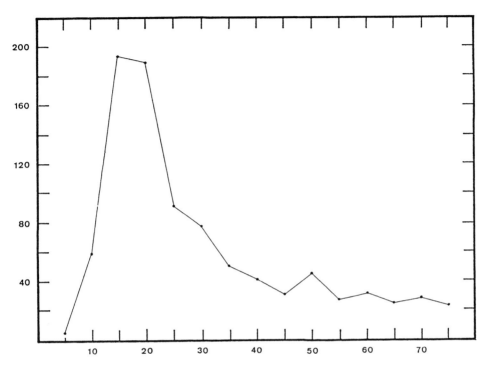

Figure 10.1 1841 census—Age distribution of female lacemakers; numbers in each five year age range

The general conclusion which emerges from these comparisons is that lacemaking was, to a substantial extent, carried on in the households of the lowest earners, though not in those of paupers. Moreover it was not an occupation associated with farmers and, though there is a strong connection with agricultural labourers, it must be appreciated that many of these lived in the towns and village centres rather than in the countryside.

2. Age distribution
For the 1841 census, people were only required to give their ages to the nearest five year round figure, but it is evident from the number of exact ages recorded that many did not take advantage of the rounding-off option. Nevertheless the ages can only be analysed by taking them in groups based on the five year periods and this is done for the female lacemakers in table

10.3, with a graphical representation in Figure 10.1. It is apparent that lacemaking was an occupation mainly for older girls and young women, there being 41 percent of the total in the 13 to 22 age bracket. The incidence of child labour is shown by the fact that 7 percent were aged 12 or less, and the possibilities of continuing to provide at least some income after what is now regarded as retirement age are shown by the fact that 9 percent were aged over 60.

Table 10.3 1841 census—age distribution of female lacemakers

Age group	Number
Below 8	6
8-12	60
13-17	194
18-22	190
23-27	92
28-32	79
33-37	51
38-42	41
43-47	32
48-52	46
53-57	27
58-62	32
63-67	26
68-72	29
73-77	24
Over 77	6

3. Family relationship

Consideration of the relationship of lacemakers to the head of the household, Table 10.4, shows that where the head was male the most common relationship was daughter or grand-daughter—nearly 59 percent. Taken in conjunction with the age distribution it is evident that this is a reflection of lacemaking carried out by unmarried daughters still at home. There was not, however, any tendency for such daughters to be kept at home to retain their earnings for the family income, since a comparison for Honiton between the average age of such girls and those from households where no lacemaking took place, shows that there was no significant difference between them.

Table 10.4 1841 census–Position of lacemakers in household

Place	Male head of household				Female head of household				Grand Total
	Wife	Daughter	Other	Total	Self	Daughter	Other	Total	
Axminster	0	1	0	1	0	0	2	2	3
Beer	3	6	18	27	29	11	13	53	80
Bicton	11	19	4	34	0	1	0	1	35
Branscombe	30	50	13	93	13	14	3	30	123
Clyst St George	0	0	2	2	0	0	0	0	2
Clyst St Mary	0	0	0	0	0	0	1	1	1
Colaton Raleigh	0	0	6	6	5	2	2	9	15
Colyton	0	0	1	1	1	0	0	1	2
East Budleigh	3	22	12	37	15	2	7	24	61
Gittisham	0	0	1	1	0	0	0	0	1
Harpford	0	4	0	4	0	1	0	1	5
Honiton	11	53	10	74	10	19	11	40	114
Kilmington	0	0	0	0	0	2	0	2	2
Littleham	4	22	22	48	26	5	18	49	97
Lympstone	0	0	9	9	10	0	4	14	23
Musbury	0	0	0	0	0	1	0	1	1
Newton Poppleford	0	0	3	3	2	2	1	5	8
Offwell	0	2	0	2	0	0	0	0	2
Ottery St Mary	0	3	9	12	1	1	3	5	17
Otterton	0	46	15	61	20	8	8	36	97
Payhembury	0	1	0	1	0	0	1	1	2
Salcombe Regis	0	11	2	13	2	1	0	3	16
Sidbury	17	57	20	94	18	15	14	47	141
Sidmouth	0	23	1	24	5	15	3	23	47
Southleigh	0	0	2	2	0	0	0	0	2
Sowton	0	1	0	1	0	0	0	0	1
Venn Ottery	0	5	1	6	0	2	0	2	8
Withycombe Raleigh	0	1	2	3	12	2	4	18	21
Totals	79	327	153	559	169	104	95	368	927
Percentage in groups	14.1	58.5	27.4	60.3	45.9	28.2	25.8	39.7	
Percentage overall	8.5	35.3	16.5		18.2	11.2	10.2		

Note: The term daughter includes grandaughter

165

In the case of households with a female head this figure falls to 28 percent and the most common thing is for the lacemaker to be the head herself. Another feature to be noted about the incidence of lacemakers in households with a female head is that it is not evenly distributed between the various places. Table 10.5 shows the percentage of lacemakers in households with female heads for the nine places where there were more than 30 lacemakers, arranged in descending order of percentage. Even omitting the very low figure for Bicton there is a considerable variation and it may be noted that the three places at the head of the list are all involved in seafaring. The fourth, East Budleigh, included Budleigh Salterton with some fishing activity, but the remainder are inland places with the exception of Branscombe, where, however, the economy was primarily agricultural. These facts suggest that the hazards of seagoing occupations, particularly inshore fishing, may have resulted in more women having to resort to lacemaking in these places due to widowhood, and this is consistent with the figures for the incidence of widows in the nine places which are available from the next census and are shown in the table. There is a high degree of correlation between the two sets of figures (correlation coefficient = 0.93) and so the suggested explanation is a plausible one.

Table 10.5 1841 census—places with more than 30 lacemakers

Place	Percentage of lacemakers in household with female head	Widows per 1000 population in 1851
Beer	61.5	39.8
Littleham	50.5	46.0
Sidmouth	48.9	43.6
East Budleigh	39.4	38.0
Otterton	37.1	34.9
Honiton	35.1	35.0
Sidbury	33.3	30.4
Branscombe	24.4	17.7
Bicton	2.9	9.8

4. Mobility of residence

The census returns subsequent to 1841 record the pace of birth and an analysis of this information for a selection of instances is shown in Table 10.6. It will be seen that over 80 percent of the lacemakers in Honiton and Otterton were natives of those places, and that most of the others came from elsewhere in the East Devon lacemaking area. However this fairly static pattern did not obtain for the lacemakers working in Exeter, where only 20 to 25 percent were natives of the city. The majority of the remainder came from East Devon, the largest source being Honiton, and it is probable that the Exeter lacemaking workforce was being sustained by immigrants into the city, probably as a result of husband or father moving there to get work.

Table 10.6 Places of birth of lacemakers as given in census returns

Place of birth	Honiton 1871		Otterton Exeter 1871		Exeter 1861		1881	
	No.	%	No.	%	No.	%	No.	%
In named place	133	86	251	83	16	20	16	25
In other East Devon places	16	10	42	14	58	71	40	63
Elsewhere in Devon	4	3	7	2	6	7	6	9
Outside Devon	2	1	2	1	2	2	2	3

5. Topographical distribution of lacemakers.

The locations given in the enumerators' books makes it possible to determine the topographical distribution of the lacemakers. No locations are recorded in 1841 for Otterton, but in the case of the other eight places listed in Table 10.5 it is possible to classify the locations as town or village centre, or as being in scattered places throughout the parish. The classifications are shown in Table 10.7 and it will be seen that 88 percent of the lacemakers were located in town and village centres, and in the extreme case of Honiton none at all were to be found in the rural areas of the parish. These figures show a similar pattern to those of 1698, which led to the conclusion that at that time the lace industry in general, and the Honiton industry in particular, was more of an urban than a rural one. It appears that this basis continued into the nineteenth century.

Table 10.7 1841 census—Location of lacemakers

Place	Location of lacemakers		Percentage in centre
	Centre	Scattered	
Branscombe	89	34	72
Sidmouth	36	11	77
Beer	67	13	84
Littleham	84	13	87
Sidbury	129	12	92
Bicton	33	12	94
East Budleigh	59	2	97
Honiton	114	0	100
Total	611	87	88

Learning the craft

1. Learning at home.

It is probable that many lacemakers learned their craft at home under the guidance of their mother or other relative, but though such an activity would rarely be likely to result in any documentary record, the few which do exist show that this method of instruction did occur. The Children's Employment Commissioner in 1841 recorded that Mary Ann Driver of Beer, aged 7, had begun two weeks previously and worked with her aunt, and that Lucy Ball of Lympstone, aged 11, had begun to make lace some years previously with her mother.

The later Children's Employment Commissioner in 1863 recorded that Harriet Perry of Sidbury went to learn lacemaking with her aunt when 10 years old, that Emma Channon of Sidmouth, aged 9, had learned lacemaking at home for a year, that Mary Ann Paver of Sidmouth began making lace at home when she was aged 9, as also did her sister when aged 6, and that Maria Besley of Seaton learned at home aged 6.

2. Training by apprenticeship

There are records of apprenticeship of poor children to the Honiton lace industry in the seventeenth century. An assize order[7] of 1638 notes that poor children were being sent 'out of divers places', where they had been bound as apprentices, into Honiton so that they could learn lacemaking. This operation was not a legal one and the court ordered that, unless the consent of the justices of the peace had been obtained, such children should be

returned to their parishes and the justices were '. . . desired to bynde the master refusinge to do the same to the next assizes that such order may be taken therein as shalbe fitt.'

A collection of 157 apprentice indentures for poor children of the town of Honiton[8] covering the period from 1661 to 1870 includes four cases of apprenticeship to lacemaking. These were

> 3 September 1689, Martha Richards to William Charde, tailor
> 28 August 1690, Ruth Hollett to Robert Darke
> 28 December 1691, Martha Forde to John and Christian Forde
> 24 July 1697, Hannah Bishop to Mary and Elizabeth Abbot, lacemakers

The trade they were to learn is described respectively as 'the Arte, Trade and Calling of Bone lace making', 'the Craft and trade of Lacemaking', 'the Art and Mistery of Lacemaking' and 'the arte and science of a lacemaler'. They were bound until they attained the age of 21, were to be supplied with meat, drink, apparel, lodging and washing, and on discharge were to be supplied with two suits of clothing, one for working days and one for Sundays. The policy of apprenticing poor children to the lace trade appears to have ceased at the end of the seventeenth century, and thereafter apprenticeship to skilled trades in general became rare, nearly all the children being apprenticed to husbandry or housewifery, though the details of the indentures indicate that these were names for general assistance of any kind, with the former not confined to work on the land. It seems unlikely that housewifery included training in lacemaking for the occupations of the masters are not ones likely to be associated with this activity. The commonest is estate work, followed by yeoman and innkeeper, with isolated instances of gentleman, gunsmith, chandler, coachmaker, grocer, cabinet maker and the Rector of Honiton.

The next known reference to apprenticeship in the Honiton lace industry is the 1841 census, when fifteen lacemakers' apprentices are listed in Honiton. This may represent some survival of the earlier apprenticeship system, but since the original statute for apprentices (5 Eliz I c4) had been repealed in 1814 (54 Geo. 3 c96) something of a less formal nature was probably implied. This view is supported by the Children's Employment Commissioner the same year, for he stated that during the first two and a half years as a learner a girl worked for her mistress 'in this way paying for her instruction, and this is an apprenticeship'. Some of the witnesses he interviewed apparently used the word 'apprenticeship' for he recorded that Agnes Harden of Sidmouth started the previous May as an apprentice, that Ann Channon of Honiton did not take apprentices for the work of sewing on and that Jemima

Viney of Honiton said that she had brought up a great many apprentices. The period of this form of apprenticeship varied from 1 to 2½ years. The Children's Employment Commissioner in 1863 gave a similar explanation but recorded rather different apprenticeship periods, a 3 year period in Honiton and Sidmouth, but a 1½ year period in Beer, Branscombe and Seaton. Whether these differences represent differences in the thoroughness of the training or some other aspect of it is not apparent.

3. The lace schools.

Though lace schools may well have existed through much of the period of the Honiton lace industry, the earliest definite reference appears to be the evidence of Elizabeth Chalice taken by the Children's Employment Commissioner in 1841, to the effect that she remembered lace schools in Lympstone 47 years previously, that is in 1794.

Lace schools are recorded in Littleham and Otterton[9] in 1818 when it was stated of the latter that 'the girls, being chiefly lace-makers, are taught to read in the lace schools'. As regards Littleham the vicar's report on the lace schools was more expansive and he stated that there were two schools for lacemaking and reading containing 66 children, and twenty four others containing together a further 327, but added that none of these children had more than four hours tuition in reading and many only one. He considered that the lacemaking was '. . . a great obstacle to the attendance of the female children at the National school.' and that '. . . the lace schools are more productive of evil than good, as they incapacitate the girls when grown up from attending to their domestic occupations.'

The evidence gathered by the Children's Employment Commissioner in 1841 shows that there were lace schools in all the lacemaking towns and villages in East Devon, and Mary Ann Rogers, stated to be the mistress of the principal lace school in Sidmouth, described the organisation of hers. For the beginners she was either paid by the week or received the value of their work. When out of their apprenticeship time they worked for an employer with the mistress giving some general oversight and teaching the girls to read in the evening, for which task she was paid by the parents. She taught both Honiton and trolly lace making, and pointed out that the former was called 'head work' and was more difficult to make than the latter. Descriptions given by other lace school mistresses are essentially similar.

The commissioner tested a number of the girls on their ability to read and write. He found that the younger girls, aged around 7, could read letters and short words, whilst the older ones, aged around 14, could read the Bible and,

in one case, an easy book. One girl of 14 could write her name and one of 15 could write and cypher, but otherwise none had mastered anything beyond reading. It is evident that the general education received at the lace schools was very limited.

The reports of the Committee of Council for Education[9] reinforce the vicar's observation of the conflict in Littleham in 1818 between lace making and general schooling. In connection with Withycombe Raleigh it was stated in 1847 that 'the children are very irregular in attendance, and leave school very early to work at lace making', though in 1849 there was 'a female daily to teach lacemaking to the girls.' In 1853 it was stated that lacemaking caused the girls at Woodbury to attend school very irregularly and in 1846 the lacemaking in Honiton prevented the formation of a girls school. Set in this context the rudimentary education provided by the lace schools was not entirely without merit.

In 1863 the Children's Employment Commissioner obtained further information on the lace schools and recorded, for the sixteen schools visited, pupil numbers ranging from two to nineteen, though Elizabeth Ping of Sidbury stated that she had formerly had 35 pupils. Most pupils started at the schools at 6 or 7 years of age and remained until about 14, though in some cases upper age limits of 18 were recorded. This entry age is confirmed by the commissioner on the employment of children in agriculture[10] in 1867 when he stated that the girls of the area were 'taken away from day school at 7 or 8 years of age to be sent to the lace school.'

The era of the lace school was, however, drawing to a close, for the Elementary Education Act of 1870 (33/34 Vict. c75) laid down a requirement for the provision of places in efficient schools for all of school age and empowered school boards to make bye-laws which would make school attendance compulsory for all children between the ages of five and thirteen. Such bye-laws provided for exemption if a 'child is under efficient instruction in some other manner' and it is very clear that the lace schools could not be accepted as providing such alternative efficient instruction. They would, therefore, have ceased to operate on the adoption of the bye-laws by the board in their area. The only surviving school board minute book from the area which records the adoption of such bye-laws is that of Ottery St. Mary[11] where the draft was published on 11 June 1877 and the Queen's approval reported by the clerk on 21 January 1878.

The move started by the act of 1870 was completed by the Elementary Education Act of 1880 (43/44 Vict. c23) which extended the bye-law provision to all areas. No lace schools for young children could survive this legislation, though some lace schools providing instruction for older girls existed until

well into the twentieth century, as may be seen in Figure 10.2 which shows Mrs Fowler's lace school in Honiton in 1916.

There was some survival of lace schools in the 1870s under the guise of small workshops, where children could be employed provided they obtained a certificate from the local school that the girls had attended there for at least 10 hours a week as provided for by the Workshops Act (30&31 Vic c146). Such an arrangement did not always work smoothly as the log book of East Budleigh girls school shows. On 24 May 1873 Miss Vanstone, the mistress, wrote that 'In consequence of a report having been made to HM Inspector of Schools the Rev. W.W. Howard that several children under the age of 12 did not attend school for 10 hours in a week, but were in constant attendance at Lace Schools, Mr Buller Sub-Inspector of Workshops visited several of the schools this day and cautioned the Mistresses and Parents that they wd be prosecuted if they continued to infringe the Act.' Mr Buller followed this up by a strong letter requiring compliance with the law. However on 3 October Miss Vanstone noted that none of the children from Mrs Lake's school had attended there full time, and on 31 October that Rosa Gooding and Rosa Hart had been absent since 10 October, being at Mary Jane Hayman's lace school. On 14 November she warned Mrs Hayman about employing these girls whole days and on 20 November received a visit from Mrs Hart who said 'she should do as she pleased with her children and I had better mind my own business'. Mrs Hart apparently became more reasonable when she had had the position explained to her. On 5 November the reason for Annie Pile's absence is recorded as 'she had a bad foot and could not walk further than the lace school' but Miss Vanstone refrained from expressing any scepticism as to the authenticity of this excuse.

In 1874 Miss Vanstone again had to ask for Mr Buller's assistance. Thereafter things seem to have been somewhat better and there are numerous records of the issue of attendance certificates to the lace school girls. Miss Vanstone probably breathed a sigh of relief on 4 February 1876 when Rosa Gooding and Rosa Hart left school to make lace at home, though her troubles were not yet over for on 9 July 1877 she noted that 'Adelia Parsons who had not attended school since March was found to be working at Susan Hitt's Lace School'. On 15 January 1880 she wrote that 'The Lace School Attendance Book being ended the Girls asked for a Certificate which I have given them.'

In 1887 when Alan Cole investigated the state of the Honiton Lace industry[12] he found that some people regarded the demise of the lace schools and the advent of universal elementary education with regret. In Beer one dealer expressed the view that 'book-learning' had killed the trade and another that 'the Schools did not "learn" the children anything they could get a

livelihood out of afterwards.' Even Mrs Treadwin was critical of the 'purely literary training in Elementary Schools.' In his conclusions Cole stated that the Education Act had effectively closed the lace schools but had failed to provide any substitute for the training they had provided, and he suggested that some provision should be made for instruction in lacemaking to be included in the curriculum of the Elementary Schools in the lace making area.

4. Devon County Council classes.

In 1902 a special sub-committee[13] reported to the Devon County Council on the condition of the Honiton lace industry. The committee noted that for some years past the Honiton District Committee for Technical Education had aided classes in Honiton, Ottery St. Mary and Sidbury, and that the Axminster District Committee had done the same in Beer. It recommended that a staff teacher should be appointed for the whole of East Devon to organise the teaching of lacemaking and in 1904 Alan Cole[14] was able to state that classes were at work in Honiton, Colyton, Beer, Bicton, Woodbury, Sidbury and Branscombe. Nevertheless there was a weakness in the system for Penderell Moody[15] pointed out that no provision was made for practice, so she started an hour's practice session for the children after school and this was well supported. This endeavour was, however, too late to save the industry, though it did make an important contribution to the maintenance of the craft and its survival into the post-industry era.

Working conditions

The popular idea of the Honiton lacemaker has tended to be tinged with the picturesque, as in this example from 1887[16]

> Travellers in Devonshire may, in traversing the picturesque glens and verdant coombes, often come unexpectedly upon a quaint and withal charming living picture. The young lace worker, endowed with all her traditional charm of 'fair Devon's fairest daughters' sitting in her rustic porch embowered with roses, jasmine, or honeysuckle, as the case may be, swiftly plying her lace sticks . . .

This sentimental attitude was echoed in picture postcards and guide books [Plates 78, 80], though the earliest known depiction of a Honiton lacemaker [Plate 79] in *Leisure Hour* for 6 August 1869 suggests neither a cottager nor a member of the lowest economic stratum of society.

The reality of the lacemaker's working conditions seems to have been well

removed from these idyllic depictions. Descriptions of working conditions in the East Midlands area in the eighteenth century[17] include the statements that 'the rooms where these people generally work are small, low and close, in which many sit together . . .' and 'the air in these rooms becomes loaded with perspirable matter, and other effluvia, arising from their bodies.' That similar conditions obtained in the Honiton lace area is apparent in the evidence collected by the Children's Employment Commissioner in 1863. He was much concerned with working conditions and in a number of instances he recorded the dimensions of workrooms, together with the number of persons working in them, and these data are summarised in Table 10.8. It is clear that there was acute overcrowding, for the modern requirement under the Factories Act (9/10 Eliz 2 c34) for workrooms is a minimum of 400 cubic feet per person, though the people involved were possibly not as concerned as we should be since there was much overcrowding in cottage living conditions at that period.[18] With such conditions it is not surprising to find the following descriptions of some of the workrooms—'close outside the door is a sink smelling strongly, and the air on entering is very close', '. . . the girls had left for dinner, but the room was offensively close . . .' and 'the smell from the crowded state of the room was almost unbearable, even without the full number present.' It must be remembered, however, that the offensiveness of the odours would have been far more obvious to the commissioner than to the workers who, apart from any general inurement to such an atmosphere through their living conditions, would soon have been oblivious to it through olfactory fatigue.

Table 10.8 Dimensions and occupancy of workrooms 1863

Place	Dimensions of room (feet)			Number of persons	Cubic feet per person
	length	breadth	height		
N. Poppleford	8.9	6.8	6.8	17	24
Seaton	7	7	6.5	12	27
Sidbury	9.5	9.5	7	19	33
Beer	10	10	6.5	10	65
N. Poppleford	—	—	6.5	—	70
Beer	10	8	7.5	8	75

Apart from the biological odours the air in the room would, at times, have been contaminated with carbon monoxide, for in cold weather lacemakers

would fill a sort of chafing dish with embers from the fire, or even glowing charcoal, and place this beneath their dresses, and this tended '. . . to vitiate the atmosphere of their small ill-ventilated cottages'.[19] The 1863 commissioner stated of a room at Sidbury that 'It was said by the sister of the mistress to be "very headachy" ' though the mistress 'would not allow this'. Such an observation is consistent with the effects of carbon monoxide which produces headaches and to which people have varying degrees of susceptibility.

By modern standards the illumination available for work after dark was inadequate—normally a candle. However, spherical glass globes were available and when these were filled with water they could be used as lenses to concentrate the light onto the work [Plate 77]. By this technique it was possible to obtain a light intensity of 50 lux on the working area, a level of illumination used in modern museums for galleries where delicate materials are displayed. By this means not only could the lacemaker obtain better light for herself but her candle could be shared by as many others as could arrange their globes and themselves around it. When paraffin lamps came in these were adopted, though not without some misgiving, for Miss Martha Musgrave of Sidbury[20] recollected the lord of the manor passing by and saying 'you will ruin your eyesight with that strong light.' What illumination was used at the manor house is not known but it is evident that the baronet was not appreciative of the accommodating powers of the human eye.

Health

The earliest observation associating Honiton lacemakers and health appears to be that of Thomas Fuller[21] in 1662 who, referring to children, observed that '. . . many lame in their limbs, and impotent in their arms, if able in their fingers, gain a livelihood thereby.' That people barred by infirmity from more physically exacting occupations were able to earn a living by lacemaking must have been true throughout the history of the industry. Mary Ann Rogers stated that in 1841 there were weakly and crippled boys making lace at Exmouth and even as late as the twentieth century a crippled Honiton man became a lacemaker [Plate 82] and earned his living thereby until becoming a watchmaker.

It is well-known that conditions in various industries caused deleterious effects on the health of the workers[22] and there is a long history of the enactment of legislation designed to alleviate adverse effects on the health of those engaged in industrial processes. Lacemakers were not at risk from handling dangerous chemicals or hazardous machinery, but there is evidence

that their working conditions were not without undesirable effects on their physique and health. Eighteenth century observations on the East Midlands lacemakers describe '. . . the frequent sight of deformed and diseased women . . .' and ascribe this situation to the constricted posture involved in lacemaking. Qualified medical observation in 1861 confirmed these views,[24] stating that 'many of the women have a pallid anaemic aspect, and are subject to disturbance of the menstrual functions, and to leucorrhaea . . . slight spinal curvature is common, and the chest is almost always flat and ill-developed.' 'The women are said to neglect their children, to feed them on an improper diet, and drug them with Godfrey's cordial.' Godfrey's cordial was a mixture of treacle, water, sassafras oil, alcohol and tincture of opium containing 1 percent of morphine, and its potential dangers when used, without medical control, to quieten children and so free the mother for her lace making can readily he appreciated.

Similar observations were made about the Devon lacemakers[23] in 1832, when Cooke drew attention to the ill effects of the confining of young children to a sedentary occupation in unwholesome conditions

> The sedentary nature of this employment, and the early age of the poor children confined to it, make a terrible havoc of life and health. The sallow complexions, the rickety frames, and the general appearance of languor and debility, are sad and decisive proofs of the pernicious nature of the employment. The small unwholesome rooms in which numbers of these females, especially during their apprenticeship, are crowded together, are great aggravations of this evil. It is no wonder that the offspring of such mothers in a majority of such instances, are a puny, feeble and frequently short lived race.

Less flamboyant statements about the ill effects of lacemaking are to be found in the evidence collected by the Children's Employment Commissioner in 1841. Sarah Hart (Otterton) said of her daughter Betty that she 'do think that this sitting so long have injured her health' and that her eldest daughter gave up lacemaking on this account; Betty herself said that she sometimes had a pain in her side; Mary Driver (Beer) said of children that 'sitting so long as some do hurts their constitution'; Maria Lewis (Lympstone) said that she thought that sitting so many hours a day quite still harmed the children; Anne Stark (Lympstone) stated that she thought that her health had suffered from the confinement 'which is usually nine hours a day', and Susan Crutchell (Exmouth) considered that long hours had done her some hurt.

Spenchley's study[24] on the health of children in the industry in the

nineteenth century, which deals predominently with conditions in the East Midlands area, confirms these expressions of opinion as to the deleterious effect of the industry on health.

However not all observers agreed with these opinions and the commissioner himself in 1841 observed of Beer that 'The young women are singularly pretty, and (in spite of lace-making) are generally healthy-looking . . .'. Among his witnesses Mary Ann Rogers (Sidmouth) stated that she did not know of any particular injury suffered from lace making; Sarah Tovey (Newton Poppleford) considered that 'the freedom from the accidents which are common in many other occupations, is a great advantage'; Eleanor Rice (Newton Poppleford) stated that she did not know of any particular injury that the lacemakers suffered in their health or condition; Mary Bansey (Lympstone) did not consider the occupation injurious to children, nor did Maria Hutchins (Woodbury Salterton), and Jemima Viney (Honiton) said that 'she knows nothing against the occupation, as particularly injurious to the health or general condition of the children and young persons who follow it.'

In 1883 Mrs Treadwin[25] stated that ' . . . though the lace worker may in after life be lest robust in appearance than the farm servant or the Cheshire milkmaid, her life is more healthy by far than that of the female operative in our northern manufacturing districts.' A totally sanguine view was taken by an unidentified medical correspondent quoted by Baring Gould[26] in 1900 who wrote 'I have never had cases of decline come under my notice, and if there were any I must have known it . . . I think it [i.e. lacemaking] may fairly be assumed to be at any rate not injurious to health, and judging from the age to which they continue to work, not to the sight either.' Baring Gould adds 'Thus the buyers of lace can do it with a safe conscience.'

There are thus two sets of views, one of which ascribed a range of ills to lacemaking and one which suggested that there were few bad effects on health. A possible explanation for this is that, since the milder views were also later ones, they represent a state of affairs after some improvement in conditions had taken place, though this does not seem altogether likely in view of the information in the 1863 commissioner's report on working conditions. It is to be noted that those who described the many ills do not offer any evidence that what they observed, and perhaps to some extent imagined, was due to lacemaking by comparing the health and physique of the lacemakers with those of workers in other occupations. The suspicion that perhaps at least some of the conditions observed were equally found in non-lacemakers emerges from the medical report of 1861 where it was recorded that 'Ophthalmia is not infrequent, but on inquiry, it did not appear to be more

prevalent among the females, who work during several hours in the long winter evenings by artificial light, than among the rest of the community.' It seems probable that the long hours, constricted position and crowded rooms would have had some adverse effect on the health of the lacemakers, but that the true story was neither as bad as that depicted by Cooke in 1832, nor so comforting as Baring Gould's assurance to the ladies who bought lace.

Hours worked

There does not appear to be any evidence that at any time there were standard hours in the Honiton lace industry. The information gathered by the Children's Employment Commissioner in 1841 indicates a working day of 4 to 6 hours by small children, 8 hours by girls and 10 to 12 hours by older girls. Ten hour working days are quoted by Cooke in 1832, by Mrs Treadwin in 1853 and by the Children's Employment Commissioner in 1863.

The lack of generally recognised regular hours, and also the lack of any evidence of unionisation, can be associated with the essentially piece work nature of Honiton lacemaking, coupled with the facility with which the work could be carried on at home as and when convenient. Mrs Treadwin[27] stated that '. . . as a body they dislike regular work. I do not mean to say that they are not industrious, but they have a great dislike to working anywhere where regular attendance at certain hours is required, preferring to work at home home by piece, so that they can begin or leave work as they please.' The Reverend James Frazer made a similar point when he wrote[28] that 'It is extraordinary that these wretched handicrafts should be so popular. Young girls prefer them infinitely to domestic service, chiefly from the love of indepedence, though the remuneration is strikingly inferior.' The lacemakers were thus tending to preserve a pre-industrial attitude.[29] Mrs Treadwin's comment on the industry of the lacemakers was fully justified, for when urgent orders were to be fulfilled very long hours indeed were worked with no indication that any extra payment was involved. Mrs Godolphin of Honiton told the commissioner in 1863 that workers would occasionally sit up all night and that she had herself had work going on until 3 am, and Mrs Channon of Sidmouth said she had first worked all night when she was aged 12 or 13, that then she never sat up for more than a night at a time, but since her marriage she had sat up two nights running. Mrs Stevens of Honiton said that she periodically started work at 4 am and that the previous night she had worked until midnight '. . . till she was freezed with the cold'.

In the 1890s Miss Helen Elizabeth Morris worked as a lace sewer with her great aunt, Mrs Pearson of Sidbury, and in times of pressure would work until 3 am, when she was given a small nip of whisky and sent to bed.[30] Mrs Pearson, however, would continue working.

Earnings

Apparently the only direct statement of lacemakers' earnings before the nineteenth century is that made by Thomas Robinson to a Parliamentary committee that reported to the House of Commons in 1700. Referring to Buckinghamshire he stated that '. . . Men, Women, and Children, one with another, earn about Three Shillings a Week' and that 'a good Workwoman will earn Seven Shillings a Weel'. Other witnesses made statements of overall payments and numbers of lacemakers employed and, though these are evidently for the most part round figure estimates, earnings calculated from them are broadly in conformity with Thomas Robinson's statement.

Both Gilboy[31] and Cole and Postgate[6] have estimated labourers wages around 1700 at 7s per week and this suggests that Robinson's good workwoman could earn a full labourers wage. His figure of 3s can probably be taken as a median wage and is comparable with that suggested by Clarke[32] for the earnings of spinsters in the late seventeenth century. It is apparent that in the East Midlands, earnings ranging from the low level current for spinsters to the full labourers wage were obtainable, and the latter would have been regarded as high earnings for women. It is possible that the earnings in the Honiton lace industry were above this level for its products were valued at some three times those of the East Midlands (Chapter 4), and if this was reflected by even a small amount in earnings they could have been brought up to, or even above, the 8s per week found by Gilboy as the median craftsman's wage for Devon outside Exeter at that time.

Statements of earnings in the nineteenth and twentieth centuries are more frequent, though they relate to the period of decline of the industry and not that of its prosperity. A summary of them is shown in Table 10.8 which, in view of the correlation between lacemakers and labourers at this time, also gives estimates of the latter's earnings.

Table 10.8 Lacemakers' weekly earnings

Year		Earnings	Reference	Labourers' wage[43]
1841		10s	33	7s
1844		3s	9	7s
1853		7s	27	8s 6d
1863		4s 6d	34	9s 2d
1871		2s 6d to 6s	35	10s 3d
1887	(1)	3s in bad times	12	
	(2)	4s 6d to 5s		13s 6d
	(3)	5s to 6s		,,
	(4)	12s to 15s, the best workers		,,
1891		4s	36	13s 6d
1902		5s to 12s	37	
1905		6s to 12s 6d	38	
1906		6s to 8s	39	17s 6d
1909		12s	40	
1919		5s	41	46s
1940s		10s	42	

Note: Earnings calculated as a 6 day 48 hour week where rates other than weekly were quoted

Some of these figures, notably those quoted by Mrs Treadwin to Alan Cole in 1887, show that, as in the earlier period, the best workers could equal or even surpass the labourer's wage. The remainder, however, averaged less than half this level, also as in the earlier period. The figures support the conclusion reached from the 1841 census data that the lacemakers were to be found at the lowest end of the economic spectrum, and that their earnings would act as a family income supplement rather than an individual's living wage. It is possible that the supplement was not always as effective as might be expected, for the vicar of Colyton told the Children's Employment Commissioner in 1863 that lacemaking '. . . diminishes the wages of the men, the farmers giving less in proportion as the wives and daughters earn something on which the family may be supported'. Apart from this the lacemakers themselves also suffered a diminution in their earnings owing to the widespread occurrence of payment by the truck system.

Payment by truck

In 1700 Edward Purcell, laceman of Buckinghamshire, stated to a parliamentary committee[4] that '. . . 3000L a week is paid in ready Money, to the Bone-lace-makers in that County:', an observation which suggests that the workers were paid in cash. However in 1779 legislation was enacted (19 Geo 3 c49) forbidding the payment of lacemakers in goods, though no evidence is known which suggests that the practice was prevalent nor that subsequent proceedings were taken against anybody, and this provision was incorporation in the general truck act of 1831 (1 and 2 Will 4 c37). Nevertheless payment of lacemakers in goods was prevalent in the Honiton lace industry in the nineteenth century and continued in a somewhat modified form well into the twentieth.

Cooke[23] writing in 1832, stated that the lacemakers' '. . . employers, who keep hucksters shops, obliged them to purchase whatever they dealt in, and frequently articles they did not want; and if money was insisted upon, a penny has been unfeelingly and unjustly deducted out of a shilling.' The Children's Employment Commissioner in 1841 recorded many complaints about this form of payment; some witnesses stated that payment was half in money and half in goods, but most that payment was all in goods and that even then full value was not given, a figure of 9d. worth of goods for a shilling's worth of lace being quoted both in Beer and Woodbury Salterton. In 1852 a young lacemaker stated[44] that 'I gets eighteenpence a week at my lace-pill, that is, I get sugar and butter; for if they pay me in money they expect seven pennyworth of lace for sixpence, or fourteen pennyworth for a shilling'.

The Children's Employment Commissioner in 1863, like his predecessor in 1841, recorded many statements on the system of payment in goods, including ones by the lace manufacturers themselves admitting that this was their practice. The injustices produced by the system were described by Mrs Harriet Wheeler of Sidbury.

> Nearly all the lace manufacturers in the neighbourhood keep general shops, and make the lacemakers take goods for money . . . and then not what the lacemakers wish, but what they, the manufacturers, like to allow and think needed for actual use. Thus two loaves of bread and ½lb. of butter form part of a common weekly allowance for girls. The object of this is to prevent the people from selling the goods again and so getting any ready money, which would enable them to be independent, and buy anything which they might wish for at other shops where they could get it better. Sometimes a manufacturer actually refuses something that is asked for, on the ground that it cannot be wanted for use but for sale.

. . . On the same ground manufacturers are very jealous of their girls working over hours for anyone else and will ask a girl what she had a light so late at night for. Sometimes a few girls, say four, will club together to make a collar or something, and get a few shillings in money by selling it privately, but if they are found out in this they are turned out of employment by the shop. The lacemakers feel this very much, and I have seen them even crying because they are not allowed to get money. Besides this, it is expected, that the other members of the family shall buy their goods at the shop to which the girls lace is taken. An instance of this occurred just lately, when complaint was made of a child, who had been sent on an errand, being seen to enter another shop.

It is apparent, however, that Honiton was an exception to the general rule, for Mrs Godolphin stated that 'In Honiton the work is brought in when it is done, very often on Fridays, and then paid for in ready money, and the people are thus able to buy their food and goods in the market on Saturday.' She added that '. . . in most of the villages money is not paid, but the lace-shops truck and charge very high, i.e. above the ordinary prices for their goods,' and that if the lacemakers press for money '. . . something is taken off, as 2d. in 1s.' The rector, Rev. J.A. Mackarness added that 'The bad workers who cannot get their work taken in the town have to take it for sale into the villages, where the truck system is very general, and which they must therefore submit to.'

Essentially similar observations were recorded by the truck system commission[35] in 1871 and by Alan Cole[12] in 1887.

In the twentieth century a somewhat modified truck system was in operation in which lace motifs were regarded as being a form of currency. In 1956 Mrs Allen of Beer stated[45] that 'a piece of lace fifty years ago was regarded as currency. A fisherman's wife would put the children to bed and make a sprig. She would take it to the grocer and get half a pound of butter, a pound of sugar, and a halfpenny change—all the result of her evening's work'. Miss Pidgeon[30] stated that her mother, working in the general store at Sidbury at the turn of the century, would weigh out dry goods in very small quantities because the lacemakers were poor and could not afford larger quantities. At times poor workers would sit up late to make motifs to bring to the shop in order to obtain what they needed for breakfast. In the 1920s Mr Harris, who kept a baker's shop in Honiton, would accept lace sprigs in exchange for bread when his round included poor lacemakers. The sprigs were never turned into money but were used to construct a wedding veil which remains in the family.[46]

The existence of the truck system is a striking and notorious feature of the Honiton lace industry, and its persistence, in spite of being well documented in no less than four government reports over a period of nearly half a century, is difficult to account for. It cannot be explained in terms of the Webb hypothesis that the truck system flourished where there was an agreed minimum wage rate as a device for defeating this, for there is no evidence that any wage agreement or union to negotiate one ever existed in the industry. The truck system inspector in 1871 specifically stated that he did not think there was any possibility of the lacemakers forming a combination (question 44010) and echoed Mrs Treadwin's opinion of some twenty years previously that they seemed to be very independent (question 44028).

It is possible that it grew out of a tendency, which still exists to some extent in East Devon villages, to carry on barter transactions, whereby goods and services are exchanged without bothering with the intermediate steps of conversion into and out of money. Such a system was convenient in villages from which market towns were only reached with difficulty, and it may be significant that the Children's Employment Commissioner in 1863 recorded that both Mrs Godolphin and the rector of Honiton regarded the truck system as being associated with villages. Moreover the commissioner in 1841 recorded that Susan Skinner and her sister, of Woodbury, had stated that they considered it 'very convenient to get what they want at the shop and to give work afterwards for the bill' and did not 'know what they should do without it', whilst the inspector in 1871 deposed that he had found lacemakers who almost liked the system and found it a convenience, and that he had found this to be especially so in Branscombe which he described s 'an out-of-the-way place' (question 44010).

Some degree of acceptance of truck payments of lacemakers may have arisen from familiarity with the cider truck system. Agricultural labourers were not included among the occupations specified in the general truck legislation of 1831 (1 and 2 Will 4 c37) and it was common practice in the cider making areas, of which East Devon was one, to pay part of an agricultural labourer's wages in cider,[47] normally of low quality, made by the farmer. Estimates indicate that the nominal value of the cider was the equivalent of between 20 and 50 percent of the wage, though there is good reason to question whether the true value of the 5 to 10 gallons of cider per week really amounted to the cash equivalent withheld. The system continued until the Truck Act of 1887 which allowed only non-alcoholic drink to be given. This form of truck would have been a familiar aspect of life in the Honiton lacemaking district and would have been especially so to the

lacemakers, owing to the marked tendency for lacemaking to be an occupation in the households of agricultural labourers.

Though the truck system in the lacemaking industry could have proved a convenience for villagers, the very isolation which gave rise to it would also produce conditions which could be, and obviously were, exploited by the unscrupulous. In days when villages were more isolated than now such people could maintain a hold over the local lacemakers and so perpetuate the system, whilst the local people would be very reluctant to invoke the law and so probably lose their means of livelihood. What is difficult to understand, and remains unexplained, is why, in the face of so much officially published evidence of widespread law breaking, no concerted official effort was made to remove this abuse. Perhaps the inertia was due to a realisation of the virtual impossibility of finding witnesses who would have been willing to testify publically in a court of law.

References

1. DRO, Devon Quarter Session records, 17.4.1638, 2129M/Q24.
2. Allhallows Museum.
3. Some Considerations.
4. CJ, XXI p.269-271.
5. Powys, 1899, p.77.
6. Cole and Postgate, p.76.
7. Cockburn, p.635.
8. Allhallows Museum.
9. Council for Education.
10. House of Commons, 1867.
11. DRO.
12. Cole, 1888.
13. DCC Minute Book.
14. Cole, 1904.
15. Moody, 1907, p.60.
16. DEI, Stones Scrapbooks, unidentified local newspaper 5.11.1887.
17. Gentleman's Magazine, 1785 p.938, 1791 p.692.
18. Burnett, Ch2.
19. Committee of Council on Public Health, 1861.
20. Private communication from Miss Musgrave's great neice, 18.9.1984.
21. Fuller, I p.194.
22. eg. Rule Ch3.
23. Cooke, p.105.
24. Spenceley, 1976.
25. Treadwin, 1883.

26. Gould, 1900, p.58.
27. Wyatt.
28. House of Commons, 1861.
29. Thompson, 1963.
30. Private communication from Miss Morris's daughter, Miss Doris Pigeon, 6.9.1983.
31. Gilboy, p.265.
32. Clarke, 1919.
33. House of Commons, 1843.
34. House of Commons, 1863.
35. House of Commons, 1871.
36. Farquharson, 1891, p.232.
37. Kelly, Devonshire, 1902, Honiton.
38. Letters to the Times, Trevelyan 13.9.1905, Roach 25.9.1905.
39. Letter from unknown woman Ada, 14.11.1906, Allhallows Museum.
40. Moody, 1909, p.7.
41. Wright, p.241.
42. Private communication from Mrs Newton, 29.8.1984, concerning 'Grannie' Wright of Withycombe Raleigh.
43. Bowley, 1900, 1921.
44. Anon, 1852.
45. Express and Echo, 12.10.1956.
46. Private communication from Mrs G M Hamblin, great neice of Mr Harris, 2.7.1984.
47. Heath, p.122. J. Board of Agriculture, 1909-10, p.42. Spender.

Chapter Eleven

The Lacemakers—At Play

... lacemakers headed by a magnificant banner with the Royal Coat of Arms and 'God Save the Queen' elegantly worked in Honiton lace.

The Western Times 24.6.1887(7d)

Although, as we have seen, the lacemakers' lives were often hard there were, nevertheless, lighter moments. They clearly enjoyed processions and there are records of them taking part in such events both in connection with national and with local celebrations. Singing whilst working does not appear to have been a practice as it was in the East Midlands lace making area. However, scope was given to artistic talent in the decoration of bobbins and, though the Honiton lace sticks did not lend themselves to the elaborate forms developed elsewhere, some striking results were achieved.

National celebrations

The lacemakers made their distinctive contributions to the celebrations held on the occasion of various national events. Nearly all the surviving records relate to what happened in Honiton and cover the period from the coronation of Queen Anne in 1702 to the golden jubilee of Queen Victoria in 1887.

On 23 April 1702, the day of Queen Anne's coronation, Dr James Yonge visited Honiton and was in time to witness the celebrations.[1]

> April 23, coronation day, I left Exeter at 4 afternoon to avoid the hard drinking that occasion put that whole city on. I got to Honiton at 8 and there saw a very pretty procession of three hundred women and girls in good order two and two, march with three women drummers beating, and a guard of 25 young men on horseback. Each of the females had a

long white rod in her hand on the top of which was a tassel made of white and blue ribbon (which they said was the Queen's colours) and bone lace, the great manufacture of the town. Thus they marched in and about the town from ten in the morning, hurraing every now and then, and then weaving their rods. Thus they returned at 9, and then broke up very weary and hungry. My sister-in-law and her two daughters supped with me, and till morning the town was not quiet.

Yonge does not specifically state that the ladies concerned were lacemakers, but in view of his statements that there were three hundred women and girls and that their rods were dressed with lace it is reasonable to assume that the party was composed of lacemakers.

The physically exhausting nature of the proceedings was probably repeated in the next coronation celebrations recorded, for *Woolmer's Exeter and Plymouth Gazette* for 21 July 1821 (4d) stated that 'As early as four o'clock in the morning, a detachment of Sir John Kennaway's Yeomanry Cavalry, under the command of Capt Mules, fired a royal salute of 21 volleys from the Chapel Tower of Honiton.' Since they would have been armed with muzzle loading muskets the whole operation would have taken some time and would doubtless have roused most of the inhabitants of the town centre at this untimely hour. Although a procession is referred to in the reports of the occasion no specific reference to lacemakers is given, though no doubt they were involved, as they certainly were at the time of the next coronation, for the same newspaper for 10 September 1831 (3b) stated that

All the houses in the town were most tastefully decorated with laurels, flowers, &c. and a few were illuminated particularly Miss Lathy's, who had a very tasteful display of variegated lamps in her shop windows forming W.R. and the crown, with the shop full lighted, and the lace flag suspended on two poles across, and the whole passed off with the utmost hilarity and good feeling and is allowed by all who witnessed it to be one of the most splended sights ever seen.

This is the first mention of a lace flag and its qualification by the defintie article suggests that it was a familiar or noted object but, perhaps because of this, no description of it is given.

The festivities to celebrate Queen Victoria's coronation were organised by a committee[2] which considered not only the arrangements but also money raising and the distribution of food to the poor. At a meeting held at the Dolphin on 20 June 1838 the order of procession was agreed and the first people were to be a band of music, the school children, the ladies, lacemakers

with garlands, female club with garlands and another band. These were to be followed by the clergy and civic officers, the friendly societies and the various tradesmen and all were to assemble opposite the market house at nine o'clock. The last named were to carry banners but there is no indication whether the lacemakers did likewise. A report of the occasion in *Woolmer's Exeter and Plymouth Gazette* for 30 June (3c) makes it clear that this proposed order of procession was that used on the day.

Less than two years later the committee was reconvened[2] to consider celebrations for the occasion of the Queen's wedding, but the recorded proceedings are fewer than on the occasion of the coronation and there does not appear to have been the same degree of support. Perhaps it was too soon to recapture the spirit of such an event. Nevertheless beef, bread, tea and beer were distributed to the poor and the 'respectable inhabitants' partook of a sumptuous dinner The account of the occasion in *Woolmer's Exeter and Plymouth Gazette* for 15 February 1840 (3b) states that 'The appearance of the town was very animated;—there being a great display of flags, banners, and evergreens, and in the evenng her Majesty's Honiton Lace Manufacturer "BY APPOINTMENT", Mrs Clarke, illuminated a splendid transparency of Industry (represented by a figure) receiving from the Queen encouragement and support . . .' Though it is not actually stated that the figure was made from lace the probability is that it was, for Mrs Clarke is known to have made Honiton lace royal arms which incorporate depictions of living creatures, and Pam Inder records[3] meeting a schoolgirl who claimed that her great-grandmother, Mrs Bess, made the figure of a coal man in lace for Queen Victoria's wedding.

The same issue of the newspaper carried an account of celebrations in Beer, which included a procession and music. '. . . in the afternoon about 150 of the lacemakers, who had the honour of working on her Majesty's Bridal Dress, drank tea at the New Inn, her Majesty being so well pleased with the dress, that Miss Bidney, who superintended its execution, sent down Ten Pounds for the purpose.' A loyal address was composed which congratulated the Queen on her marriage and thanked her '. . . for the patronage and support she has conferred on the inhabitants.'

The Peace of Paris, which concluded the Crimean War in 1856, was celebrated on a considerable scale in Honiton. The buildings were decorated, the High Street was lined with evergreen trees and Farquharson,[4] who may well have been an eye witness, recorded that 'The inhabitants paraded the town—each trade by itself, with conspicuous badges and banners . . .'. It is evident that the lacemakers were involved for the *Western Times* for 24 June 1887 (7d), in describing the procession through the town in honour of Queen

Victoria's Golden Jubilee, stated that it included '. . . lacemakers headed by a magnificant banner with the Royal Coat of Arms and "God save the Queen" elegantly worked in Honiton lace; the banner being the same as that used on the occasion of the peace rejoicings in 1856 . . .' The size of the contingent on the later occasion is known, for Alan Cole,[5] visiting the town on 4 June, recorded that 'For the Jubilee celebration the lace-makers of Honiton are going to form a procession, and already over 100 have sent in their names for this purpose.' It seems likely that this figure was an overestimate, for the 1881 census records only 59 lacemakers in the town, but it is possible that lacemakers from outside were involved and also that a number of people rather loosely attached to the lace industry had wished to join in.

The Golden Jubilee is the last occasion in which lacemakers are recorded as taking part in such celebrations and although details of the procession for the Diamond Jubilee of 1897 are given in newspaper accounts there is no mention of lacemakers. There is no record of the fate of the lace banners and it is to be feared that they were destroyed, which is to be regretted since they would have been notable relics of the industry.

Local celebrations

Apart from their contributions to the celebrations on the occasion of national rejoicings the lacemakers were involved in various local events which were organised either by or for them.

1. The Honiton lacemakers' society
In 1778 Samuel Curwen was in Sidmouth and on 1 July made this record in his journal[6]

> With Messrs Smith and Ogburn rode to Honiton, to see the annual procession of lace-makers; alighted at the Golden Lion, and was soon called over and invited to dine at a Mrs Youat's, whose daughter is presidentess of this society, in number exceeding a hundred. They have an afternoon sermon, and afterwards walk in procession in the following order:- the presidentess with a wand adorned with flowers; then four maidens, eight years old, with each a basket of flowers and large bouquets, walking between two arches adorned with flowers; then follow the patronesses, each with a white wand; then the standard-bearer, followed by two dozen couple, with a standard-bearer attending them. In this order they paraded through the principal streets, and then adjourned to the Golden Lion Inn to take tea and pass the evening in dancing and festivity. To this we were invited but my occasions calling me to Exeter,

and a want of relish for such mirth, concurred to send me off the ground
before the street parade was over, leaving my companions to return home
by moonlight.

Since Samuel Curwen dined with the mother of the presidentess he would
have had the opportunity not only of seeing the event but also of learning
the facts and it may be presumed, therefore, that the information recorded
by him is accurate. He states that the members of the lacemakers' society
numbered more than one hundred, but since the total number in the
procession, excluding the patronesses who were not lacemakers, was only
fifty-nine it is probable that the membership did not greatly exceed an
hundred. However, Countney Gidley writing in 1820, stated[7] that 'about 40
or 50 years since when this manufacture flourished the number of females
imployed by Honiton in Honiton and the neighbouring villages was abt
2400 . . .' This total is similar to that which can be calculated for the same
area from the information in the lacemakers' memorandum of 1698 and it is
reasonable, therefore, to postulate that the number of lacemakers in Honiton
in the 1770s was comparable with that in 1698, namely 1341. This is so much
in excess of the figure quoted by Curwen for the membership of the society
that it may be concluded that it was not comprised of all the lacemakers in
the town, but only some 10 percent of them. Perhaps the members were an
elite who required a qualification based upon skills for acceptance into the
society, or it may be that it was confined to lacemakers in the sense of those
who carried out the operation of assembling the motifs into pieces of lace.
In the nineteenth century such people formed an elite of higher paid workers
and, at that time, were largely to be found in Honiton.

Curwen noted that the patronesses carried white wands, as did the women
observed by James Yonge in 1702, and it is possible that this was a customary
feature of the processions held by the lacemakers of Honiton. There is no
apparent significance in this for the use of white rods for ceremonial use is
not uncommon and even the staff of office of the Lord Chamberlain takes
this form. Nor does there appear to be any significance in the date of the
event. The patron saint of lacemakers is the wholly mythical St. Catherine of
Alexandria and her festal day, 25 November, was celebrated at one time in
the East Midlands lace area under the name 'Cattens Day', with which was
associated also Queen Catherine of Aragon (1485–1536) to whom was ascribed
an equally mythical patronage of the lace industry. There is no record of any
such celebrations by the Honiton lace industry and the choice of 1 July may
have been no more than that of a summer's day shortly before, and therefore
not clashing with, the annual fair on St Margaret's day—20 July.

2. The Otterton Lace Institution.

The *Exeter Flying Post* for 13 May 1852 (5b) stated that 'On Friday week Messrs. Stephens and Co., of Sidmouth and Otterton, Honiton lace merchants, gave a tea to all the lace workers whom they deal with, numbering 703. Triumphant arches were erected—the bells rang merrily—and the day was kept as a fete.' The census returns for 1851 record a total of 402 lacemakers in Sidmouth and Otterton, so it is evident that Messrs. Stephens dealt with lacemakers over a wider area. However if the lacemakers listed in the parishes contiguous with those of Sidmouth and Otterton are taken into account the total becomes 1162 which would be sufficient to produce a workforce of the size quoted.

Apparently the event was formalised into the Otterton Lace Institution for the *Exeter Flying Post* for 13 May 1853 (5f) carried the following news item:-

> The gayest day ever witnessed at Otterton was the first anniversary of the Otterton Lace Institution, which was celebrated on Tuesday, July 5, when all the members, amounting to about 130, met and paraded (headed by two clergymen and the founder, Mr J. Stephens of Sidmouth) through the ancient town, in different parts of which were placed five splendid arches, with flags flying in all directions. The day being very fine, thousands of spectators congregated to witness the scene, among whom we noticed many of the gentry and clergy from the surrounding neighbourhood. The church had a most pleasing appearance; it was crowded to excess; notwithstanding which the greatest order prevailed. After prayers, the chaplain, the Rev. S.P. Coldridge, delivered a most appropriate and able discourse from 1st Thes. chap 4, ver 12—'that ye may walk honestly towards them that are without, and that ye may have lack of nothing.' Tea was afterwards provided under the beautiful clump of chestnut trees, where all the members took their seats in a circle. The Exmouth band played and glees were sung during the whole time. Afterwards rural sports commenced, and the evening concluded with dancing, which was kept up with much spirit till a late hour. The Honiton lace flag was a source of great admiration.

The account finished with the words that 'The liberal manner in which everything was conducted by Mr Stephens was frequently commented upon in terms of the highest praise'. After such an encomium it is, perhaps, surprising that no further reference to the Otterton Lace Institution has been found. Mr Stephens appears to have had a short commercial life, for though the firm of John Stephens is recorded as situated in High Street, Sidmouth and in Otterton in *Slater's Royal National and Commercial Directory* for 1852-3,

there is no reference to the firm in the numerous local directories published either before or after this date. It is possible that Mr Stephens, attracted by the commercial opening apparently offered by the mid-century boom in the Honiton lace industry, over-estimated the potential. If the figures quoted are even moderately reliable the fall in numbers from 703 in 1852 to 130 in 1853 indicate that a cut-back was already occurring and that there was an unintended irony in the second half of the chaplain's text. It is not apparent why the Rev. S.P. Coleridge, who was curate of Seaton and Beer, acted as chaplain when both Otterton and Sidmouth had incumbents and the latter a curate as well.[8]

3. The Seaton and Beer parochial schools fete.

In the mid-nineteenth century the accounts of the combined fete for Seaton and Beer schoolchildren show the impact of the lace industry on these events. *Woolmer's Exeter and Plymouth Gazette* for 9 August 1851 (7e) stated of this event that 'It may be observed that the female portion of the children are remarkable for their industry as lacemakers, and owing to the prosperous state of their manufacture, through the immediate and direct patronage of the Queen, they were enabled to contribute largely to the expenses of the fete.' The concept of a fete for schoolchildren paid for by them is an unusual one but was evidently made possible by their earning capacity as lacemakers.

A report on this event the following year was printed in the same newspaper for 17 July 1852 (8c) and also referred to lacemakers. 'The young people having met half way between the two villages formed in a large field their procession . . . Above one hundred young women, employed chiefly in the lace trade, dressed in white and decorated with flowers and lace, the produce of their own labour, were the parties at the two extremeties of the line, and in the centre were placed the band, and the more juvenile members of the schools. At proper distances came the waving flags, bearing suitable devices, and this among the most conspicuous, "God bless the Queen, our kind patroness".'

The total number of lacemakers recorded in Seaton and Beer in the 1851 census was 418 so the young women referred to would represent about a quarter of the total. If the age distribution of the lacemakers in Seaton and Beer was similar to that noted for the whole area, then the hundred lacemakers would represent the age group up to the age of about 17. It is evident therefore that this schools fete catered for a wider age range than that associated with primary education and may have been used by the older girls as an occasion for obtaining a holiday.

Lacemakers' Songs

Shakespeare was apparently aware of the idea of songs sung by lacemakers, for in *Twelfth-Night* Act 3 Scene 4 he puts into the mouth of the Duke of Illyria the words

> O, fellow! come the song we had last night.
> Mark it Cesario; it is old and plain;
> The spinsters and the knitters in the sun,
> And the free maids that weave their thread with bones,
> Do use to chant it;

Thomas Wright in his study of the East Midlands lace industry[9] was able to record many songs used by the lacemakers of that area, and was able to classify them into types sung in the different counties. Investigation of the Honiton lace area has failed to produce either evidence or tradition for lacemakers' songs or chants, even in the areas where trolly lace, virtually identical with that of Buckinghamshire, was made. The latter fact tends to support the other evidence (Chapter 5) that the origin of Devon trolly lace was not Buckinghamshire.

A possible reason for the difference between the two areas in this respect emerges from the evidence collected by the Children's Employment Commissioner in 1841[10] when interviewing lacemakers who could make both trolly and Honiton lace, the latter being frequently referred to as 'head work'. Mary Ann Rogers, of Sidmouth, stated that the trolly lace 'is easier than the "head work", or "springs and flowers"; "that is called Honiton work" '. Elizabeth Newbury, of Newton Poppleford, stated that 'the "trolly" is sooner learned than the "head-work", but is not quie so well paid'. Eleanor Rice, also of Newton Poppleford, stated that she could make all kinds of trolly lace 'but not "head work" or "Honiton work", as it is called; this is much more difficult . . .' Elizabeth Perry, of Beer, stated that she '. . . works under the mistresses eye, as the "head work" is very difficult to do well . . .' It is evident that the making of Honiton lace was regarded as being a more difficult task than that of making trolly lace, and it is possible, therefore, that the greater concentration evidently required precluded the distraction of songs and, maybe, the need for them.

The decoration of bobbins

The decoration of bobbins in the two English lacemaking districts of Honiton and the East Midlands took entirely different forms and represent different branches of folk art. The East Midlands bobbins are the most elaborate recorded from any lacemaking area in the world and are frequently remarkable examples of the turner's craft. They have been classified[11] into twenty seven types and inscriptions on them have been divided into forty nine categories. Such elaboration was not possible with Honiton bobbins since, due to the technical requirement of passing bobbins through loops to make sewings, they had to take the form of simple smooth pointed cylinders. This limited the decoration possibilities to the two techniques of staining and of incisive designs with the incisions subsequently filled with coloured wax, though in some cases colour only was applied to shallow incisions with smooth edges. The colours used were almost invariably red and black, only a few instances of any other being observed.

Decoration by staining the wood with aqua fortis (nitric acid) was quite common, though little attempt was made to produce any definite pattern. Occasionally streaks or spots were attempted but normally such decoration took the form of irregular blotches. Decorations produced by incision and filling, on the other hand, took a number of well defined forms which may be classified as follows.

a. Circumferential rings.

Decoration by a series of coloured circumferential rings, which were created by the bobbin turner, is periodically referred to as being a peculiarity of bobbins made in Branscombe, though there does not appear to be any evidence to confirm or deny this attribution. The rings were arranged in groups with the number of rings in a group normally ranging from one to eleven, though a few larger numbers up to twenty three have been observed. Groups of one to seven rings were more or less equally represented, though a study of 180 sets showed a marked deficiency of groups of four. The total number of rings on a bobbin commonly lay in the range from twenty five to thirty two, though totals as low as nineteen and as high as thirty nine have been observed. All the rings in each group were coloured either red or black, and in nearly all cases black and red groups alternate without any bias towards either colour as first in the sequence.

b. Abstract patterns.

Types of abstract pattern observed in the course of a study of one hundred

and thirty decorated bobbins are shown in Figures 12.1 and 12.2. The use of triangles was very common, either used by themselves or as components of more complex arrangements and this is understandable since a triangular cut is a particularly easy one to achieve with the point of a knife.

Another common pattern may be likened to the bonding of a brick wall and such may have been the inspiration for this device. Patterns made from simple linear cuts were used but these are mostly associated with the simplest and crudest decorative work.

Both diamond and heart shapes were frequently used and these were elaborted to a lesser or greater extent by the addition of lines and triangles. In two of the examples illustrated it is possible that the heart was intended to depict to some extent the face of the beloved.

c. Depictions of natural or man made objects.

There are many patterns, a selection of which are shown in Figures 12.3 and 12.4, which depict, usually rather formally, foliage and flowers, the former ranging from simple stylised single stems with leaves to quite elaborate and lifelike sprays. The flowers tend to be formalised and no case has been observed in which it was possible to recognise an actual species.

Living creatures represented are birds, fish, cats and a snake, but no instances have been observed in which creatures of the farm, such as cows, sheep, horses or dogs have been depicted. The rotund cat illustrated appeared with its head view on one side of the bobbin and its rear view on the other.

The human artifacts found and illustrated are anchors, a house, a window and the symbols of the suits from a pack of cards. A special class of this subject is ships, which are often drawn sufficiently realistically for the type to be identified and among those reproduced are a barque, a brig and brigantine. There is also a fishing boat which is trailing a trawl net in which a fish has been caught.

d. Human figures.

The portrayal of humans (and quasi-humans) was limited and may have been beyond the capability of most amateur decorators; certainly the figures of FAITH, HOPE and the mermaid shown are moderately accomplished drawings which could well have been by the same hand. Hope is accompanied by an anchor, as in nautical tradition, but it is not apparent what the object held up by Faith is intended to represent. On a much lower artistic level is the lady who apparently has four arms and the device which may be abstract but could be a crude attempt to portray a human figure. The nude male figure

Figure *12.1* *Honiton bobbin decorations*

Figure 12.2 Honiton bobbin decorations

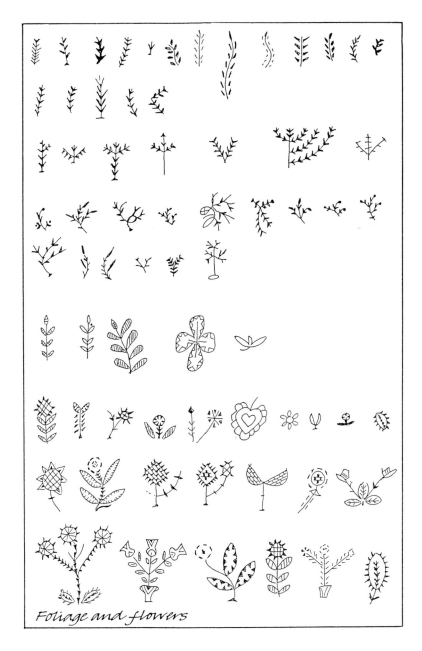

Figure 12.3 Honiton bobbin decorations

Figure 12.4 Honiton bobbin decorations

199

is surprising in view of the tradition that carved bobbins were given by young men to their sweethearts.

e. Initials.

Initials are frequently found, usually near the top of the bobbin, and these are evidently those of the owner. In some instances two sets of initials are present and these presumably represent a donor and a recipient.

f. Dates

The placing of dates on bobbins was quite frequently done, though the surviving bobbins of this type suggest that it was a fashion which developed in the early nineteenth century. In a random sample of fifty five dated bobbins it was found that there were four each from the third and fourth quarters of the eighteenth century, but twenty three and fifteen each from the first and second quarters of the nineteenth. The earliest date found was 1704 and the latest 1900.

g. Words[12]

Inscriptions which consist of words can be classified into several types. One, which appears to be peculiar to the Honiton area, is a multiline piece of writing, arranged helically round the bobbin, which has to be read from the last line upwards and in which it is necessary to carry letters or parts of words over from one line to the next without benefit of hyphens. The following examples have been observed.

```
SHOW that MerCY shoW to me
see that MerCY to others
thers Woe to hIde faULt
teaCH me to feel ano                    (L)

H THE RUE HOW F
AUREL AND SO DOT
GREN GROWS THE L                        (P)

BRITISH SOLDER SLAIN
D PLEN WER MANEY
ON WATERLO DESERT                       (A)
```

It is possible that these were carved by essentially illiterate persons who had been given a copy of the words but who had not appreciated the normal

conventions of writing. The end of the second one suggests that it was part of a set with the rhyme continuing.

The following are examples of religious themes, in one case associated with patriotism:-

JESUS TO THY ARMS I FLY
SAVE O SAVE ME OR I DIE (P)

DEATH ONLY PARTS UNITED HARTS (R)

PRAY WITHOUT CEASING (L)

FEAR GOD AND HONOUR THE KING (L)

Personal observations and good wishes are expressed in these examples:-

WHEN I AM GONE AND FAR AT SEA
FORGET NOT LOVE TO THINK ON ME (P)

LOVE ME AND LEAVE ME NOT (P)

AS THE GRAPES GRAWS ON TE VINE
A CHOSE YOU FOR MY VALANTINE TINE (R)

MaY HeaLTH AND HaPPYNeSS ATTeND YOU (R)

M A WALKER WAS BORN AUGUST 24 1801 (R)

An improving maxim is dated 1817 and the bobbin, like the one bearing the first of the inverted messages, carries the initials EE.

Who LIVeS to natURE rareLY can be
poor who LIVes to FancY neVer can be rIch. (L)

One couplet, though bearing the stamp of some sophistication in rhythm, has an elusive significance which may mean that it was part of a set, the whole comprising the complete poem:-

THIS LITTLE FLOWER OF TENDER HVE
SHALL LIVE AND GROW IN ENGLAND TOO (A)

The technique of decoration of Honiton bobbins is somewhat reminiscent of scrimshaw work, and this typically seaman's craft could be associated with Thomas Wright's opinion[13] that '. . . most of the Devon bobbins smack of the ocean'. Wright's view is, however, not borne out by observation, for, of a random sample of 145 decorated bobbins studied, only ten had subjects associated with the sea. Those that did generally depicted ships which make a spectacular and easily noted decoration and this can lead to a tendency to overlook the many others with simple designs and abstract patterns.

The techniques of decoration was also used on stay busks, which were made from wood or bone.[14] Lambert and Marx[15] observe of these objects that 'they are chip carved, with a date, linked initials, hearts and other love emblems, flowers and geometrical patterns, sometimes picked out in colour . . .'. 'the bone ones . . . are ornamented with "scrimshaw" work, scratched decoration filled with red or black colour, and have the same devices as the wooden ones.' Though not identical there is a clear parallel between these two classes of objects and the decoration of the Honiton bobbins may be regarded as belonging to the same tradition of folk art as that of the decorated stay busk.

A lace manufacturer's brawl

A curious episode[16] involving some of the lace manufacturers of Honiton which, although shocking, has some elements of humour occurred in the parish church on the afternoon of Sunday 18 March 1827 and is recorded in proceedings of the court of the Archdeacon of Exeter.[17] The service was about to begin and one pew was occupied, in order, by Theophilus Clarke, John Pidgeon and Amy Lathy, opposite whom sat respectively Hender Clarke, his wife Nancy and their daughter Eliza. Theophilus was the son of Hender and Nancy and Amy Lathy had been his sister in law since 2 August 1825. What ensued is described in the words of the indictment as follows:

> Amy Lathy having in her attendance at Divine Service on Sunday the Eighteenth day of this instant March taken her usual seat or sitting in the said Seat or Pew and having placed her feet on the hassock you the said Theophilus Clarke and Nancy Clarke entered the same seat or pew and soon after both of you with great passion and violence attempted to remove the said Amy Lathy's feet from such Hassock and you the said Theophilus Clarke exclaiming that the said Amy Lathy was—'A Nasty Hussy'—that on the said Amy Lathy's saying—'That an old person like you the said Nancy Clarke ought to know better than behave so at Church

or to have remained at home' You the said Nancy Clarke desired your son the said Theophilus Clarke to put the Creature as you expressed yourself and thereby meaning the said Amy Lathy out of the church on which you the said Theophilus Clarke desired your Mother the said Nancy Clarke to change places with you and thereon being influenced with passion and not regarding the sacredness of the place wherein you then were you said 'you had Iron at the Heels of your Boots and would therewith make the Damn'd She Devil (meaning the said Amy Lathy) take off her Feet and know how to behave"—and after your exclamatuion of—'God Damn Your Blood' You with great violence kicked the shins of the said Amy Lathy Three times and forced the hassock from her to the great scandal of Religion.

The Archdeacon found the charge proved, admonished Theophilus and Nancy Clarke to be of good behaviour in future and ordered them to pay the costs which amounted to £38. 2s 10d.

Theophilus Clarke was a lace dealer and his wife subsequently received the royal warrant as a manufacturer from Queen Victoria. She also made the notable flounce shown at the Great Exhibition and which was designed by her sister-in-law, Eliza. Amy Lathy was a lace manufacturer who subsequently received royal warrants from both Queen Adelaide and Queen Victoria (Chapter 9).

This occurrence appears to have been actuated by something more than ordinary commercial rivalry between the town's lace manufacturers, but what lay behind it does not emerge from the court papers. The probable explanation is animosity between the Clarke and Lathy families, despite the marriage of Theophilus and Esther, to which both Hender Clarke and Amy Lathy were witnesses, but if so, peace was evidently made later, for Nancy Clarke is recorded in the 1851 census as a widow aged 78 lodging in the house of Harriet Lathy, who was probably the widowed sister-in-law of Amy.

References

1. Poynter, p210.
2. BL Add MS 34699.
3. Index, p6.
4. Farquharson, 1868, p69.
5. Cole, 1888.
6. Ward, p195.
7. BL Add MS 9427 Item 255.

8. The Clergy List, 1853.
9. Wright, Ch 14.
10. House of Commons, 1843.
11. Freeman, p30-39.
12. The letter in brackets after each inscription quoted denotes the collection in which the bobbin was found: A = Allhallows Museum, L = Mrs E Luxton of Topsham, P = Mrs P Perryman of Hontiton, R = Royal Albert Museum, Exeter.
13. Wright, p178.
14. Pinto, p22.
15. Lambert and Marx, p20.
16. For a full account of this see Yallop, Devon Historian, 1990 p20.
17. Bundle AE/iv/2/57.

Chapter Twelve

Designs and Designers

Baby's Christening bonnet, Honiton lace on machine made base, motifs: butterflies, elephant's backside.

Exhibition catalogue 1973

The manufacturers supplied the lacemakers with their thread and generally their designs, though there is evidence that sometimes in the nineteenth century some lacemakers produced designs for themselves. The manufacturers obtained the designs from designers, who may have been elsewhere or in their employment, the latter particularly in the case of the nineteenth century application onto machine net. Little is known about the designers during the prosperous years of the industry in the seventeenth and eighteenth centuries, but there is a considerable body of information surviving from the years of decline in the nineteenth and early twentieth centuries. It is convenient therefore to consider the designers and their designs separately in these two periods.

The years of prosperity

No name of an English designer of bobbin lace appears to have survived from the seventeenth or eighteenth centuries, though designers of other types are known such as Matthias Mignerak who published a book of designs[1] in France in 1605 and who, despite his un-English name, is described on the title page as being English. It is apparent, however, that good designers and designs were available since there is a considerable body of evidence that English lace in general and Honiton lace in particular was able to compete in the high fashion markets both at home and on the continent.

Early evidence for the latter is found in the correspondence of William

Trumbell[2] who served in Brussels from 1605 to 1625, first as ambassador's secretary and later as resident. Each year from 1606 to 1609 Trumbell paid a visit to England in the spring and the correspondence between himself and his colleague John Beaulieu, who remained in Brussels, shows that Trumbell was asked to procure various items, including English lace, for people in Brussels. On 27 July 1607 Beaulieu acknowledged receipt of '. . . a little bundle of black and white lace which I had written for at the request of a friend.' On 26 April 1609 he wrote that Mrs Mary Montpesson wanted '. . . 50 yards of the lace enclosed, and my Valentine cobweb lace instead of Tiffany', on 10 May 1609 that '. . . instead of the 20 yards of the stripe cobweb lace my la. wants as much of the enclosed pattern . . .' and on 17 May acknowledged the receipt of the goods. Beaulieu himself visited London in the winter of 1609/10 and wrote to Trumbell in Brussels on 12 November 1609 that 'Mr Wake will bring your commissions . . . 25 yards of cobweb lace', and on 18 January 1610 that he could not find lace of the pattern and fineness desired but was sending six yards of plain cobweb lace and six of stripes.

That the demand for English lace occurred at a time when local Brussels lace was available is shown by Beaulieu's letter of 7 December 1609, in which he wrote that 'My lady wishes 24 Dutch ells of the enclosed lace which she says may be had for 6d. an ell of the workwoman who lives in the new street leading to the Oxon market.' It may be noted in comparison that the cobweb and stripes laces referred to on 18 January were priced at 20d. and 15d. a yard respectively, and it is evident that at this time there were people in Brussels who were prepared to pay the higher price for the English lace in preference to the local product.

Evidence for the standing of English lace on the continent and its place in the market there throughout the seventeenth century emerges from several sources. In 1636 the Earl of Leicester, English ambassador in Paris, considered English lace to be a worthy present for the Queen of France.[3] *La revolte des passaments* of 1661, considered in detail in Chapter 4, shows that at that time English laces were well-known in France and that imitations of them were being manufactured. In 1676 Jacques Savary stated in his book *Le parfait negociant* that the businessmen of France imported both silk and thread lace from England.[4] In 1660 a royal decree required all foreign lace imported into France to be marked and a further one in 1687 restricted the points of entry[5] but allowed three to England, more than to any other country.

In the last decade of the century there were several observations made on the high quality of the products of the Honiton lace industry. In 1691 Edward Bird was detected in an attempt to smuggle foreign lace into England,[6] as

he had been in 1688[7] when he claimed that he wanted the lace for patterns, and he stated that Devon, Dorset and Wiltshire were producing lace that was as good as that from any part of the world. In 1695 Celia Fiennes when visiting Honiton recorded the opinion that the lace made there was as fine as that of Flanders,[8] and the lacemakers memorandum to parliament in 1698[9] claimed that 'The English are now arrived to make as good Lace, in Fineness, and all other respects, as any that is wrought in Flanders.' These views were confirmed by Defoe[10] in 1724 who said of lace at Blandford that he had never seen better in Flanders, France or Italy.

The first half of the eighteenth century saw the rise of Bath, largely under the impetus of Beau Nash, to become a fashionable resort for the well-to-do and it was at this period that John Wood[11] recorded the great sale of lace from the Honiton area in that city. He also observed that Bath was the point of origin of design and that he had heard of one manufacturer whose expenses in letters alone in procuring new designs from there amounted to £70 a year. Another indication of the extent of the trade in this fashionable centre is the elaborate monument of 1764 erected in Bath Abbey to the memory of Leonard Coward 'of this City LACE MERCHANT.'

The retention of the high quality, of international market level, in this century is shown by Mrs Powys' diary,[12] for in 1760 when she visited Honiton to examine the lace made there she observed that on comparing it with the Flemish she considered the former to be the finer.

Too little is, as yet, known about the products of the Honiton lace industry in the seventeenth century for any detailed analysis of design to be made, though it is apparent that Sir Coplestone Bamfylde's sash of 1661 [Plate 5] and the flounce of c1700 shown in [Plates 6 and 8] share the commonly observed characteristic of the Flemish lace of the period, namely a tendency to symmetrical designs. A similar tendency may be observed in the illustrations of English bobbin lace of the period assembled by Santina Levey.[13]

There are no known examples of fully provenanced items from the output of the Honiton lace industry which date from the eighteenth century, but there are at least fifty specimens in museum collections which have been assigned to the area and period by informed opinion. Some of these assignemnts were made by Mrs Treadwin in the third quarter of the nineteenth century, and this is an early enough date that she may have had traditions, or even evidence, to support her attributions, though no record of such information was made.

Consideration of the designs of these pieces shows that there is a tendency to be less formal and less strictly symmetrical than was the case in the previous century, or was the case in general with the Flemish lace of the period. It

would be possible to interpret this difference as indicating an inferiority in the quality of the Honiton designs, but such an interpretation would more likely be an expression of taste and fashion rather than one of any absolute aesthetic standard. It is probably significant to draw a parallel between the lace designs and the differences in fashions of garden design on either side of the English Channel in the seventeenth and eighteenth centuries.[14] In the seventeenth the greatest ideal both in England and on the continent was a formal garden layout in which there was much emphasis on symmetry. In the early eighteenth century sentiment in England started to undergo a change, with a move towards layouts in which plants and trees were allowed to develop more naturally, with a consequent loss of strict symmetry, culminating in the work of Capability Brown. On the continent, although the concept of the 'jardin Anglais' gradually found favour, it was nevertheless resisted and as late as 1765 the Chevalier de Jancourt was praising the symmetrical formal style of Le Nôtre as the model to follow. It could be, therefore, that the symmetrical designs of the continental laces were a reflection of continental taste, whilst the less formal designs found in the products of the Honiton lace industry represent that of England.

Both the formal and the informal designs are legitimate aspects of artistic expression and in judging the merits of the designs of eighteenth century Honiton lace it is well to recall some words of Herbert Read.[15]

> It is well known that a perfectly regular metre in verse is so monotonous as to become intolerable. Poets have therefore taken liberties with their measure; feet are reversed within the metre, and the whole rhythm may be counterpoised. The result is incomparably more beautiful. In the same way in the plastic arts certain geometrical proportions . . . may be the regular measure from which art departs in subtle degrees. The extent of that departure, like the poet's variation of his rhythm and metre, is determined not by laws, but by the instinct or sensibility of the artist . . . Greek vases do conform to exact geometric laws and that is why their perfection is so cold and lifeless. There is often more vitality and more joy in an unsophisticated peasant pot.

It may be that the degree of informality found in the designs of eighteenth century Honiton lace inspired a response in those who were ready to react from the strictness of symmetry which had gone before. This does not necessarily mean that the designers deliberately set out to avoid symmetry and formality, any more than did Read's peasant, but rather that, using their

instinctive 'feel' for what was right, were not constrained to regard these qualities as of first importance.

Another design feature which forms a noticeable element in the Honiton lace of the first half of the eighteenth century, and which is especially found in edgings, is a swirling tape-like form. Typical examples of this in edgings are shown in [Plates 62D, G and H] and an example of its use in a flounce in [Plate 62C]. This form has a clear affinity with seventeenth century Milanese lace [Plates 62B and F]. Forms of this type may be traced further back still for they are to be found in *Le Pompe*, the earliest bobbin lace pattern book of 1559 and two examples from this source, photographically reversed to create the effect of the lace which would be produced from the design, are shown in [Plates 62A and E].

This feature is not the only one observable in eighteenth century Honiton lace which suggests an affinity with that of Milan. The placing of net ground in the Flemish lace of the period tends to be such that the mesh forms uniform lines parallel to the edge, whereas in both Milanese and Honiton there is a marked tendency to work the net in various directions within the same piece of lace, as shown in [Plates 14 and 15]. Moreover the double bars, each with a single picot, which are shown in [Plate 62F] are regarded as typical of Milanese lace but one example of Honiton lace of the eighteenth century has been observed to incorporate some of them.

The swirling tape form suggests that its use in eighteenth century Honiton lace may represent a strand of tradition leading from the Venetian origins of bobbin lace and which may have originated at an early stage of the introduction of bobbin lace into England. It is possible, therefore, that some specimens of lace, at present catalogued in the world's collections as seventeenth century Italian, may be products of the Honiton lace industry, but the research needed to test this hypothesis has yet to be undertaken.

The years of decline

During the years of decline of the industry following the introduction of Heathcoat's bobbinet machine a number of writers expressed their views on the design quality of Honiton lace and many of these were unfavourable. The lean years of the industry were succeeded in the 1840s by a revival, so that by the time of the first great international exhibition, the Great Exhibition of 1851, there were people interested in exhibiting Honiton lace, and seven did so. Four received prize medals and two honourable mention. The jury, in its report[17] on the Honiton lace exhibited, made the following observations:-

... during the past twenty years considerable progress has been made, resulting in the manufacture of fabrics, displaying not only extreme delicacy of execution, but also of beauty, and taste in design ... This striking change has not arisen from fortuituous circumstances, but has been mainly induced by eminent houses in the trade; who, to meet the taste required by their customers, have employed every means at their disposal to raise the character of this description of lace. They are fully alive to the conviction that the more the British manufacture becomes assimilated to the characteristics of the foreign (which are chiefly suitable, beautiful, and clearly defined patterns, with refinement of execution), the more the demand for this lace will extend; and proportionally with such increased demand, they will be induced to expend still larger sums, in order to produce a higher class of designs. They are further encouraged in their exertions by the fact, that although the British cannot boast of design so exquisite, and execution so delicate as Brussels lace, it yet possesses remarkable and valuable qualities inasmuch as it is produced perfectly white, does not change colour, and the price is very moderate.

Felix Aubry was the French representative on the jury and he presumably concurred with these xenophilic sentiments. However when he made his own report[18] to the French commission he stated that the Honiton lace was, without fear of contradiction, the most perfect of its type which could be produced. He also made the point that its price exceeded that of the finest pieces of Brussels lace, a comment from a neutral observer which does not appear to support the English assessment of the quality of their own. The latter may well have been influenced by the frequently seen confusion of thought between aesthetic standards and fashion, and also by the common tendency to regard the relatively unfamiliar products of other countries, both natural and manufactured, as being exotic and therefore superior to those of ones own.

However, expression of dissatisfaction with English design continued and Mrs Treadwin,[19] writing in 1853, stated that 'There is not a professed lace-designer in Devonshire; my own I have procured until last year from Paris, since then from Somerset House and Nottingham.' Even so it may be noted that a report in *Woolmer's Exeter and Plymouth Gazette* for 1 March 1851 (5c) stated that, though the design for the flounce exhibited by Mrs Treadwin at the Great Exhibition was produced by the school of design at Somerset House, this was only an outline and that the details were the work of Mrs Treadwin herself.

The same year Octavius Hudson, then of the Department of Practical Arts, commissioned a design for a Honiton lace collar from a Miss Ashworth and

arranged with Lady Trevelyan of Seaton[20], who was trying to encourage the local industry, to have it made by two lacemakers in Beer. When it was complete Lady Trevelyan sent it to Mr Hudson, but expressed the view that it would prove too costly to find any significant market. In her letter, of 21 May 1853, she made some observations on lace design:-

> I don't know if you saw the patterns that were sent here some time ago—(from various schools of design I believe)—but I am sorry to say many of them are absolutely impracticable—& most of them useless—it is a great pity. Many of them are charming groups of flowers, really admirable as drawings, but quite unfit for lace, flowers and leaves in perspective, coming one before the other—which in lace could never be intelligbly expressed—there is, generally speaking, throughout them—a total want of <u>feeling for the material</u> and a manifest ignorance of the possibilities and requirements of lace designs . . .

She expressed the hope that Mr Hudson might get some plan arranged for making the pupils at the design schools acquainted with the technique of lace making. It appears that the foreign designs were hardly more practicable, for she observed:-

> There is a sort of <u>evil satisfaction</u> to me in the fact that Mr Tucker of Branscombe lately got some designs from Paris & that, though some were beautiful, others were of as little use as our own—I shall try to see these French ones.

This does not seem to be consistent with the high estimate of foreign designs expressed by the Great Exhibition jury.

On 10 October Mr Hudson wrote to Lady Trevelyan to say that there was a possibility that he could do something for the local industry in that he would consider recommending to the Department that qualified persons should be appointed to teach drawing and ornamental art to the lace workers. It would, however, be necessary for the local authorities to provide a suitable place for such classes to be held. He asked for her opinion on the idea and stated that he was also writing to the vicar, Mr Glascott, to ask for his opinion. On 21 October Mr Glascott wrote to Lady Trevelyan to say that he had heard from Mr Hudson and reported that he had '. . . already sounded some of the Lace Dealers in this neighbourhood & they treat the scheme with something approaching contempt, as being entirely visionary.' He continued 'with their ideas I do not accord, as I am quite sure some improvement might be made in our manufacture & some good would arise

if a Class of young Persons, possessing a little education, were placed under the instruction of a Teacher of Drawing & Ornamental Art.'

Nothing further is known of Hudson's proposal, but with such an unpromising reception it seems likely that he did not take the scheme any further. Nevertheless the idea of improving lace designs by local efforts was revived from time to time, in particular by Alan Cole who, in 1887, recommended[21] that '. . . lectures upon Devonshire lace might be given and inspections granted to encourage efforts in designs' and also that 'A private committee might be formed and raise a fund for prizes to be awarded for improved designs . . .' There is no evidence to show that this initiative was any more successful than that of Mr Hudson. As late as 1907 Penderel Moody[22] proposed that there was work for artists in the lacemaking villages and she envisaged artists who would be manufacturers combining the designing of patterns with the arranging of the completed work and the training of young workers. There is no evidence that these proposals either were ever translated into reality.

The type of design work which actually obtained among some of the manufacturers was revealed by Alan Cole's investigations. C, at Beer, stated that 'sometimes we sees a new wall paper and prick a pattern off it, changing a bit here, or leave a little, or add a little.' Moreover she found it best to keep to the old patterns for experience showed her that when she produced a new one 'gentlefolks' called it machine, a comment which suggests that her customers were no more discriminating in matters of design than she was. M, of Exmouth, had taken prizes at the Bath and West of England shows and stated that she made up her own patterns. Sometimes she induced a visitor to give her a drawing, but at others she used patterns from wall papers, table cloths and 'anything'. N, of Otterton, stated that she bought no patterns, but took some from the journals, some from the workers, 'who prick off flowers from table-cloths, &c.' She could not herself draw at all.

Another approach to the problem of poor design and the encouragement of improvements at local level was that of the Bath and West Agricultural Society which, in 1864, instituted a competition for Honiton lace at its annual show with prizes for exhibitors and designers. The writer of a report on the event in *Woolmer's Exeter and Plymouth Gazette* for 17 June 1864 (1a), though expressing himself unable to judge such work, wrote that

> . . . we should have thought that the distribution of the prizes would have been left to a committee of ladies; but Mr Hudson, late of the Kensington Museum—the authority on lace— assures us that ladies, as a rule, really know little about the matter. That is to say, they are not

able to decide on the artistic merits of a piece of lace, and are not infrequently imposed upon. Mr Hudson is a lecturer upon textile fabric. Some of the lace, he informs us, is exceedinly beautiful, and the greater part is quite equal to the highest expectations . . .

In view of the experience of C of Beer, recorded by Alan Cole, it could be that there was some justification for Mr Hudson's male chauvenistic attitude. Taking into account his proposals conveyed to Lady Trevelyan eleven years previously and the fact that the prizes were instituted in an endeavour to encourage improvements in design, it could be that the highest expectations to which he referred had not been set at a very elevated level.

The society continued to hold the event and the report in the same newspaper for 8 June 1866 (1a) stated that 'The Society are [sic] expecially anxious to establish a high standard of design, and their efforts are already producing good effects in this direction.' However in 1871 when Mrs Fowler sent in a finely worked and designed banner screen the judges refused to believe that it was Honiton lace until Mrs Fowler offered to work another one like it whilst they watched.[21] A few years later the competition faded out, there being only ten entries in 1877.

There must have been some difficulties for the lace manufacturers in judging the quality of the designs of their productions owing to conflicting opinions of commentators, and the difference between the 1851 jury's official report and that of one of its members has already been noted. In 1867 Mrs Palliser[23] wrote that 'Neither our English nor our Irish lacemakers show much improvement in the taste of their patterns, in which they are far behind their French and Belgian competitors'. She then apparently contradicted herself with the observation that 'Mrs Treadwin exhibits a half-shawl of beautiful workmanship, and there are many other specimens most creditable to the Devonshire lacemakers', though she may have been distinguishing between design and craftmanship. The report on the lace exhibited at Bristol at the Bath and West show in *Woolmer's Exeter and Plymouth Gazette* for 6 June 1874 (6e) suggests high quality design:-

> The cherries, strawberries, passion flowers, convolvuli, roses, and ferns are all so excellently reproduced that we recognise them directly. Even the various sorts of ferns are familiar to us, and it pleases us to call to mind their long latin names, and to think of the pleasant places where they grow; whilst the butterflies and insects that hover about them we have known from our earliest school-days. The beauty of these natural designs has been increased by careful admixture of conventional ornamentation, in the form of scrolls and arabesques, which not only aid the

designer in the production of a fitting and graceful pattern, but also supply the lacemaker with an opportunity of displaying various stitches for which no place can be found n the delineation of natural forms.

However an echo of the exhibition appeared in an article on Honiton lace in *The Graphic* for 6 February 1875 (p.136), for this included the statement that the filling in the piece of lace illustrated, which was being made for a royal order, '. . . has never been made, except for Her Majesty's lace, and for the pattern exhibited at Bristol.' Examination of the illustration, [Plate 34], reveals a piece of lace consisting of a variety of motifs, by no means as readily recognised as the newspaper correspondent indicated, assembled in a haphazard manner with a ground of questionable suitability, the whole suggesting little appreciation of design either formal or informal.

The Rev. Baring Gould looking back from the viewpoint of 1900 condemned the designs of the whole period and even before it[24]

> Taste declined during the latter part of the last century, and some of the designs of Honiton lace were truly barbarous . . . At the beginning of this century all taste was bad . . . Unhappily, design sank very low. perhaps the lowest stage of degradation in design was reached in 1867, when a Honiton lace shawl sent to the Paris Exhibition from Exeter received a prize and commendation. Nothing can be conceived worse. That it should have been rewarded with a medal shows that either the judges pardoned the ineptitude in design for the sake of the excellence of the work, or else that they themselves stood on the same level of artistic incompetence which then prevailed. Since then, happily, design has been more studied. There is still a good deal of very sorry stuff produced—as far as artistic design is concerned—but at the same time there is much faithful copying of good antique work. All old work is not good; there were bad artists in the past, but the general taste was better than it is now.

Baring Gould's condemnation of the design of nineteenth century Honiton lace was certainly the most sweeping, but it serves to sum up the general tenor of contemporary commentators. Though there was some praise the tendency was to regard the designs as bad.

The most obvious characteristic of the design of Honiton lace in the nineteenth century was the use of motifs based on nature in the form of flowers, leaves, birds and insects. This tendency became particularly marked after the introduction of the competitions at the Bath and West shows, where designs were required to be 'strictly after nature'. At their best they achieved

a marked air of realism, as may be seen in [Plates 48, 60 and 61] though
this tendency was perhaps taken too far in the case of the banner screen
displayed by Mrs Sharp at the Bath and West show in 1874, for the report
in *Woolmer's Exeter and Plymouth Gazette* for 6 June (6c) in describing it
referred to 'The ferns, of which the entire plant, root and all, is in some cases
portrayed . . .'

Retrospective assessment

It is a familiar fact that the assessment of the merits of a work of art is
affected, sometimes substantially, by fashion and that it is difficult to make
a sound judgement on either contemporary productions or on those of the
recent past. James Laver summed this up in relation to womens' clothing in
his famous table[25]

The same costume will be:

Dowdy	1 year after its time
Hideous	10 years after its time
Ridiculous	20 years after its time
Amusing	30 years after its time
Quaint	50 years after its time
Charming	70 years after its time
Romantic	100 years after its time
Beautiful	150 years after its time

Attempts are made to differentiate between fashion and taste with the
assumption that the latter has a less ephemeral quality than the former, or
even a permanent character, though Eric Newton[26] plausibly denied that such
a difference existed. Whether or not Newton was right, there is certainly a
tendency for taste as well as fashion to be involved in a time scale and he
cited the example of the lectures given on interior design by Professor Edis[27]
to the Royal Society of Arts in 1881. In these Edis stated that he could '. . .
conceive of nothing more terrible than to be doomed to spend one's life in
a house furnished after the fashon of twenty years ago . . .' He then
undermined his argument by quoting[28] a writer of 1856 'In this aesthetic age
. . . grates and fenders, chairs and couches must be designed in conformity
with the dictates of elevated taste'.

When viewed from the perspective of a century later it is difficult to see
any appreciable difference in merit between typical interiors of 1861 and those
of 1881, and still less to accept the professor's suggestion of a great aesthetic
divide. It is equally difficult to accept as valid Baring Gould's sweeping
assertions of the shortcomings of the design of Honiton lace (and apparently

everything else) over a period of more than a century. Nor do the improvements claimed by the 1851 Great Exhibition jury seem to be any more credible, but all these judgements appear in reality to be reflecting only the changing fashions of the times in which they were uttered.

It is a common failing among self-styled arbiters of taste to claim that good taste was a gift that was withheld from some past generation but vouchsafed to their own. It would be unsafe, therefore, to accept the designations of contemporaries as a reliable judgement on the absolute merits of the quality of the designs of Honiton lace in the nineteenth and early twentieth centuries, but to regard them only as historic statements of the sentiments of their authors as products of their age. The contrast between the pessimism of their remarks and the confident assertions in the earlier centuries confirms the view that in the earlier period the lace produced was of the latest fashion competing in the major markets at home and abroad.

A valid assessment of the merits of the designs of Honiton lace over the years of the industry must be made not in terms of fashion or taste but by absolute aesthetic standards. That such standards do exist is manifest by the way in which the works of master painters such as Giotto, Veronese and Rembrandt, or of the unknown master builders of the medieval gothic cathedrals, are acclaimed year after year, generation after generation, irrespective of the constant changes in fashion and taste. No artist can produce a work of art deliberately, but if they fulfill three requirements they may achieve something which is a work of art. The first requirement is that the work must be an act of love in which the artist has an inspiration which drives him or her to express that vision in material form. The vision may emerge from within or may be stimulated from without by an imaginative challenge or a commission from an enlightened patron. Secondly there must be a total understanding of and complete sympathy with the medium, which explains the failure of the Government School of Design, complained of by Lady Trevelyan, where the designers appear to have been set to work without any proper understanding of the medium. The artist's vision can be translated into reality by virtue of a correctly chosen medium, or the very existence of a particular medium can be the starting point which generates the vision through its inherent qualities. Thirdly the work must be original—works of art cannot be produced by copying others created by people of a different age, in which a different and unrecoverable taste obtained. This may be seen strikingly in the comparison between Victorian church finishings, where the heavy dependence on gothic originals led to a deadness not present in the prototypes, and the domestic furniture of the same period where originality was allowed free rein. This is not to say that the contemplation of the past

may not be the starting point for inspiration—but it must be an inspiration to create and not just to copy or reproduce.

In the years of prosperity of the industry there must have been many inspiring challenges in designing for an ever changing fashion market in which lace was an essential dress accessory with no effective rival. In addition there were the challenges arising from royal orders and from others, such as Sir Coplestone Bampfylde's sash and the competitions of the Anti-Gallican Society. Examination of the Honiton lace of the period reveals many pieces which excite admiration and show a real quality of beauty. Second rate pieces, lacking in inspiration, were also produced, but this was the inevitable consequence of reproducing designs and of making copies locally for the lower end of the market, in the way that copies of the products of top couturiers lose something of their quality when reproduced for mass sales.

In the nineteenth and twentieth centuries the inspiration of creating for the top fashion market largely disappeared. The industry faced massive competition from the machine and it must have been far more interesting for potential designers to work in this new and exciting field than in the decayed and ailing hand industry. Nevertheless some challenging possibilities did exist in the shape of royal orders and the new development of international exhibitions. One may see pieces of distinction in the lace designed by William Dyce[29] for Queen Victoria's wedding [Plate 24] and the fan designed by Wolliscroft Rhead[30] for Queen Mary's coronation [Plate 51], both of which appear to have been the designers' only essays in lace design. Examples of notable pieces from the world of international exhibitions include the flounce designed for the Great Exhibition [Plate 26] by Eliza Clarke[31] and that for the 1862 exhibition [Plate 27] for which Mary Tucker[32] was responsible. These various pieces will appeal to different extents to different people according to their personal preference but when these are discounted it is evident that fine pieces of lace were produced in the years of decline of the Honiton lace industry.

As with the earlier period undistinguished pieces were also produced, and the large number of these which have survived has tended to give Honiton lace a poor reputation, since they are all that many people, including collectors, have seen of the output of the industry. As has already been noted the pressure of competition from the machine-made product led to simplification and deterioration of motifs and also their ill advised throwing together by local manufacturers without benefit of professional designers. Even the latter process, however, was not necessarily completely disastrous, for the shawl shown in [Plate 43], though utterly without design, nevertheless by the inclusion of the characteristic boteh and rose motifs of the Kashmir

shawl contrives to produce a not uninteresting representation of a Paisley shawl in Honiton lace. There are also pieces which, though well executed, lack impact through unoriginality produced by mere reproduction of old designs. This unprofitable line was mistakenly adopted by Miss Audrey Trevelyan[35] at the turn of the twentieth century in an endeavour to help the industry. Mrs Treadwin also created reproductions but in her case it appears to have been more in the nature of research projects in her studies of lace construction, though her advertisements in the *Exeter Flying Post* for 25 July 1877 (4c) and 11 June 1879 (4c) both refer to reproductions of rose and Spanish point, and the latter to Exeter lace as being a reproduction of old lace.

A type of design which was very popular at the turn of the century was that usually known as Art Nouveau but it seems to have found little favour with the designers of lace, though some examples are known from Austria and the Netherlands.[34] Audrey Trevelyan does not appear to have realised its potential for a revival and the only example of an Art Nouveau design for Honiton lace at present known is one for a fan by Miss E.M. Byrde, of Honiton, which is endorsed with the information that it was used by Miss Ward [Plate 86].

All too often struggling textile enterprises have sought to cut costs by giving up the 'luxury' of designers and sticking to 'tradition'.[35] That is a formula for stagnation and decay, and the history of the Honiton lace industry in its years of decline is a case in point. In this it was not unique and the contemporary Brussels industry fared little better, as may be seen by the numerous low quality examples surviving from the period.

References

1. Mignerak.
2. HMC, Devonshire MS Vol 2 p27, 92, 182, 198, 220.
3. HMC, 77 vi p82, 105.
4. Savary, 1676, p106.
5. Savary, 1726, II c 1150.
6. CTB, 1691, p1054.
7. CTB, 1688, p2068.
8. Fiennes.
9. Some Considerations . . .
10. Defoe, 1927, p217.
11. Wood, II p436.
12. Powys, 1899, p77.
13. Levey, figures 163-169.

14. Adams, Dutton, Thacker.
15. Read, p23.
16. Allhallows Museum.
17. Great Exhibition, p1013.
18. Aubry, p64.
19. Wyatt.
20. Trevelyan MSS.
21. Cole, 1888.
22. Moody, 1907, p85.
23. Art Journal, special number devoted to the Paris Exhibition, 1867.
24. Gould, Book of the West, I p56.
25. Laver, p202.
26. Newton, p142-149.
27. Edis, p17.
28. Jones, 1856, p21.
29. Staniland and Levery, p26.
30. Illustrated London News, 1.7.1911, p50.
31. Woolmer's Exeter and Plymouth Gazette, 18.10.1851 (3b).
32. Sraniland and Levery, p26.
33. eg. Glenavon.
34. Casanova—catalogue illustrations.
35. Johnstone, p4.

Chapter Thirteen

Distribution and Sales

... no Person, being a Maker or wholesale Trader in English Bone- lace
and selling the same by whole sale, shall be adjudged, deemed or taken
to be a Hawker, Pedlar or petty Chapman ...

<div align="right">4 George I c6, 1717</div>

Methods of distribution

Apparently the earliest comment on the distribution of the products of the
Honiton lace industry was that by Thomas Fuller[1] in 1661 when he wrote
of bone lace that 'Much of this is made in and about Honiton, and weekly
returned to London.' It has sometimes been assumed that this meant that the
lace was sent to London, but it does not seem possible to deduce conclusively
from Fuller's words the nature of the method of conveyance. It could have
been taken by the manufacturers, or consigned to carriers or fetched by the
London dealers. In view of the facts that a parcel of lace represented a
considerable sum in a small bulk and that evidence from later in the century
points to the manufacturers taking the lace to London it is possible that
Fuller's comment should be interpreted in this sense.

John Pinney of Bettiscombe, in west Dorset, who combined the activities
of a minister of religion with that of lace manufacturer, wrote[2] to his daughter
Rachel, who was dealing in lace in London, on 28 March 1679 that 'We have
sent a pcell of 4 pieces of lace to Mr Hill to Exchange for thred ...' but
does not specify the means he used to send it. However when writing to her
again on 31 July 1682 he stated that 'Your mother sent you a parcell of lace
last Saturday Senight by old Clarke' and when writing to his daughter Hester,
also dealing in lace in London, on 4 September 1682 he stated that 'There
was sent to you a parcell of lace by Morris as I understand last week.' These

observations suggest that Pinney made use of agents to get the lace from Dorset to London, though their precise status is not clear.

It is apparent, however, that at this period provincial lace manufacturers brought their wares to London, for in 1686 the Lord Mayor and Court of Aldermen gave a licence[3] to Thomas Powell, a citizen and mercer of London, for country chapmen, not being freeman of the city, to sell country lace at first hand at Thanet House in Aldersgate Street. The licence ran for twenty one years from Christmas 1686 and Thomas Powell petitioned the Lord Chancellor for a licence under the great seal to hold the market at Thanet House or 'any other convenient place in Aldersgate on the days usual in London'. It appears that Thomas Powell was granted his wish for it was recorded on 5 February[4] that the conversion of Thanet House into an exchange for the lacemen was being carried out, and that all who brought lace from the country would be able to expose it for sale for two days a week, Mr Powell having been granted a patent for it.

Mr Powell's scheme was not without its critics. In 1707 when the House of Lords came to consider the bill which in due course became the act (5 Anne c17) which repealed all laws prohibiting the importation of thread lace, a petition was received which protested at a clause which had been inserted during the debate in the House of Commons.[5] The petition was worded as follows[6]

> Petition of several makers and buyers of English lace in behalf of themselves and many others. Petitioners are informed that there is a clause inserted in the bill whereby they are confined to sell their lace only at such place or places as the Lord Mayor and Aldermen of London have licenced within the liberties of London, which clause although it seems to insinuate as if the same would be an ease and advantage to the country lace buyers and lace makers, yet it tends only to the particular advantage of one Mr Powell, who for his own private lucre and gain has been for several years past endeavoring to bring all the country lace makers to his own house in Aldersgate Street and, in order there unto, has used many indirect practices to the grevious vexation and trouble of several of them, whereas, in truth, if the said clause pass it will be greatly detrimental to all the country lace buyers and lace makers. The said clause was brought in at the Committee of the House of Commons unknown to the Petitioners when they were in the country and so could not oppose it.

There were seventy seven signatories to this petition and the House decided that the offending clause should be expunged.[7] The Commons agreed[8] and

the bill became law without it. It may be noted that when the clause was inserted one of the tellers for the yeas was Sir Walter Yonge, member for Honiton, but it is possible that he had not had the opportunity to be briefed adequately by the manufacturers of the Honiton lace industry.

Apart from problems with Mr Powell, the provincial lace manufacturers ran into other difficulties with the distribution of their products in London. In 1697 legislation was enacted (8 and 9 William III c25) whereby a licence, costing £4, was required by '. . . every Hawker, Pedlar and petty Chapman, or any other trading Person or Persons going from Town to Town or to other Men's Houses, and travelling either on Foot or with Horse . . . carrying to sell or exposing to Sale any Goods, Wares or Merchandizes . . .' In the event of anyone being '. . . found trading as aforesaid without or contrary to such Licence, such Person should for each and every such Offense forfeit the Sum of twelve Pounds, the one Moiety thereof to the Informer, and the other Moiety thereof to the Poor of the Parish wherein such Offender should be discovered:' This act, as no doubt was intended, stimulated the activities of informers and it was not long before they turned their attention to the lace manufacturers whilst engaged in their distribution activities. It fell to the lot of Edward Hooton of Newport Pagnell to take up their cause and on 13 March 1699 he sent a petition to Parliament[9] on behalf of himself 'and great Numbers of other Persons in their Trade and Dealing . . .' He complained that the petitioners and their agents in travelling to sell their wares by wholesale to shopkeepers who then sold by retail '. . . are frequently disturbed and oppressed by Informers, or pretended Officers of the Commissioners for Transportation; sometimes forcibly taking away their Goods, and refusing to deliver them, without considerable Sums; which they have been forced to comply with:' The House of Commons referred this petition to a committee which included among its number Sir William Drake and Sir Walter Young, the members for Honiton.

The committee reported back to the House[10] on 6 April and informed the members that a Mrs White, who kept a milliners shop in the Minories, had deposed that when wholesale lacemen, especially Hooten and Stoaks, had come to her shop they had been seized by the commissioners officers and taken before a Justice of the Peace, and that she had sent them money to give to the officers to release them. Hooten had stated that he had twice been taken up by Briggs, Lindsey and Scott, three of the officers, once in the street and once at Mrs White's premises. In each case the Justice had discharged him. Richard Gournay had stated that Stoaks had been taken up and that he gave the officers a pistol and half a crown to discharge him and prevent being taken up again that night. Evidence for blackmailing activities of this kind

was given by other witnesses for Thomas Pigdall secured his release by paying over a pound in money and a piece of lace worth ten shillings, John Arrowsmith by paying thirty shillings in money, Thomas Hard by giving the officers half a crown each and Edward Spencer by giving them two guineas.

Briggs was examined by the committee and stated that the commissioners paid no distinct wages, deeming the amount to be paid to informers to be sufficient. He complained that when he carried lacemen before the Justices they swore that they were wholesalers and were discharged, so that he did not receive the money envisaged. Hooten, recalled, stated that Briggs had told him that if they, the lacemen, would raise him a sum of money, he would burn his licence and follow it no longer.

Having listened to this unsavoury story the House resolved

> That the Workers of Bone-lace, his, her, or their children, apprentices, Servants, or Agents, and all wholesale Dealers in the said Manufacture, though they go from show to shop, to any their Customers who sell the same again by retail, shall not be deemed Hawkers and Pedlars, by the Act made in the Ninth and Tenth Years of his Majesty's Reign.

Such a decision by the House was insufficient to ensure that this view of the act would prevail, since interpretation of the law is a function of the judiciary, and what was needed was an amending act. Such an act (4 George I c6) was eventually passed in 1717 and incorporated to a great extent the wording of the resolution of 1699.

This evidence indicates that the procedure for the distribution of lace from the East Midlands area, at least, to London was one of taking rather than sending. Similar evidence for this method is found in the report made to the House of Commons[11] on 6 March 1700 by the committee appointed to examine the petition of the clothiers of Salisbury, together with other related petitions. Edward Hooten again appeared and stated that he bought in Newport Pagnell and sold in London, whilst Thomas Robinson stated that there were two hundred lace dealers in Buckinghamshire of whom about one hundred and fifty went to London every week. It is of interest, however, to note that Mr Clarke of Salisbury stated that he and his partner sent between sixty and eighty pounds worth of lace per week from Salisbury to London. This does not necessarily imply that they consigned the lace to carriers but could well have made use their '. . . Children, Apprentices, Servants or Agents . . .' specified in the Act of 1717 to '. . . go from House to House, and from Shop to Shop, to any of their Customers (who sell again by wholesale or

Retail) . . .'. Apart from the evidence of the various witnesses, the wording of the Act of 1717, which was due in part to the work of the members for Honiton, makes it clear that at this period the general method for the distribution of lace was for local people, either the manufacturers or their agents, to convey it to London rather than consign it to a third party for carriage.

During the second half of the eighteenth century and the earlier years of the nineteenth a number of books relating to travel and commerce were published and nine of these have been identified in which the entries for Honiton make reference to the distribution of lace. The earliest, by Bowen in 1747, refers to '. . . lace, the broadest sort that is made in England; of which great quantities are sent to London' but the comments by Postlethwayt in 1774, in the Universal British Dictionary in 1792 and by Evans in 1810 so closely resemble this observation as to leave no reasonable doubt that they are copied from each other or from a common source. All refer to the lace as being sent to London but give no indication as to the actual mechanism of transportation.

The observation of Britten and Bayley in 1803 was that 'The chief article of manufacture is broad lace and edgings, considerable quantities of which are disposed of in the Metropolis', and the comments by Crosby in 1818, by Robins in 1819, by Anon in 1830 and in the Penny Cyclopaedia in 1838 appear to be derivitive from this. Although all identify the market as London none gives any indication of the method whereby the lace reached there.

The Milles parochial returns[12] of 1755/56 also make some reference to the distribution of lace in the case of four parishes:-

> Honiton. '. . . the lace is chiefly disposed of in London, Bath and other noted places.'
> Ottery St. Mary. '. . . the lace is mostly sent to London, Bath etc.'
> Sidbury. '. . . the lacemakers are employed by persons of Honiton who sell their laces at London and Bath chiefly.'
> Sidmouth. '. . . there are lace gatherers who dispose of it at Bath and London.'

Here again there is no statement as to how the distribution was effected, though the entry for Sidmouth could plausibly be interpreted as indicating that the manufacturers, having collected the lace from the workers, took it to Bath and London for disposal.

In the first half of the nineteenth century Abigail Chick ran a business as lace manufacturer in Branscombe and Margaret Tomlinson in her study of

the Chick family[13] has concluded that Abigail travelled long distances to sell her lace at centres of fashion. A family record relates that on one occasion a servant, John Parrett, carried her pack of lace to a convenient place for boarding a coach, probably Honiton or Axminster. She asked him if he knew the value of the load and when he declined even to guess told him that it was seven hundred pounds. This would have represented a substantial fraction of Parrett's lifetime earnings, so it is no wonder that he remembered the incident to relate it as an old man, or that Abigail took a package of such value herself rather than entrust it to a carrier. In 1833 she was in Brighton and placed the following advertisement in the Brighton Herald for 9 February 1833:

<div align="center">

MRS. CHICK

HONITON LACE MANUFACTURER

AT MISS. PHILCOX'S MILLINERY ESTABLISHMENT

No 8, KINGS ROAD

</div>

Returns her thanks to the Public for the kind and liberal support which she has experienced since her residence in Brighton, and begs to inform them that she has received a large and elegant assortment of Borderings and Sprigs, of every description, ready-trimmed Laces of all widths, Habit skirts black and white Voils, Dresses, Cansous, and Pelerines, Falls for Bonnets, Infants' and other Cap. The whole of the best manufacture, and after the first fashion.

Mrs Chick respectfully solicits an early inspection of her Goods, as the sale will continue but a short time.

It is apparent that Abigail combined the roles of lace manufacturer, distributor and seller.

Abigail Chick's wide ranging travel was emulated by others, for in 1856 Roberts[14] recorded the mid-century revival, stating that 'The trade revived, and affords a good livelihood to many thousand hands, the majority of the female labouring population. Sidmouth, Beer, Branscombe, Colyton, and Honiton are the residences of many workers and dealers, some of whom travel through England.'

The development of the railways with the consequent ease and reliability of travel both for persons and goods was reflected in the 1860s when various forms of method of distribution of lace are recorded. It is evident that the Tuckers of Branscombe[15] made use of the post for on 6 January 1860 Samuel Tucker in London wrote to his sister Mary in Branscombe 'Please send by return of post in Box tomorrow all the rose pattern Collars you have ab[t]

10/-. I mean drawings . . .' That posting extended to the lace itself is shown by a letter to Mary Tucker from Ann Maria Plackeekre at an indicipherable address in France, probably in 1856, in which she wrote 'I have just received the collar you sent me which I find very pretty, if you have not forwarded the others to me when you get this send them by post to my Mother at her address, Mrs Hall, 6 Bedford Place, Church Lane, Kensington . . .' In another letter dated 12 September 1856 she wrote '. . . am going to get you to send me over two other pretty Honiton lace collars, different patterns, (to give away).'

In the 1860s Samuel Chick, Abigail's grandson, resided in London as agent for his father, then in business as a lace manufacturer in Sidmouth, and sold lace to London dealers.[16] How the lace reached Samuel is not clear but could well have been by railway for he is recorded as using this method of travel when he himself took lace to customers in Edinburgh, Glasgow, Huddersfield, Hull, Manchester, Liverpool and Wolverhampton. Lady Trevelyan also used the railway for on 21 May 1853 she wrote[17] to Octavius Hudson that 'I have just sent to you by G Western railway the collar you gave me to me to make [sic]'.

The use of the railway was not, however, entirely satisfactory as Mrs Treadwin found to her cost. The *Exeter Flying Post* for 29 January 1868 stated that she had sent a corperal worth £20 to the Clerical Congress Exhibition in Norwich and that it was mounted in a gilt frame, which was enclosed in a deal box. On the return journey the box was known to have reached Reading after which all sign of it was lost. Mrs Treadwin decided to sue the railway company and the result of the subsequent proceedings was described thus

> . . . at the trial it was held that the plaintiff could not recover for the lace, because its value had not been previously declared. Consequently a verdict was entered for the plaintiff to this extent: 28s for the gilt frame and 7s 6d. for the case. In the Court of Common Pleas on Saturday cause was shown against the rule being made absolute. On the part of the defendents it was argued that the frame and the packing case were merely accessories to the lace, and must, therefore, be ruled to be themselves within the exceptions in the Carriers Act. The Lord Chief Justice said that the question of the gilt frame depended upon the matter of fact whether the frame was part of the corperal; and he had come to the conclusion that the frame was a separate and distinct article from the corperal itself. The corperal was placed in the frame merely for the exhibition of the work, and not for the purpose of use to which the piece of lace was intended to be applied. Another question might arise: whether the frame was so connected with the glass as to be part of it, within the

meaning of the Carriers Act? But, in his opinion, the frame was the principal, and the glass the accessory, and that protection given by the Act in respect of the glass could not be extended to the frame. As to the packing case, as that contained not only protected articles but also the gilt frame, there could be no protection as to the packing case. The verdict, therefore, in respect of both articles would stand, and the rule would be discharged. Mr Justice Byles concurred. Mr Justice Willes, however, could not arrive at the same conclusion as the rest of the court. The governing intention of sending the lace to the exhibition was the foundation of the whole transaction, nothing would have gone unless the lace went; and the other things were, he thought, accessories to the lace. Rule discharged.

There is no record of what the costs of all this were but they must, surely, have greatly exceeded the value of the loss, though from the point of view of the Great Eastern Railway the principle at stake may, in their opinion, have justified the expenditure. There is equally no record of whether Mrs Treadwin entrusted any further pieces of lace to transport by rail.

It is apparent that, even before Mrs Treadwin's experience, the manufacturers were consigning lace for distribution to third parties as carriers, for in 1830 Parliament passed the Carriers Act (11 George 4 and 1 William 4 c68) as a measure to protect the operators of '. . . public Mails, Stage Coaches, Waggons, Vans and other Public Conveyances by land . . .' in cases where '. . . Articles of great Value in small compass . . .' were consigned. It was enacted that no such carrier should be liable for loss if the value of the contents of a package exceeded ten pounds unless the value had been declared at the time of consignment. A list of articles covered by the act was given and this included lace. The development of the machine made lace industry with the consequent production of lace which could not be regarded as an article of great value in small compass led to an amending act (28 and 29 Victoria c94) in 1865. This stated that for purposes of the Carriers Act the term lace should '. . . be construed as not including Machine-made Lace.'

It may be concluded, therefore, that the method of distribution varied somewhat over the years. In the mid seventeenth century the system is uncertain, and though in the 1680s there is evidence of conveyance by agents, in the late seventeenth century and early eighteenth there is ample evidence to show that the lace manufacturers themselves took the lace to London, then the chief market. Through the main part of the eighteenth century the method is again uncertain but, since there is evidence for conveyance by the manufacturers in the first half of the nineteenth, it is possible that this procedure persisted. The improvements in communication and transport in

the nineteenth century evidently led to a diversification in methods and there is evidence of consignment to carriers by road, to the developing railway system and to the postal service.

It has sometimes been suggested that the name 'Honiton lace' is derived from the method of distribution, the idea put forward being that the lace was consigned by coach from Honiton and that the London dealers in meeting the coach would ask for the boxes from Honiton. This theory seems to be quite modern and appears to be derived from a lecture on the lace industry given by Mr A.A. Carnes, of Bedford, in Taunton (Pulmans Weekly News 20.3.1923). In the course of this, admitting that he had no idea why Honiton lace was so called, he put forward this speculation. It was put into print in 1951 by Coxhead,[18] who discounted the story. A reporter in the *Express and Echo* for 12 October 1956 repeated it and it was later mentioned, in 1971, by Inder[19] who likewise discounted it. There appears to be no contemporary evidence to support it, and the fact that all definite evidence on distribution methods until well into the nineteenth century points to the lace being taken to London by the manufacturers themselves, or their agents, suggests that the theory, like that of the Flemish refugees, is without foundation.

The retailers in the lacemaking area

In the nineteenth and twentieth centuries a number of the manufacturers also kept shops for retail sale of their products. Amy Lathy, the holder of the royal warrant from Queen Adelaide, inserted an advertisement into the *Exeter Flying Post* of 19 August 1830 (2c) which stated that '. . . Amy Lathy, Lace Manufacturer, Honiton, Devon, has on SALE an elegant Assortment of VEILS, PELERENES, CAPS, CUFFS, a great variety of SPRIGS BORDERS, &c, &c. . . .', and *Woolmer's Exeter and Plymouth Gazette* for 10 September 1831 (3b) refers to the windows of Miss Lathy's shop.

Mrs Treadwin of Exeter advertised many times in the *Exeter Flying Post* and the wording clearly shows that this well-known Honiton lace manufacturer sold by retail from her premises in the Cathedral Close. She not only sold the lace to callers but her advertisement of 15 March 1849 (4d) states that 'Orders by Post attended to and punctually forwarded' and that of 3 November 1859 (4e) indicates that she also sold millinery, coiffeurs and ribbons which she obtained from Paris. Another manufacturer in the cathedral close was H. and F. Davis, whose advertisement in the *Exeter Flying Post* for 18 March 1830 (2c) stated that:-

H. and F. Davis, Manufacturers of HONITON and BRITISH LACE,

&c. beg respectfully to inform their Friends, that a MALICIOUS REPORT has been circulated that they had left Exeter and declined their Business, they take this method of informing the Public that such a report is utterly false. That they continue to sell HONITON SPRIGS and BORDERS, for Veils, Caps, &c., at their old-established Shop, in the Cathedral-Yard, where they have carried on the Business for 23 years.

Mrs C. Hayman of Sidmouth placed advertisements for her shop on the Esplanade in the *Sidmouth Journal and Directory* monthly from September 1866 to March 1876 and in these she described herself as lace manufacturer. She made particular mention of her successes in the Bath and West of England Agricultural Society's shows, in which she had exhibited and won prizes for pieces made under her direction. Mrs Allen of Beer likewise combined the role of manufacturer with retailing and the *Express and Echo* for 12 October 1956 reporting an interview for her eightieth birthday stated that 'she has had a lace shop in Beer for 45 years . . . has been making and designing lace for 60 years . . . At one time Mrs Allen had 90 lacemakers working for her, among them two men.' In the case of Mrs Fowler of Honiton pictorial records of her combined activities have survived in the form of a letterhead [Plate 93], in which she describes herself as a lace manufacturer.

It is evident that these well-known manufacturers were not the only ones who also sold retail in the nineteenth and twentieth centuries, but the entries in the various Devon directories are equivocal, making it impossible to identify definite distinctions between manufacturers and retailers. As an example Mrs Elizabeth Hutchings of Exmouth is designated 'Honiton lace dealer' in *Kelly's Post Office Directory of Devonshire 1866*, 'Honiton lace manufacturer and dealer' in *Morris's Directory of Devonshire* 1870, 'Honiton lace dealer' in *Kelly's Directory of Devonshire* 1873 and 'Lace manufacturer' in *Whites History Gazetteer and Directory of the County of Devon* 1878.

An example of a man in the area who appears to have been purely a retailer is John Hitt of Woodbury. The *Exeter Flying Post* for 17 December 1779 (2d) carried the following notice:

> To be sold by Public Auction by Thomas Coffin, At the late Dwelling-House of John Hitt, Laceman and Shopkeeper, deceased, in the Parish of Woodbury, about Six Miles from Exeter, on Monday the 27th Day of this Instant December, and the following Days—All the Genuine Stock in trade of the said deceased, consisting of a Variety of Lace, Linens, Woollens, Groceries, and Haberdashery Goods, together with the Household Furniture belonging to the said deceased. The sale to begin each Day at Ten o'clock in the Forenoon.

The sale evidently did not proceed uneventfully for the same paper of 31 December (2c) carried a further announcement:-

> The Creditors of John Hitt, late of Woodbury, in Devon, Laceman and shopkeeper, deceased, are desired to meet Mr William Huxham, his Administrator, on Wednesday the 5th Day of January next, at Four o'Clock in the Afternoon, at the Globe Tavern in Exeter, relative to a Claim made by Mr Guard of Honiton, Lacemaker, of a Quantity of Lace which was in the Custody and Possession of the said deceased at the Time of his Decease, to take the same into their Serious Consideration.

The outcome of Guard's claim is not recorded, but the sale of the effects was again announced in the issue for 21 January 1780 (3a) to be '. . . absolutely Sold without Reserve, to the highest Bidder.'

The general picture is, however, one of manufacturers in the area engaging in at least some retailing, and it is possible that this dual activity represented a tradition in the industry. It could be, therefore, that such people as James Rodge, described as a lace seller on his tombstone of 1617 in Honiton churchyard, and James Minifie and Raynbourne Thomas, described as lace sellers in 1655 and 1656 respectively in the Honiton church registers, operated in this way. The same could apply to John Guard, John Stocker and William Stocker who were decribed as lace merchants in Honiton in 1763,[20] though John Guard evidently was a wholesale supplier to John Hitt. It is not clear whether it applied to 'Mr Aberdein and Messdms Tuckett and Martin' of Honiton who, in the report concerning the relief scheme for the local lacemakers printed in the *Exeter Flying Post* for 27 February 1817 (1c,d), are described as the principal manufacturers of Honiton lace, and who would '. . . immediately deliver lace to the Subscribers to the amount of their Subscription, at the wholesale prices . . .'. It is not apparent from this whether they normally sold by retail or wholesale, for this was clearly a special case. The obituary notice for Mrs [sic] Tuckett in the same newspaper for 14 November 1833 (2e) describes her as a '. . . spinster (lace manufacturer above 60 years) . . .' which leaves the matter undecided, both as to her business and her marital status.

The retailers outside the lacemaking area

The retailers to whom the lace manufacturers sold their products followed a variety of occupations, but these were, as is to be expected, associated in some way with clothing. Robert Bamford in 1667 is described as merchant

taylor (haberdasher by trade)[21] and William Taylor in 1692 as weaver (haberdasher by trade)[22] and the contents of their shops included 'Devonshire' lace and 'Westcountry' lace respectively. Hester Pinney in 1689 combined lace selling with sewing and the washing of linen and lace[23] whilst Mrs White of the Minories described herself in 1699 as a milliner.[24] In the next century John Wood of Bath[25] referred to the connection of lace with the business of the milliner when he wrote 'By this Lace the Milliners Business is not a little enhanced, Suits of Wedding Cloaths for the Ladies, from far and near, being constantly making in the Shops of the City:' and later still it was at Miss Philcox's millinery shop that Abigail Chick's lace was offered for sale (*Brighton Herald* 9 February 1833). In 1862 Haywards of Oxford Street,[26] described as lacemen to the Royal Family, advertised themselves as supplying British and foreign lace, linen, robes, mantles and Paris millinery.

During the period of the Napoleonic wars, the lace retailers were subjected to a special tax (46 George III c81, 1806) by being required to take out licences at a rate of 5s per annum for retailers of British lace and £3. 3s. for retailers of foreign lace. This war-time revenue raising measure was not repealed until the Statute Law Reform Act of 1872. The extent of the retail lace trade is shown by the surviving return for the year ended 5 January 1826[27] which gives 2975 dealers in British lace and 74 in foreign, though, since this was a period when the hand made lace industry was in a very depressed state, it is probable that much of the trade carried on by these retailers was in machine made lace.

It is evident that some of the retailers tended to make the sale of lace a major feature of their business and such traders were often referred to as lacemen. A number of these major lace retailers received royal orders and some of them were granted warrants as suppliers of lace. Those who have been identified in the Lord Chamberlain's records[28] are listed in Table 13.1, and in addition to these there were thirty six appointments of suppliers of gold decorative braiding as gold lacemen in ordinary.

Table 13.1 Royal Warrants to Lacemen (excluding gold and silver lacemen) in royal wardrobe accounts

Date	Name	Place	Designation
10.11.1714	Mr Jno. Turner	—	Laceman in ordinary
9.1.2.1782	Mr Edd Parker	—	Silk laceman
5.4.1820	Mr William Winter	—	Silk laceman in ordinary

5.4.1820	Messrs John Howell & Isaac James	—	Furriers and lace merchants in ordinary
14.8.1830	Messrs James Birgh & James Birgh Jnr.	—	Silk lacemen in ordinary
11.8.1837	Mr Henry Dison	—	Principal laceman in ordinary
11.8.1837	Messieurs John Howell, Henry Gillett, Thomas Stroud, Charle Lee & William Sedgewick trading under the Firm of Howell, James & Company	—	Silk mercers and lacemen in ordinary
12.8.1837	Messieurs Anthony Harding & Samuel Smith	—	Lace merchants, silk mercers etc. in ordinary
27.2.1838	Mr William Turner Hayward	—	Laceman in ordinary
8.5.1838	Mrs Sarah Peers	Bedford	Dealer in lace in ordinary
3.11.1843	Mons. Joseph Jean Vanden Abeele	Ostend	Laceman
18.4.1845	Mr James Forrest	Dublin	Laceman and silk mercer
5.1.1847	Mrs Jane Clarke	London	Lace merchant

In the reign of Queen Victroria the royal wardrobe accounts make a distinction between lace and embroidery until the year 1849, but not thereafter. Table 13.2 shows the annual sums paid for lace in the years 1837 to 1849 to the lacemen who were warrant holders, to other lacemen and to the lacemakers, essentially the Honiton lacemakers Miss Bidney and Mrs Esther Clarke. Jane Clarke is little involved since she did not receive her appointment until 1847, though why she was so honoured when apparently she supplied no lace until two years later is not clear, but Henry Dison received orders in all but one year in the period. Nevertheless lacemen who were not warrant holders supplied lace to a value almost twice that received by Dison, and it appears that the Queen by no means confined her purchases to those to whom she had granted warrants, either as lacemen or as lacemakers. During the period from 1837 to 1842 when the Queen made purchases of Honiton lace from Miss Bidney and Mrs Esther Clarke her payments to them amounted to 43 per cent of her total expenditure on lace, which gives substance to claims such as that in *Woolmer's Exeter and Plymouth Gazette* for 10 June 1843 (3c) that the Queen was a notable patron of the

Honiton lace industry. It is, however, clear from the table that patronage at this level was not sustained, though some may be hidden in the amounts paid to the lacemen, for the advertisement by Haywards in the catalogue of the 1862 London International Exhibition shows that the firm sold Honiton lace among others.

Table 13.2 Payments (£.s.d) to royal warrant holders for lace in the years 1837–1849[a] in royal wardrobe accounts

| Year | Lacemen by appointment | | Other | Lacemakers by appointment | |
	Henry Dison	Jane Clarke	lacemen	Miss Bidney	Mrs Clarke
1837	38.16. 6	—	—	12.12. 0	66.16. 0
1838	161. 4. 2	—	115.10. 0	168.16. 0	140.17. 0
1839	143. 1. 0	—	92. 5. 5	34. 0. 0	210. 0. 0
1840	56.14. 6	—	237. 4. 2	250. 0. 0	86. 1. 0
1841	25.19. 6	—	481.19. 6	—	25.10. 0
1842[b]	76. 6. 1	—	64.15. 4	62. 0. 0	68. 1. 0
1843	60. 5. 8[c]	—	—	—	—
1844	22.10.11	—	46.12. 5	—	—
1845	—	—	72. 4. 3	—	—
1846	9.10. 0	—	44.13.10	—	—
1847	40.10. 6	—	76. 0. 0	—	—
1848[d]	87.13. 4	—	210. 6. 3	—	—
1849	30.17.10	16.10.6	37. 4.11	—	—
Total	753.10.0	16.10.6	1478.14.1	527.8.0	597.5.0

Notes:

a The accounts in subsequent years do not permit separation of payments for lace from other items.

b In this year there was a payment also to Mrs Darwall, of £16.5.0 in respect of Honiton lace.

c This figure is for three quarters only.

d In this year there was a payment also to Miss Dobbs (Mrs Treadwin) of £7.7.0 in respect of Honiton lace.

Apart from granting warrants to lacemakers and lacemen Queen Victoria also appointed Mrs Lydia Amelia Curling to be Lace Cleaner in Ordinary on

12 August 1837. The association with the Curling family continued until the Queen's death, for Mrs Curling was joined by her daughter in 1842, to become L.A. Curling and Daughter, the daughter, E. Curling, continued alone from 1856 until 1868 and thereafter the service was supplied by Curling and Lawrence. At intervals between 1844 and 1866 some cleaning was also undertaken by A. Burdock who, however, is not recorded as being a royal warrant holder.

The queen's expenditure on keeping her lace in order (Table 13.3) averaged around £40 per annum until the middle 1850s, then rose in the next five years to nearly £55, but thereafter more or less steadily declined for the rest of her life. The decline may be associated with her widowhood and advancing years when she would not have worn lace to the same extent as when a young woman with a full social life. Whether the Curlings were ever entrusted with the major items of Honiton lace, the Queen's wedding flounce and the royal christening robe, is not known. Perhaps not since the mark on the veil visible in [*plate 24*] is equally visible in modern photographs.

Table 13.3 Payments (£.s.d) by Queen Victoria for cleaning of lace in royal wardrobe accounts

Year	Amount	Year	Amount
1837	1. 7. 8	1870	41.10. 4
1838	46. 1. 4	1871	36. 1. 8
1839	44. 2. 2	1872	38. 5. 4
1840	49.13.10	1873	36. 6. 5
1841	47.13. 1	1874	36. 7. 7
1842	39. 0. 7	1875	34.10. 0
1843	32. 8. 7	1876	33. 6. 5
1844	36.15. 0	1877	33.12. 5
1845	52.17. 1	1878	27. 3. 0
1846	47. 5. 1	1879	18.14. 3
1847	48.14.11	1880	21.11. 2
1848	25. 0. 1	1881	22.15. 3
1849	34. 9.10	1882	21.14. 0
1850	24.15. 4	1883	20. 7. 7
1851	36. 0. 9	1884	16. 4. 5
1852	43.12. 4	1885	19. 7. 4

1853	29.12. 9	1886	26.12. 4
1854	53. 9. 7	1887	24.11.10
1855	55.19.11	1888	20. 2. 0
1856	63. 8. 2	1889	18.17. 9
1857	54. 9. 3	1890	14.14. 4
1858	42.19. 9	1891	15.16. 7
1859	59.12. 5	1892	13. 0. 8
1860	45.11. 7	1893	12. 7. 9
1861	29. 8. 8	1894	12. 9.10
1862	32.19. 7	1895	13.19. 6
1863	45.16.10	1896	15. 9. 6
1864	39. 9. 7	1897	16.15.10
1865	38.19. 4	1898	15. 3. 5
1866	50.17.13	1899	17.11. 7
1867	33. 8. 8	1900	15. 3. 4
1868	30. 1. 4	1901	1.16. 0
1869	8. 9. 4		

Markets

The history of English lacemaking and costume contains no parallels with the peasant laces widespread on the continent, but this may well be a consequence of the lack of development of a national costume. English lace, and particularly the high quality products of the Honiton industry, tended therefore to find an important part of their home market in the centres of fashion of which the capital, London, was the chief. There are numerous references to Honiton lace finding its way to the London market, such as Fuller's observation in 1662 that it was 'weekly returned to London', the London haberdasher Robert Bamford's inventory[21] of 1667 which included 'Devonshire lace', Hester Pinney's sales of her father's lace[23] in 1682, the London haberdasher William Taylor's inventory of 1691[22] which included 'Westcountry lace', the Milles returns of 1755/56 which refer to Honiton lace being sold in London, the long list of travel and topographical writers in the eighteenth and nineteenth centuries who refer to London as the market and on to the nineteenth century lacemen's advertisements such as that of Haywards in 1862, together with John Tucker's entries in the various Devon directories from 1852 to 1873 which show that he had an establishment in London for the sale of his lace.

In the eighteenth century various spa and seaside towns became fashionable resorts for the well-to-do, led by Bath during the period of Beau Nash from

1704 to 1761. It is not unexpected, therefore, to find that this town was, at this time, a considerable market for Honiton lace, so much so that, for a time it became known as Bath lace. There are no records whether George III's patronage of Cheltenham and Weymouth gave rise to markets for Honiton lace at the time, though later,[29] in 1848, Samuel Chick of the East Devon lace manufacturing family was in business at the latter as a Honiton lace dealer. His mother, Abigail Chick, was selling Honiton lace in Brighton[30] in 1833, the town made fashionable by George IV when Prince Regent.

In the nineteenth century the increase in wealth in the northern manufacturing towns led to further markets, but the industry was by then in decline and Alan Cole[31] in 1887 records that an Otterton lace manufacturer had informed him that there had formerly been a good trade with the North of England 'but this had been destroyed, probably by Nottingham machines and foreign laces.'

There is evidence for a varied export trade and that concerning France in the seventeenth century is considered in detail in Chapters 4 and 11. The Pinney family correspondence[32] shows that in the late seventeenth century John Pinney marketed his own products in Dublin, whilst his son Azariah used his exile to sell them in Nevis.[33] East Midlands lace also found a transatlantic market at this time for in 1700 John Smith testified[34] to a House of Commons committee that he sent lace to Jamaica. In 1679 an unknown traveller[35] described Spanish ladies as wearing the finest English lace which was also used to trim the sheets of a princess and the curtains of her carriage.

Although these references provide evidence for an export trade, in particular in the seventeenth century, it is not possible to make any estimate of its magnitude. No business records of a lace merchant or dealer are known to have survived, even from recent times, and, although port books contain ome references to consignments of haberdashery these do not specify whether lace was included.

Prices

Information on the selling price of lace in the seventeenth and sighteenth centuries is scarce, but a number of values from a variety of sources are given in Appendix 6 Table 1. It is possible from these to make a comparison between the prices of Honiton and Buckinghamshire lace in the second half of the seventeenth century and a summary of the relevant figures is given in Table 13.4. Not all values are strictly selling prices since those for 1667 and 1691 are derived from inventories, but this does not affect conclusions on relativities. It will be seen that the Buckinghamshire lace is always cheaper

and the average difference is about threefold. This could reflect an average difference in width, since the Honiton free lace could be made in wider strips than could the Buckinghamshire straight lace. However the various encomiums expressed on the quality of the products of the Honiton lace industry at this time suggest that the differential is a reflection of a difference in quality, and this idea receives some support from the comparability in value between the Flemish lace of 1658 and that of the Devonshire only nine years later. The price of the French trolly lace of 1691 illustrates the marketing of a cheaper lace, though its lowest price is the same as that for Buckinghamshire.

Table 13.4 Prices of Honiton and Buckinghamshire lace from Appendix L

| Year | Description | Price per yard | | |
		min	max	mean
1655/8	Black, black bone lace	1s	10s 6d	3s 11d
"	Black Flanders	1s	11s 6d	5s 8d
1667	Devonshire	5s	12s 0d	8s 10d
"	Buckingham			5s
"	Narrow lace	7d	8s 0d	1s 4d
1691	Westcountry	10d	6s 0d	3s 3d
"	Buckingham	4d	4s 3d	1s 0d
"	French trolly	4d	8d	5d
1698	Devonshire	—	£6	—
"	Buckingham	—	30s	—
1700	West of England	£3	£6	£4 10s
"	Buckingham	10s	36s	23s

The mean value is the weighted mean taking into account the yardage of each priced length in the sample

Appendix 6 Table 4 gives comparisons between minimum and maximum lace prices and the price of selected household commodities, as well as the wages of labourers and craftsmen whose earnings were in the same range as the people who made the lace. It is very apparent that the lace could only have been marketed among the better-to-do section of the community and this applies in particular to the products of the Honiton lace industry. It clearly could not have been afforded by those who made it and even a yard

of the cheapest French trolly lace in 1691 would have required some 30 per cent of a labourer's daily wage, an impossible amount to afford for such a luxury from a very tight budget. This does not mean that the less well off never had any lace since, when pieces went out of fashion they, like clothes, would find their way down the social scale.

Some prices from the nineteenth century are given in Appendix 6 Tables 2 and 3 and these serve to confirm the continuation of the situation that those who made the lace would not have been able to afford to buy it. It is apparent, however, that at this period there was an exception to this owing to the development of the technique of appliqué on machine made net. Pieces of net were available for a few pence and the cheapest motifs could be obtained for a penny or even less each. This led to the possibility of a quite a poor girl building up a modest collection of motifs and so making herself a veil for her wedding. An instance of this in a tradesman's family is described in Chapter 10 and the survival of appliqué veils sprinkled with few motifs of indifferent quality suggests that the habit stretched well down the social scale.

References

1. Fuller, I p396.
2. Nuttall, p5, 13, 14.
3. CSPD, 1687, p352.
4. CSPD, 1687, p359.
5. CJ, XV p315.
6. HMC, vii (New Series), p68.
7. LJ, XVIII p287.
8. CJ, XV p351.
9. CJ, XII p583.
10. CJ, XII p633.
11. CJ, XV p315.
12. Milles.
13. Tomlinson, p18.
14. Roberts, 1856, p381.
15. DRO, 1037 M/F2/1.
16. Tomlinson, p56.
17. Trevelyan MSS.
18. Coxhead, 1952, p35.
19. Inder, p3.
20. Roll taken . . .
21. CLRO, Orphans inventories—Robert Bamford—347A, 20.6.1667.
22. CLRO, Orphans inventories—William Taylor—2197, 6.1.1691/2.

23. Nuttall, p66.
24. CJ, XII p633.
25. Wood, II p436.
26. Catalogue of the International Exhibition, London, 1862, p70.
27. Parliamentary Papers, 1826-27, (124) xvii, 31.
28. PRO, LC3/63, LC3/67, LC3/69, LC3/70, LC13/2.
29. Directory of Dorset, 1848.
30. Brighton Herald, 9.2.1833.
31. Cole, 1888.
32. Nuttall, p13, 16, 17, 23, 31, 37, 44, 47.
33. Pares, p9.
34. CJ, XIII p269-271.
35. Anon, 1736.

Postscript

. . . a staff teacher should be appointed for the whole district of East
Devon . . . to organise instruction in lacemaking . . .

Report of County Council Sub-Committee 1902

Survival of a craft

In Chapter 7 it was shown that the Honiton lace industry had virtually died
out by 1940 and that even at that date the possibility of making a living
thereby had disappeared. However the dimise of the industry has not meant
the disappearance of the craft of Honiton lace making. In 1887 Alan Cole
had proposed that some instruction in lace making should be instituted in
the schools of the area, and in 1902 a Devon County Council Sub-Committee
had recommended that classes should be organised as evening schools.
Although these proposals were implemented they could not arrest the decline
of the industry. The teaching however was continued and played a con-
siderable part in ensuring that a practical knowledge of the craft of Honiton
lace making survived. This, allied to the resurgance of interest in hand crafts
in the third quarter of the twentieth century, has resulted in there being more
makers of Honiton lace today than for many years past. Most of the work is
carried out for the lacemaker's own interest, but periodically pieces are made
for special presentations, as for example that shown in Plate 55.

Industrial archaeology of the industry

Tangible relics of the Honiton lace industry are to be seen in museum and
private collections in the form of specimens of the lace itself. Surviving items
of lacemakers' equipment also to be seen include bobbins [Plate 89], bobbin
winders, specimens of thread, prickers, scissors, pins, prickings [Plate 84] and
patterns.

Premises occupied by notable people associated with the industry can be
identified, for example Mrs Treadwin's later establishment in the Cathedral
Close in Exeter [Plate 97], and Mrs Fowler's nineteenth century shop in
Honiton High Street. The houses of John Tucker and of Lady Trevelyan

still stand and it is likely that others could be located. Many cottages survive from the days of the industry but the task of proving which of these houses lacemakers would be very difficult.

Perhaps the finest surviving structure associated with the industry is the tomb of James Rodge, [Plate 96]. Mrs Treadwin's headstone can still be seen in the Higher Cemetary in Exeter though this, like her obituary notice, curiously makes no mention of her distinguished connections with lace. Mrs Fowler was buried in a part of Honiton churchyard which has been cleared and her headstone is not to be found among those surviving from this area. The anonymity accorded in death to these two notable pillars of the Honiton lace industry is symbolic, for its finest memorial is the exquisite products of its heyday, designed by unknown designers and worked for largely unknown manufacturers by a great army of almost unknown lacemakers.

Appendices

1. Numbers of lacemakers in East Devon.

2. Numbers of lace manufacturers and dealers in Kelly's directories of Devon.

3. Numbers of lace manufacturers and dealers in miscellaneous directories of Devon.

4. A directory of Honiton lace manufacturers.

5. A directory of Honiton lace designers.

6. The price of lace in England.

Appendix One

Number of Lacemakers in East Devon

| Parish | 1698 | Census | | | | |
		1841	1851	1861	1871	1881
Axminster	60	3	10	15	11	8
Axmouth	73	0	61	74	63	11
Awliscombe	—	0	6	6	2	3
Aylesbeare	—	0	41	22	12	5
Beer	108[1]	80	320	368	319	204
Bicton	—	35	24	26	11	0
Branscombe	109[1]	123	310	236	206	176
Broadclyst	—	0	1	2	6	2
Broadhembury	118	0	7	2	0	0
Buckerell	90	0	1	0	3	1
Clyst St. George	—	2	6	6	11	4
Clyst Honiton	—	0	4	3	1	0
Clyst St. Lawrence	—	0	0	0	0	0
Clyst St. Mary	—	1	2	7	0	0
Colaton Raleigh	—	15	120	142	95	109
Colyton	353	2	216	273	226	120
Combe Raleigh	65	0	1	0	0	0
Combpyne	—	0	8	0	7	2
Cotleigh	—	0	0	0	0	0
Dunkeswell	—	0	12	0	1	1
East Budleigh	—	61	132	213	234	102
Farringdon	—	0	6	6	2	4
Farway	70	0	36	34	3	9

Feniton	60	0	0	1	5	0
Gittisham	139	1	1	1	1	1
Harpford	—	5	12	31	21	3
Honiton	1341	114	353	191	155	59
Kilmington	—	2	20	9	18	9
Littleham	—	97	422	307	254	151
Luppitt	215	0	15	0	3	2
Lympstone	—	23	58	60	42	19
Membury	—	0	4	0	1	0
Monkton	—	0	2	0	0	0
Musbury	12[2]	1	46	45	20	6
Newton Poppleford	—	8	89	54	83	65
Northleigh	32	0	45	35	24	11
Offwell	64[3]	2	24	25	18	0
Ottery St. Mary	814	17	176	214	281	136
Otterton	—	97	223	230	302	196
Payhembury	—	2	0	0	0	0
Rockbeare	—	0	10	12	21	10
Rousdon	—	0	0	0	0	0
Salcombe Regis	—	15	21	21	32	11
Seaton	109[1]	0	98	84	47	15
Sheldon	—	0	0	0	2	0
Shute	13[2]	0	45	21	20	4
Sidbury	321	141	362	244	220	103
Sidmouth	302	47	179	146	172	97
Southleigh	45	2	55	59	22	10
Sowton	—	1	0	0	0	0
Topsham	—	0	57	70	100	30
Uplyme	—	0	4	5	5	0
Upottery	118	0	1	1	1	0
Venn Ottery	—	8	13	2	4	0
Whimple	—	0	7	9	7	1
Widworthy	64[3]	0	2	4	1	1
Withycombe Raleigh	—	21	140	129	175	126
Woodbury	—	16	313	249	256	180
Total	4695	927	4101	3694	3531	1908
Exeter	—	NA	46	82	90	64

1. Total of 326 for Beer, Branscombe and Seaton assigned as a third each
2. Total of 25 for Musbury and Shute assigned as a half each
3. Total of 128 for Offwell and Widworthy assigned as a half each

Numbers of lace manufacturers and dealers in Kelly's directories of Devon (Machine lace manufacturers and dealers omitted)

Place	1856	1866	1873	1883	1885	1889	1893	1897	1902	1910	1914	1919	1923	1926	1930	1935	1939
Axminster								1	1	1	1		1	1			
Beer	1		2	2	2	2	2	1				2	1	1	1	1	1
Branscombe	4	2	2	1	2	1	1										
Budleigh Salterton	3	1	1	1	1	1	1	1	1	2							1
Colaton Raleigh				1													
Colyton	3	1	1	1	1	1	2	1	1	1	1	2	2	1	1	1	1
Culmstock							1	1	1	1	1	1	1	1			
East Budleigh	1	2	2	2	2	1	1	1	1								
Exmouth	11	10	5	7	7	7	5	5	4	4	4	2	1	1	1		
Honiton	7	4	7	1	1	1	1	1	1	1	1	1	1	1	2	2	2
Lympstone	1	1	1	1	1	1	1	1	1	1	1						
Newton Poppleford							1	1									
Otterton							1	1	1	1	2	2	1	1	1		
Ottery St Mary	2		3	2	2	1	1	1	1	1	1	2					
Seaton			1	1	1	2	2	1									
Sidbury	3						1	1	1		1	1	1	1			
Sidmouth	10	9	11	4	4	3	3	3	1	2	5	3	3	3		1	1
Tiverton		1															
Topsham		2															
Whimple									1	1	1	1	1				
Woodbury	1	1															
East Devon—Total	**47**	**36**	**33**	**24**	**24**	**20**	**21**	**21**	**17**	**15**	**17**	**16**	**14**	**12**	**18**	**6**	**6**
Exeter	**5**	**5**	**9**	**5**	**5**	**4**	**4**	**4**	**4**	**3**	**3**	**2**	**1**		**1**	**1**	**1**
Dawlish		1	1	1	1	1		1	1	1	1	1	1	1	1	1	1
Devonport		1	1	1	1	1											

Plymouth	2	4	2	4	4	1	1			1	1		1				1
Teignmouth	1	1	1	1	1	1			2	1				1			
Torquay	4	3	4	2	2	2	2	2	1	2	2	1	1	1	1	1	1
South Devon—Total	**7**	**9**	**8**	**9**	**9**	**5**	**3**	**2**	**3**	**3**	**3**	**2**	**1**	**2**	**2**	**1**	**1**
Chudleigh	1	1	1	1					1	1	1						
Chulmleigh																	
Morchard Bishop				1	1	1	1	1									
Okehampton	1	1	1														
Mid Devon—Total	**1**	**2**	**2**	**1**	**1**	**1**	**1**	**1**	**1**	**1**	**1**		**1**				
Barnstaple	1	1	2	1	1	1				1	1				1	1	
Bideford			2	2		1	2	2	2	1				1	1	1	
Ilfracombe		3	4	4	4	3	3	4	3	3	1	1	1				
North Devon—Total	**1**	**1**	**5**	**6**	**6**	**5**	**5**	**6**	**6**	**5**	**2**	**2**	**1**	**1**	**2**	**1**	**1**
County Total	**61**	**53**	**57**	**45**	**45**	**35**	**33**	**33**	**31**	**28**	**28**	**22**	**17**	**15**	**12**	**9**	**9**

Numbers of Lace Manufacturers and Dealers in miscellaneous directories of Devon

(Machine lace manufacturers and dealers omitted)

Place	Pigot 1830	Pigot 1844	White 1850	Slater 1852	Billins 1857	Morris 1870	White 1878	White 1890
Axminster	1							
Beer			1			2	1	3
Branscombe			1	1	2	1		
Budleigh Salterton				1			1	1
Colaton Raleigh								
Colyton				1	2	1		1
Culmstock								
East Budleigh			1			2		
Exmouth	1	5	8	9	10	9	13	9
Honiton	4	5	4	4	3	2	2	1
Lympstone				1	1			
Newton Poppleford					1	1		
Otterton				1	1			
Ottery St Mary						1	3	1
Seaton					1	2	2	
Sidbury			2		2			
Sidmouth	3	5	9	7	8	10	9	4
Tiverton								
Topsham							1	

Whimple								
Woodbury		I		I				
East Devon								
—total	9	15	27	25	32	31	33	20
Exeter	I	I	5	I	4	7	8	6
Dawlish			I				I	
Devonport								I
Plymouth			I		4		6	
Teignmouth		2	2	I			4	I
Torquay			5	6	4		4	I
South Devon								
—total	0	2	9	7	8	0	15	3
Chudleigh								
Chulmleigh							I	
Morchard Bishop								
Okehampton							I	
Mid Devon								
—total	0	0	0	0	0	0	2	0
Barnstaple					I		I	
Bideford							I	I
Ilfracombe							6	5
North Devon								
—total	0	0	0	0	1	0	8	6
County total	10	18	41	33	45	38	66	35

Appendix Four

A Directory of Honiton Lace Manufacturers

It has not been possible to distinguish between manufacturers without shops and those who combined dealing with manufacturing.

Abbreviations of sources

A	Apprentice indentures	EFP	Exeter Flying Post
B	Broadsheet	GM	Gentleman's Magazine
C	Census books	L	Letters
CL	Exeter Cathedral Library	R	Parish registers
D	Directories	T	Tomlinson, *Three generations*
DRO	Devon Record Office		*in the Honiton lace trade*
EE	Express and Echo	W	Royal Wardrobe Letter
WT	Western Times		books

A, B and L are in Allhallows Museum, Honiton

Abbot, Mary and Elizabeth. Honiton. fl.1697. A.
Aberdein, Robert. Honiton. fl.1816. EFP.
Agland, William J. Beer. fl.1870. D. Also draper.
Allen, Ida Mrs. Beer. fl.1919–39 D—1956. EE. [Plates 54, 92]
Arundell, Mary Ann Mrs. Exeter. fl.1870–73. D.
Ash, Mary Ann Mrs. Newton Poppleford. fl.1897-1902. D. Also shopkeeper.
Avery, S.A. Miss. Honiton. fl.1856. D.
Baker, Alice Mrs. Sidmouth. fl.1914–26. D.
Baker, Emily Miss. Honiton. fl.1866–1878. D.
Baker, John. Honiton. d. 1692. R.
Balunano, Mrs. Exmouth. fl.1870. D.
Barnard, Hannah Miss. Sidmouth. fl.1926–39. D.

Barnard, Mary N. Mrs. Sidmouth. fl.1893–1923. D.

Baron, Ann Mrs. Sidmouth. fl.1866–78. D. Also greengrocer.

Barrett, Caroline Mrs. Ottery St. Mary. fl.1870–93. D.

Barrett, Lottie Mrs. Ottery St. Mary. fl.1897–1914. D.

Bartlett, Mary Anne and Mary Jane, Misses. Exmouth. fl.1866–78. D, Miss M.J. only in 1878.

Baston, Isaac. Honiton. d.1683. R.

Bastone, John James. Exeter. fl.1906. D.

Beavis, Eliza Miss. Exmouth. fl.1866–85. Bath and West Prizewinner 1864.

Berry, Samuel D. Exeter. fl.1890. D.

Berry, W. Ottery St. Mary. fl.1856. D.

Bidney, Jane Miss. London. fl.1837–42. W. Royal appointment as Honiton Brussels point lace manufacturer in ordinary 14.8.1837. Responsible for Queen Victoria's wedding lace, but contemporary evidence on the details of this is conflicting. Apparently ceased business after 1842. [Plate 24]

Bishop, John. Honiton. d.1692. R.

Bishop, John. Honiton. d.1811. R.

Blackmore, Sarah. Sidmouth. fl.1844–50. D.

Blake, Mary Dennar Mrs. Honiton. fl.1850–52. D. Also ran baby linen warehouse.

Boalch, M. Mrs. Seaton. fl.1856. D. Also grocer.

Bond, Mary S. Mrs. Okehampton. fl.1856–78. D.

Border, Alice Mrs. Teignmouth—Dawlish. fl.1910–35. D.

Bovett, A. Miss. Sidmouth. fl.1856. D.

Bowers, Eliza Mrs. Ilfracombe. fl.1883–85. D.

Bradbeer, Elizabeth. Exeter. fl.1850. D.

Birdgman, Maria Miss. Torquay. fl.1866. D.

Brimicombe, Susan. Torquay. fl.1850–52. D.

Brown, Anne Miss. Puddletown, Dorset. fl.1895. D.

Bucknell, Robert. Otterton—East Budleigh. fl.1857–93. D. Also shopkeeper and cider retailer.

Bucknell, Sophia and Jane Misses. East Budleigh. fl. 1897–1906. D.

Burden, Mary Mrs. Barnstaple. fl.1873. D.

Burnard, Edward. Plymouth. fl.1878. D.

Carnell, Emma Miss. Exmouth. fl.1923–31. D.

Carslake, Elizabeth Mrs. Wimbourne, Dorset. fl.1895. D.

Carter, Fanny Miss. Exmouth. fl.1890. D.

Carter, F. and E. Misses. Plymouth. fl.1878. D.

Channon, E. Mrs. Barnstaple. fl.1910. D.

Channon, Mary. Lyme Regis, Dorset. fl.1753. GM. Anti-Gallican Society prizewinner 1753.

Chapman, Elizabeth. Torquay. fl.1850–52. D.

Chapple, Elizabeth Mrs. Beer. fl.1890. D.

Chard, Stephen. Honiton. d.1682. R.

Chick, Abigail Mrs. Branscombe. b.1781 d.1858. T.

Chick, Harriett Mrs. Sidmouth. b.1812 d.1892. T. fl.1883–85. D but in business with her husband Samuel Chick before his death.

Chick, Samuel. Sidmouth. b.1811 d.1880 T. fl.1850–78. D.

Churchill, Amelia. Honiton. fl.1844. D.

Churchill, M.A. Mrs. Sidmouth. fl.1878. D.

Clarke, Esther Mrs. Honiton—London. b.c1800 m.Theophilus Clarke 1825. R. Sister to Amy Lathy. The Clarkes moved from Honiton to London between 1844 and 1846 (D), and took up residence at 18A Margaret Street. Royal appointment as 'Honiton lace manufacturer in ordinary' 18.12.1837. Exhibited prizewinning flounce at Great Exhibition 1851. Exhibited at Paris Exhibition 1855, London Exhibition 1862. Last business directory entry 1863. [Plate 26]

Clarke, Mary Ann Mrs. Honiton. fl.1856–78. D.

Clarke, Theophilus. Honiton—London. b.1799. R. m.1825 Esther Lathy. R. fl.1827–46. D. Tried before the Archdeacon's court and found guilty in 1827 for brawling in Honiton church and assaulting Amy Lathy, who laid the information.

Clark, Thomas. Honiton. fl.1656. R.

Clode, Isaac. Sidbury. fl.1850. D.

Cole, Mary Priscilla Mrs. Exmouth. fl.1866–78. D.

Collier, E. Beer. fl.1906. D. Also draper.

Colwill, Thomas S. Mrs. Ilfracombe. fl.1902–14. D.

Copp, Mrs. Ilfracombe. fl.1873–78. D.

Copp, Hannah Mrs. Exmouth. fl.1850–57. D.

Copp, Jemima Miss. Exmouth. fl.1890–1910. D.

Copp, Rosa Mrs. Exmouth. fl.1883–89. D.

Corner, Jane Mrs. Honiton. fl.1873–78. D.

Cossins, Caroline Brock Miss. Exeter. fl.1875–1902. EFP, D.

Cross, William. Honiton. fl.1655. R.

Crosse, William, Honiton. d.1682. R.

Curtis, Emma Mrs. Dawlish. fl.1873–89. D.

Dailey, Jane Mrs. Barnstaple. fl.1873–78. D.

Dalling, A. and Emma Misses. Ilfracombe. fl. 1878–85. D.

Dark, James. Honiton. d.1682. R.

Dark, Mary, Honiton. d.1687. R.

Darke, John. Newton Poppleford. fl.1857-70. D. Also grocer and draper.

Darke, Robert. Honiton. fl.1690. A.

Darwall, Eliza Mrs. Dalston, London. fl.1842–56. W. Royal appointment 'Manufacturer of Honiton lace' 28.6.1842.

Davey, Amy Mrs. See Lathy, Amy Miss.

Davey, Mary Ann Mrs. Woodbury. fl.1866. D.

Davis, Anne Mrs. Dawlish. fl.1866. D.

Davis, F. Exeter. fl.1830. EFP.

Dawe, J. Branscombe. fl.1856. D.

Denby, Alfred Thomas, Sidmouth. fl.1852–75. D.

Denby, Martha. Sidmouth. fl.1844–50. D.

Dixon, Jane Mrs. Exeter. fl.1889–1914. D.

Dobbs, Charlotte E. Miss. See Treadwin, Charlotte Elizabeth Mrs.

Dobbs, Elizabeth Miss. Chulmleigh. fl.1866. D.

Drake, Francis. Exmouth. fl.1844–57. D.

Driver, Louisa Miss. Beer. fl.1873–93. D. Also grocer.

Dymond, Susan Miss. Bideford. fl.1878–85. D.

Easterling, Mary Mrs. Exeter. fl.1873. D.

Easterling, Thomas. Exeter. fl.1856–78. D.

Easton, Mrs. Exeter. fl.1857. D.

Elliott, J.N. Mrs. Plymouth. fl.1883–85. D.

Elliott, Mary Mrs. Plymouth. fl.1857–85. D.

Elliott, William. Exmouth. fl.1850–57. D.

Ellis, Hannah Mrs. Bideford. fl.1883–1910. D.

Ellis, Winnie A. Miss. Bideford. fl.1914–19. D.

Elsner, R. Mrs. Exmouth. fl.1856. D.

Elston, Anna Miss. Morchard Bishop. fl.1889–1902. D.

Emmett, E. Mrs. Exeter. fl.1873. D.

Essery, Harriett Mrs. Exmouth. fl.1866–97. D.

Evans, Charlotte. Sidmouth. fl.1850–52. D.

Evans, Elizabeth M. Sidmouth. fl.1857. D.

Evans, Louisa Miss. Sidmouth. fl.1852–78. D.

Evans, Maria. Sidmouth. fl.1844. D.

Farrant, Julia Willmett Miss. Budleigh Salterton. fl.1878–1910. D.

Finch, Ada Miss. Teignmouth. fl.1910. D. Also needlework shop.

Flay, John. Sidmouth. fl.1897. D.

Follett, Gilbert. Sidmouth. fl.1870. D. Also grocer.

Forde, Christian Miss. Honiton. fl.1691. A.

Forde, John. Honiton. fl.1691. A.

Fowler, Ann Mrs. Honiton. b.1839 d.1929. fl.1874–1926. D. Royal appoint- ments 1882 (unconfirmed) and 18 March 1911. Prizewinner at Bath and West Show 1874, 1876, 1877, Edinburgh 1886, Chicago 1893, Paris 1900, St. Louis 1904, Paris 1908. Made various pieces for royalty. [Plates 48, 50, 51, 52, 53, 81, 83, 93, 95]

Fowler, William, Honiton. fl.1878. D.

Frain, Oliver Mrs. Bideford. fl.1897–1910. D.

Gaudee, Martha Mrs. Richmond, London. fl.1848. Royal appointment 'Manufacturer of Honiton point lace' 26 August 1848. W.

German, Mary Ann Mrs. Otterton. fl.1939. D.

Gill, William Lewis. Colyton. fl.1852–57. D. Also draper, grocer and agent for Yorkshire Fire and Life Assurance Company. Exhibited Colyton Chromatic lace at Great Exhibition 1851. [Plate 1]

Godolphin, Louisa Miss. Honiton. fl.1873. D.

Godolphin, Sarah Mrs. Honiton. fl.1850–70. D.

Goldthwaite, M. Miss. Torquay. fl.1914. D.

Goodman, G.L. Mrs. Honiton. fl.1931–39. D.

Gorman, Mary Ann Mrs. Oterton. fl.1919–35. D.

Guard, John. Honiton. fl.1763. B.

Halse, S. Mrs. Exeter. fl.1856. D.

Hamlin, Henry. Sidbury. fl.1856–57. D. Also draper and grocer.

Hart, Robert. Sidmouth. fl.1866. D.

Hayman, Caroline Mrs. Sidmouth. fl.1856–1878. D. Prizewinner at Bath and West
Show 1864, 1865, 1866, 1874.

Hayman, Emma. Sidbury. fl.1850. D.

Hayman, Herman. East Budleigh. fl.1856–70. D. Also shopkeeper.

Hayman, Lavinia Mrs. Exmouth. fl.1914–19. D.

Hayman, Stephen. Sidmouth. fl.1844–52. D.

Hayman, T. Sidbury. fl.1856. D. Also general shopkeeper.

Hayman, William. Woodbury. fl.1850–57. D. Also shopkeeper.

Hayman, William. East Budleigh. fl.1873–85. D.

Heber, Mrs. Lyme Regis, Dorset. fl.1753. GM. Anti-Gallican Society Prizewinner
1753.

Herbert, Ellen Miss. Exeter. fl.1891–1923. D. Succeeded to Mrs. Treadwin's business.
Royal appointment 1891 unconfirmed.

Heyward, M.A. Mrs. Sidbury. fl.1856. D. Also shopkeeper.

Hill, Annie Mrs. Teignmouth. fl.1902. D.

Horman, Elizabeth. Honiton. d.1685. R.

Hudder, F.E. Mrs. Torquay. fl.1873. D.

Hughes, Ann Mrs. Torquay. fl.1856–1919. D. The business may have been continued
under the same name in the latter part of the period.

Humphrey Daniel. Honiton. fl.1690. R.

Humphrey, Thomas. Honiton. d.1658, register of Honiton charities.

Hutchings, Eliza. Mrs. Budleigh Salterton. fl.1866–73. D. Prizewinner at Bath and
West Show, 1866, 1871.

Hutchings, Elizabeth Mrs. Exmouth. fl.1866–90. D.

Hutchinson, Samuel. Exeter. fl.1873. D.

Hutchinson, I. Mrs. Exeter. fl.1870. D.

Hutchinson, Emily Isabella Mrs. Exeter. fl.1878–85. D. Also furrier.

Irwin, John. Topsham. fl.1866–78. D. Also shopkeeper.

Jessep, Charlotte F. Exeter. fl.1850–66. D.

Jessop, Fanny Mrs. Exeter. fl.1873–78. D. Perhaps same as previous entry.

Kelly, John Mrs. Ilfracombe. fl.1883–1931. D.

Knott, K. Miss. Exeter. fl.1878. D.

Lacey, Alice Mrs. Exeter. fl.1883–85. D.

Lacey, George, Ilfracombe. fl.1878. D.

Lacey, George Walter. Exmouth. fl.1870–85.

Lathy, Mr. Honiton. d.1824. EFP.

Lathy, Amy Miss. Honiton. b.1798. C. m.11 July 1837 Albion Davey. R. fl.1827–73. CL, D. Royal appointments as 'Manufacturer of thread lace' 24 August 1830 and as 'Manufacturer of thread lace' 28 March 1850. [Plates 20, 84, 90, 94]

Lathy, H. Mrs. Honiton. fl.1856. D. Also draper and tea dealer. Probably sister-in-law of Amy.

Lediard, Maria Miss. Exmouth. fl.1856–57. D. Also boot and shoe maker.

Lewis, W. Mrs. Bideford. fl.1931–39. D.

Litton, Emily Mrs. Exmouth. fl.1889. D.

Loader, William. Honiton. fl.1696. R.

Lowman, Emily Mrs. Bridgewater, Somerset. fl.1906–31. D.

Luckes, Elizabeth. Dawlish. fl.1850. D.

Major, Mary. Beer. fl.1850–78. D. Possibly also a Miss. H. Major.

Martin, Mrs. Honiton. fl.1816. EFP.

Martyns, Misses. Plymouth. fl.1857–85. D.

Maynard, James. Honiton. d.1786. R.

Maynard, Lydia. Honiton. fl.1753. GM. Anti-Gallican Society prizewinner 1753.

McKno, Margaret and Jane. Honiton. fl.1852. D.

Mead, Susan Miss. Exeter. fl.1873–78. D.

Mildon, Caroline Mrs. Torquay. fl.1878–1902. D.

Millard, Richard. Sidmouth. fl.1883–85. D.

Miller, Elizabeth. Sidmouth. fl.1850–57. D.

Miller, Henry. Beer—Seaton. fl.1870–97. D. Also china and glass dealer.

Miller, Richard. Sidmouth. fl.1856–90. D. Also grocer.

Minefie, James. Honiton. d.1655. R.

Mitchell, Ann Mrs. Plymouth. fl.1856–57. D.

Moon, Edward. Exmouth. fl.1852. D.

Moore, Edward. Exmouth. fl.1844–50. D.

More, Phillip. Honiton. fl.1654. R.

Neilson, Edith Mrs. Exeter. fl.1919. D.

Neilson, Elmer Montgomerie. Newquay, Cornwall. fl.1914. D.

Newberry, Susannah, Mrs. Lympstone. fl.1889–1910. D.

Newberry, William. Exmouth—Lympstone. fl.1844–85. D.

Newton, Miss. Beer. fl.1897–1906. D. Also grocer.

Newton, E. Miss. Beer. fl.1856. D. Also grocer.

Newton, George. Beer. fl.1883–93. D. Also shopkeeper.

Nieas, Elizabeth. Torquay. fl.1850. D.

Oake, Richard. Ottery St. Mary. d.1687. R.

Parker, Margaret C. Mrs. Exeter. fl.1935–39. R.

Patch, Mary. Torquay. fl.1852. D.

Paul, Eliza Mrs. Sidmouth. fl.1866–73. D.

Paver, Georgina Miss. Exmouth. fl.1866. D.

Payne, Sarah Mrs. Teignmouth. fl.1844–78. D.

Payton, Sarah Mrs. Sidmouth. fl.1844–66. D.

Payton, Thomasin Mrs. Sidmouth. fl.1852–73. D.

Payton, William. Sidmouth. fl.1850. D.

Pearce, Elizabeth Mrs. Torquay. fl.1893–97. D.

Pearce, Sarah Ann Mrs. Devonport. fl.1883–90. D.

Pearce, Thomas. Honiton. d.1681. R.

Pearson, Susan Mrs. Sidbury. fl.1893–1926. D. Also stationer, fancy reposi- tory and post office.

Perriman, Martha Miss. Exmouth. fl.1906–14. D.

Phillips, Charlotte Miss. Ilfracombe. fl.1889–1910. D.

Picton, Eilen and Emily Misses. Torquay. fl.1873. D.

Pidgeon, Catherine Mary Miss. Otterton. fl.1897–1923. D. Also shopkeeper.

Pidgeon, J. Mrs. Honiton. fl.1850–56. D.

Pike, George, Exmouth. d.1832. EFP.

Pinch, Elizabeth Mrs. Beer. fl.1866–73. D.

Pollard, Caroline Mrs. Exmouth. fl.1878–90. D.

Pollard, Edwin. Exmouth. fl.1897–1902. D.

Pollard, Elizabeth Mrs. Exeter. fl.1871–73. EFP, D.

Pollard, George William. Exmouth. fl,1889–93. D.

Pope, Joanna Mrs. Topsham. fl.1866. D.

Prescott Jane Mrs. Beer. fl.1919. D.

Prince, Sarah and Eliza Misses. Sidmouth. fl.1873–90. D.

Pring, John. Honiton. fl.1681. DRO.

Pugsley, Mary Ann Miss. Exeter. fl.1906–14. D.

Pulman, Sarah. Honiton. d.1680. R.

Radford, Amy Miss. Sidmouth. fl.1910. D.

Radford, Charity Mrs. Sidmouth. fl.1852–57. D.

Radford, Emma Miss. Sidmouth. fl.1870–97. D. Prizewinner Bath and West Show 1864, 1865, 1866, 1871, 1874, 1876, 1877. [Plate 36]

Radford, Harriet Miss. Sidmouth. fl.1866. D.

Radford, John. Sidmouth. fl.1850. D.

Radford, Lydia Mrs. Sidmouth. fl.1906–14. D.

Reed, Susan Mrs. Branscombe. fl.1883–85. D.

Reeves, L. Miss. Exmouth. fl,1878. D.

Rendal, George. Exmouth. fl.1844–56. D.

Rendle, Sarah. Exmouth. fl.1857. D.

Richards, Elizabeth. Teignmouth. fl.1844–50. D.

Rippon, Edward. Honiton. fl.1873. D.

Rockett, Elizabeth Miss. Sidbury. fl.1856–57. Also draper and grocer in business with Miss Grace Wells. D.

Rodge, James. Honiton. d.1617. R. [Plate 96]

Rother, Charlotte Mrs. Ilfracombe. fl.1914. D.

Rowett, Ann Mrs. Ilfracombe. fl.1890. D.

Rowett, Hannah Mrs. Exmouth. fl.1878–97. D.

Rowett, William Barrett. Exmouth. fl.1890–1914. D.

Rowland, Jane Mrs. Whimple. fl.1906–26. D.

Rugg, William. Lyme Regis, Dorset. fl.1895. D.

Salter, M.J. Mrs. Exmouth. fl.1878. d.

Satterly, Louise. Beer. fl.1870–71. L.

Saunders, J. Miss. Ilfracombe fl.1878. D.

Saunders, Joanna Miss. Barnstaple. fl.1856–66. D.

Scudding, L. Mrs. Exeter. fl.1866–70. D. Prizewinner Bath and West Show 1864, 1865, 1866.

Searle, George. Exmouth. fl.1852–57. D.

Searle, Maria. Torquay. fl.1850. D.

Selly, Sarah. Mrs. Branscombe. fl.1856–73. D. Also shopkeeper.

Sharp, Annie Miss. Ilfracombe. fl.1902–06. D.

Sharp, Georgina Mrs. Ilfracombe. fl.1873–97. D.

Sheppard, Susan. Seaton. Prizewinner Bath and West Show 1864.

Silverston, C. Miss. Exeter. fl.1856–57. D.

Simms, Louisa Miss. Lympstone. fl.1914. D.

Skarr, Elizabeth. Honiton. d.1687. R.

Skinner, Annie Mrs. Sidmouth. fl.1914–26. D.

Skinner, J. Miss. Teignmouth. fl.1878. D.

Smith, Mary. Sidmouth. fl.1857. D.

Smyth, Elizabeth. Exeter. fl.1870. D.

Southcott, Sarah Miss. Exmouth. fl.1850–1902. D. Also grocer and linen draper with Miss Ellen Southcott.

Spear, Mary Ann Miss. Exmouth. fl.1890. D.

Spiller, C. Miss. Exeter. fl.1856. D.

Start, George Mrs. Exmouth. fl.1870. D.

Stephens, John. Sidmouth and Otterton. fl.1852–53. D, EFP.

Stewart, Mary and Sarah. Exeter. fl.1850. D.

Stocker, John. Honiton. fl.1763. B.

Stocker, William. Honiton. fl.1763. B.

Stockman, Emblin. Honiton. d.1682. R.

Summers, Dinah Miss. Culmstock. fl.1919–31. D. With Miss Ruth Summers from 1926.

Swaine, Sarah. Honiton. fl.1844. D.

Tanner, Mrs. Seaton (?) Prizewinner Bristol and West Show 1864.

Tapscott, Mrs. Dawlish. d.1854. EFP.

Taylor, S. Mrs. Ilfracombe. fl.1897. D.

Taylor, Sarah Mrs. Teignmouth. fl.1878–93. D.

Thomas, Raynborne. Honiton. fl.1656. R.

Thorn, Caroline Mrs. Exeter. fl.1866–1902. D.

Thorn, Henry. Exeter. fl.1890. D.

Toby, B. Colaton Raleigh. fl.1856–66. D.

Tompson, Henry. Colyton. fl.1725. DRO.

Towning, S. Mrs. Exmouth. fl.1878. D.

Treadwin, Charlotte Elizabeth Mrs. Exeter. b.1821. EFP. m.1850. WT. d.1890. EFP.
 fl.1848–90. EFP, D. Royal appointment as 'Manufacturer of Honiton Brussels
 point lace' 28 June 1848. Prizewinner Great Exhibition 1851. Cornwall Poly-
 technic 1852, Paris 1855. [Plates 25, 28, 30, 39, 91, 97]

Tregale, Lilian Miss. Torquay. fl.1926–31. Also newsagent.

Trevail, J. Colaton Raleigh. fl.1873. D.

Tucker, John. Branscombe. b.1807 m.1832 d.1877. T. fl.1850–1873. D. Exhibited
 notable flounce at London exhibition 1862.

Tucker, Sally Mrs. Exmouth. fl.1866. D.

Tuckett, Mrs. Honiton. b.1747. d.1833. EFP.

Tupman, George. Exmouth. fl.1878. D.

Tupman, Sophia Mrs. Exmouth. fl.1856–57. D.

Upright, Edmund Bidgood. Colyton. fl.1856–93. D. Prizewinner Bath and West Show
 1864, 1865. Also shopkeeper, postmaster and agent for Provincial Life Assurance.

Vickery, E.A. Mrs. Budleigh Salterton. fl.1856. D.

Voysey, Harriett Mrs. Chulmleigh. fl.1873–85. D. Acted as agent for Mrs Treadwin.

Walker, Eleanor. Exmouth. fl.1850. D.

Walters, Eliza. Exmouth. fl.1906–19. D.

Ward, Ann Miss. Honiton. Later Mrs. Fowler

Ward, B.D. Miss. Honiton. Worked with her aunt Mrs Fowler and continued the
 business after her death until 1939. D.

Ware, Elizabeth Mrs. Sidmouth. fl.1890. D.

Ware, Joseph. Sidmouth. fl.1870–78. D. Also draper and grocer.

Weeks, Ann Elizabeth Mrs. Torquay. fl.1850–56. D.

Weeks, Elizabeth Mrs. Exmouth. fl.1844–78. D.

Weeks, William. Torquay. fl.1857. D.

Westcott, E. Mrs. Honiton. fl.1856. D.

Westlake, Caroline Mrs. Seaton. fl.1883–1902. D.

Wheeler, Caroline. Torquay. fl.1852–56. D.

Whitford, Thomas. Teignmouth. fl.1878. D.

Wicking, Mary. Exmouth. fl.1852. D.

Williams, Alfred. East Budleigh. fl.1850. D. Also grocer and draper.

Winsford, E. Mrs. Exmouth. fl.1856–57. D.

Withall, Mary Chapel Mrs. Exmouth. fl.1866. D.

Wood, Elizabeth Mrs. Sidmouth. fl.1893. D.

Wood, William. Ottery St. Mary—Sidmouth. fl.1873–90. D. Also grocer and
 provision dealer.

Woodgate, Anna Miss. Budleigh Salterton. fl.1852–56. D.

Wright, M.A. Mrs. Ilfracombe. fl.1878–89. D.

Wright, Mary Mrs. Torquay. fl.1873–78. D.
Wright, Thomas A. Torquay. fl.1856–57. D.
Wright, Thomas A. Ilfracombe. fl.1873–90. D.
Wyatt, Ann. Honiton. fl.1844. D.

Appendix Five

A Directory of Honiton Lace Designers

Abbreviations of sources

CTB Calendar of the Treasury Books
ILN Illustrated London News
WEPG Woolmer's Exeter and Plymouth Gazette
WMN Western Morning News

BUTLER ADAMS, Jnr. London.
 1843 Designed collars made for Queen Victoria at Beer (*WEPG*, 10.6.43)
Miss. ASHWORTH. London.
 1853. Designed collar made for Lady Trevelyan at Beer (Trevelyan MSS)
SELINA AND SARAH BARON. Sidmouth.
 1881. Described as lace designers (census)
BATH.
 1749. Wood stated that at that time many designs were made in Bath, but no names given
MRS BERNARD. Honiton.
 1913. Designed piece shown by Mrs Fowler at Mansion House exhibition (catalogue)
 1914. Exhibited fan leaf made for Queen Mary at Paris exhibition (catalogue)
EDWARD BIRD. Dorset/Devon/Wilts.
 1688. Imported French lace illegally 'for patterns' (*CTB*, VIII Pt.IV, p.2068)
Miss EVELYN BYRDE. Honiton.
 Designed Art Nouveau fan leaf. (Allhallows Museum) [Plate 86]
ANN CHANNON. Honiton.
 1841. Sewer on of sprigs 'the great requisite in a sewer on is taste in the arrangement of the sprigs' (Children's Employment Commissioner)
Miss GERTRUDE CHAPMAN.
 1908. Designed item exhibited by East Devon Lace Industry at Daily Mail exhibition (catalogue)

EDWIN CHICK. Sidmouth.

1881. Described as lace designer (census)

ELIZA CLARKE. Honiton.

1851. Designed prizewinning flounce for Great Exhibition (*WEPG*, 18.10.51) [Plate 26]

Mrs. LEWIS F. DAY

1914. Designed collar exhibited by East Devon Lace Industry at Paris exhibition (catalogue)

WILLIAM DYCE. London.

1840. Designed Queen Victoria's Wedding lace (Staniland and Levey) [Plate 24]

Mrs. ELLIS. Bideford.

1913. Designed piece shown by herself at Mansion House exhibition (catalogue)

ELIZABETH FILDEW. Honiton.

1841. Sewer on of sprigs 'The principal difficulty is the disposing of the sprigs with taste' (Children's Employment Commissioner)

Miss FLOUD.

1866. Designed prizewinning sprigs and coiffure at Bath and West show (*WEPG*, 8.6.66)

Mrs. FRERE. Roydon.

1908. Designed piece exhibited by the Diss Lace Association at the Daily Mail exhibition (catalogue)

Miss. FYLER. Bagshot.

1871. Designed prizewinning shawl, bonnet veil and trimming for Bath and West show (*WEPG*, 2.6.71)

Mrs. GARDNER. Dawlish.

1871. Designed prizewinning shawl for Bath and West show (*WEPG*, 2.6.71)

Miss. EDITH HARPER.

1913. Designs exhibited at Mansion House exhibition (catalogue)

Mrs. CHARLES HARRISON.

1910. Designed rejected design for a fan to be presented to Queen Mary for her coronation. Subsequently exhibited at the Mansion House exhibi- tion 1913 (catalogue)

1914. Designed fan leaf exhibited by the Diss Lace Assocaition, Paris (catalogue)

M. HAYMAN

1866. Designed prizewinning coiffure at Bath and West show (*WEPG*, 8.6.66)

Miss CECELIA KEYES.

1908. Designed piece exhibited by East Devon Lace Industry at Daily Mail Exhibition (catalogue)

1914. Designed two ties exhibited by East Devon Lace Industry at Paris (catalogue)

Mrs. MASON. Taunton.

1913. Designed pieces exhibited by Taunton Lace School at Mansion House exhibition (catalogue)

Miss. MARRYATT. Sidmouth.

1864/66. Designed prizewinning sprigs, nosegays, borders, coiffure, lap- petts,

chemisette, collar and cuffs, application veil, wedding veil, handker- chief and trimmings at Bath and West shows (*WEPG*, 17.6.64, 9.6.65, 8.6.66)

ALIC MINIFIE. Branscombe.

1871. Described as artist in household of John Tucker (census)

Miss. NORRIS. Taunton

1913. Designed pieces exhibited by Taunton Lace School at Mansion House exhibition (catalogue)

NOTTINGHAM.

1853. Mrs. Treadwin stated that she obtained designs from an unspecified source in this town (Wyatt Sir D.)

Mlle. IRENE D'OLSZOWSKA.

1913. Designs exhibited at Mansion House exhibition (catalogue)

PARIS.

1853. Mrs. Treadwin stated that she obtained designs from an unspecified source in this city (Wyatt Sir D.)

Mrs. SUSAN PEARSON.

1914. Exhibited Honiton lace designed by herself at Paris exhibition (catalogue)

Mrs. PEARSE.

1914. Exhibited Honiton lace collar designed by herself at Paris exhibition (catalogue). It is possible that this is Mrs. Pearson.

Miss. PAULINE POWER.

1865. Designed prizewinning collar and cuffs at Bath and West show (*WEPG*, 9.6.65)

Miss. R.P. RADFORD. Sidmouth.

1871/7. Designed prizewinning shawl, fans, coiffeur, lappett and fichu at Bath and West show (*WEPG*, 2.6.71, 6.6.74, 8.6.77)

WOLLISCROFT RHEAD.

1910. Designed fan given by Fanmakers Company to Queen Mary for her coronation (ILN). [Plate 51]

Mrs. FREEMAN ROPER.

1908. Designed piece exhibited by East Devon Lace Industry at Daily Mail exhibition (catalogue)

1913. Designed piece exhibited by East Devon Lace Industry at Mansion House exhibition (catalogue)

1914. Designed 'reproduction of old model' shown at Paris exhibition (catalogue)

Miss. SAVORY.

1908. Designed pieces exhibited by Diss Lace Association at Daily Mail exhibition (catalogue)

Miss. SCADDING. Exeter.

1864. Designed prizewinning collar and cuffs and lappett at Bath and West show (*WEPG*, 17.4.64)

MAUD SEARLEY. Kinkerswell.

1889. Designed Kerswell lace (*Torquay Directory*, 1889)

SEWERS ON.

Many sewers on are recorded in census returns, but more are unknown. Many must have been involved in design work.

T. SHARP.

1851. Designed pieces made by J. Tucker and exhibited by D. Biddle at the Great Exhibition (catalogue)

Mrs. SHARP.

1874. Designer prizewinning trimming at Bath and West show (*WEPG*, 6.6.74.

SOMERSET HOUSE. London.

1851. Government School of Design produced outline for flounce ex- hibited by Mrs. Treadwin at Great Exhibition. Mrs. Treadwin was responsible for details (*WEPG*, 1.3.51)

LADY TREVELYAN. Seaton.

1864/66. Designed prizewinning collar and cuffs, handkerchief, application veil, necktie and sleeves at Bath and West show (*WEPG*, 7.6.64, 8.6.66) [Plate 29]

JOHN TUCKER. Branscombe.

1863. The firm of John Tucker designed the Princess of Wales' wedding lace (DRO, Ford papers)

1864. Certificate of merit for design awarded at Bath and West show (*WEPG*, 17.6.64)

MARY TUCKER. Branscombe.

1862. Designed flounce shown by John Tucker at London exhibition (Staniland and Levey); also items in several museum collections [Plates 27, 31, 32, 33]

Mrs. UPRIGHT. Colyton.

1864/65. Designed prizewinning collar and cuffs, and coiffure at Bath and West show (*WEPG*, 17.6.64, 9.6.65)

QUEEN VICTORIA. London.

1843. Specified shape for collars to be made in Beer (*WEPG*, 10.6.43)

A. and W. WARD. Honiton.

1874. Designed prizewinning trimming at Bath and West show (*WEPG*, 6.6.74)

Miss B. D. WARD. Honiton.

1907. Described as chief designer for Mrs. Fowler

1910. Designed handkerchief for presentation to Queen Mary (*WMN*, 3.11.38)

1914. Designed fan leaf exhibited at Paris exhibition (catalogue)

1937. Designed Queen Elizabeth's coronation fan (*WMN*, 3.11.38) [Plates 48, 50, 53, 85]

Mr. T.K. WERE. Sidmouth.

1871/77. Designed prizewinning trimming, fan and fichu at Bath and West show (*WEPG*, 2.6.71, 8.6.77)

Appendix Six

The Price of Lace in England

Table A/6.1 Seventeenth and eighteenth centuries

Source	Year	Price Per Yard	Description	Yards
1	1603	6s	fine lace (bought at Basing)	18
1	1603	9s	great bone lace (bought at Winchester)	4
2	1620	4d	bone lace	6
2	1651	5s 6d	lace	8
3	1655	8d	black and white lace	18
3	1655	1s	black lace	2
3	1658	2s	black lace	4
3	1658	2s 6d	black lace	4
3	1658	10s	black bone lace	2
3	1658	10s 6d	black broad lace	1
3	1658	1s	black Flanders lace	2
3	1658	3s 4d	black Flanders lace	1
3	1658	8s	black Flanders lace	1½
3	1658	9s 8d	black Flanders lace	1½
3	1658	11s 6d	black Flanders lace	5/8
3	1660	4s	black lace	2
4	1660	6s 8d	bone lace of thred (import price)	—
5	1667	5s	Devonshire lace	11
5	1667	8s	Devonshire lace	36½
5	1667	12s	Devonshire lace	23
5	1667	5s	Buckingham lace	31
5	1667	7d	narrow edging lace	140

5	1667	1s 4d	narrow lace	48
5	1667	2s 6d	narrow lace	71
5	1667	8s	narrow lace	3½
5	1667	8d	lace of Sundry sort	36
2	1685	12s	bonelace for 4 handkerchiefs	12
2	1685	2s 4d	lace for 4 smocks	10
2	1685	8s	lace	4½
6	1691	10d	Westcountry lace	15
6	1691	2s 3½d	Westcountry lace	9
6	1691	2s 10d	Westcountry lace	9½
6	1691	3s	Westcountry lace (six lots)	127
6	1691	4s	Westcountry lace	15
6	1691	5s	Westcountry lace	16
6	1691	6s	Westcountry lace	14
6	1691	4d	Buckingham lace	185
6	1691	6d	Buckingham lace	19
6	1691	9d	Buckingham lace (two lots)	78
6	1691	10½d	Buckingham lace	131
6	1691	1s	Buckingham lace (two lots)	45
6	1691	1s 0½d	Buckingham lace	25
6	1691	1s 2d	Buckingham lace	25
6	1691	1s 4d	Buckingham lace	23
6	1691	1s 6d	Buckingham lace	23
6	1691	1s 6½d	Buckingham lace	19
6	1691	2s	Buckingham lace (two lots)	64
6	1691	2s 6d	Buckingham lace	18
6	1691	4s 3d	Buckingham lace	8
6	1691	4d	French trolly and trolly (two lots)	98
6	1691	6d	French trolly	13
6	1691	8d	French trolly	12
7	1698	8s	highest price Buckingham lace before this	—
7	1698	£1 10s	highest price Buckingham lace now	—
7	1698	£6	highest price Devonshire lace now	—
8	1700	£1 16s	Buckingham lace (highest price)	—
8	1700	£1 6s	Buckingham lace	—
8	1700	10s	Buckingham lace	—
8	1700	£1	Buckingham lace	—
8	1700	£6	West of England lace	—
8	1700	£3	Dorset lace	—
9	1724	£30	Dorset lace (Blandford)	—

10	1749	£3 3s	'Bath' lace	—
11	1779	5s	Foreign lace top of lower price range	—
11	1779	10s	Foreign lace top of middle price range	—
12	1787	2s 6d	Foreign lace price in book of rates	—

Table A/6.3 Honiton lace prices, nineteenth century

Source	Date	Description	Price
14	1853	A collar (thought to be too expensive)	£3 3s 9d
15	1865	A vandyke	£4 5s) price
15	1865	A veil	£2 5s) from
15	1865	A pair of sleeves	£1 7s) maker
15	1865	A collar	10s 6d
15	1865	A flounce 6½ yards	£20 (= £3 1s 6d/yard)
16	1871	Motif—cowslip	2s
16	1871	Motif—lilly	4½d
16	1871	Motif—hornet	3d
16	1871	Motif—jasmine	6d
16	1871	Motif—daisy	1s
16	1871	Motif—butterfly	3d
16	1871	Motif—large butterfly	1s 6d
16	1871	Motif—fern	8d
16	1871	Motif—bramble	1s
16	1871	Motif—bee	3d
16	1871	Motif—lilly of the valley	8d
16	1871	Motif—round	¾d
16	1872	Bridal veils	£5 5s to £52 10s
16	1872	Flounces applique 10" wide	15s to £3 3s/yard
16	1872	Flounces Honiton point 10-15" wide	£3 3s to £15 15s/yard
16	1872	Garniture lace 4" wide	£1 1s to £4/yard
16	1872	Handkerchiefs	£1 1s to £10 10s
16	1872	Lappets	£1 1s upwards
16	1872	Fans	£2 2s to £12 12s
16	1872	Parasol covers	£4 4s to £21
17	1875	Handkerchief	£1 1s
18	1897	Honiton lace	from 3s 9d/yard
18	1897	Collars and sets	5s 6d to £6 6s
18	1897	Flounces	£3 3s to £10 10s/yard
18	1897	Handkerchief	8s 9d to £10 10s
19	1905	Handkerchief	8s 9d (sale price)
19	1905	Handkerchief	5s to £1 5s

Table A/6.2 Pieces purchased by A.S. Cole in 1887.[13]

Illustration	Place	Thread	Item	Price	Per
1 A	Colyton	8 or 9	small sprigs (vague flowers)	1d	each
B	Colyton	8 or 9	medium sprigs (vague flowers)	4½d	each
C	Colyton	10	thistle (smallish)	6d	each
D	Colyton	—	medium thistle (?)	8d	each
E	Colyton	8 or 9	rose (large)	1/6d	each
F	Colyton	8	edging (7½" x 1½")	1/-	each
2 A	Branscombe	14 or 16	large fern leaf with pearl bars	2/9d	each
B	Branscombe	10	rose/tulip/cyclamen/leaves motif	2/-	each
C	Branscombe	10	oak spray with acorns	1/4d	each
D	Branscombe	—	rose	1/2d	each
E	Branscombe	16	bird	1/1d	each
F	Branscombe	—	rose (odd looking motif)	6d	each
G	Branscombe	—	shape (a bit like boteh but not much)	4½d	each
H	Branscombe	—	small butterfly	2½d	each
3 —	Branscombe	14	edging, rose design, 2" wide	£1 2 6d	yard
4 A	Sidmouth	12	edging, 2½" wide	£1 2 6d	yard
B	Sidmouth	16	violets (spray)	8/-	each
C	Sidmouth	22½	three birds on a twig	10/-	each
5 —	Sidmouth	20 or 22	large spray 9" long x 4½" wide	£1 10 0d	each
6 —	Sidbury	—	'rose' (circular)	1/-	each
—	Sidbury	—	flower sprays	1/-	each
7 A	Honiton	12	bunch of primroses	—	—
B	Honiton	14	medium fern leaf	—	—
8 A	Ottery St Mary	14	spray of stylised plants (Princess Beatrice)	6/6d	each
B	Ottery St Mary	8	edging	3/6d	yard
C	Ottery St Mary	10	edging	4/6d	yard
9 —	Ottery St Mary	12	edging (adapted from C18 Flemish) 2½"w x 8"l	7/6d	piece
10 A	Exmouth	14	spray of lilies of the valley	2/-	each
B	Exmouth	12	compound leaf	1/6d	each
C	Exmouth	10	rose	1/-	each
D	Exmouth	16	fritillary	1/6d	each
E	Exmouth	20	flower (unidentified)	3/-	each
F	Exmouth	—	black silk flower and fern leaf	3/-	each
11 A	Otterton	10	vague flower	1/9d	dozen
B	Otterton	7	vague flower (very)	5d	dozen
C	Otterton	9	vague flower	1/1d	dozen
D	Otterton	9	spray of vague flowers	6d	each
12 A	Woodbury	12	spray (rose, thistle and shamrock)	1/3d	each
B	Woodbury	10	spray of tulips	1/-	each
C	Woodbury	10	3 rose spray	9d	each

Notes to Table A/6.4:

1. The figures for 1749 (except the craftsman's wage) and for the Westminster and Maundy cloth are from Beveridge, W.H. *Prices and wages in England*. The craftsmen's wage for 1749 is from Gilboy, E.W. *Wages in eighteenth century England*. The remainder are from Rogers, J.E.T. *Agriculture and prices in England*, Vol. VI.

2. All the commodity prices and wages are averaged from the data in the sources.

3. The price of seacoal varied considerably in different parts of the country up to 30 per cent above and below the mean figure quoted. A chaldron corresponded to about 26 hundredweight (= 1.3 tons), 6 and 7 William III c10 and Beveridge *Prices and Wages in England*, p.266, 402.

4. The following craftsmen are represented, though not all are included in each year figure:- artizan, bricklayer, carver, cooper, freemason, gardener, glasier, joiner, journeyman, master mason, painter, pargetter, paviour, plumber, slater, smith, stonemason, tabulator, wheelwright.

Sources

1. CSPD, JI III N°89.
2. Rogers, 1887, vi.
3. National Art Library, MSS box VI, 86, DD(ix).
4. 12 Charles 2 c4.
5. CLRO, Orphans Inventories—Robert Bamford—347A, 20.6.1667.
6. CLRO, Orphans Inventories—William Taylor—2197, 6.1.1691/2.
7. National Art Library, 43A 2h.
8. CJ, XIII p269-271.
9. Defoe, 1927, p217.
10. Wood, II p436.
11. CJ, XXXVII, p185.
12. 27 George 3 c13.
13. Cole, 1888.
14. Trevelyan MSS.
15. Burritt, p190.
16. Lacemaker's order book, Allhallows Museum.
17. Treadwin, 1873, p71.
18. Bacon.
19. John Wilson's Successors Limited, Trade Catalogue, p31.

Table A/6.4 Lace prices compared with selected commodity prices and wages – seventeenth and eighteenth centuries

Year	Lace price per yard min	max	Lace Type	Butter per pound	Candles per dozen	Seacoal per chaldron	Westminster Scholars Broadcloth per yard	Maundy cloth per yard	Labourer's daily wage	Craftsman's daily wage
1603	6s	9s	Probably westcountry	4d	3s 6d	13s 3d	7s	9s 6d	8d	1s 1d
1655/8	1s	10s 6d	Possibly westcountry	6d	4s 3d	23s 6d	–	10s	1s	1s 8d
1658	1s	11s 6d	Black Flanders	6d	4s 3d	23s 6d	–	10s	1s	2s
1667	5s	12s	Devonshire	6½d	5s 1d	27s	9s	8s 4d	1s 3d	1s 10d
1667	5s	–	Buckingham	6½d	5s 1d	27s	9s	8s 4d	1s 3d	1s 10d
1691	10d	6s	Westcountry	5½d	4s 4d	34s	8s 6d	8s	1s 1d	2s 9d
1691	4d	4s 3d	Buckingham	5½d	4s 4d	34s	8s 6d	8s	1s 1d	2s 9d
1691	4d	8d	French Trolley	5½d	4s 4d	34s	8s 6d	8s	1s 1d	2s 9d
1698	–	30s	Buckingham	8d	5s 7d	30s	8s 6d	14s	1s 10d	2s 4d
1698	–	£6	Devonshire	8d	5s 7d	30s	8s 6d	14s	1s 10d	2s 4d
1700	10s	26s	Buckingham	7d	5s 4d	31s	8s 6d	14s	1s 4d	2s 8d
1700	–	£6	West of England	7d	5s 4d	31s	8s 6d	14s	1s 4d	2s 8d
1749	–	£3 3s	'Bath'	9d	6s	33s 6d	8s	9s	1s 2d	2s

Notes:

1. The figure for 1749 (except the craftmen's wage) and for the Westminster and Maunday cloth are from Beveridge, W.H. *Prices and wages in England*. The craftsmen's wage for 1749 is from Gilboy, E.W. *Wages in eighteenth century England*. The remainder are from Rogers, J.E.T. *Agriculture and prices in England*, Vo. VI.

2. All the commodity prices and wages are averaged from the data in the sources.

3. The price of seacoal varied considerably in different parts of the country up to 30 per cent above and below the mean figure quoted. A chaldon corresponded to about 26 hundredweight (= 1.3 tons), 6 and 7 William III c10 and Beveridge *Prices and Wages in England*, p. 266, 402.

4. The following craftsmen are represented, though not all are included in each year figure: artisan, bricklayer, carver, cooper, freemason, gardener, glazier, joiner, journeyman, master mason, painter, pargetter, paviour, plumber, slater, smith, stonemason, tabulator, wheelright.

Price of lace expressed in commodities

Year	Butter pounds		Candles each		Seacoal chaldrons		Westminster Broadcloth		Maundy Cloth yards		Labourer's days work		Craftsman's days work	
	min	max	min	max	min	max	min	max	min	max	min	max	min	max
1603	18	27	21	31	0.45	0.68	0.86	1.28	0.63	0.95	9.0	13.5	5.5	8.3
1655/8	2	21	3	30	0.04	0.45			0.10	1.05	1.0	10.5	0.6	6.3
1658	2	23	3	32	0.04	0.49			0.10	1.15	1.0	11.5	0.5	5.8
1667	9	22	12	28	0.19	0.44	0.55	1.33	0.60	1.45	4.0	9.6	2.7	6.5
1667	9		12		0.19		0.55		0.60		4.0		2.7	
1691	2	13	2	17	0.02	0.18	0.10	0.71	0.10	0.75	0.8	5.5	0.3	2.2
1691	1	9	1	12	0.01	0.13	0.04	0.50	0.04	0.53	0.3	3.9	0.1	1.5
1691	1	1	1	2	0.01	0.02	0.04	0.08	0.04	0.08	0.3	0.6	0.1	0.2
1698		45		64		1.00		3.53		2.14		16.3		12.9
1698		180		258		4.00		14.12		8.57		65.5		51.4
1700	17	45	23	59	0.32	0.84	1.18	3.02	0.71	1.86	7.5	19.5	3.8	9.8
1700		206		270		3.87		14.11		8.57		90.0		45.0
1749		84		126		1.88		7.88		7.00		54.0		31.5

Bibliography

Adams, W.H. *The French garden 1500–1800* (London) 1979.

Allen's West London Street Court and Trades Directory, 1869.

Anderson, A. *An historical and chronological deduction of the origin of commerce* (London) 1764.

Andriette, E.A. *Devon and Exeter in the Civil War* (Newton Abbot) 1971.

Anon. *A description of the county of Devonshire* (unknown) ND (c1830).

Anon. *A new and accurate description of the present great roads of England and Wales* (London) 1756.

Anon. *A topographical description of Honiton*, Gentleman's Magazine, 1793, *63*, p.113.

Anon. *Darkness in Devonshire*, Household Words, 1852, p. 325.

Anon. *Ingenious and Diverting Letters of a Lady's Travels into Spain*. 10th English Edition 1736

Anon. *Le Pompe* (Venice) 1559.

Apprentice indentures for poor children in the parish of Honiton, 1661-1887, Allhallows Museum, Honiton.

Arnheim, R. *Entropy and Art* (Berkeley) 1971.

Arnold, J. *Lost from her Majesies back* (Unknown) 1980.

Arnold, R. *The customs of London, otherwise called Arnold's Chronicle* (London) 1811 (reprint from the first edition).

Aubry, F. *Rapport sur les dentelles les blondes, les tulles et les broderies, fait a la Commission Francaise du jury international de l'Exposition Universelle de Londres* (Paris) 1854.

Bacon, J. and Co. *A short history of Honiton lace* (unknown) ND (probably 1897).

Barnard, H. *A history of lace* (Sidmouth) ND.

Barnard, H. *The origin and history of Honiton lace* (Sidmouth) ND (c1950).

Bath and West of England Agricultural Society Transactions, 1864–1894.

Berg, M. *The age of manufactures—industry, innovation and work in Britain 1700–820* (London) 1985.

Besant, W. *London* (London) 1904.

Besley, T. and H. *Exeter itinerary and general directory* (Exeter) 1828, 1831, 1835.

Beveridge, W.H. *Prices and wages in England* (London) 1965.

Billins, *Directory of Devonshire* (Exeter) 1857.

Biographie universelle ancienne et moderne (Paris) 1819.

Black. *Guide to the South Western counties of England* (Edinburgh) 1866.

Black, J.A. and Garland, M. *A history of fashion* (London) 1980.

Bodleian Library Manuscripts, Western, Lyell. (Relevant to lace making)

Books of Rates—Known Editions

c.1490 The Customs of London, otherwise called Arnold's Chronicle. Reprinted from the first edition, 1811, p.234.

1507 Gras N.S.B. The Early English Customs System, 1918. Appendix C pp.694-706. 'The text here printed is not from a contemporary manuscript but from an early eighteenth century transcript'.

1545 The rates of the custome house bothe inwarde and outwarde the difference of measures and weights and other comodities very necessarye for all marchantes to knowe newly correctyd and imprynted. An. MDXLV. Imprynted at London by me Rycharde Kele dwellynge at the longe shoppe in the Poultrye under Saynt Myldreds churche.

The only known surviving copy is in the Bodleian Library, Oxford, 8°C23 JUR(5)

1558 Patent Rolls 4 and 5 Phillip and Mary pt. 3 ms 12d-22d, not calendared.

1562 The Rates of the Custom house, Sybsidye or Poundage, as well for all kinde of Marchandise inwarde, as also Wolle, Clothes, and all other Merchaundise, outwarde in any of the Queenes Maiesties Portes, Havens or Creekes, Stablished by an Acte of Parliament in the first year of the rayne of Queene Mary newly corrected, amended in many places enlarged. Imprynted at London, at the long Shop, adjoining unto Sainct Mildred's Churche, in the Pultrie, by Jhon Alde Anno 1562.

The only known surviving copy is in Hatfield House Library; a microfilm of it is in the British Library, Salisbury MSS 334/1.

1582 Willan T.S. A Tudor Book of Rates, 1962.

A modern transcript of the original in the Bodleian Library, Oxford—Douce C70.

1590 THE RATES OF the Custome house. Reduced into much better order for the redier finding of any thing therein contained, then at any time heertofore hath beene: and now againe newly corrected, enlarged, and amended. Whereunto is also added the true difference and contents of waights and measures, with other things never before Imprinted. 1590. AT LONDON. Printed by John Winder for the Widdow of John Allde, and are to be solde at the long shop adioning unto S Mildreds Church in the Polltrye.

The only known surviving copy is in the British Library—C40 b29.

1643 Firth C.H. and Rait E.S. Acts and Ordinance of the Interregnum 1642–1660, 1978. Excise Ordinance, 22 July 1643.

1653 Firth C.H. and Rait R.S. Acts and Ordinance of the Interregnum 1642–1660, 1978. Excise Ordinances, 17 March 1653/4 and 26 June 1657.

1660 12 Charles 2, Cap 4, Appenxix.

1787 27 George 3, Cap 13, Appendix.

1803 43 George 3, Cap 68, Appendix.

1825 6 George 4, Cap 104, Appendix.

Bowen, E. *Complete system of geography* (London) 1747.

Bowley, A.L. *Prices and wages in the United Kingdom 1914–1920* (Oxford) 1921.

Bowley, A.L. *Wages in the United Kingdom in the nineteenth century* (Cambridge) 1900.

Brice, A. *The grand gazetteer and topographical dictionary* (Exeter) 1759.

Brighouse, U.W. *Woodbury—a view from the Beacon* (Woodbury) 1981.

Bright, E. *Honiton lace, Mrs Fowler—lacemaker* (unknown) ND (c1910).

British Library Manuscripts. Egerton, Salisbury, Lansdowne, Stowe, Harleian, Royal and Kings, Cottonian, Additional. (Relevant to lacemaking).

Britton, J. and Brayley, E.W. *The beauties of England and Wales IV Devonshire* (London) 1803.

Brooke, M.L. *Lace in the making* (London) 1923.

Buck, A. *Thomas Lester, his lace and the East Midlands industry* (Carlton) 1981.

Bullock, A-M. *Lace and lace-making* (London) 1981.

Burke, *Extinct and dormant boronetcies* (London) 1883.

Burnett, J. *A social history of housing* (London) 1980.

Burnet Morris Index. West Country Studies Library.

Burritt, E. *A walk from London to Land's End and back* (London) 1865.

The Business Directory, Volume 3 (London) 1862-3.

Bush, E. *The Book of Exmouth* (Buckingham) 1978.

Calendars of the Patent Rolls.

Calendara of the State Papers, Domestic Series.

Calendars of the State Papers, Venetian Series.

Calendars of the Treasure Books.

Camden, W. *Britannia.* Enlarged edition by Gough R. (London) 1806.

Campbell, J. *A political survey of Britain* (London) 1774.

Campbell, R. *The London tradesman* (London) 1747 (1969 reprint).

Casanova, L.B. *Venice and her lagoon.* Exhibition catalogue—Cinque secoli di merletti europei: i capolavori (Burano) 1984.

Chalke, E.S. *Notes on the members for Tiverton (Devon) 1621-1832* Transactions of the Devonshire Association, 1935, p.315.

Chamberlain, E. *The present state of England* (London) 1685.

Charity Commissioners, *The report of the Commissioners concerning charities containing that part which relates to the county of Devon* (Exeter) 1826.

Checkland, S.G. *The rise of the industrial society in England 1815-1855* (London) 1964.

City of London Record Office. Manuscript probate inventories.

Clark, A. *Working life of women in the seventeenth century* (New York) 1919.

Clark, E.A.G. *The estuarine ports of the Exe and Teign, with special reference to the period 1660-1860. A study in historical geography.* PhD thesis, London University, 1956.

Clark, E.A.G. *The ports of the Exe estuary 1660-1860* (London) 1960.

Clarkson, L.A. *The pre-industrial economy of England 1500-1750* (London) 1971.

Clay, C.G.A. *Economic expansion and social change: England 1500-1700* (Cambridge) 1984.

The Clergy List.

Cockburn, J.S. ed. *Western circuit assize orders 1629-1648* Camden Society, fourth series, XVII, 1976.

Cole, A.S. *Ancient needlepoint and pillow lace* (London) 1875.

Cole, A.S. *Honiton lace industry*. Ordered by the House of Commons to be printed 19 April 1888.

Cole, A.S. *Recent developments in Devonshire lace making*, Journal of the Society of Arts LII, 1904, p.431.

Cole, A.S. *Two lectures on the art of lace making* (Royal Dublin Society) 1884.

Cole, C.W. *Colbert and a century of French mercantilism* (New York) 1939.

Cole, G.D.H. and Postgate, R. *The common people 1746–1946* (London) 1946 (2nd edition).

Coleman, D.C. *Industry in Tudor and Stuart England* (London) 1975.

Coleman, D.C. *Proto-industrialisation: a concept too many*, Economic History Review, Second Series XXXVI, 1983, p.435.

Collier, A. *Lace, its history and identification* (Newbury) ND.

Committee of Council on the state of public health. *Third report of the medical officer of the committee of council on the state of public health*, 1861. PP 1861, XVI, 339.

Committee of Council on the state of public health, *Seventh report of the medical officer of the committee of council on the state of public health*, 1865. PP 1865, XXVI, 1.

Cooke, G.A. *Topographical and statistical decription of the county of Devon* (London) 1832.

Cosmo III, Grand Duke of Tuscany. *Diary of a tour of England*, Reproduced in Chope, R.P. *Early tours of Devon and Cornwall* (Exeter) 1918.

Cottle, B. *The Penguin dictionary of surnames* (London) 1966.

Cotton, W. *An Elizabethan guild of the city of Exeter* (Exeter) 1873.

Council for Education. *Reports of the committee of Council for Education*, 1844, 1846, 1847, 1848/9, 1853/4 PP 1845, XXV, 337, 1847, XLV, 1, 1847/48, L, 1, 1849, XLII, 83, 1854, LI, 1, 1854, LII, 1.

Cox, T. *Devonshire* (London) 1738.

Coxhead, J.R.W. *Honiton. a history of the manor and the borough* (Exeter) 1984.

Coxhead, J.R.W. *Smuggling days in Devon* (Exmouth) 1956.

Coxhead, J.R.W. *The romance of the wool, lace and pottery trades in Honiton*(Offwell) 1952 (second edition).

Croix, J. de la *Les images de Therese d'Avila et d'Anne de Jesus dans le couvre-pied des archducs*. Bulletin de Musees royeaux d'art et d'histoire, 6e serie, 43e-44e annees 1971–2, p.89.

Crosby B. and Co. *Complete pocket gazetteer of England and Wales* (London) 1818.

Croslegh C. Bradninch (London) 1911.

Cunningham, P. and Lucas C. *Costume for births, marriages and deaths* (unknown) 1972.

Cunningham, W. *Alien immigrants to England* (London) 1897.

Cunningham, W. *The growth of English industry and commerce* (Cambridge) 1892.

Davies, G. *The early Stuarts, 1603–1660 (Oxford) 1959.*

Davis, D. *A history of shopping* (London) 1966.

DCRS. *Devon inventories of the sixteenth and seventeenth centuries* 1966.

Defoe, D. *Diary of a tour of England*. Reprinted in Chope, R.P. *Early tours of Devon and Cornwall* (Exeter) 1918.

Defoe, D. *A plan of the English commerce* (Oxford) 1927 (facsimile of first edition of 1728).

Defoe, D. *A tour through England and Wales* (London) 1927 (reprint of original edition of 1724).

Devon Arts and crafts. A compendium of assorted papers in the West Country Studies Library.

Devon and Exeter Institute. *Stones Newspaper Scrapbooks*.

Devon County Council minute book, 1902.

'Devonia', *Honiton Lace* (London) ND (about 1870).

Devon Record Office. Manuscript items relating to lace.

Devon Union List. Compiled by Brockett, A.

Diderot, M. *Encyclopedie ou dictionnaire raisonne des sciences, arts et des metiers* (London) 1759.

Dodsley R. and J. *A new and accurate description of the present great roads and the principal cross roads of England and Wales* (unknown) 1756.

Dryden, A. *Honiton lace*, Pall Mall magazine, 1897, p.492.

Dryden, A. *Honiton lace* In Snell, F.J. Ed. *Memorials of old Devonshire* (London) 1904.

Dutton, R. *The English Garden* (London) 1937.

Earnshaw, P. *A dictionary of lace* (Princes Risborough) 1982.

Earnshaw, P. *Bobbin and needle laces, identification and care* (London) 1983.

Earnshaw, P. *Lace in fashion (London) 1985*.

Earnshaw, P. *Lace machines and machine laces* (London) 1986.

Earnshaw, P. *The identification of lace* (Princes Risborough) 1980.

East Budleigh Girls School. *Log book, 1872-1880*.

Edis, R.W. *Decoration and furniture of town houses* (London) 1881.

Einstein, L. *The Italian renaissance in England* (London) 1902.

Evans, J. *The juvenile tourist* (London) 1810.

Eveleth, L. *Chart for lace identification* (unknown) 1974.

Exeter Cathedral Library Manuscripts relating to lace making.

Exhibition Catalogues. 1851, The Great Exhibition, London. 1855, Universal Exhibition, Paris. 1862, International Exhibition, London. 1866, Bath and West of England Agricultural Society, Salisbury. 1867, Universal Exhibition, Paris. 1889, Arts and Crafts Exhibition Society, London. 1908, Daily Mail Exhibition London. 1913, National Association for the Organisation of Hand- made lace, London. 1914, British Exhibition Paris. 1973, Handmade Bobbin Lace Today, London.

Farquharson, A.S. *History of Honiton* (Exeter) 1868.

Farquharson, A.S. *History of Honiton*, 1891. MS in Honiton public library.

Felkin, W. *History of the machine wrought hosiery and lace manufactures* (Newton Abbot) 1967 (reprint of original 1867 edition).

Fiennes, C. *Diary of a tour of England*. Reprinted in Chope R.P. *Early tours of Devon and Cornwall* (Exeter) 1918.

Firth, C.H. and Rait, R.S. *Acts and Ordinance of the Interregnum 1642–1660* (Abingdon) 1978.

Fisher, F.J. ed. *Essays on the economic and social history of Tudor and Stuart England* (Cambridge) 1961.

Fortescue Foulkes, R. *From Celtic settlement to 20th century hospital. The story of Poltimore House* (unknown) 1971.

Freeman, C. *Pillow lace in the East Midlands* (Luton) 1958.

Fuller, T. *Worthies of England* (London) 1840 (reprint of 1662 edition).

Gaskell, E.C. *Cranford* (London) 1853.

Gay, J. *A journey to Exeter* in *Poetry and prose* I (London) 1974, p.203.

Gayer, A.S., Rostow, W.W. and Schwartz, A.J. *The growth and fluctuation of the British economy 1790–1850* (Oxford) 1953.

Gardiner, S.R. ed. *Notes of the debates in the House of Lords, officially taken by Henry Elsing, Clerk of the parliaments AD 1624 and 1625.* Camden Society publications, New Series XXIV, 1879.

G.E.C. *The complete baronetage* (Exeter) 1900 (Volume 1), 1902 (Volume 2).

The Gentleman's magazine.

The Gentlewoman's royal record of the wedding of HSH the Princess Victoria Mary of Teck and HRH the Duke of York (London) 1893.

Gidley, C. *History of the public charities or charitable donations of the parish of Honiton in the county of Devon* 1814. MS in Allhallows Museum, Honiton.

Gidley, C. *Letter to Lysons, D. dated 24 April 1820.* BL Add MS 9427, Item 255.

Gilboy, E.W. *Wages in eighteenth century England* (Harvard) 1934.

Ginsburg, M. *Wedding dress 1740–1970* (London) 1981.

Glenarvon *The beauties of Honiton lace*, Hearth and Home, 9 June 1904, p.227.

Gosse, P. *St. Helena 1502–1938* (Bath) 1990.

Gouboud, Mme. *Pillow lace book* (London) 1871.

Gould, S.B. *A book of the west* (London) 1900.

Gould, S.B. *Devonshire characters and strange events* (London) 1908.

Gras, N.S.B. *The early English customs system* (Cambridge Mass.) 1918.

Graves, Henry and Co. *The Royal Bal Costume* (London) 1845.

The Great Exhibition. *Catalogue and report of the juries.* 1851.

Hackett, F. *The little lace book* (Luton) ND (c1980).

Harper, G.W. *The South Devon coast* (London) 1907.

Hatton, E. *The merchant's magazine or tradesman's treasure* (London) 1726.

Harrison, W. *Description of England* (London) 1587. Reprinted 1968.

Head, R.E. *The lace and embroidery collector* (London) 1922.

Heath, F.G. *Peasant life in the West of England* (London) 1880.

Hedley, O. *Queen Charlotte* (London) 1975.

Hilton, G.W. *The truck system* (Cambridge) 1950.

Historic Manuscripts Commission, series of published volumes.

HLRO. *Notes of the Lord's committee on the decay of rents and trade* 1669.

Hooker, J. *Synopsis chorographical of Devonshire.* BL Harleian MS 5827, c1599.

Hopewell, J. *Pillow lace and bobbins* (Princes Risborough) 1975.

Hoskins, W.G. *Devon* (Newton Abbot) 1972.

Hoskins, W.G. *Harvest fluctuations and English economic life 1480–1619*, Agricultural History Review XII, 1964.

Hoskins, W.G. *Harvest fluctuations and English economic life 1620–1759*, Agricultural History review XVI, 1968.

Hoskins, W.G. *Industry, trade and people in Exeter 1688–1800* (Exeter) 1968 (second edition).

House of Commons. *Digest of returns on the education of the poor*, 1819, PP IX, 1.

House of Commons. *Second report of the commissioners for enquiry into the employment and conditions of children in mines and manufactures*, 1843. PP 1843, XIII, 307.

House of Commons. *First report of the Department of Practical Art*, 1853. PP 1852/53, LIV, 1.

House of Commons. *Report on the state of popular education* (The Newcastle report) 1861. PP 1861, XXI, 1.

House of Commons. *First report of the commissioners on the employment of children and young persons in trades and manufactures not already regulated by law*, 1863. PP 1863, XVIII, 1.

House of Commons. *Second report on the commission on the employment of children, young persons and women in agriculture*, 1867. PP 1868/69 XIII, 1.

House of Commons. *Report of the commissioners appointed to inquire into the truck system*, 1871. PP 1871, XXXVI, 1.

House of Lords. *Report by the Lord's select committee appointed to consider the poor laws and to whom several petitions on the subject have been referred*, 1818. PP 1818, V, 1.

House of Lords Record Office. Notes of the Committee on the Decay of Trade, 28.10.1669.

Houston, R. and Snell, K.D.M. *Proto-Industrialisation? Cottage industry, social change and industrial revolution*, The Historical Journal, 27, 2, 1984, p.473.

Huetson, T.L. *Lace and bobbins* (Newton Abbot) 1973.

Huguenot Society. *Returns of aliens dwelling in the city and suburbs of London* (London) 1900.

Huguenot Society. *Registers of the church of La Patente, Spitalfields* (London) 1898.

Huguenot Society. *Registers of the Walloon church at Canterbury* (London) 1898.

Huguenot Society. *Register of Walloon church of Jersey etc. established in Southampton* (London) 1890.

Hugues, P.L. and Larkin, J.F. *Tudor royal proclamations* (Yale) 1964 and 1969.

Hulme, E.W. *The history of the patent system under the prerogative and at common law*. Law Quarterly Review XII, 1896, p.141 and XVI, 1900, p.44.

Hutchinson, P.O. *Diary*. ND—MS in Devon Record Office.

Hutchinson, P.O. *History of Sidmouth*. ND—MS in Sidmouth Museum.

Hutchinson, P.O. *A new guide to Sidmouth* (Sidmouth) 1858.

Inder, P.M. *Honiton lace* (Exeter) 1971.

Insull, M.E. *Lympstone heritage* (Gainsborough) 1965.

International Geneological Index.

Jackson, F.N. *A history of hand made lace* (London) 1900.

Jackson, F.N. *Human figures in lace*. The Connoissuer IV, 1902, p.183.

Jarvis, A. and Raine, P. *Fancy dress* (Princes Risborough) 1984.

Jenkins, A. *History of the city of Exeter* (Exeter) 1806.

John Wilson's Successors Limited. *Trade catalogue* (London) c1905.

Johnstone, W.N. *A legacy in wool*. The Textile Society Newspaper, Autumn 1985.

Jones, M.E. *The romance of lace* (London) 1951.

Jones, O. *The grammar of ornament* (London) 1856.

Jourdain, M. *Alencon and Argenton lace*, Connoisseur VI, 1903, p.101.

Jourdain, M. *Old lace* (London) 1908.

Journal of the Board of Agriculture.

Journals. Devon and Cornwall Notes and Queries. Devon Historian. Notes and Gleanings.

Journals of the House of Commons 1660–1800.

Journals of the House of Lords 1660–1800.

Kelly. *Directory of Cornwall*, 1883, 1889, 1902, 1906, 1910, 1914, 1919, 1926.

Kelly. *Directory of Devonshire*, 1856, 1866, 1873, 1883, 1885, 1889, 1893, 1897, 1902, 1906, 1910, 1914, 1919, 1923, 1926, 1930, 1935, 1939.

Kelly, *Directory of Dorset*, 1895, 1911, 1915, 1920, 1923, 1927, 1931, 1935, 1939.

Kelly, *Directory of London*, 1885-6.

Kelly. *Directory of Somerset*, 1897, 1914, 1923, 1927, 1931, 1935, 1939.

Kerridge, E. *Textile manufactures in early modern England* (Manchester) 1985.

Klickman, F. *Pillow lace and hand worked trimmings* (London) 1920.

Knight, F.A. and Dutton, L.M. *Devonshire* (Cambridge) 1914.

Lambert, M. and Marx, E. *English popular art* (London) 1951.

Lane, F.C. *Venice and history* (Baltimore) 1966.

de Laprade, L. *Le poinct de France et centres dentelle au XVIIe et au XVIIIe siecles* (Paris) 1905.

Laver, J. *Taste and fashion from the French Revolution to the present day* (London) 1945.

Lefebure, E. Cole A.S. trans. *Embroidery and lace* (London) 1888.

Levery, S.M. *Lace, a history* (London) 1983.

Levey, S.M. and Payne, P.C. *Le Pompe 1559 Patterns for Venetian bobbin lace* (Carlton) 1983.

Lewis, S. *Topographical directory of England* (London) 1835, 1842.

Lidia. *Merletti d'Arte*. Permanent exhibition catalogue, Burano (Burano) 1985.

Llandover Lady, ed. *Mary Glanville, Mrs Delaney. The autobiography and correspondence* (unknown) 1861/2.

London Record Society. *The port and trade of early Elizabethan London, documents* (London) 1972.

London and Suburban Court Guide, 1861.

Longfield, A. *Irish lace* (Dublin) 1978.

Lowes, E.L. *Chats on old lace and needlework* (London) 1908.

Lysons, Rev. D. and Lysons, S. *Magna Britannia I, Part 1. Bedfordshire* (London) 1813.

Lysons, Rev. D. and Lysons, S. *Magna Britannia I, Part 3. Buckinghamshire* (London) 1813.

Lysons, Rev. D. and Lysons, S. *Magna Britannia VI. Devonshire* (London) 1822.

Maidment, M. *A manual of hand-made bobbin lace work* (London) 1931.

Mate. *Illustrated Honiton—official guide* (London) 1903 and 1907.

Mate. *Illustrated Sidmouth* (London) 1905 (3rd edition).

May, F.L. *Hispanic lace and lace making* (New York) 1939.

McFarlane, K.B. *John Wycliffe and the beginnings of English nonconformity* (London) 1952.

McPherson, D. *History of Commerce* (London) 1785.

Mendels, F.F. *Proto-industrialisation: the first phase of the industrialisation process.* J. Economic History XXXII, 1972, p.241.

Mignerak, M. *La practique d'l'aiguille industrieuse, du tres-excellent Milour Matthias Mignerak anglois ouvrier fort expert en toute sorte de lingerie* (Paris) 1605.

Millard, A.M. *Analysis of port books recording merchandise imported into the port of London by English and alien and denizen merchants for certain years between 1588 and 1640*, MS 1950–1959.

Milles, Dean. *MS Parochial collections for Devon.* Microfilm in West Country Studies Library, 1755/56.

Mincoff, E. and Marriage, M.S. *Pillow lace, a practical handbook* (London) 1907.

Mogridge, T.H. *A descriptive sketch of Sidmouth* (Sidmouth) ND (c1836).

Moody, A.P. *Devon pillow lace* (London) 1907.

Moody, A P. *Lace making and collecting* (London) 1909.

Moore, N.H. *The lace book* (New York) 1904.

Moore, Rev. T. *The history of Devonshire from the earliest period to the present* (London) 1829.

Morris. *Directory of Devonshire* (Exeter) 1870.

Moule, T. *The English counties delineated* (London) 1837.

The Municapal Directory (London) 1856.

Murray, J. *A handbook for travellers in Devon* (London) 1895.

McCulloch, J.R. *A dictionary, geographical, statistical, and historical of commerce and commercial navigation* (London) 1843).

McPherson, D. *Dictionary of Commerce* (London) 1778.

National Art Library Manuscripts relating to lacemaking.

Newspapers. Alfred. Besley's Devonshire Chronicle and Exeter News. Brighton Herald. Daily Chronicle. Daily Telegraph. Devon and Exeter Daily Gazette. Dorset Evening Echo. Exeter Flying Post. Express and Echo. Pulman's Weekly News. Sidmouth Journal and Directory. Teignmouth Post and Gazette. Times. Tiverton Gazette. Torquay Directory. Western Luminary. Western Morning News. Western News. Western Times. Woolmer's Exeter and Plymouth Gazette.

Newton, E. *The meaning of beauty* (London) 1950.

Nouvelle biographie general (Paris) 1867.

Nuttall, G. ed. *Letters of John Pinney 1679-1699* (Oxford) 1939.

Office of Population Censuses and Surveys. *Census enumerators books for Devon*, 1841, 1851, 1861, 1881. Microfilms in West Country Studies Library.

Ogilby and Morgan. *Pocket book of the roads*. (London) 1745.

Oral testimony Mrs Milly Perryman (lace making in Honiton). Mrs C.D. R. Mitchum (lace making in Honiton). Miss Doris Pidgeon (Lace making and selling in Sidbury). Belgian lacemakers visiting Allhallows Museum, Honiton. Mrs G.L. Hamblin (truck system in Honiton). Mrs J.E.McD. Wood (lace dealing in Honiton). Mr D. Cload (lace making in Beer). Mrs Newton (lace making in Withycombe Raleigh). Transcripts in the possession of the author.

Overloop, E. van. *Une dentelle de Bruxelles de 1599*. Materiaux pour servir a l'histoire de la dentelle en Belgique (Brussels) 1903.

Page, J.L. W. *The coasts of Devon* (London) 1895.

Page, J.L. W. *The rivers of Devon* (London) 1893.

Palliser, B. *History of lace* (London) 1865.

Palliser, B. *Bistory of lace*. Revised and enlarged by Jourdain, M. and Dryden, A. (London) 1910.

Pares, R. *A West India fortune* (London) 1950.

Paries, L. *Les points a l'Aiguelle Belges* (Brussels) 1947.

Paris Telephone Directory.

Parish registers Aylesbeare. Ashburton. Axminster. Axmouth. Barnstaple. Bradninch. Branscombe. Braunton, Buckerell. Colyton. Cotleigh. Crediton. Dalwood. Dartmouth. East Budleigh. Farway. Honiton. Knowstone. Offwell. Otterton. Ottery St. Mary. Salcombe Regis. Seaton and Beer. Sidbury. Sidmouth. Upottery. Widworthy.

Partridge, W. *A practical treatise of dyeing* (New York) 1823.

Paulis, L. *La passe de la dentelle Belge* (Brussels) ND.

Paulis, L. *Les points a l'aiguille Belges* (Brussels) 1947.

Paulis, L. *Une dentelle de Bruxelles de 1599*. Bulletin des musees royeaux d'art et d'histoire, l'e annee, No.5, Sept./Oct. 1942, p.114.

Pearse, R. *Huguenots and the lace industry in Devon*, DCNQ, 1952/3, XXV, p.106.

The Penny Cyclopaedia 1838.

Periodicals. Annual Register. La Belle Assemblé. Art Journal. Country Fair. Country Life. Devon Life. Gentlemans Magazine. Graphic. Hearth and Home. Household Words. Illustrated London News. Illustrated Queen Almanac. Leisure Hour. Lace. Mercure Galant. Pall Mall Gazette. Queen. Weavers Journal. Who's Who. Womans Realm. Womans Weekly. Young Ladies Journal.

Peters, R.H. *Textile chemistry* (Unknown) 1963, 1975.

Pigot and Co. *Royal national and commercial directory*, 1830, 1844.

Pinchbeck, I. *Women workers and the industrial revolution* (London) 1969.

Pinto, E.H. *Treen and other wooden bygones* (London) 1979.

Pole, Sir W. *Collections towards a description of the county of Devon* (London) 1791.

A poll taken the 21st. day of November 1763 at the House of John Barnes within the Borough of Honiton. Broadsheet. Allhallows Museum, Honiton.

Pond, G. *An introduction to lace* (London) 1973.

Ponting, K.G. *A dictionary of dyes and dyeing* (London) 1981.

Pope, C. *A practical abridgement of the laws and customs relating to the import, export and coasting trade* (London) 1812.

Postlethwayt, M. *The universal dictionary of trade and commerce* (London) 1774.

Post Office Directory of London, 1846.

Powys, M. *Lace and lace making* (Boston) 1981 (reprint of original of 1953).

Powys, P.L. *Passages from the diaries of, 1756 to 1808*, Climenson, E.J. ed. (London) 1899.

Poynter, F.N.L. ed. *The journal of James Yonge 1647–1721* (London) 1963.

Prince, J. *Worthies of Devon* (Exeter) 1701.

Privy Council. *Report of the medical officer of health for the Privy Council*, 1865.

Public Record Office. State Papers Domestic 1630–1640. Royal Wardrobe Accounts 1700–1901. Port Books—London E190 series.

Pullan, B. ed. *Crisis and change in the Venetian economy in the sixteenth and seventeenth centuries* (London) 1968.

Pulman, G.P.R. *The book of the Axe* (London) 1875 (4th edition)

Rattenbury J. *Memoirs of a smuggler* (Sidmouth) 1837.

Read, H. *The meaning of art* (Harmondsworth) 1949 (reprint of original edition of 1931).

Reaney, P.H. *A dictionary of British surnames* (London) 1958.

Rees, A. *The cyclopaedia or universal dictionary of arts, sciences and literature* (London) 1819.

Reigate, E. *An illustrated guide to lace* (Woodbridge) 1986.

Relazioni di ambasciatori Veneti al Senato. I. Inghilterra (Torino) 1965.

Rhead, G.W. *The history of the fan* (London) 1910.

Ricci, E. *Old Italian lace* (London) 1908.

Risdon, T. The chorographical description or survey of the county of Devon, printed from a genuine copy of the original (London) 1811.

Risselin-Steenebrugen, M. *Carolin d'Halluin, marchande de dentelles a Bruxelles au XVIIIe siecle*. Annales de la societe royale d'archeologie de Bruxelles, 1956, p.1.

Risselin-Steenebrugen, M. *Le Colbertisme et la dentelle de Bruxelles aux fuseaux*. Annales de la Society Royale d'Archeoogie de Bruxelles, 1956–66, p.111.

Risselin-Steenebrugen, M. *Martine et Catherine Plantin*. Revue Belge d'archeologie et d'histoire d'art, XXVI, 1957, p.169.

RM. *Nüw Modelbuch, allerley Giattungen Däntelschnür.* (Zurich) 1561.

Roberts, G. *History and antiquities of the borough of Lyme Regis and Charmouth* (London) 1834.

Roberts, G. *A social history of the people of the southern counties of England in past centuries* (London) 1856.

Robins, J.C. *The new British traveller* (unknown) 1819.

Robson's London Commercial Directoryf 1830.

Rogers, I. *The Huguenots in Devonshire* (Barnstaple) 1942.

Rogers, J.E.T. *Agriculture and prices in England* (Oxford) 1887.

Rogers, W.H.H. *Memorials of the west* (Exeter) 1888.

Ruddock, A.A. *Italian merchants and shipping in Southampton 1270-1600* (Southampton) 1951.

Rule, J. *The experience of labour in eighteenth century industry* (London) 1981.

Russell, C. ed. *The origins of the English civil war* (London) 1975.

Sanderson, R. ed. *Foedera, conventiones, literae et cujusconque generis acta publica, inter reges Angliae et alios quo suis* (London) 1732.

Savary, J. *Le parfait negociant* (Geneva) 1676.

Savary des Bruslons J. *Dictionnaire universel de commerce* (Amsterdam) 1726.

Schumpeter, E.B. *English overseas trade statistics 1697–1808* (Oxford) 1960.

Scott, W.R. *The constitution and finance of English, Scottish and Irish joint stock companies to 1720. Volume 1* (Cambridge) 1912.

Scoville, W.C. *The persecution of Huguenots and French economic development 1680–1720*, (Berkeley and Los Angeles) 1960.

Seguin J. *La dentelle* (Paris) 1875.

Sellman, R.R. *The development of Devon rural schools in the nineteenth century* (Exeter University PhD thesis) 1974.

Sharp, M. *Point and pillow lace* (London) 1905.

Sheldon, G. *From trackway to turnpike* (Oxford) 1928.

Simeon, M. *The history of lace* (London) 1979.

Slater. *Royal national and commercial directory, Devonshire*, 1852/3.

Smiles, S. *The Huguenots—their settlements, churches and industries in England and Ireland* (London) 1880.

Snell, F.J. *Memorials of old Devonshire* (London) 1904.

Some Considerations, Humbly offered to the Honourable House of Commons, concerning the Proposed Repeal of an Act lately Passed to render the Laws Prohibiting the Importation of Foreign Bonelace, &c. more Effectual. 1. National Art Library, Victoria and Albert Museum, 43.A.2h. 2. BL. 816 m13. Item 16.

Spenceley, G.F.R. *The health and disciplining of children in the pillow lace industry in the nineteenth century.* Textile History, I, 1976, p.154.

Spenceley, G.F.R. *The lace associations.* Victorian Studies XVI, 1973, p.433.

Spenceley, G.F.R. *The origins of the English pillow lace industry.* Agricultural History Review, XXI, 1973.

Spender, E. *On the cider truck system in some parts of the west of England.* Journal of the Statistical Society of London, XXVII, 1864, p.256.

Stanes, R. *The Compton census for the diocese of Exeter.* Devon Historian, October 1974, April 1975.

Staniland, K. and Levey, S.M. *Queen Victoria's wedding dress and lace*, Costume 17, 1983, p.1.

Statutes of the Realm.

Steele, R.R. ed. *Tudor and Stuart proclamations* (Oxford) 1910.

Stirling, D.M. *Beauties of the shore* (Exeter) 1838.

Stoate, T.L. *Devon hearth tax returns, Lady Day 1674* (Bristol) 1982.

Stow, J. *The Annales of England*, updated by Howes E. (London) 1614.

Supple, B.E. *Commercial crisis and change in England 1600–1642* (Cambridge) 1959.

Swain, A. *Ayshire and other whitework* (Princes Risborough) 1982.

Tawney, R.H. and Power, E. ed. *Tudor economic documents* (London) 1924.

Tebbs, L.A. *The art of bobbin lace* (London) 1907, reprinted facsimile 1972.

Tebbs, L. and Tebbs, R. *Supplement to the art of bobbin lace* (London) 1911, reprinted in facsimile 1973.

Tenenti, A. *Piracy and the decline of Venice 1580–1615* (London) 1967.

Thacker, C. *The history of gardens* (London) 1979.

Thirsk, J. ed. *The agrarian history of England and Wales 1500–1640* (Cambridge) 1967.

Thirsk, J. *Economic policy and projects. The development of a consumer society in early modern England* (Oxford) 1978.

Thirsk, J. *Industries in the countryside* in Fisher, F.J. ed. *Essays in the economic and social history of Tudor and Stuart England* (Cambridge) 1961.

Thirsk, J. and Cooper, J.P. eds. *Seventeenth century economic documents* (Oxford) 1972.

Thompson, E.P. *The making of the English working class* (London) 1963.

Thompson, J.A.F. *The later Lollards 1414–1520* (London) 1965.

Thompson, W.H. and Clark, G. *The Devon landscape* (London) 1934.

Tomlinson, M. *Three generations in the Honiton lace trade* (unknown) 1983.

Toomer, H. and Toomer, C.J. *Costume and lace through the ages*. Exhibition catalogue, Bickham House, Roborough, Devon (Roborough) 1985.

Tracts on trade. BL 816 m13 item 17.

Treadwin, C.E. *Antique point and Honiton lace* (London) 1873.

Treadwin, C.E. *Devonshire lace*. TDA, XV, 1883, p.231.

Trevelyan MSS. University Library, Newcastle-upon-Tyne, WCT 154.

Trevelyan, R. *A pre-Raphaelite circle* (London) 1978.

Trewin and Son. *The Exeter Pocket journal* (Exeter) 1801.

Tunnicliff, W. *Survey of the counties of Hants, Wilts, Dorset, Somerset, Devon and Cornwall* (Salisbury) 1791.

Turner, P. *Crochet* (Princes Risborough) 1984.

The Universal British Directory (London) 1792.

University College of the South West. *Devon and Cornwall, a preliminary survey* (Exeter) 1947.

Unknown author. *Devonshire* (unknown) 1754.

Unknown author. *Carte e documenti spettanti a Girolamo Venier e Lorenzo Soranzo ambasciatori straordinari a Guglielmo III Re d'Inghilterra 1695'*. St Mark's Library, Venice. segn. marc. It VII 1934 (= 9060) ff.171v-172r.

Van Arsdell, R.D. *Celtic Coinage of Britain*. (London) 1989.

Vancouver, C. *General view of the agriculture of the county of Devon (London) 1808.*

Victoria and Albert Museum. *Picture book of English lace* (London) 1924.

Victoria County History. *Devonshire.*

Victoria County History. *Dorset.*

Victoria County History. *Somerset.*

Victoria County History. *Wiltshire.*

Vinciolo, F. *Les singuliers et nouveaux pourtraicts du seigneur Frederic de Vincolo Venitien, pour touts sortes d'ouvrages de lingerie* (Paris) 1606 (reprinted 1971).

Wakeman, H.O. *The ascendency of France 1598–1715* (London) 1919.

Walpole Society. *The inventories and valuations of the King's goods 1649–1651*, 43rd volume, 1970–1972.

Wardle, P. *Victorian lace* (Carlton) 1982 (revised second edition).

Ward, G.A. ed. *Journal and letters of the late Samuel Curwen, Judge of Admiralty etc. An American refugee in England from 1775 to 1784* (London) 1842.

Ward, C.S. and Baddeley, M.J.B. *South Devon and South Cornwall* (London) 1908.

Ward Lock and Co. *Guide to South East Devon* (London) 1910/11, 1925/26, 1933/34, 1936/37.

Watkins Commercial and General London Directory 1852, 1853, 1854.

Weldon. *Practical Honiton lace* (London) ND, c1930.

Westcote, T. *A view of Devonshire in MDCXXX* (Exeter) 1845.

White, W. *History, gazetteer and directory of Devonshire*, 1850, 1878, 1890.

Whiting, G. ed. *La revolte des passaments.* Bulletin of the Needle and Bobbin Club, XIV, (New York) 1930, pp.3-39.

Whiting, G. *Old-time tools and toys of needlework* (New York) 1928.

Wigfield, W. McD. *Azariah Pinney, Yeoman of Axminster.* Devon Historian 29, 1984, p.17.

Wigfield, W. McD. *The Monmouth rebellion* (Bradford-on-Avon) 1980.

Willan, T.S. *A tudor book of rates* (London) 1962.

Wood, J. *An essay towards a description of Bath* (Bath) 1749 (second edition).

Worth, R.N. *A history of Devonshire* (London) 1886.

Wright, T. *The romance of the lace pillow* (Olney) 1919.

Wyatt, Sir D. *Industrial arts of the nineteenth century* (London) 1853.

Wyld, H.C. *Universal dictionary of the English language* (London) 1936.

Yallop, H.J. *An example of the 17th Century Honiton lace?.* The Devon Historian 29, 1984, p.27.

Yallop, H.J. *The decoration of Honiton Lace Bobbins.* Transactions of the Devonshire Association, 1990, p.121.

Yallop, H.J. *The history of the Honiton lace industry.* Textile History 14, 1983, p.195.

Yallop, H.J. *The history of the Honiton lace industry* (Exeter University PhD thesis) 1987.

Yallop, H.J. *The lacemaker's globe.* Transactions of the Devonshire Association, 1991, p.189.

Yallop, H.J. *The making of a myth—the origin of Honiton lace.* Devon Historian 28, 1984, p.20.

Yallop, H.J. *To the great scandal of religion.* Devon Historian 41, 1990, p.20.

Young, A. *A six weeks tour through the southern counties of England and Wales* (London) 1772.

Plates

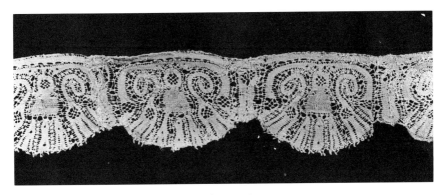

3. Edging, c1630.

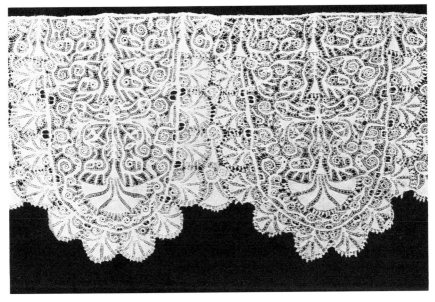

4. Flounce, 1630-1640, incorporating two interpretations of a single design.

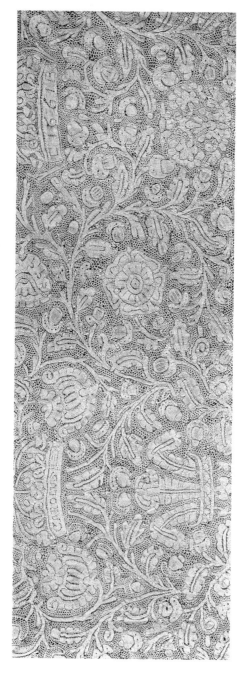

5. Detail of sash 1661, most probably celebrating the appointment of Sir Copleston Bampfylde as High Sheriff of Devon in that year. (Art Institute of Chicago).

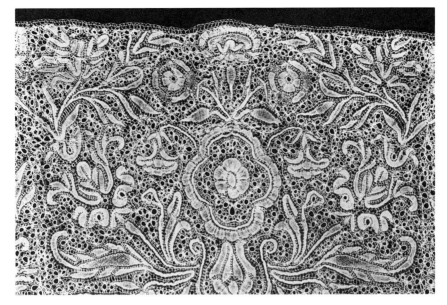

6. Panel from flounce, 1690s.

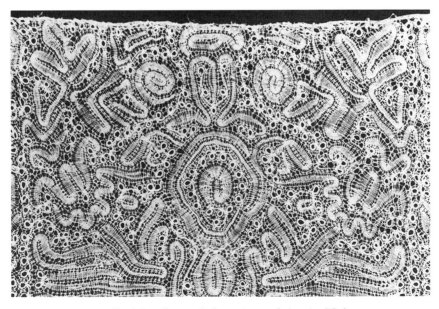

7. Panel from flounce similar to 6, same design simplified.

291

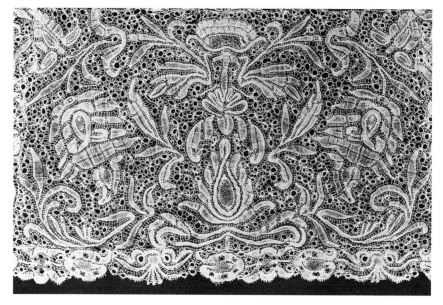

8. Second panel from flounce 6.

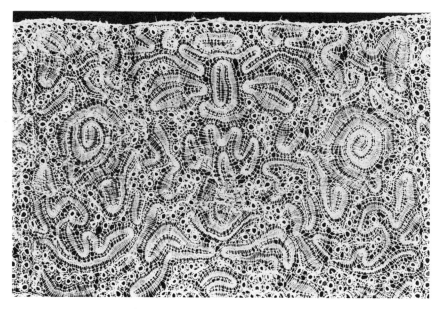

9. Second panel from flounce 7, same design as 8 simplified.

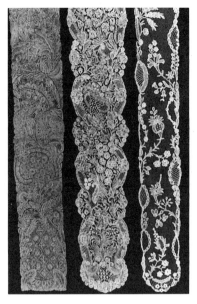

10. Lappets, (L to R) c1720, c1740, c1770.

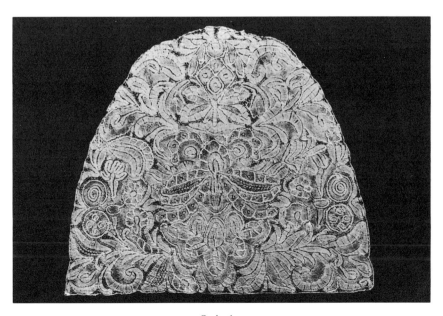

11. Capback, c1720.

293

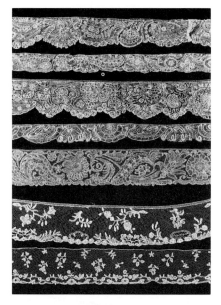

12. Edgings, c1720-c1800.

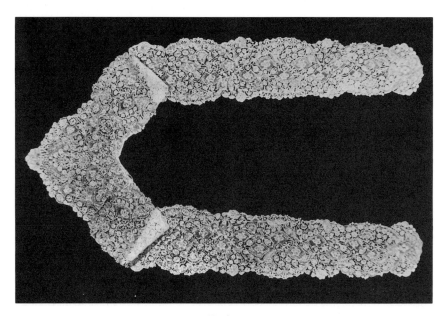

13. Head, c1740.

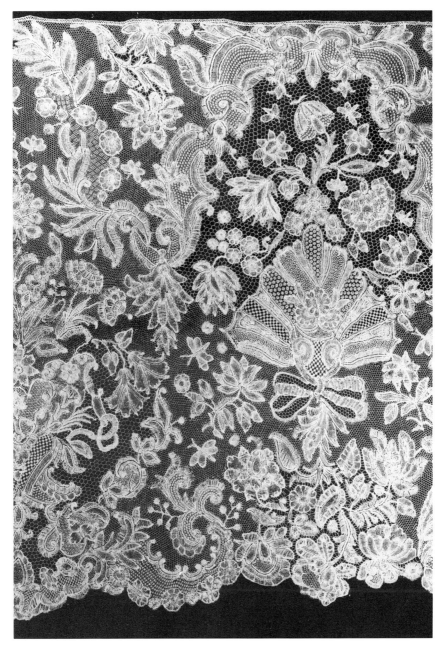

14. Flounce, 'The broadest sort made in England,' c1760.

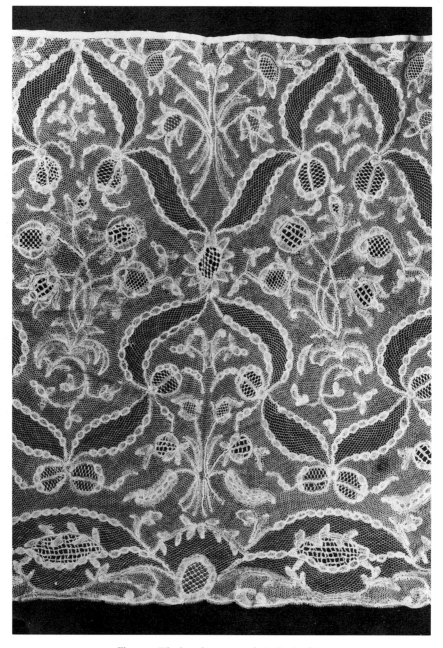

15. Flounce, 'The broadest sort made in England,' c1780.

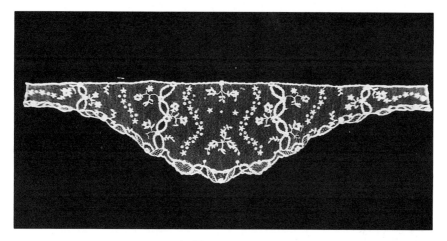

16. Engageant, c1780.

17. Pillow made net showing the 'invisible' joins between the strips.

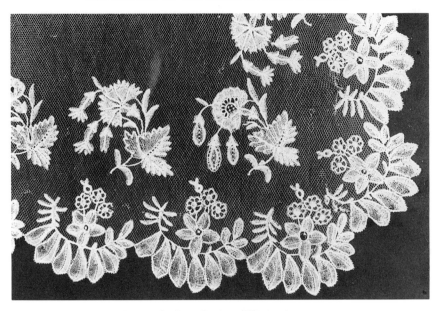

18. Corner of veil, appliqué on pillow made net, c1800.

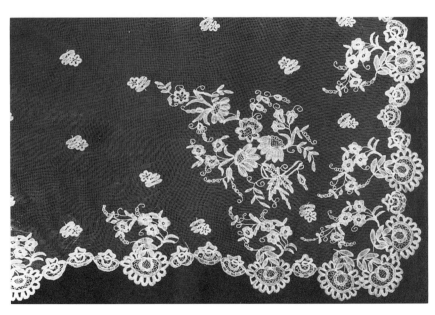

19. Corner of veil, appliqué on machine made net, mid 19th century.

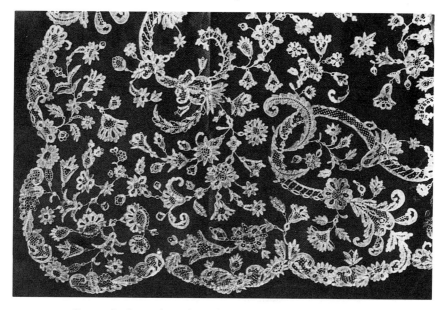

20. Corner of veil worn by Lady Yarde-Buller at her marriage 24 January 1823, appliqué on machine made net (Lord Roborough).

21. Circular device, possibly a watch 'paper', 1836.

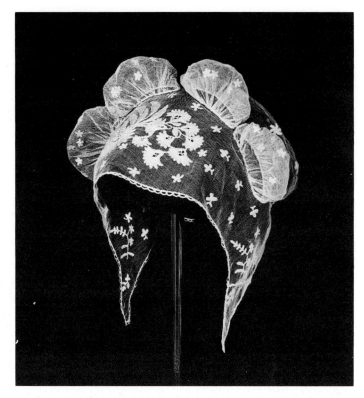

22. Cap or cornette, appliqué on machine made net, c1820-1840.

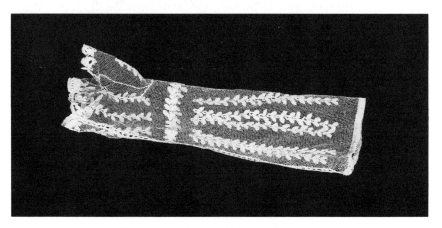

23. Mitten, appliqué on machine made net, c1820-1840.

24. Queen Victoria's wedding veil. Designed by William Dyce, made under the direction of Miss Bidney. (HM the Queen).

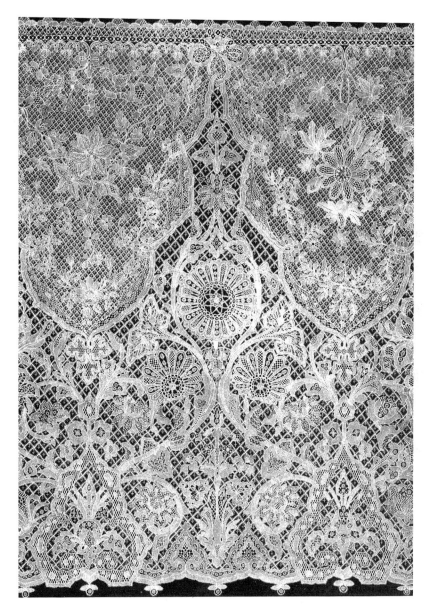

25. Flounce designed by C.P. Slocombe of the Government School of Design
with details by Mrs Treadwin. Shown by Mrs Treadwin at the Great Exhibition,
1851 (Wyatt).

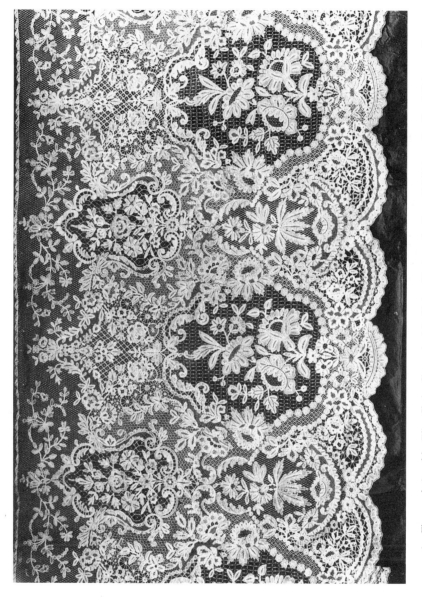

26. Flounce designed by Eliza Clarks. Shown by Mrs Esther Clarke at the Great Exhibition, 1851 (Lord Roborough).

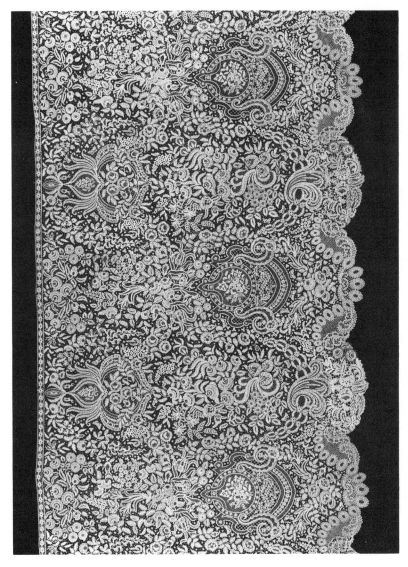

27. Flounce designed by Mary Tucker. Shown by Howell and James at the International Exhibition 1862. (Victoria and Albert Museum, T.274-1982).

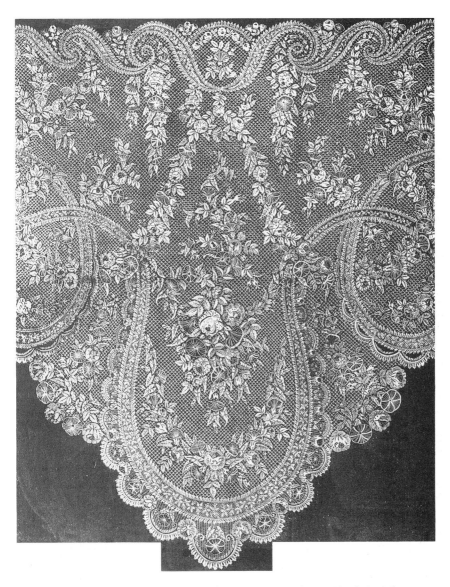

28. Half shawl, designed by a Nottingham artist. Shown by Mrs Treadwin at the
International Exhibition 1867. (Art Journal Catalogue).

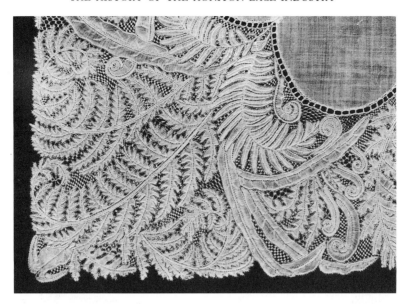

29. Corner of handerchief designed by Lady Trevelyan. Shown at Bath and West Show, 1864 (Victoria and Albert Museum, 785-1864).

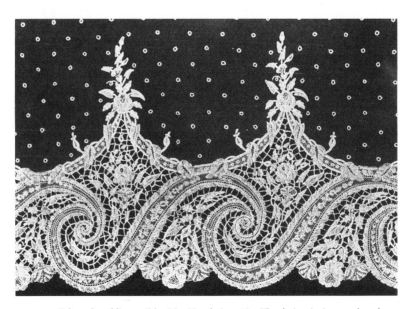

30. Edge of wedding veil by Mrs Treadwin, 1869. The design is, in part, based on that of the top edge of 28.

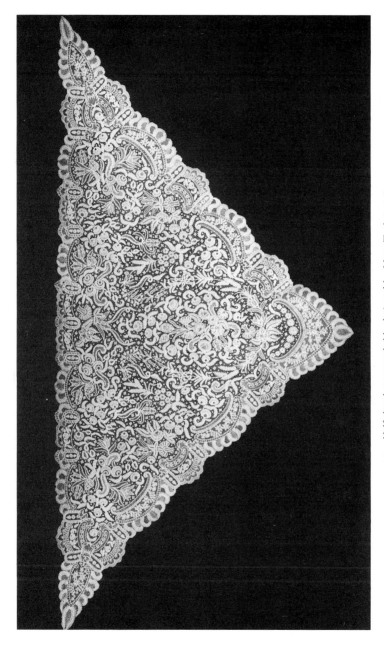

31. Half shawl most probably designed by Mary Tucker, c1870.

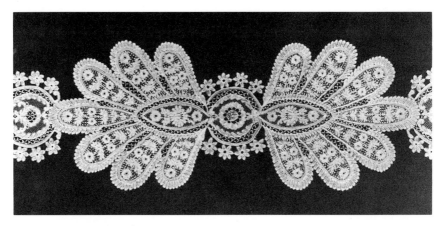

32. Centre section of a tie or head, most probably designed by Mary Tucker. The impractical shape of this object suggests that it may have been an exhibition piece.

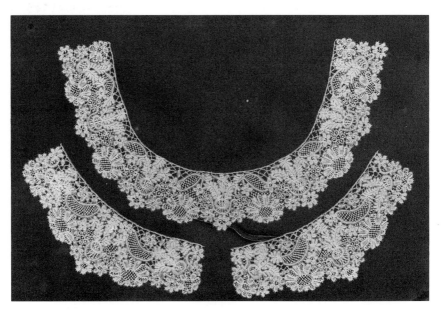

33. Collar and cuffs set, most probably designed by Mary Tucker. Closely similar sets known to be by her, are in the Victoria and Albert Museum and Buckland Abbey.

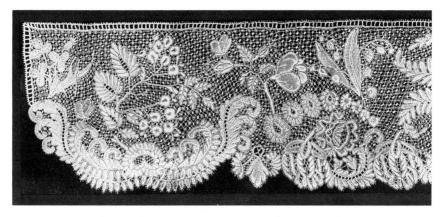

34. Edging made for Queen Victoria, illustrated in The Graphic 6.2.75.

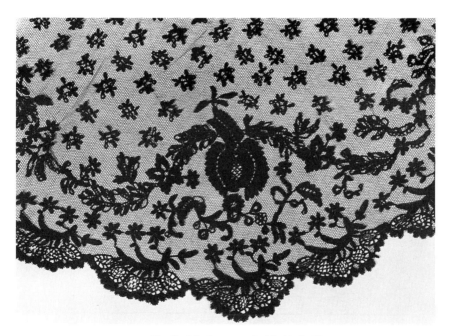

35. Detail of fascinator worked in black silk.

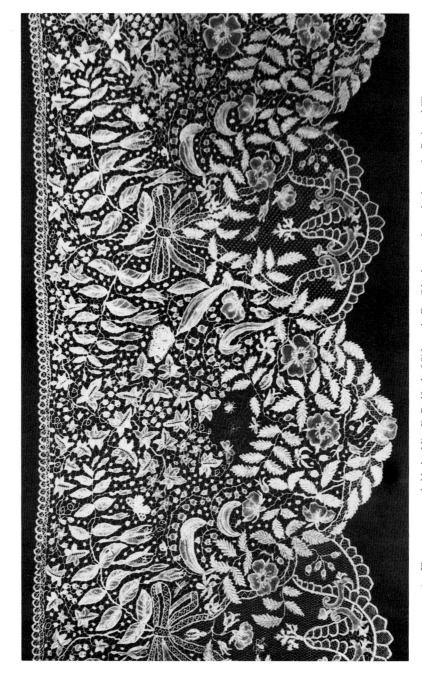

36. Flounce, most probably by Miss E. Radford of Sidmouth. Possibly the one shown by her at the Bath and West Show, 1874.

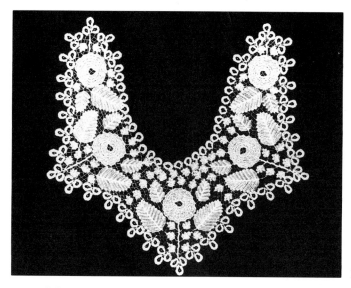

37. Collar made by one of the lacemaker's who had worked on Queen
Alexandra's wedding lace. The exceptionally large roses are an unusual feature.
Second half 19th century.

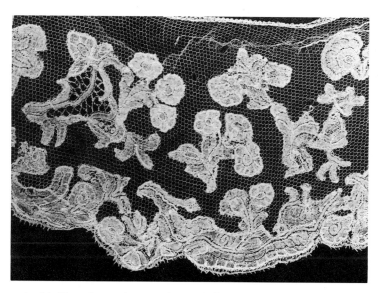

38. Motifs cut from 18th century lace applied to machine made net. This is an
outstanding example of how Mrs Treadwin stated that Honiton lace should not be
renovated. Undatable.

311

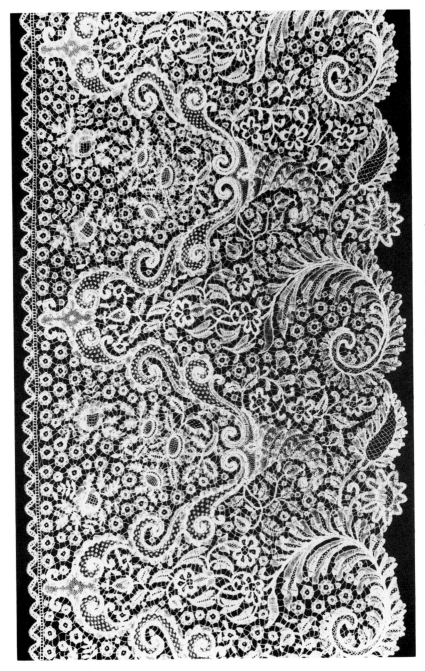

39. Flounce, possibly by Mrs Treadwin. Fourth quarter 19th century.

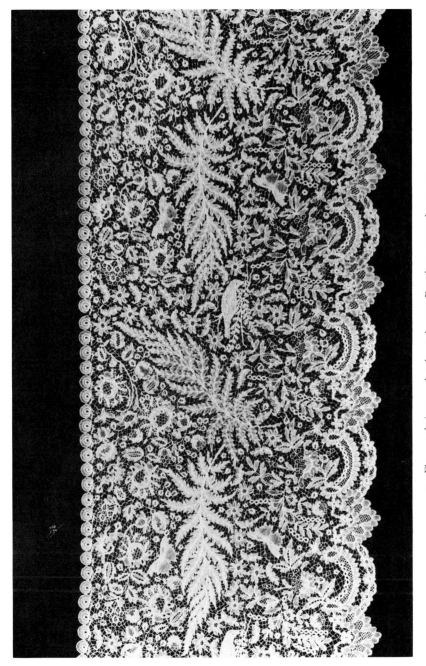

40. Flounce, designer and maker unknown. Fourth quarter 19th century.

41. End of stole, designer and maker unknown. Fourth quarter 19th century.

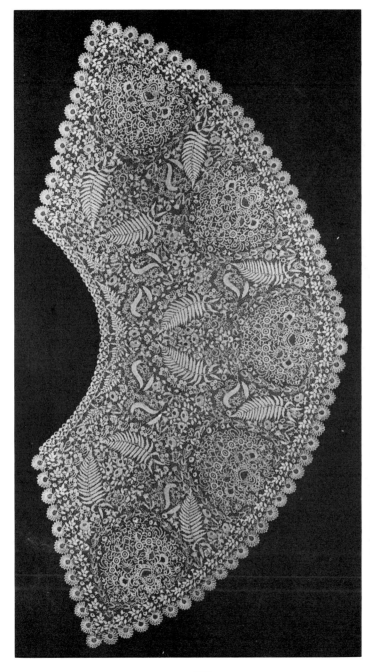

42. Overskirt, designer and maker unknown. Fourth quarter 19th century. The dimensions are appropriate for Queen Victoria at this period of her life but there is no evidence that it was made for or worn by her.

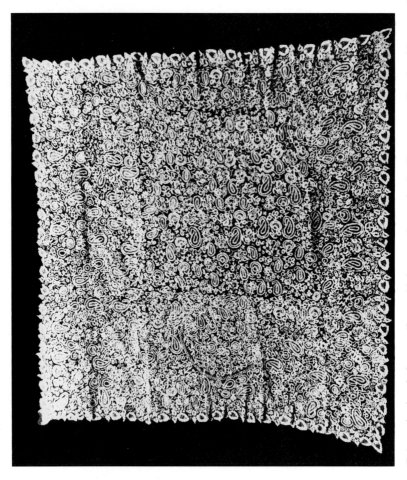

43. Guipure shawl made from motifs assembled more or less randomly. The presence of boteh and lotus motifs reflects the fashion for Paisley shawls in the 19th century. Second half 19th century.

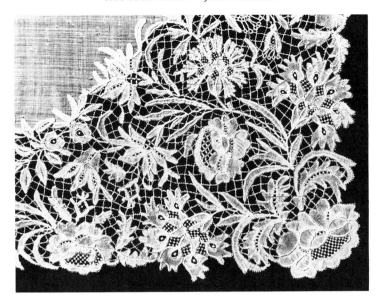

44. Corner of handkerchief, designed and maker unknown. The stylised flowers appear to have been inspired by roses and dianthus. c1900.

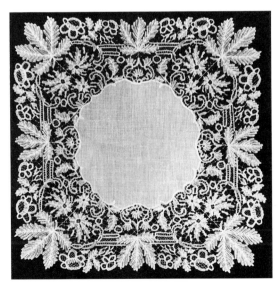

45. Handkerchief made from the same design as one presented to the Duchess of York, later Queen Mary, in 1893.

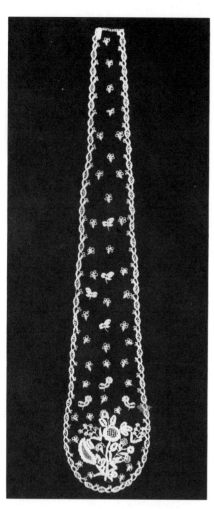

46. Back lappet, white motifs appliqué on black machine made net. When worn with a dark coloured dress the motifs appear to float in the air behind the wearer. Second half 19th century.

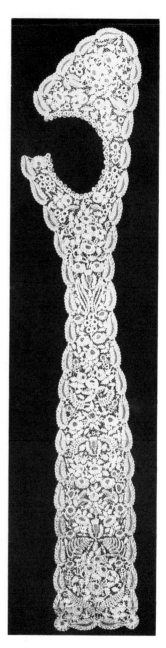

47. Collar and tablier, c1900.

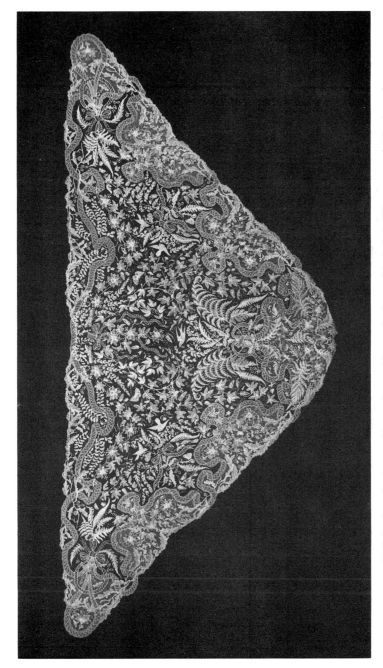

48. Half shawl, appliqué on machine made net with areas having toad-in-the-hole filling as ground. The size and shape of this piece suggests a mid 19th century date, but the design is unlike that of any major example of Honiton lace known to be from that period. However the design characteristics are very similar to those of pieces designed by Mrs Fowler, a gold medal at the St Louis exhibition of 1904. Whatever the date this is a fine piece of excellent design and outstanding craftsmanship.

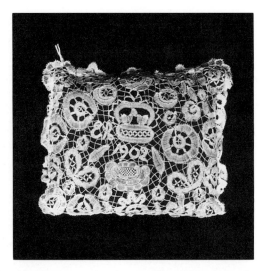

49. Pincushion commemorating the coronation of King Edward VII, 1902.

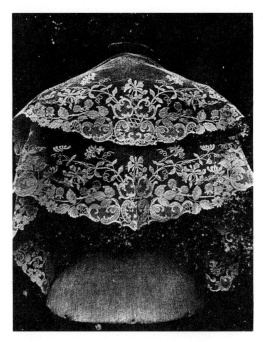

50. Cape designed by Miss D.B. Ward, part of Mrs Fowler's gold medal winning
entry at St. Louis, 1904. Compare with 48. (Coxhead, 1952).

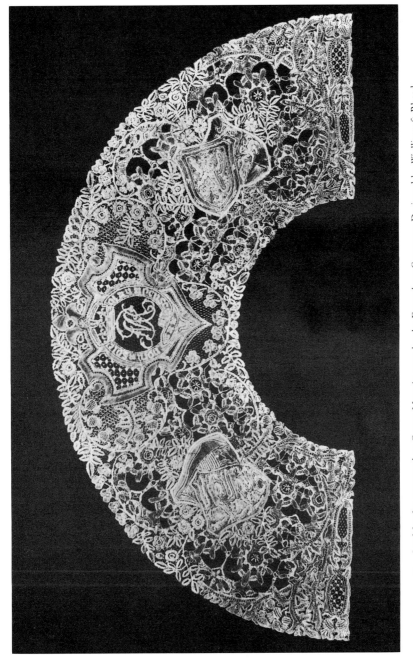

51. Leaf for fan presented to Queen Mary in 1911 by the Fanmakers Company: Designed by Wolliscroft Rhead, made under the direction of Mrs Fowler.

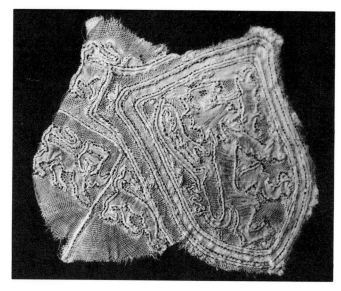

52. Pair of shields for 51 worked with the pricking upside down. Mrs Fowler's comments are not recorded!

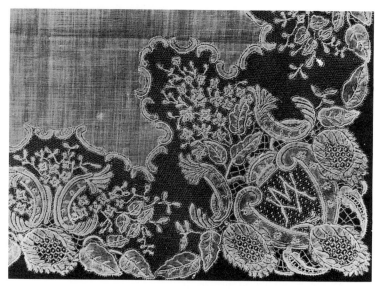

53. Corner of handkerchief designed by Miss D.B. Ward [85] and made by Mrs Fowler for Queen Mary, 1910. Shown at the Brussels Exhibition of that year and the Paris Exhibition, 1944.

54. Corner of wedding veil sold by Mrs Ida Allen of Beer in 1931 for £8.0.0.
[92].

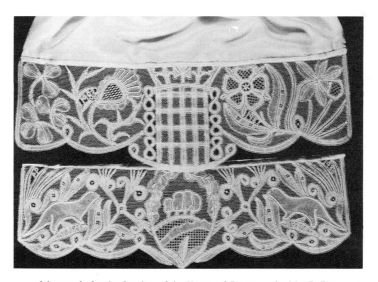

55. Jabot made for the Speaker of the House of Commons by Mrs P. Perryman
of Honiton, 1984. The top fall symbolises the House with its portcullis badge and
the emblems of England, Scotland, Ireland and Wales. The lower fall symbolises
Honiton, with the tree crowned hill of Dumpdon, a local landmark, otters and
trout representing the valley of the river Otter in which the town stands and
honeysuckle as a punning allusion to the town itself.

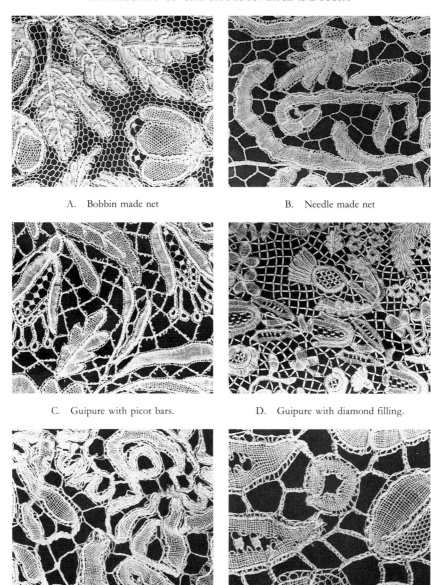

A. Bobbin made net

B. Needle made net

C. Guipure with picot bars.

D. Guipure with diamond filling.

E. Guipure with plain bars.

F. Guipure with oversewn bars.

56. Forms of ground used in 19th century Honiton lace.

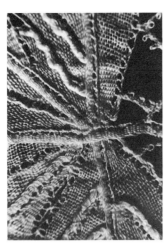

A. Rib raided work.

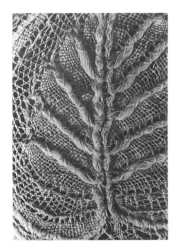

B. Roll and tie raised work.

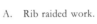

C. Gimp or shiny thread.

D. Open and close whole stitch work.

E. No emphasis used.

57. Techniques of emphasis used in 19th century Honiton lace.

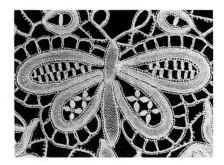

A. Naturalistic depiction gives way to tape outline with fillings.

B. Slugs and other vague forms.

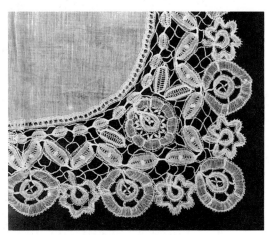

C. Machine tape replaces pillow made motifs.

58. Development of raglace.

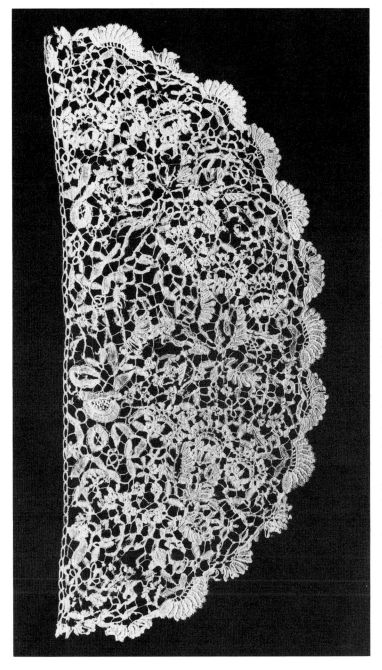

59. A remarkable example of rag lace assembled from an inconsequential combination of fragments.

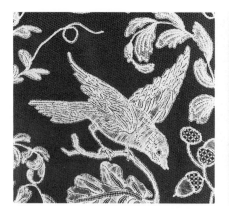
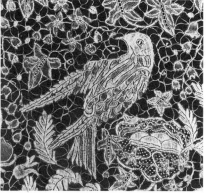

A. Warbler B. Dunnock at nest.

C. Swallow—though they do not eat acorns!

D. Thrush with snail.

60. Designs after nature—birds.

A. Male fern frond, underside with spores.

B. Cowslips.

C. Butterfly. D. Spider and Catch.

61. Designs after nature—leaves, flowers, insects and arachnids.

A. Le Pompe, Venice, 1559.

E. Le Pompe, Venice, 1559.

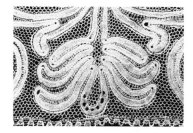

B. Milanese, 17th century.

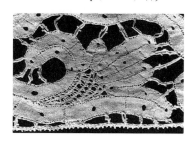

F. Milanese, 17th century.

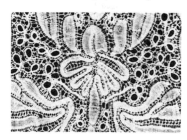

C. Honiton, 1690s.

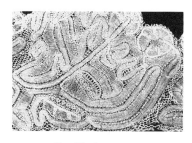

G. Honiton, c1730.

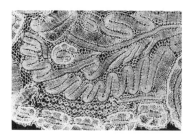

D. Honiton, c1730.

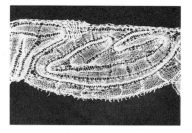

H. Honiton, c1730.

62. The incidence of swirling forms in Honiton and other laces.

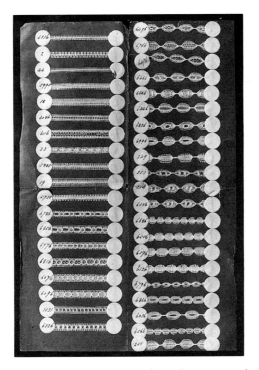

63. Sample card of fancy tapes used in 19th century tape laces.

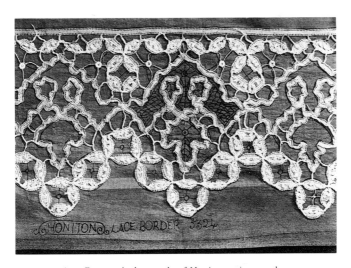

64. Part worked example of Honiton point tape lace.

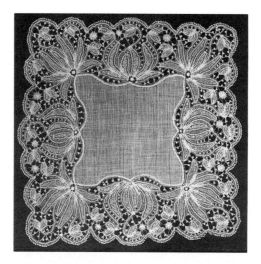

65. Branscombe point handkerchief.

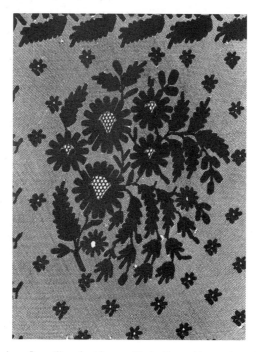

66. Exeter lace, floss silk embroidery on black silk machine made net in imitation of Honiton motifs.

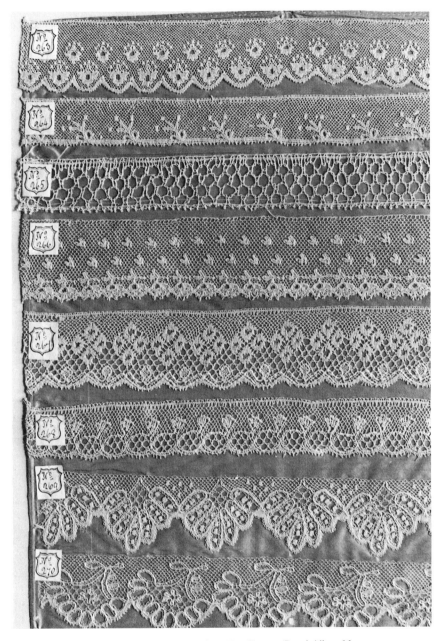

67. Examples of trolly lace made in East Devon (Royal Albert Museum,
Treadwin collection).

68. Woodbury Greek lace (Royal Albert Museum, Palliser collecton).

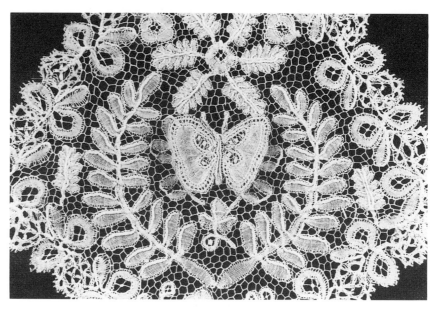

69. Devonia lace with three dimensional butterfly having flappable wings.

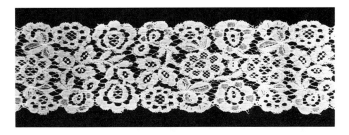

70. Imitation Honiton—Levers machine.

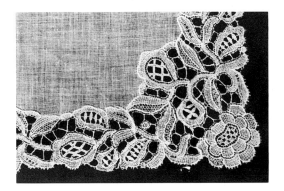

71. Imitation Honiton—Chemical lace.

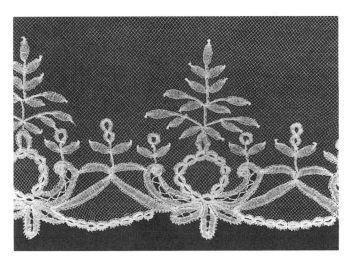

72. Imitation Honiton—tape appliqué on machine made net.

335

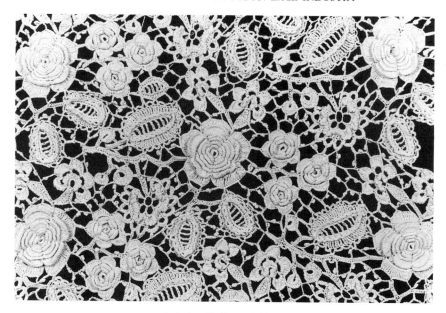

73. Imitation Honiton—Irish crochet.

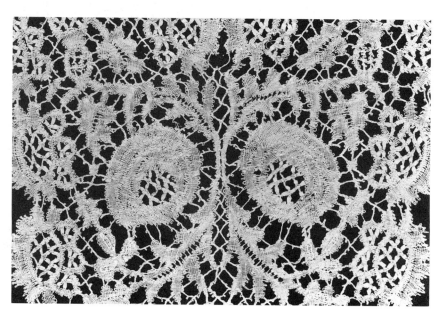

74. Imitation Honiton—Bedfordshire lace.

75. Dew retted flax showing incomplete removal of the woody material from the fibres. (SEM photograph, Department of Engineering, Exeter University).

76. Water retted flax showing more complete removal than in the case of dew retting. (SEM photograph, Department of Engineering, Exeter University).

77. The lacemaker's globe concentrating the light of a candle onto the working area of a pillow.

78. The lacemaker of popular imagination (Rivington's Book of Trades, 1827).

79. The earliest known depiction of a Honiton lacemaker (Leisure Hour, 1869).

80. Mrs Adelaide Salter, lacemaker of Honiton (1851-1939).

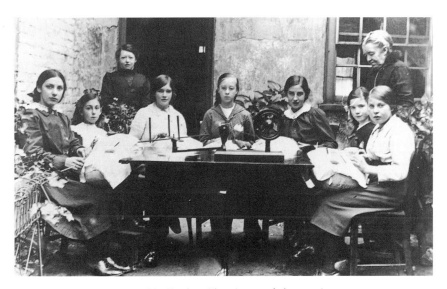

81. Mrs Fowler with assistant and class, 1916.

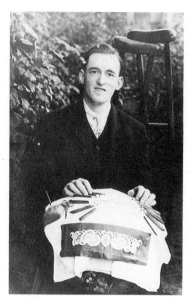

82. Walter Linscott, the last man known to have tried to make a living as a
Honiton lacemaker, c1915.

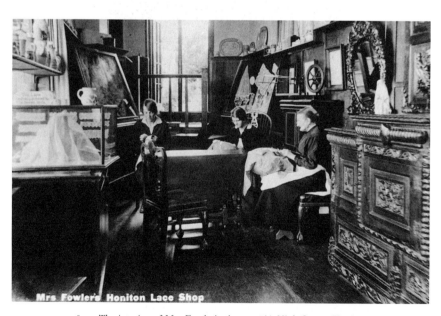

83. The interior of Mrs Fowler's shop at 8½ High Street, Honiton.

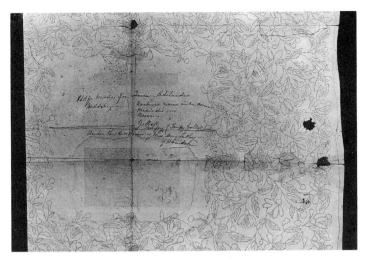

84. Section of a pricking for a handkerchief made for Queen Adelaide under the direction of Amy Lathy, probably 1830. This is the only known surviving example of her work, but there is some resemblance to the Yarde-Buller wedding veil [20].

85. Design by Miss D.B. Ward for the corner of a handkerchief made by Mrs Fowler for Queen Mary, 1910. [53].

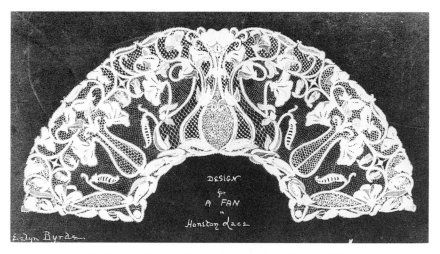

86. Design for a Honiton lace fan by Miss Evelyn Byrde of Honiton.

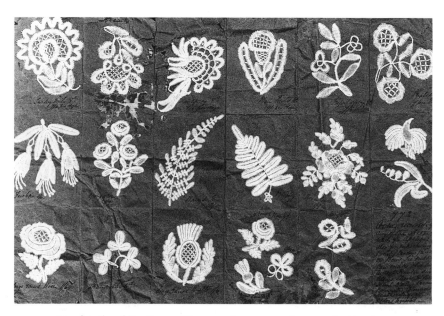

87. Samples of Honiton motifs mounted on paper and annotated with prices.
Such motifs were sold so that ladies could make up their own appliqué pieces.

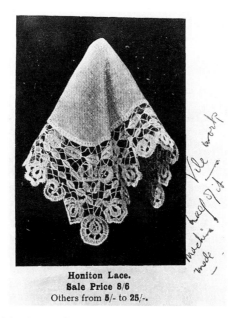

Honiton Lace.
Sale Price 8/6
Others from **5/-** to **25/-**.

88. A candid and justified comment by a lacemaker observed in a copy of the catalogue of a London store.

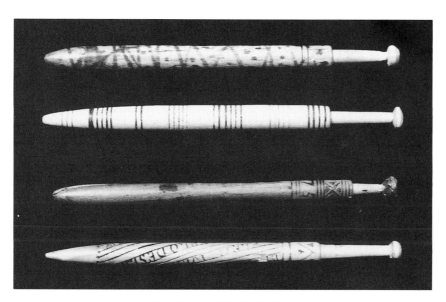

89. Decorated Honiton bobbins.

343

90. Trade card of Mrs Davey (neé Amy Lathy) used before her second royal
appointment.

91. Trade card of Mrs Treadwin (Devon and Exeter Institute).

344

92. Receipt by Ida Allen of Beer for a Honiton lace wedding veil, 1931. [54].

93. Mrs Fowler's notepaper heading, 1910.

94. Amy Lathy's royal appointment warrant, 1830.

95. Mrs Fowler's gold medal certificate, 1904. [50].

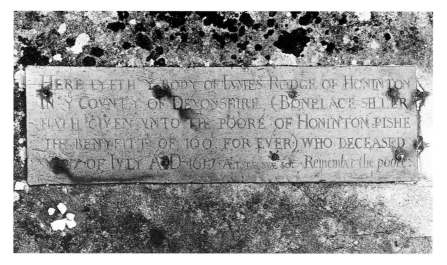

96. The earliest known reference to the Honiton lace industry; the plate on the tomb of James Rodge in Honiton churchyard, 1617.

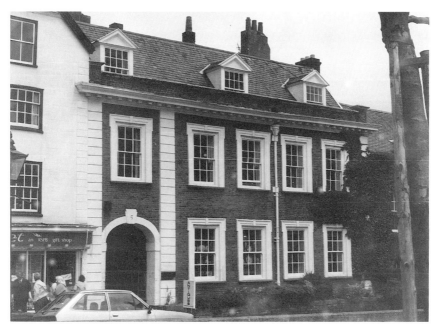

97. The premises formerly occupied by Mrs Treadwin in the Cathedral Close, Exeter.

Index